GEORGIA O'KEEFFE
A Private Friendship

Other books by Nancy Hopkins Reily

I Am At An Age, Best of East Texas Publishers, 1990

Joseph Imhof, Artist of the Pueblos, Sunstone Press, 1998

Classic Outdoor Color Portraits
 A Guide for Photographers, Sunstone Press, 2001

GEORGIA O'KEEFFE
A Private Friendship

PART I
Walking the Sun Prairie Land

Nancy Hopkins Reily

SANTA FE

All dimensions of art work are listed as height followed by width.
Spelling and punctuation in letters are left as is, only corrected for clarification.
Any variance in mileages depends on the individual odometer.

Book design by Vicki Ahl

Sunstone books may be purchased for educational, business, or sales promotional use.
For information please write: Special Markets Department, Sunstone Press,
P.O. Box 2321, Santa Fe, New Mexico 87504-2321.

Library of Congress Cataloging-in-Publication Data:
Reily, Nancy Hopkins, 1934–
 Georgia O'keeffe, a private friendship / by Nancy Hopkins Reily.
 p. cm.
 Includes bibliographical references and index.
ISBN-13: 978-0-86534-451-8 (hardcover: alk. paper) —ISBN-10: 0-86534-451-5
1. O'Keeffe, Gerogia, 1887–1986. 2. Painters—United States—Biography.
I. Title.

ND237.O5R45 2006
759.13—dc22

 2005037491

Published in
WWW.SUNSTONEPRESS.COM
SUNSTONE PRESS / POST OFFICE BOX 2321 / SANTA FE, NM 87504-2321 /USA
(505) 988-4418 / ORDERS ONLY (800) 243-5644 / FAX (505) 988-1025

To my family

Donald Earle Reily
Jane (Read) and Mark Hopkins Reily
Donna Reily Davis

Read Hopkins Reily
Thomas Donald Reily
Carolyn Frances Davis
John Mark Reily
Julia Archer Davis
Anna Catherine Reily

May your life experiences
exceed your visions.

☒ CONTENTS

THE EARLY YEARS 1887-1912 / 17

THE INFLUENTIAL YEARS 1912-1918 / 131

MORE INFLUENTIAL YEARS 1918-1945 / 277

ILLUSTRATIONS / BLACK AND WHITE

Front cover: Georgia O'Keeffe Reclining on Bench, Campfire Outing, Ghost Ranch, Near Abiquiu, New Mexico, ca. 1940

ILLUSTRATIONS / COLOR (DUSTJACKET)

✍ FOREWORD

"The holy calm of nature."
—James Fenimore Cooper

The time was 1946. I met Georgia O'Keeffe in Abiquiu, New Mexico while visiting my Aunt Helen and Uncle Winfield Morten of Dallas, Texas, at their Rancho de Abiquiu.

To know of Georgia O'Keeffe in her early days is to chronicle the historical experiences of the times colored with the great beauty of Sun Prairie, Wisconsin's prairie, sky, people, and culture, and their interactions. From the influence of her Sun Prairie days, Georgia discovered Texas and New Mexico. From these western lands, ablaze with color, space and sky, Georgia formed her sense of place.

In a time when most women chose marriage and children, Georgia dared to dedicate her life to art. With this proclamation Georgia claimed the right to become as original as her paintings. She joined the ranks of American artists capturing the immensity of nature's design to experience in solitude what James Fenimore Cooper claimed as "The holy calm of nature."

In April, 2002, when I walked the Sun Prairie land, the essence of Georgia's prairie and sky was the same as in her times. I observed the surroundings, visualized what Georgia saw, and listened to the past voices. *Georgia O'Keeffe, A Private Friendship, Part 1, Walking the Sun Prairie Land*, explores Georgia's life before I knew her.

This prologue invites you to enjoy *Georgia O'Keeffe, A Private Friendship, Part 2, Walking the Abiquiu and Ghost Ranch Land*. In a narrative of excerpts featuring my youthful experiences, glimpses of my family's memorabilia and photographic snapshots, I tell of Georgia's human scale as revealed with the landscape, culture, people and history.

ACKNOWLEDGMENTS

In my continuation of writing of "what I know" and how I "walked the land" many people contributed to the journey. Thank you to: Jane Duncan Ainsworth, Clauda C. Baker, Barbara Barrett, Ursula Beck, Carl Bode, Derek Bok, Frank Bowie, Denise Bowley, Debra K. Burton, Sister Marjorie Buttner, OP, Pauline Hopkins Castleberry, Joe Chase, Elizabeth Clementson, Amy Cook, Jane Ewing Cramer, Frederick T. Dove, Marianna G. Duncan, Joan N. Duncan, Laurie H. Dunlap, Teresa Ebie, Lucille Enix, Ray Franks, Joy A. Fredrick, Napoleon Paul Garcia, Sr., Joyce E. Gray, Barbara Hays, Ellen Herring, Michelle Holt, E. Morten Hopkins, Jane Reynolds Hopkins, Joanne Schneider Hopkins, Robert H. Hopkins, Jr., Elizabeth Hyde, Caroline K. Keck, Ann Kuhlman, Jim W. Kuhlman, Melvin Kurth, Paula Devereaux Kurth, Abbot Philip Lawrence, OSB, Gregory Letney, Herman Letney, Stanley Marcus, Molly Martin, Robin McKinney Martin, Eunice Mayhew, Jeanelle McCall, Carol Merrill, Helen Morten, Winfield Morten, Jerrie Newsom, Allen Nossaman, Ann Paden, Chris Palmer, Willie Picaro, Linda Pogozelski, Jean Dudley Reily, Roxana Robinson, Versia Sanders, Michael K.

Smith, Harry W. Stafford, Jane Starks, Mary Jule Tatum, Doug Terry, Thelma Terry, Betty B. Tucker, Sharyn R. Udall, Joelle Walker, Mary Twohig Wilson, Barbara Witemeyer, Christopher With.

I am indebted to the skills of many reference departments of libraries, museums and archive collections. They kept the book moving forward with my routes of ingress and egress into the land's color, people, culture and history. Thank you to: Loretta Torres, Grace Salazar, Isabel W. Trujillo, Abiquiu Public Library; Kathleen Kienholz, American Academy of Arts and Letters; Amarillo Public Library; Tomas Jaehn, Angélico Chávez History Library, Palace of the Governors; Bart Ryckbosch, Art Institute of Chicago, Ryerson Library; Maria Fernanda Meza, Cristin O'Keefe, Artists Rights Society; Frederick T. Dove, Charlottesville Albemarle Historical Society; Del Moore, The Colonial Williamsburg Foundation, John D. Rockefeller, Jr., Library; Dallas Museum of Fine Arts; Dallas Public Library; Walter DeClerck, Dar al-Islam; Gretchen Dowling, Elizabeth Arden; Victoria Fox, Farrar, Straus and Giroux, LLC; Sarah Burt, Barbara Buhler Lynes, Agapita Judy Lopez, Georgia Smith, Georgia O'Keeffe Foundation; Edgar W. Davy, Barbara Schmidtzinsky, Ghost Ranch Education and Retreat Center; Kim Bush, Guggenheim Museum; David Witt, Harwood Museum; Carmen K. Little, Don McManus, Julie Massey, Kurth Memorial Library, Lufkin, Texas; Museum of New Mexico; Museum of New Mexico History Library; Arthur L. Olivas, Museum of New Mexico, Photograph Archives; Gini Blodgett, National Press Club; Anthony Montoya, Paul Strand Archive, Aperture Foundation; Michael Grauer, Betty Bustos, Panhandle Plains Historical Museum; Holly Frisbee, Philadelphia Museum of Art; Jérome Monoukian, Rodin Museum, Paris, France; Ken Gallagher, Michele Barbieri, Sanborn Map Company; Santa Fe Public Library; Peter Michael Klein, Sun Prairie Historical Museum; Dick Rhody, Suburban Studio, Sun Prairie, Wisconsin; Steve Guldan, Sustainable Agriculture Center, Alcalde, New Mexico; Patsy Chávez, United States Department of Agriculture, Forest Service, Coyote Ranger Station; Cathy Jacob, Steve Massar, Bernard Schermetzler, University of Wisconsin-Madison Archives; Barbara Frank, Waco-McLennan County Library; Joseph C. Cepeda, West Texas A&M University; Liza Hinzman, Geraldine Strey, Wisconsin Historical Society; Jennifer Lawyer, Adam Marchman, Patricia Willis, Yale University Beinecke Rare Book and Manuscript Library.

Grateful acknowledgment is made to the following for permission to quote from copyrighted material and/or unpublished material. Thank you to: Patricia Willis, Beinecke Rare Book and Manuscript Library, Yale University, New Haven,

Connecticut, Yale Collection of American Literature, Alfred Stiegltiz/Georgia O'Keeffe MSS-85 Archive; Dover Publications, *Concerning the Spiritual in Art* by Wassily Kandinsky; Kent State University Press, *Kenyon Cox, 1856–1919, A Life in American Art*, by H. Wayne Morgan, 1994, Kent, Ohio; Peter Michael Klein, *Sun Prairie's People, Part 1, Shadows and Dreams*, Sun Prairie Historical Library and Museum, Sun Prairie, Wisconsin, 1993; Jim W. Kuhlman, *The Block Pasture*, Iowa Printing Services, Mason City, Iowa, 1998; La Alameda Press, Albuquerque, New Mexico, distributed by University of New Mexico Press, *O'Keeffe, Days in a Life*, by C. S. Merrill, 1995, poem number eighty-four; The Georgia O'Keeffe Foundation, Abiquiu, New Mexico; Estate of Ronald G. Pisano; Simon and Schuster Adult Publishing Group, from *Lovingly Georgia: The Complete Correspondence of Georgia O'Keeffe and Anita Pollitzer*, edited by Clive Giboire, Letters of Anita Pollitzer, copyright © 1990 by the Estate of Anita Pollitzer, copyright © 1990 by Tenth Avenue Editions, All rights reserved; University of New Mexico University Libraries, Center for the Southwest Research.

My family accompanied my journey. Thank you to: Donald Earle Reily, Jane (Read) and Mark Hopkins Reily, Donna Reily Davis, Read Hopkins Reily, Thomas Donald Reily, Carolyn Frances Davis, John Mark Reily, Julia Archer Davis, Anna Catherine Reily.

For joining in the passage, thank you to: Brenda Meeks who punctuated each meeting with joyful willingness; Carl Condit who greeted me with pleasant efficiency; Vicki Ahl who created the spirit of the book's design; and to James Clois Smith, Jr. who welcomed me beyond my highest expectations as he executed his editorial expertise.

Lastly, I thank you, the reader, for walking the land with me as the past and present come together.

THE EARLY YEARS
1887–1912

1

HERITAGE FROM THE PRAIRIE AND SKY

"Where I come from, the earth means everything."

-Georgia O'Keeffe

Georgia's journey to discover her "faraway, nearby" began shortly after her home birth on Tuesday, November 18, 1887, only three and one-half miles southeast of Sun Prairie, Wisconsin.[1]

The not-taken-for-granted Wisconsin landscape of broad, rolling expanses, striking to any one's eye, was caused by the creeping tongues of Canada's glacial ice as early as 700,000 years ago. Roughly 23,000 years ago the last glacial ice penetrated southward leaving various land features. The ice-scraped hilltops filled in valleys to form the flat plains in south central Wisconsin. As the ice melted and the glaciers wasted, thick deposits of earth materials caused the water's drainage to stagnate, forming marshes and lakes. Escaping water turned into rivers which formed the original "roads" that moved people and goods. Chief among the life-giving river systems, the Wisconsin River rises on the northern Wisconsin border to flow four hundred thirty miles south through the heart of the rolling prairie, past Portage, then makes its westerly turn to join the Mississippi River at Prairie du Chien.[2]

In this southern Wisconsin area, formed by tremendous forces deep within the earth, rose the town known today as Sun Prairie, only one hundred miles east of the Illinois border and in the unbroken wilderness west of Milwaukee at an elevation of nine hundred fifty-one feet. Its gentle low ridges and smooth rounded hills harbored only a trace of the last glaciers and left groves of oak, hickory, and black walnut trees with occasional black cherry and chokecherry trees among the prairie. Scattered marshlands, meadows, and creeks leading into shallow lakes completed the terrain of the top layer of loam, then clay, then limestone—all part of the bottomland of the Wisconsin River.[3]

Approximately 15,000 years ago the Mound Builders and Copper Age people lived there as evidenced by the mounds full of tools and weapons found at their sites. Later the Winnebagos, among several Wisconsin Native American tribes, claimed this land. In the 1660s the French brought in their missionaries, trappers and explorers, each looking for converts, furs, and a shorter route to the China seas. For about three hundred years the Winnebagos made contact with the Euro-Americans for their fur trade. Other than the established forts, including one at Fort Winnebago at Portage in 1828, Wisconsin remained a wilderness. The Winnebagos' game reserves depleted and a smallpox epidemic in 1834 killed one-fourth of their tribe in Portage. With other diseases brought by the missionaries and fur traders, the Winnebagos, forced by the United States government between 1829 and 1848, gave up their lands to live on fixed reservations.[4]

The Euro-Americans had little interest in the land until the Federal Land Survey of 1831–1835 that classified the land as first, second and third rate with its rolling prairies interlaced with marshes, creeks and groves of trees. Surveyors often further specified the features as "prairie," "copse" (a sparse growth of briers, saplings, wild plum, sumac, dogwood, elderberry, scrub oaks, wild cherry, etc.), "oak opening," "marsh," "bottomland" and "run." The prairie established itself as the outstanding feature covered with grass and herbaceous plants. The Sun Prairie area qualified for a "first" rating, the outstanding feature being the large, thick crescent shaped prairie several miles long. The prairie separated by stretches of thickets and timberland lay under a giant umbrella of blue sky.[5]

The revealed agricultural possibilities of the Sun Prairie area as surveyed for running boundary lines of Indian treaty lands, exterior township lands, and even sub-divisions, brought a rush of Euro-Americans in the 1830s to settle this virgin prairie.[6] With only one road through this newly surveyed land the first Wisconsin

Territorial Legislature in December, 1836, acted to "locate a territorial road from the town of Milwaukee, via the town of Madison, to the Blue Mounds."[7] See figure 1-1.

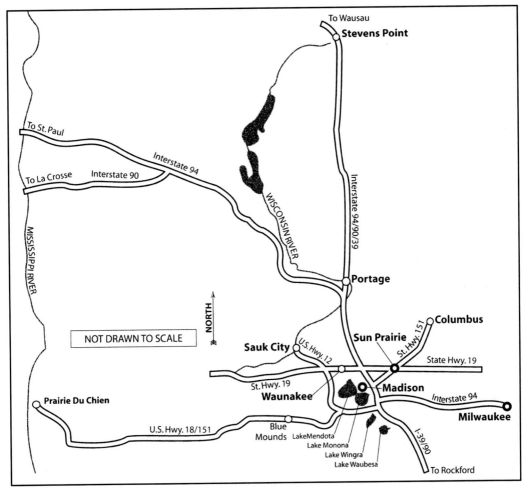

1-1 *Map of Sun Prairie, Wisconsin, Area*

The road passed near Sun Prairie and ended thirty to forty miles west of Sun Prairie at the "Blue Mounds," so named because the mounds were the only evidence of ancient dwellers in the land. The earthwork could be seen as covered with fog that looked blue.[8]

Today the State Historical Society acknowledges the presence of mounds in

Sun Prairie on a hill overlooking what is now called Patrick Marsh.[9]

The Legislature selected Madison, at an elevation of eight hundred sixty-three feet, as the capitol. President Van Buren commissioned Augustus A. Bird to build the capitol.[10]

On May 26, 1837, an expedition of forty-five men, mostly laborers led by Augustus Bird, left Milwaukee. Equipped with cooking utensils, provisions, and mechanical tools to begin the operations at the capitol, they made their own road as they traveled for days in the dismal rain. On June 9 the group emerged at the edge of the prairie about one and one-half miles east of the now Sun Prairie just as the sun erupted from the rain-filled clouds to showcase the expanse of prairie.[11]

Stories handed down from persons who have a vested interest in the telling of the times to other persons are often surrounded by legends and myths. Sun Prairie, rightfully named out of history and topography, advantaged other towns by having more than one legend about its naming, all based on one fact—the sky opening and the sun emerging after days of rain.

A Bird family member offered a description of Augustus Bird's journey at the dedication of Angell Park in Sun Prairie in 1903:

> The journey from Milwaukee had been laborious and toilsome, with the skies constantly overcast, the rain continuously falling and the gloom of the darkening days pressing heavily upon us. But when we reached the prairie that skirts your village the sun suddenly appeared through a rift in the clouds and dispelled the gloom of the previous days, sending a thrill of joy to our hearts in view of the country spread out before us. The prairie from that circumstance was then and there, and with thanksgiving, appropriately named "Sun Prairie."[12]

Another Bird family member orally accounted for the naming of Sun Prairie to Augustus Bird's brother, Charles H. Bird, who carved "Sun Prairie" on a large burr oak tree.[13]

The oldest written account by a German explorer in 1855 claimed:

> Suffice to say that bad weather, rain, fog and the worst of trails plagued him on the trek.... At last, after days, the sun peeped out, exceptionally bright and most delightful. It illuminated beautifully the prairie... They

decided to name the place after what happened. He recorded on a board the name, circumstances, and date. After his companions had signed the wooden document, he nailed it to a picket inside the trail. The name stuck. The place near Madison, to the east, is still called Sun Prairie.[14]

At this location Augustus's brother, Charles H. Bird, returned in 1839 to become the first white settler surrounded by Winnebagos. At first he lived in a hunting cabin, later replaced by a peaked roof house painted yellow like New England homes. In 1844, Jerrimiah Brayton, Bird's father-in-law, sold five acres of land to Charles Bird and Colonel William Angell. In 1846, Bird and Angell decided to found a village. By 1850, merchandising with a general store was in full swing with the Native Americans. A dance hall and a hotel added to the community. The Chicago, Milwaukee and Saint Paul Railroad had its terminus in Sun Prairie in 1859. The railroad established Sun Prairie as the grain market center, thus the village expanded with new houses, streets, grain elevators and hotels. The village was incorporated in 1868. When the railroad continued on to Madison in 1869 and discontinued using Sun Prairie as a terminus, the depression of 1870 forced Sun Prairie into dairying and stock farming. But good times came by the 1880s. Sun Prairie's cultural life grew as churches abounded, schools that had begun in 1842 continued, and municipal improvements improved daily living with a water works in 1899, telephones in 1900 and an electrical plant in 1900.[15]

The naming of Sun Prairie lingered not just on the earth but intertwined with the sky pierced by the sun. The sky free of roads, pull-offs, scenic overlooks, or entrance gates since the beginning of history, shaped the destiny of all by its bounty of sunshine and moisture to form creeks, canyons, and even the routes of travel from city to city. The view in any direction offers nature's changing colors, allowing the sky to rule the whole of the earth. The prairie became a complimentary, secondary color to the over-prevailing sky.

The mere name, Sun Prairie, must have imbedded in Georgia a liking for prairie and sky. She would never tire of space as long as she could see far enough as phrased by Ralph Waldo Emerson in 1836, "The health of the eye seems to demand a horizon."[16] To Georgia, the view in any direction offered nature's changing colors for the sky appeared loose from its earthly moorings and ruler of the whole of the earth. Her sky with its clouds shifting, dancing, fading and

growing bigger easily symbolized the mysterious and spiritual. She could easily see more sky than prairie to establish a sense of place. Her sense of self and her sense of place became intertwined. At an early age Georgia must have sensed an unwavering regard for the sky as her never-ending "far."

Georgia's seeing the earth's colors saturated with textures must have given her a feeling of "discovery," the same feeling anyone has when looking at art with its continuous, surprising beauty. Her intimate scrutiny of the earth's crust as the land quietly breathed form through the ages became her everlasting "near." She recalled many years later: "Where I come from, the earth means everything. Life depends on it."[17]

From these origins could have come Georgia's harboring forever a feeling and need for spaciousness intertwined with her need for freedom to concentrate on herself. After a successful career as an artist Georgia declared, "Where I was born and where and how I have lived is unimportant. It is what I have done with where I have been that should be of interest."[18] But in the land of her birth and where Georgia called home the prairie and sky never strayed from her consciousness as she was drawn to large, strong shapes and slashes of color.

Into this blend of prairie, sky, and legend came Georgia's Irish grandparents on her father's side, Pierce and Catherine Mary (Shortall) O'Keeffe, using different spellings of the O'Keeffe name.[19]

Prosperity flourished in Ireland during the European wars between 1793 and 1815. The Irish farmers provided food for the wars and the expanding English population. The Irish depended on the potatoes for their crop yield. But potato crop failures began in 1822 and a fungus destroyed their crops which began the Great Famine of 1845. Discouraged farmers planted less potatoes and the yield didn't even feed their families. Out of a population of less than nine million, at least one million Irish died of malnutrition, scurvy or fever.

The fallout extended to other facets of Irish life. Delayed marriage, celibacy and emigration became ways to handle the living conditions. The Irish Catholics who had vowed to always live in Ireland adjusted their thinking as a result of the famine and began thinking of emigrating. They joined the massive emigration from Europe to all parts of the world in the late 1840s and 1850s. In the 1840s, forty-five percent of all new arrivals in the United States were Irish but the ratio declined in the 1850s. In 1845, 77,000 people immigrated from Ireland; in 1846 106,000; and emigration peaked at 250,000 in 1851. Often the poorest families

moved in two stages by sending one family member with relatives or friends, then this one member remitted funds for the remainder of the family. As the family finances improved in Ireland, moving to the United States came not from desperation but from a concern for their family's well-being. The most destitute Irish only migrated as far as Great Britain, but Canada and America became the destination of others.[20]

In addition to the Great Famine of 1845, economic change came about as the factories in the northeast of Ireland could not keep pace with the successful English factories. The result was that many urban artisans, merchants and professionals could not make a living. These Irish immigrants possessed qualities similar to those in the United States.[21]

With the mass arrival of the Irish in the eastern urban areas of the United States, the Irish filed into their ghettos and started at the bottom of the economic ladder. By their sheer numbers the Irish immigrants advanced the urbanization and industrialization of America as they worked at dangerous jobs and helped build roads and railroads. But there was a wave of selective, more resourceful Irish immigrants—those skilled and literate—who filtered westward through the Great Lakes for less gloomy inland conditions. They shed the Easterners' concepts of the Irish being of "weak character" and of Easterners considering themselves the only true Americans and all other to be just Irish-Americans or German-Americans.[22]

Georgia's great-grandfather, Edward Joseph O'Keeffe, born in 1770 in County Cork, had two sons: Pierce, born in 1800 in County Cork and who died in 1869, and Henry O'Keeffe, born in 1805 in County Cork and who died June 18, 1871.[23]

Edward Joseph's oldest son, Pierce, became part of the massive Irish emigration. A Catholic, Pierce suffered in the fallout from the Great Famine of 1845 when his family woolen business foundered from too much taxation. Regardless of the importance of family, most emigrants in the early nineteenth century were unmarried. O'Keeffe arrived from Liverpool in New York on April 22, 1848, with his wife Mary Catherine (Shorthall) O'Keeffe. The O'Keeffe family migrated through the Great Lakes to the Township of Sun Prairie in the summer of 1848.[24]

By now the Irish were experiencing upward gains in occupations, establishing themselves in neighborhood churches and paving the way for future generations. In the open prairie of Sun Prairie, the O'Keeffe immigrants probably

encountered less of a barrier to social and economic position than they would have in the Eastern cities

The original township of Sun Prairie included the towns of York, Medina and Bristol with a population of 1,553 in 1846. With its own post office and the creation of the town of Sun Prairie, the 1850 population consisted of five hundred six people. Most of the land remained wooded with natural meadows. Farming consisted mainly of growing wheat and winter wheat.[25]

North of the Sun Prairie township, Bristol, originally part of Sun Prairie township, became an independent township on March 11, 1848. The exact dating of Pierce O'Keeffe's first land purchase is problematic. With a backlog in the General Land Office in Washington, D. C., "it was not unusual for several years to pass between the time an individual purchased land from the local land office and the time a patent for the tract was finally signed by the General Land office."[26]

Pierce came to Sun Prairie with the family silver and china tea set to signify that his family had arrived with money.[27] Patent land during this time sold for $1.25 an acre. There is speculation that Pierce bought land in Bristol before he bought the land in Sun Prairie that is known as the Pierce O'Keeffe home. Bristol records that could have had delayed recording list Pierce O'Keeffe buying two hundred forty acres in Bristol on January 1, 1850, and a second purchase of forty acres the same day in Bristol. Bought as an investment, it is doubtful that Pierce ever lived on his Bristol property because he sold the parcel of land one year later.[28]

As recording possibly became current on July 10, 1848, Pierce and Catherine purchased one hundred sixty acres of marshland in Section Eight along Koshkonong Creek, near today's Linnerud Drive and South Bird Street.[29] See Sections 21, 27, 28 of the plat of O'Keeffe's land, 1899. See figure 1-2.

Land with standing water was called moorlands, or bottomland if the land bordered the small streams. Regardless of the terminology, Pierce's land remained marsh land because water stood in all but the driest seasons. This land was originally far wetter than today. Pierce more than likely quickly found this wet land unsuitable for farming, but good for cattle raising.[30]

A little over three and one-half years later on October 20, 1853, Pierce bought an additional forty acres and another forty acres in another section where he built his house, the original O'Keeffe homestead south of the home Georgia knew as a child.[31] See figure 1-3.

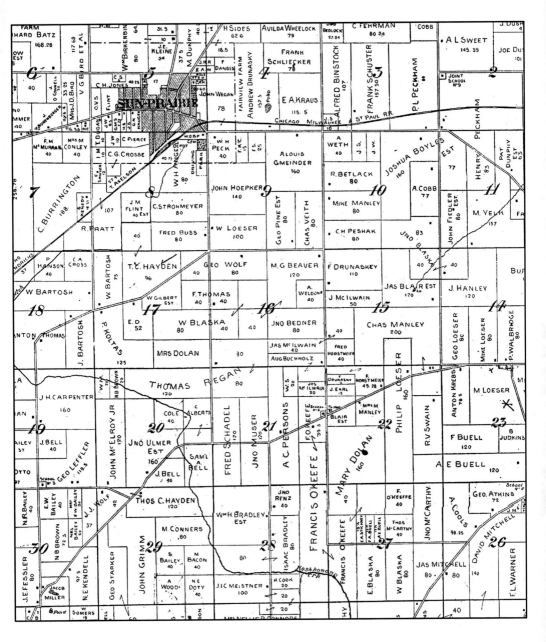

1-2 Plat of O'Keeffe's Land, 1899

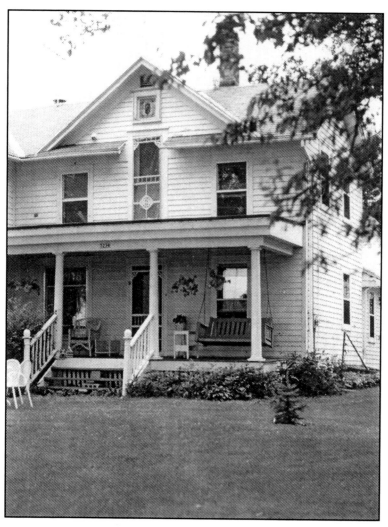

1-3 Catherine and Pierce O'Keeffe's House

The oldest part of Pierce's house featured a stained glass window. Later additions made the house larger. Past Pierce's house, the land stretched into an openness to Koshkonong Creek in the lowland marshes.

For Pierce to have an Irish wife to match his Irishness added to his standing among other Irish in the community. Plus, for "social insurance," Pierce and Catherine had four children: Boniface, who died November 16, 1888 at age

thirty-eight; Francis Calyxtus, who died November 5, 1918, at age sixty-five; Peter, who died October 23, 1883 at age thirty; and Bernard, who died September 3, 1898 at age forty-two. Francis Calyxtus would be the only son to marry.[32]

Dr. Charles G. Crosse arrived in Sun Prairie ten years after Pierce's arrival. A native New Yorker, Crosse received his medical degree from Cincinnati Medical College. After setting up his practice in various towns, Crosse moved to Newport, Sauk County, Wisconsin where he invested in a land speculation deal anticipating the arrival of the railroad to Newport. When the railroad bypassed Newport, Crosse lost considerable money, forcing him to reestablish his medical practice in Sun Prairie in 1860. Crosse soon earned respect in Sun Prairie for his concern for his patients and his tireless efforts to better the community.[33] In December 1877, Crosse, living at 133 West Main Street in a Gothic revival frame residence with barge board trim, and his son, Charles S., published Sun Prairie's first edition of *The Countryman*.[34] Crosse's use of his newspaper included recording the daily activity of the area, presenting his firm ideas and beliefs, and reporting the rural news by categorizing the news according to the rural school or the settlement at the crossroads.[35]

In time Pierce's land and liking for the area became the focal point for what became known as the O'Keeffe Neighborhood near the intersection of Town Hall Road and County Road T. Pierce's interest in his community and the rural news from the O'Keeffe Neighborhood captured the attention of *The Countryman*.[36] From all indications, Pierce and Catherine liked the farming life that Sun Prairie offered. Forward-looking Pierce, seeing the need for good roads for the dairy farmers to deliver milk products, supported improvements for roads. Pierce, aware of tuberculosis, would have destroyed his dairy herd if contaminated milk existed in his herd.[37]

Churches were an important part of Sun Prairie. Pierce, a Roman Catholic, became one of the founders and a trustee of the 1863 wooden Sacred Hearts of Jesus and Mary Catholic Church at 227 Columbus Street. Its wooden 22 x 32 foot structure became the first Catholic parochial school where the O'Keeffe family worshiped weekly, seated in their designated family pew.[38]

With only three donations larger, Catherine continued her church participation by donating $350 toward the completion of a new church in 1886 and 1887. The completed church cost $14,933.48.[39]

Farmers endured a scarcity of money and they often paid for services

by trading or bartering. Patrick Doyle, Sun Prairie's first blacksmith, knew the community could not exist without his craft. For non-payment of his services for repairing the farmer's tools, Doyle often sued the farmers. An early document stated that Doyle brought a lawsuit against Pierce for non-payment in 1852. This case with court costs amounted to $2.29.[40]

Pierce died on August 11, 1869, at age sixty and was interred in Sacred Hearts Cemetery.[41]

Catherine's presence provided a role model for Georgia. Catherine's sweet disposition did not deter her orderliness and discipline. As expected for the times, Catherine painted still lifes of fruit and flowers which indicated some natural talent for Georgia to follow. Catherine lived much longer than Pierce. On February 27, 1896, The Countryman reported "Mrs. Catherine O'Keeffe suffered a colles fracture of the radius of her left arm Thursday afternoon. This was the result of a fall sustained while about her duties at her home in the township. She was walking across the room when she slipped and fell." Not quite two years later Catherine died at eighty-three years of age at her home from the infirmities of old age. The Countryman reported November 4, 1897, "The deceased was a woman of high intelligence and commanded the respect of all who knew her."[42] With Catherine's death, Georgia, at age ten, lost one of her role models, but her mother's influence remained for Georgia's lifetime.[43]

When Pierce died, Francis ended his schooling in his adolescent years and placed himself in the family farm fields with his brothers, Peter and Boniface. Francis became "land rich" and not especially well-educated.[44] Peter had left home in 1874, lived in Florida, then Saint Louis, and contacted tuberculosis before returning to the Sun Prairie farm in 1883 to spend his last days.[45] Francis, seeing his first brother die, must have become aware of life passing by in a hurry because about this time he started courting Ida Totto, a woman of education and aristocratic presence.[46]

Georgia's grandparents on her mother's side, George Victor Totto and Isabella Wyckoff Totto, arrived in Sun Prairie in the mid-1850s.[47]

George Victor Totto, a Hungarian count, was born in 1820. According to legend his arrival in America resulted from his Hungarian political beliefs.[48]

The Danube River bisects a land-locked Hungary in central Europe. The Magyars who came from Asia settled Hungary in the ninth century and absorbed the tribes in the area. They accepted Roman Catholic Christianity in 1001. Because

of their location in the Carpathian Basin, a crossroads between East and West, their history is filled with war, invasions and occupations. Through their suffering they became a bulwark of Western Christianity and civilization. In the thirteenth century Genghis Khan overran the country, but Hungary survived, then held off the Turks and thrived until neighboring Austria's House of Hapsburgs gained control of Hungary in the mid-nineteenth century.[49]

At that time, in 1848, Louis Kossuth declared the country independent of Hapsburg rule. He envisioned a Hungary participating in a vibrant democratic system based on equality and parliamentary representation. Russia joined with the Hapsburgs and defeated the rebellion led by Kossuth.[50]

George Victor Totto's participation in the 1848 Hungarian revolt against Austria for self-rule placed him in a treacherous predicament as he owned considerable land.[51]

After his defeat Kossuth fled the country in August 1849. With four thousand refugees Kossuth came two years later to the United States as the first foreign statesman officially invited to the United States since the Marquis de Lafayette. He met with President Millard Fillmore, Secretary of State Daniel Webster and Ralph Waldo Emerson. A speech before the pre-Civil War United States Congress caused nervousness because of his democratic views on the equality of all men.[52]

On February 16, 1852, a decade before Lincoln's Gettysburg Address, Kossuth spoke to the Ohio State Legislature: "All for the People and All by the People; Nothing About the People Without the People—That is Democracy!"[53]

In May of the same year Ralph Waldo Emerson said on meeting Kossuth in Concord, Massachusetts, "[we] have been hungry to see the man whose extraordinary eloquence is seconded by the splendor of the solidity of his actions."[54]

Democratic America turned him away and he returned to Europe. The Compromise of 1867 led Austria and Hungary into equal partnership in an Austro-Hungarian Empire ruled by the Hapsburgs. More recently, the fight for Hungarian democracy was fought for in 1956 and gained in 1989.[55]

Hungarians have arrived on New World soil since America's discovery. One Hungarian is alleged to have sailed with Leif Ericson and others fought in the American Revolution. Hungarians flooded into the United States where wages were higher, performed hard work, and lived cheaply in America. Becoming

"sojourners," they then returned to Hungary to improve their land and satisfy any ambitions in the homeland. Some simply revised their plans and remained in America.[56]

The first wave of Kossuth followers arrived in America in December 1849. One Hungarian immigrant was Agoston Haraszthy (1821–1869) who preceded George Victor Totto's arrival in the mid-1850s.[57]

Haraszthy, born in 1812 at Futak in Bacska County, Hungary, was from one of the oldest, most influential noble families, their name appearing frequently in Hungarian history over a period of seven hundred sixty years. As the custom prevailed, Haraszthy received an education in law. At eighteen years of age he received his commission as a member of the bodyguard for Emperor Ferdinand. Later his position and education offered him positions as chief executive officer of his state and private secretary to the Viceroy of Hungary. During this time he developed a close friendship with the future Hungarian 1848 Revolutionary hero, Louis Kossuth. Haraszthy's leadership of his party in the Hungarian liberal movement of 1839 and 1840, feeling the heat of the Austrian Empire, the arrest of Kossuth for treason, and subsequent failure of the movement compelled him to leave Hungary.[58]

Haraszthy's arrival in New York and his travels over the United States led him to write a book praising America's resources and inviting emigration from Hungary. It was the first published book in the Hungarian language on such a subject.[59] He was invited by President John Tyler (1790–1862) to discuss commercial relations of his country and the United States. In his full-dress Hungarian uniform he added sparkle to the Washington social season. His American tour included visits to Ohio, Indiana, Illinois and Wisconsin.[60]

Haraszthy possessed important Hungarian state papers and was given permission to return to Hungary for a year. Although his Hungarian estate did not escape confiscation, Haraszthy saved $150,000 and convinced his family to immigrate to America. Coupled with his wife's substantial dowry, he returned to America with his family's paintings.[61]

His land purchase near a lake a few miles from Madison ended with his being swindled out of the title to the land. Furious at such a maneuver, he relocated on 6,000 acres on the Wisconsin River three miles south of Prairie de Sauk. He named his colony Haraszthy.[62]

These colonists set out to build the town of Szdptzj (Beautiful View) which

was later changed by the residents to Sauk City. As a Wisconsin writer in 1874 declared:

> In 1842 a wealthy Hungarian nobleman named [Agoston] Haraszthy, with a company of attendants and servants, numbering about twenty, came to the United States, intending to settle in the territory of Wisconsin and form a colony. Upon his arrival in Milwaukee, at that time a frontier village of not less than 3,000 inhabitants, was hailed as an important event. Of course, a gentleman traveling all the way from Europe with such a large retinue, and paying promptly in gold for everything he purchased, was notably presumed to be possessed of fabulous wealth, and his coming to that far-off territory was hailed as a harbinger of great prosperity.[63]

In Wisconsin, Haraszthy's successes included mercantile endeavors, building and owning steamships, supplying Fort Winnebago with wood, and becoming the first to plant hops in Wisconsin. As head of the Emigration Association of Wisconsin, he was responsible for settling large colonies of English, German and Swiss emigrants in Wisconsin.[64]

When Harazsthy learned of the Hungarian Revolution of 1848, he led and funded a group who gathered arms and ammunition to send to their Hungarian countrymen.[65] But by 1849, Harazsthy had left Wisconsin for California where he later became known as the "Father of the California Wine Industry."[66]

Georgia's grandmother, Isabella Wyckoff, born of Dutch ancestry and with the distinction of having one ancestor who arrived on the *Mayflower*, lived in New York with her father, Charles, her mother, Alletta, and her sister, Jane Eliza (Jennie). Following in his father's footsteps, Charles became an innkeeper. In bustling New York, George Victor Totto met Isabella Wyckoff, who would become his wife.[67]

After Alletta's death, Charles married Elizabeth, a widow from New Jersey. With Totto's knowledge of Sauk City, it is possible that Totto influenced Charles's restlessness to move to Sauk City where he managed a small hotel. Charles died of cholera shortly afterward in 1854, leaving his two daughters with their stepmother, Elizabeth. The two daughters chose matrimony: Jennie to Ezra L. Varney, Isabella to George Victor Totto.[68]

Totto had envisioned that Sauk City, Wisconsin, would be a safe place

for his beliefs, only to discover the community was German. Unsettled by the German element, Totto and his wife moved to Waunakee, north of Lake Mendota, then to Westport in 1864. By 1872, they had settled in Sun Prairie. Here they bought acreage southeast of the Pierce O'Keeffe land. Town Hall School records indicate that George Totto constructed a fence for the school earning him $1.12. George Totto eventually left for Hungary, never to return. Speculation is that he was involved in internal politics in his homeland.[69]

When George Totto left Sun Prairie, his wife, Isabella, being strong of character, moved to Madison with their six children: Alleta ("Ollie"), Josephine, Charles, Ida, Leonore ("Lola") and George. Isabella's authoritarian voice provided Georgia with another female role model as Isabella went about the business of raising her children in a university community, managing the family's finances, and thinking little of making her own decisions as a way to control impending disaster. Isabella would live in Madison until she died on Friday, April 13, 1894, in her home on Spaight Street. Of her six children, only Ida would marry.[70]

Ida, of half-Dutch and half-Hungarian ancestry, had continued living with her mother, Isabella, in Madison, and displayed the same capabilities as her mother with a strong sense of self. Isabella stressed the importance of studying and Ida considered a medical career. Francis Calyxtus O'Keeffe, from the neighboring Sun Prairie farm his family had leased from the Tottos, came calling on Ida. She weighed the proposal deliberately and did not fall into the usual belief of the times that matrimony provided the only happy ending for her life. From Isabella's spirit, Ida had accepted that her life demonstrated value as a woman, not merely as a wife.[71]

On February 19, 1884, in Grace Episcopal Church at 116 West Washington Street on the square in Madison, the third son of Pierce and Mary Catherine O'Keeffe, Francis Calyxtus O'Keeffe, married Ida Totto, the second daughter of George and Isabella Wyckoff Totto.[72]

Ida returned with Francis to Sun Prairie. Francis, the last of the brothers, had inherited everything. Money may have been scarce but Francis owned land. They settled on Totto land and Francis built their home on the Totto home site possibly by adding an addition to the existing home, complete with a barn. The immigrants skillfully built barns which provided an inheritance. Their life was simple and Georgia would always remember the barn on their six hundred acres which included the Totto holdings.[73] See figure 1-4.

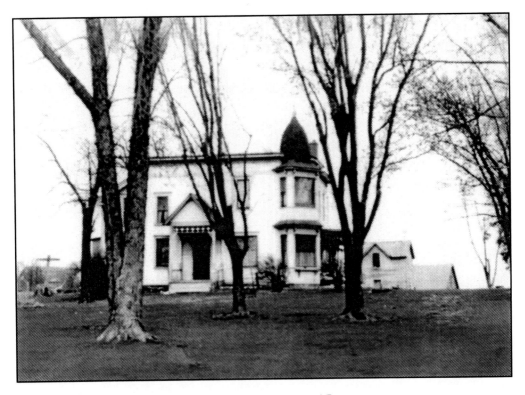

1-4 *Ida and Francis O'Keeffe's House Showing Part of Barn*

Francis and Ida would have seven children in the ten years from 1885 to 1895, all born in Sun Prairie: Francis Calyxtus, Jr. (1885-1959), Georgia Totto (1887-1986), Ida Ten Eyck (1889-1961), Anita Natalie (1891-1985), Alexius Wyckoff (1892-1930), Catherine Blanche (1895-1987) and Claudia Ruth (1899-1984).[74] Ida, as a stern disciplinarian, would show her children her love not with physical hugs but with high standards and her constant approval. A role model before her times, she raised her children to be individuals. Georgia's role model mother left Georgia with a lifelong feeling of distance between her and her mother.[75]

To demonstrate Ida's integrity, two days after Ida birthed Georgia, *The Countryman* reported: "William Woerpel against Mrs. O'Keefe for $5,000 damages. Woerpel and son driving on highway and a dog rushed out and frightened horse. The boy was thrown out of the wagon and sustained a broken arm. Ruled in favor of the defendant."[76] ("O'Keeffe" was misspelled.)

Sun Prairie responded to the Civil War demands at the same time the railroad was extended to Madison in the 1860s. By now, Horace Greeley, supporter of New York Governor William H. Seward, had popularized the advice of *Terre Haute Express* journalist John Soule: "Go west, young man." By the 1870s, a movement of settlers opened the frontier western lands, particularly the Dakotas. So many Sun Prairians left for the Dakotas that *The Countryman* editorialized for the last one to leave to please close the village.[77] Finally, by the 1880s, farming had become more diversified, farm land prices were stabilized, and all of Sun Prairie benefitted from the farmer's better financial status.[78]

Even before Georgia's birth in 1887, Francis's business dealings were not as successful as his father's. Francis's instability in the business world took on a more wandering aspect. According to the August 16, 1882, *Countryman*, "Francis O'Keeffe started for Dakota. He had 12 horses for sale and took along enough timber to construct a large barn." *The Countryman* reported on September 3, 1885, "Francis O'Keeffe went to Dakota about a month ago and sold a carload of horses. He returned with a carload of cattle. O'Keeffe did not like Dakota."[79] With no more newspaper notices of Francis's trips to Dakota, an assumption can be made that after several years he didn't find the Dakotas profitable.

In 1882, Francis added to his list of business dealings by becoming assessor for the Township of Sun Prairie.[80]

Francis not only displayed restlessness but questionable actions. *The Countryman* reported on March 18, 1886, "Francis O'Keeffe in Municipal Court in Madison. Trial postponed to May 28." Again, *The Countryman* reported on June 10, 1886, "Francis O'Keeffe used a swindling device in Cottage Grove [a town just a few miles south of Sun Prairie on County Highway N]. Stock sale moved to July 8 for trial."[81]

The July 15, 1886, *Countryman* reported "Francis O'Keeffe convicted and fined $10.00 for stock swindle. The stock scales were at Cottage Grove. Dane County court convicted him and fined him the $10.00."[82]

Francis O'Keeffe adopted a son, Aaron Flickinger, born in 1886 of wealthy parents in Monroe. Aaron lived with Francis until 1891, when the boy was caught stealing a fine revolver and a few articles of clothing and disappeared to Saint Louis. With no substantial proof on the youth, Francis accepted advice to not bring Aaron back for trial.[83]

In March 1893, with Grover Cleveland's inauguration as President, the country hovered on the brink of financial panic. The complex causes focused on the gold reserve. When it fell to an abnormally low level, the psychological effects rippled through Sun Prairie.[84] By the end of 1894 the depression had ended.[85]

By 1893, Francis had business dealings of an unknown nature in Stevens Point, a town about one hundred miles north on the Wisconsin River.[86]

By 1897, the Roach and Seeber Creamery of Waterloo, which had opened in 1881, had created a company town-atmosphere in Sun Prairie which aggravated the community.[87]

Whether to compete with the Waterloo Creamery or for fear of tuberculosis in 1896, Francis and other farmers bought a plot of land at Seminary Springs to erect a creamery. A creamery quite a distance from Francis's home already existed at Seminary Springs. The distance from the O'Keeffe home created a likely fear of impending tuberculosis. Any hint of catching tuberculosis from animals meant the killing of an entire herd of milk cows. Naturally, this caused great emotional and financial stress for the creamery and the consumers.[88]

Later, on August 20, 1896, *The Countryman* reported that Francis had spent a week looking after business interests in Chicago and Elgin, Illinois. Over three years later *The Countryman* reported on December 21, 1899, that Francis had rented his farm and in a few days would auction all of his stock on Saturday, December 23 at 10:00 a.m.[89]

Ida dealt with Francis's inconsistency and instability by always performing her fair share of the domestic workload and farm work. She avoided the depression common in women of this time, caused by isolation, by taking part in community life at Town Hall and working steadily for the enrichment of her children. Her concern revolved around the children not as objects of play, but as living minds. She obviously thought of her children as most personal investments that validated her as a parent. Additionally, through her motions, posture and voice, Ida strove for all her children to better themselves on the social ladder rather than just to be farm children and to disappear as individuals.

Ida intended for her daughters to move through childhood as women with an independent purpose in life, with patterns beyond those of wife and mother. She surrounded them with a community of women where they gained strength from role models.

One such role model, Sarah Haner Mann, the daughter of J. M. Haner

and Sarah Ann (Stroup), was born in 1856. Her parents had come to Wisconsin in 1851 from New York to settle in Bristol. Sarah, one of seven children, married William T. Mann. After several moves they arrived in Sun Prairie in 1895.[90] See figure 1-5.

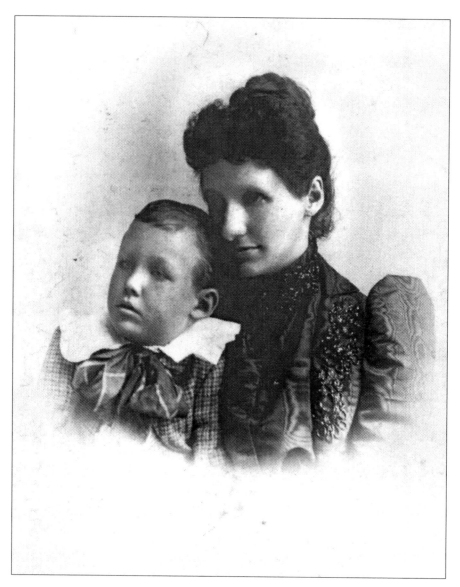

1-5 *Sarah Haner Mann and Son*

In Sun Prairie, Sarah Haner Mann provided a prominent voice in the women's movement in its striving for equality with men. In 1890, the women formed an auxilary to the Grand Army of the Republic. Its importance resided in what the women said:

> The endless duration of this government depends largely upon the patriotism of her women. They are the educators of the new generations. It is far more important that we should have sensible patriotic mothers than that we should have gifted statesmen. Mothers train masses, statesmen lead the few. As a society we have scarcely touched with our finger tip the rim of the womanhood of this country....[91]

As the twentieth century opened, women felt a new sense of their individuality and began to reach for more freedom by organizing improvement and advancing clubs. As one club formed in the Midwest, others followed. Up until 1901, the only club in Sun Prairie had a limited membership. Women in Sun Prairie, hearing of these clubs, joined forces to ask "When are we to have a club?" As women gained their voice in government, social concerns, and the arts, Sarah Mann was in the forefront in Sun Prairie. On January 25, 1901, Sarah Mann led eight Sun Prairie women, including Mrs. C. A. Lewis, who was active in the temperance movement, to form the Twentieth Century Club, developing their membership from the wisdom of an older woman who said, "Let this club be democratic. Do not limit the membership."[92]

The lack of a Sun Prairie public library came not from a lack of interest in reading. Libraries in Sun Prairie had been developing for years. As early as 1880, Colonel Angell had placed a bookshelf in the village hall. Businesses such as the Crosse and Crosse Pharmacy maintained private libraries for their customers and all social clubs had libraries. Before 1901, Sun Prairie women had formed a small library in the private home of C. L. Long at 145 Church Street.[93]

As one of the new projects of the Twentieth Century Club, a new library began in the Council Room of the City Hall, aided by the support of the Village Council and a $20 gold piece given by Colonel Angell.[94]

Not content only with library endeavors, in 1903, forty-seven-year-old Sarah Mann, president of the Twentieth Century Club, and other club members petitioned the village trustees for waste paper containers to be placed on each

street. The trustees responded by placing the petition on file.[95]

The club motivated civic improvements by paying for a membership for a man to serve in the Dane County Humane Society, by contacting the governor and legislature regarding suffrage and, in 1903, by establishing a chair of Domestic Science at the University of Wisconsin.[96]

In addition to the Twentieth Century Club, Ida belonged to the *Entre Nous* (Among Us) Club as noted in *The Countryman* on February 5, 1903:

> The *Entre Nous* Club, consisting of Madams O'Keefe, McIlwain, Persons and Horstmeier gave their annual supper...thirty-five guests were present. A short literary program was first enjoyed, then games, and the fun of the evening was the auction, at which various unknown articles were sold; being paid for in beans, which had been given each guest in little bags...and each bean valued at a dollar...sales ran as high as $300 (or beans).

Ida, at thirty-seven years of age, evidently had reached a level of individualism where she could choose her own relationships. She seemed partially free from society's expectations to do as she pleased. Ida, without the advantage of a formal advanced education, prepared Georgia for the lessons of life by being a role model.

She instilled in Georgia a yearning for her full potential and individualism that would conquer any of society's restrictions. Belonging to a study club became Ida's way of following through on the early nineteenth century movement to provide an advanced education for women. Although colonial schools generally excluded girls from town schools, by the eighteenth century some form of schooling was provided. Then efforts were made to establish women's colleges. Emma Hart Willard's Troy Female Seminary began in 1821 in New York City. Mount Holyoke College, the oldest women's college in the United States, opened its doors in 1837. After the Civil War, the new land-grant colleges encouraged women. Simultaneously the founding of women's colleges such as Smith, Wellesley, Vassar and Bryn Mawr furthered women's educational rights.[98]

Along with educational reforms, the major women's rights's event occurred before the Civil War at Seneca Falls, New York, in 1848. Lucretia Mott and Elizabeth Stanton, plus three hundred other men and women, gathered to conclude with a Declaration of Principles paraphrasing the Declaration of

Independence: "We hold these truths to be self-evident; that all men and women are created equal." With the emphasis on obtaining the right to vote, Stanton and Susan B. Anthony among others in their superb organization struggled to bring their vision into reality. The drafting of the United States Constitution, not the first to allow women the vote, had prompted Abigail Adams to remind John Adams of the oversight. The Nineteenth Amendment to the Constitution of the United States stated of the injustice, "The right of citizens of the United States to vote shall not be denied or abridged by the United States or by any state on account of sex."[99]

So Ida, nineteen years before women were given their right to vote, joined a community of women determined to be democratic. These groups empowered women by providing alternative patterns of behavior outside the roles of wife, mother and daughter. Ida did not wait for history but entered into the making of history, displaying boldness, courage, freedom, and self-acceptance to the degree that she spoke out on issues and did not abdicate her responsibilities to male authorities. She provided Georgia with a way to think her way out of subordination and to use her talents.[100]

Ida, as a role model, provided Georgia with an acute awareness that women belong to a subordinate group which is unnatural, that sisterhood aids this awareness, that autonomy is needed in defining goals and learning how to achieve them, and that awareness leads to developing an appropriate vision of future days. Simply, Ida's role model proclaimed that although gender differences are eternal, Geogia could be an individual.[101]

Ida was not a 1901 charter member of the Twentieth Century Club in Sun Prairie, but she was sponsored by Sarah Mann and welcomed as a member in 1901. The club's issues were important to Ida and her social acceptance related to membership in "The Club."[102] Ida demonstrated her interest in all subjects. On December 2, as soon as the club began its meetings, Ida read a paper "The Public Life of William Henry Seward."[103] See figure 1-6.

Seward served as Governor of New York in 1848, later becoming a United States Senator and then Secretary of State under Presidents Lincoln and Johnson. Seward, one of the earliest opponents of slavery due to his humane policies, proposed admitting Roman Catholics and foreign teachers into public schools. His demeanor placed him in a position where others, thinking Lincoln not qualified to manage national affairs, considered Seward the one to direct

NOVEMBER EIGHTEENTH.		DECEMBER SECOND.	
Roll Call	Current Events	Roll Call	Current Events
	Reading of Minutes.		Reading of Minutes
Business	Critic's Report	Business	Critic's Report
	TOPICS		TOPICS
Personal Life of William H. Harrison	MRS. KNAPP	Personal Life of William Henry Seward	MRS. MELVILLE
Political Life of William H. Harrison	MRS. LONG	Public Life of William Henry Seward	MRS. O'KEEFE
Mexican War	MISS MALONEY	Clayton-Bulwer Treaty	MISS PEET
Entertainment	MRS. MANN	Entertainment	MRS. REUSS

1-6 Twentieth Century Club Program–"The Public Life of William Henry Seward"

Lincoln's policies. Negotiating the purchase of Alaska from Russia in 1867 for $7,200,000 or two cents per acre, ranked as Seward's greatest accomplishment. The purchase was tagged as "Seward's Folly."[104]

In 1902, Ida followed her inaugural paper with a December 1 paper titled "Whittier As a Reformer." John Greenleaf Whittier, of Quaker ancestry, had a limited formal education, but his household loved learning as much as they loved learning of their religion. His father discouraged Whittier from making a living as a poet, so he became a journalist. Unsatisfied with his poetry career he wrote pamphlets on the Abolition Movement as its most fiery writer.[105] See figure 1-7.

With these two known papers for the Twentieth Century Club, Ida became involved in civic affairs. However, one elderly woman, whose reputation was to never speak harshly of other people, commented about Ida, and her family, "... putting on airs. They were better than their neighbors."[106] Regardless of the comment, Ida found acceptance for herself and her children.

Ida's children were shaped by the environment and their readiness to

NOVEMBER SEVENTEENTH			DECEMBER FIRST	
Roll Call	Favorite Stanzas		Roll Call	Quotations from Whittier
Reading of Minutes			Reading of Minutes	
Business	Critic's Report		Business	Critic's Report
MISCELLANEOUS			JOHN GREENLEAF WHITTIER.	
Memorized Reading — — — MISS MALONEY			Recitation from Whittier — — — MISS MILLER	
Dr. J. G. Holland — — — — MRS. MANN			Paper—Life and Characteristics of Whittier. MRS. MOSEL.	
Book Review — — — MRS. MELVILLE			Paper—Whittier as a Reformer — — MRS. O'KEEFE	
Instrumental Duet — MRS. ANGELL AND MISS MALONEY			Review of "Tent on the Beach" — MISS PEET	
Conversational—Who is your favorite Poet and why? CLUB				

1-7 Twentieth Century Club Program—"Whittier As a Reformer"

be shaped. The children's reactions fostered Ida's sense of responsibility as the primary educator of her children. She made a difference because she valued each child's uniqueness. Her American can-do attitude of hard work and responsibility translated into pride and joy in accomplishing.

The times finally caught up with Francis as the March 12, 1903, *The Countryman* reported "Auction sale next Saturday at Francis O'Keefe's home. He is selling household furniture and machinery."[107]

All the O'Keeffes found it traumatic to leave Sun Prairie, which had been their American roots.

As a farewell gift the Twentieth Century Club presented Ida with an engraved dish, which the family still possesses.[108]

As was customary, thirteen-or fourteen-year-old farm girls worked as maids, with their earnings going to their parents. To ease the departure, the O'Keeffes' maid, Lizzie Schuster, was asked to move to Williamsburg with the family. She refused the move. Whether Francis felt uncomfortable in Williamsburg is not

known, but it is known that in 1904, shortly after they moved, he returned to Sun Prairie for a visit.[109]

Diseases often ravaged a community so that the dead were buried before their memorial service. With this dread always on the surface, the O'Keeffes's departure from Sun Prairie could be explained as fear of tuberculosis or the poor health of Francis O'Keeffe.

In addition, an explanation could have been that Francis didn't like working the land and dairy herds like his father, Pierce. Francis more than likely incurred debts. The difficulties exhausted him and he hoped a change would reverse his fortunes.[110]

2

WALKING THE SUN PRAIRIE LAND

I wanted to see the land of Georgia's origin, to "walk the land" in an effort to discover and envision the Sun Prairie of 1887–1903 when Georgia walked the land, and to turn the history pages with some of the people who walked and worked where Georgia lived. I wanted to see the farm where Georgia lived, to imagine her response to the low-horizon-line prairie and vast, limitless sky that is no less marvelous than in years before.

My contact with Peter Klein, a native Sun Prairian and director of the Sun Prairie Historical Museum, resulted in an appointment to meet him. Klein eventually arranged for me to meet the recognized authority on Georgia during her Sun Prairie times, Joe Chase, a cousin to Georgia.[1]

My airplane flight departed the once black-land prairie surrounding the Dallas-Fort Worth airport to fly the two-hour, eleven-minute flight to Chicago in an MD-80 jet. In the airplane at an altitude of 30,000 feet, the earth appeared small and the sky large and unbroken.

My flight required a change of planes in Chicago to a small regional jet flying at 15,000 feet for the fifty-three-minute trip to Madison. As the airplane approached Madison, the Wisconsin State Capitol building loomed overpoweringly. Later I learned the Senate Chamber contained Kenyon Cox's 1915 oil on canvas triptych, *The Marriage of the Atlantic and the Pacific*, with each panel 11 ft. 6 in. x 7 ft. 2 in.[2] I glanced out the small window at the simple, almost vacant patterns of earth in geometric rectangles and squares relieved only by curvaceous rows of tilled soil ready for spring planting.

The static scene and my quick glance gave no life to the prairie. However, flying at any altitude, the sky seems more important than the earth. There for anyone to grab, as the plane touched the ground in Madison, lay the cold and clear "Four Lakes" almost in a direct line northwest to southeast: Mendota, Monona, Wingra and Waubesa. The easy-to-identify Madison nestled on an isthmus, a thread of land between the two most northern lakes, Mendota and Monona. These lakes have caused poets to write of them, "strung like jewels on a cord of silver."[3]

My first assignment included driving to Sun Prairie via U. S. Highway 151. My initial stop, the Sun Prairie Historical Museum at 115 Main Street, stood on the site of the Charles Bird home, the first home in Sun Prairie. Inside the museum, Peter Klein directed my attention to the O'Keeffe exhibit which consisted of O'Keeffe memoralbia such as Ida's Twentieth Century Club programs, correspondence to the museum, and a wooden cheese bucket from the O'Keeffe farm and dairy. See figure 2-1.

Then Peter and I walked downstairs into the archives room stacked with many gray archival boxes so that there was only a small path for walking. Peter commented, "In this room Catherine [O'Keeffe] Klenert in 1924 spoke to the Twentieth Century Club about her own art. At one time all the O'Keeffe sisters were quite well-known as artists."

Shortly after Georgia completed her 1939 paintings in Hawaii for the Dole Pineapple Company of Honolulu, Catherine and Ida were mentioned in *The Countryman*: "May 22, 1940, Ida Ten Eyck...is the third of the three O'Keeffe sisters to gain recognition in the art world," "Ida O'Keeffe's exhibition of paintings, which opened this week at the Argent Galleries in New York, received high critical praise for the freshness and vitality of her work," "A third sister,

2-1 Sun Prairie Historical Museum Featuring O'Keeffe Exhibit with O'Keeffe Cheese Bucket

Catherine O'Keeffe, also a painter, has been represented in several exhibitions of national importance." On May 22, 1940, Catherine then living in Portage, Wisconsin, exhibited and discussed several of her own paintings for the Twentieth Century Club.[4]

Peter Klein commented about a man who asked him about a painting, "The man who bought the painting thought that it was a Georgia painting. When I learned where he purchased it, I tried to tell him that it was probably a painting by Catherine. He hung up. He found it in a closet during the sale."[5]

In September 1932, when Ida Ten Eyck lived in New York, and shortly before Catherine and Ida Ten Eyck had exhibitions of their paintings in Milwaukee, Chicago, New York, and in Madison, Ida Ten Eyck wrote a musical pageant in January called "Sun Prairie." Sponsored by the Twentieth Century

Club, the drama was adapted from Wisconsin Native American melodies to recall the story of the Bird family and the pioneer days of Sun Prairie.[6]

Peter's walking tour of Sun Prairie gave me a good introduction to the town. See figure 2-2.

1. Angell Park
2. Sun Prairie Historical Museum, 115 East Main Street (site of first home)
3. Sarah Mann home
4. C. L. Long home (library), 145 Church Street
5. Water Tower
6. City Hall, 100 East Main Street
7. Crosse and Crosse Building, 100 West Main Street (*The Countryman*), same as number thirteen
8. Crosse Home, 133 West Main Street
9. Angell's Grove
10. Chicago, Milwaukee, Saint Paul Railroad
11. Linnerud Drive
12. Sacred Hearts of Jesus and Mary Catholic Church, 227 Columbus Street at Vine Street
13. Crosse and Crosse Pharmacy, same as number seven
14. Charles Bird Home, same as number two
15. Flat Iron Point, Church, Main, and Center streets (later part of Columbus Street)
16. Three roads confluence, Columbus Street, Lake Mills Road and Watertown Street
17. Bernard O'Keeffe, Main Street and Center Street
18. Sacred Hearts Cemetery, north of Columbus Street (not shown on map)
19. Angell Home at Flat Iron

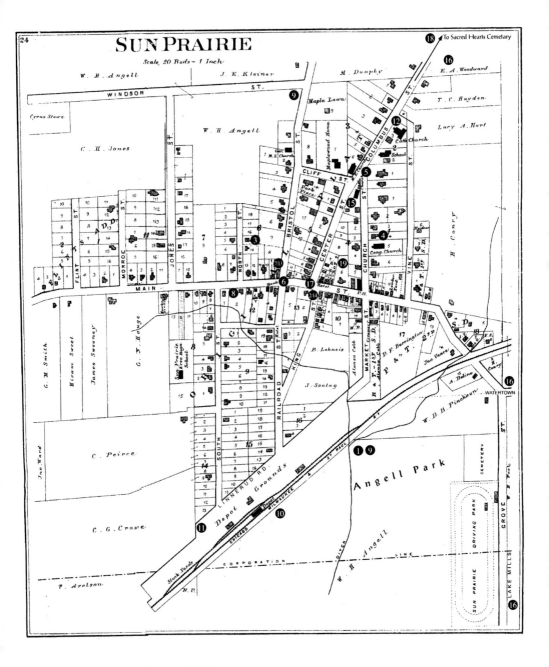

2-2 Map of Sun Prairie, 1890

Peter further noted:

1. Center Street became part of Columbus Street in the early 1950s. Map numbers fifteen and seventeen identify Center Street.
2. The Angell Home is on Main Street. There wasn't a road marked Flat Iron Road. Flat Iron Point is the area inside of Center, Church and Main (part of Columbus) streets.
3. The Crosse and Crosse Pharmacy was also the site of the *The Countryman* after 1883. Prior to 1883 the pharmacy and publisher were located on the south side of Main Street in the same 100 West Main Street block.
4. The southwest corner of Windsor Street and Bristol Street was often referred to as Angell's Grove. The Angell's Grove where picnics took place later became Angell Park after the property was donated to the Fire Department.
5. The Aztalan-Lake Mills Road and the Watertown Road actually followed Main Street until just east of the village. Grove Street is part of the Aztalan-Lake Mills Road. The Columbus Street was actually the Columbus Road.

Peter pointed out that three roads joined near the settlement of Sun Prairie. The original buildings were destroyed by fire. The present downtown is the second downtown as most of the buildings were built from 1885 to 1905. Peter showed me points of interest that Georgia would have remembered during her 1887–1903 years as she walked, not on sidewalks but on boardwalks.

The City Hall at 100 East Main Street at the corner with Bristol Street was erected in 1895 when Sun Prairie had a population of nine hundred twelve. See figure 2-3.

On the main floor, the fire department kept a fire bell that would eventually hang in the now missing tower. The second floor contained a dance hall and an auditorium for cultural events. Among others, the Twentieth Century Club rented small rooms for their cultural events.[7]

Flat Iron Point, bounded by Columbus, Church, and Main streets, included the Angell home.[8] Angell had taken advantage of the junction of three roads (Columbus Street, Lake Mills Road and Watertown Street) to build taverns

in 1850.[9] A letter dated 1850 states, "Business is on the increase in our part of the country and farmers merchants and mechanics all appear to be going well. There is now in progress of building a large brick tavern in our little village which will probably be quite an ornament to the place. I hope it may be a temperance house but have some reason to doubt." Indeed, the letter writer wrote correctly because neither one of the two taverns was a temperance house.[10]

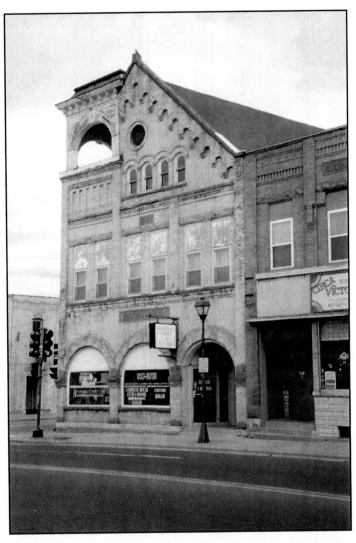

2-3 Sun Prairie City Hall, 2000

At Main and Center streets, a building housed saloon property purchased by Bernard O'Keeffe, Georgia's bachelor uncle, and William Horstmeier's from Lohneis and Dushack on May 7, 1896, for $5,200.[11] Bernard also took an active part and interest in the community. Political tickets for the Town of Sun Prairie listed Bernard as a Democratic candidate in 1889, 1890 and 1894. He vied for the office of Supervisor and for Justice of the Peace.[12]

At 133 Main Street stands the Crosse home, dating possibly to 1853, one of three homes built by Patrick Doyle, who combined his blacksmithing with carpentry.[13]

As Peter and I walked the town, I saw the Long family home where Ida Ten Eyck participated in the library's founding.

The Roman Catholic Sacred Hearts Church at the corner of Vine and Columbus streets (227 Columbus Street) across from the water tower dominated the community. Bernard, who died at the early age of forty-two in 1892, often took Georgia to church here.[14] Peter commented, "My grandmother had a pew behind the O'Keeffe pew."

In its one hundred and first year the water tower stood tall at 1,100 feet above sea level as Sun Prairie rested on a gentle slope from this highest point. The village formed southward from the water tower to the marshlands and west of Angell's Grove. Area farmers assembled the seventy-five cords of stone to create this welcome addition to the town, replacing private wells and public and private cisterns.[15] Radiating from the water tower, Angell's subdivision included Sarah Mann's residence at 173 North Street.

Sacred Hearts Cemetery, north on Columbus Street from the church, highlights the contributions of the German, Irish and Czech settlers and is where Georgia's father, uncles and paternal grandparents are buried. As I entered the cemetery, founded in 1863, through the second gate, the O'Keeffe grave sites rest near the right side of the road a short distance into the cemetery.

My next assignment was a drive to Georgia's birthplace. To reach the O'Keeffe farmland, I traveled by car a few minutes east from Sun Prairie on State Highway 19 to where Town Hall Road intersects it north and south. I turned south on Town Hall Road to the four-way intersection of Town Hall Road and County Road T.

From the car window I looked at the prairie as the car negotiated the curves that were needed in earlier days to avoid the marshland. Today the land,

drier and cultivated, shows the effect of only a two to three month growing season. See figure 2-4.

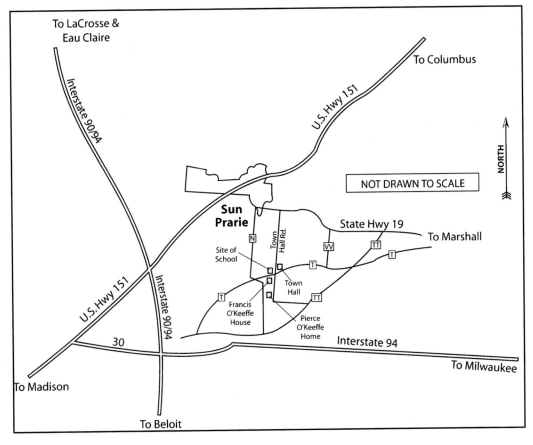

2-4 *Route to Town Hall Road and County Road T*

Today the prairie and sky gives me the feeling of how Georgia must have felt looking out her Victorian tower window facing north and west.[16] (See illustration number 1 on the dust jacket of the book, Town Hall Road and County Road T Area, 2000.)

On the left is the former Town Hall, built in 1868, which is now a private residence. At the Town Hall, Georgia and her family gathered on Saturday nights for string band concerts and magic shows.[17]

Most children who lived on farms attended schools that were within walking distance.[18] Georgia was no exception. Georgia's school, Town Hall School, also known as Sun Prairie District No. 5, is on the northwestern corner of the intersection of Town Hall Road and County Road T, across from the Town Hall. There is speculation, but no documentation, that the Totto family donated the land for the construction of the school, which was located across from the Totto home that Francis O'Keeffe added onto or possibly replaced with a newly constructed house. Walking to school probably seemed easy for Georgia because she crossed from the south side of County Road T to the school house.[19] Georgia recalled years later, "My childhood memories of living in the country near-by are pleasant."[20]

Through the years Catherine, Pierce, Francis and the family established a close relationship to the school. Georgia's parents and grandparents supplemented their incomes by painting the school, whitewashing the privy for $4, performing clerk services for $5, cleaning the school house for $2, maintaining the school stove for $4, building the school fence for $1.12, and providing firewood for $12.90. Francis would even borrow money from the school. Georgia's Aunt Ollie taught in the spring of the 1878–1882 school year for $54, her last year.[21]

Peter Klein said that the O'Keeffes boarded teachers in their home, but documentation proved illusive as to who and when and whether for financial reasons or to educate the children. *The Star Countryman* reported on November 6, 1976, "The Francis O'Keeffe home was destroyed by fire. A candle left burning in a window caused the fire."[22]

After the O'Keeffe home burned in the 1970s, the Sun Prairie Historical Library and Museum erected a red wooden historical marker in front of the homesite.

In the rear of Pierce O'Keeffe's home I saw the actual remnants of the barn. I was astonished by how similar the stone and mortar barn resembled the adobe buildings Georgia would discover in New Mexico. See figure 2-5.

I then looked south on Town Hall Road toward the open, lowland marsh leading to Koshkonong Creek, amazed at the open, spacious feeling of so much prairie and sky. Georgia often referred to the farmland, where I stood, as that which ran southward along Town Hall Road from the intersection of County Road T and which required an hour for Georgia to travel by horse and wagon into town.

In the few hours I spent walking the land, I saw the land differently than

Georgia's view in 1887–1903, yet I felt the same familiarity of linking the prairie to the sky for a sense of space. Georgia's subject matter often revolved around space which must have meant freedom and energy. The nearby prairie, so alive, powerful, life-sustaining and silent, radiated a warm solace. The faraway sky spread overhead like a never-ending canvas stretched to its limits. The color of blue in the sky drew me from the soft cerulean blue that suited the weightlessness of the near horizon, to the darker cobalt blue directly overhead, then in a subtle transition to another cerulean blue at the opposite horizon. All as if this was Georgia's claim to the blue that she painted so often as she concealed her brush strokes. The large, strong-shaped clouds during my daytime visit danced to become bigger or faded away leaving only a hint of texture.

As I turned to leave Sun Prairie, I felt Georgia's feeling for prairie, sky and space as Nature speaking as clear evidence of God's voice.

2-5 Remnants of Pierce O'Keeffe's Barn, 1997

3

DISCOVERIES AND DECLARATIONS

Georgia's first recollections of the origin of her unshakable, definite personality didn't center on Sun Prairie's Main Street, with only a telegraph system since 1881, no telephone until 1890, and Rural Mail Delivery from 1896, or the Midwestern stability and solidity coupled with the silence and sense of peace.[1] Rather, Georgia's early remembrances centered on entertainment found in the making.

In snippets, Georgia told her story in the first person, unlike the Chinese who tell their stories in the third person. In her only attempt at autobiographical writing, Georgia recalled in 1976 in her pictorial autobiography, *Georgia O'Keeffe*, an event in the spring after her November birth:

> My first memory is of the brightness of light–light all around. I was sitting among pillows on a quilt on the ground— very large white pillows. The quilt was a cotton patchwork of two different kinds of

material—white with very small red stars spotted over it quite close together, and black with a red and white flower on it. I was probably eight or nine months old. The quilt is partially a later memory, but I know it is the quilt I sat on that day.

This was all new to me—brightness of light and pillows and a quilt and ground out beyond. My mother sat on a bench beside a long table, her back turned to me. A friend called Aunt Winnie stood at the end of the table in profile. I don't remember what my mother looked like—probably because she was familiar to me. Aunt Winnie had golden hair done high on top of her head—a big twist of blond hair and lots of curly bangs. My mother was dark with straight hair and I had never seen a blond person. Aunt Winnie's dress was thin white material, a little blue flower and a sprig of green patterned over it. The bodice was close-fitting with long tight sleeves, the skirt straight and plain in front and very full and puffed and ruffled at the back—a long dress touching the ground all around, even trailing a little extra long at the back.

Years later I told my mother that I could remember something that I saw before I could walk. She laughed and said it was impossible. So I described that scene—even to the details of the material of Aunt Winnie's dress. She was much surprised and finally—a bit unwillingly—acknowledged that I must be right, particularly because she, too remembered Winnie's dress.[2]

In early infancy, Georgia saw light with varieties of color and intensity. This visual memory would stay with her a lifetime as perception developed rapidly to the fixed seeing of an adult that remained constant until old age.

The memory of the quilt's importance initiated many developmental processes. Singly, this one memory could not have been such a potent force had subsequent forces in her life not built on this visual impression.

The memory of the quilt separated her from her siblings, as Robert Massie recalls, "...that strange alchemy which, for no apparent reason, lifts one child out of a large family and endows it with a special destiny."[3]

At an early age Georgia's memory of the quilt hinted at how her genes had established themselves at birth to chart her paths of discovery and declaration.

These inborn traits didn't command her to define herself, but they did nudge her free will to refuse or agree in the use of her talents. Obviously, she didn't overrule her genes because she instinctively sought experiences and environments in her work which unlocked her creative forces and suited her genetic nature.

According to Johnson O'Connor and the Human Engineering Laboratory, these inborn traits would always be there when she called on them. Aptitude evaluations received a boost with Johnson O'Connor, who in 1922 headed the engineering department of a General Electric Company plant in West Lynn, Massachusetts. O'Connor, a young philosophy graduate from Harvard University, attempted to reduce costs at the plant by increasing worker efficiency. He reasoned that if a worker did work that was right and natural for him, efficiency increased and the worker would be more interested in his work. O'Connor set out to measure human traits such as personality, clerical ability, creative imagination, three-dimensional visualization, abstract visualization in dealing with ideas, logical reasoning from scattered facts, and analyzing random facts into sequence. O'Connor also evaluated finger dexterity; tweezer dexterity, which is the ability to handle small tools; observation; ability to memorize designs, remember sounds, differentiate musical notes, keep rhythmic time, remember numbers, and recognize the relationship between numbers; ability to learn languages; foresight; and color perception. After studying each type of worker's job, O'Connor developed a series of tests that isolated each inborn trait and measured the relationship between occupation and behavior regardless of economics, race, education and success. Then he synthesized these inborn traits into the job's work patterns. A remarkable testing result declared that for each unused aptitude, restlessness, frustration and discontent resulted from not using a person's inner strengths.[4]

O'Connor stated that the true artist's personality was quite subjective, which indicated that Georgia probably belonged in the twenty-five percent of the population that had a different point of view from the other seventy-five percent of the population. He declared that a highly subjective personality with strong creative ideas should seek some form of aesthetic expression as a visual or written evidence of the times.[5]

O'Connor added that a subjective person belonged in specialized, individual work, because such a person rebelled at regimentation, worked spasmodically, and often worked continually for days, emphasizing that an artist must work at his

own pace. Georgia's true happiness coincided with the subjective personality by creating her own individual and unconventional life style. She wasn't dependent on other people; her work depended on her knowledge rather than other people's knowledge, and her specializing took years of training to be an accomplished artist.[6] Not to be forgotten, Georgia's deep sense of being was in tune with the pulse of life which is what the architect-painter Giorgio Vasari in the sixteenth century called "soul."[7]

Knowing the end result of Georgia's life, and according to O'Connor, an easy assumption is that Georgia possessed a creative imagination, finger dexterity, observation, abstract visualization, ability to memorize designs, foresight, and color perception.[8]

Georgia's creative imagination provided a fluency of unusual ideas which allowed her another way to do what others had already done and even what she'd already done.

As Georgia developed her ideas, her ability to use her fingers skillfully enabled her to develop techniques for handling the tools of an artist. Her ability to work with small tools, which O'Connor called tweezer dexterity, provided even more delicate use of an artist's small tools.[9]

Observation must have come easy for Georgia because she saw not only everything surrounding her, but one thing at a time, thoroughly, until it was strongly impressed in her mind and eye.[10]

Georgia's inborn abstract visualization, or thinking in terms of ideas in one dimension rather than in three dimensions, easily aided her artistic endeavors.[11]

In time, Georgia would master her memory for design so that she could produce from memory the lines and angles presented to her. Eventually her memory for design would determine whether she preferred shapes of a conventional 2:3 ratio, or the more unusual 1:3 ratio. She also would consider whether her abstract paintings be hung horizontally, or vertically, or even upside down.[12]

With a slight penchant for roving, Georgia's gifts included foresight, or the setting of goals, and working with steadiness of purpose towards the goal by mastering the obstacles. She dedicated every ounce of her energy to the creative expression of her artistic feelings. Her perseverance toward long term goals, seen as obstinacy in her youth, always remained remarkable because she saw possibilities years ahead, not just about the next day's possibilities.[13]

Early in Georgia's life, she must have recognized a very strong foreknowledge at some level in her subconscious. Was it a compulsion, and where did the compulsion come from? In her teenage mind she probably showed high levels of activity in a region of her brain responsible for instinctive responses, so often called "gut responses." As a teenager matures into adulthood this instinctive response turns into more rational thinking.

Perceiving color came easily to Georgia as she processed her awareness of color through her senses. She distinguished one color simply from another, combining them in a satisfying manner to get a viewer's own response time.[14]

Regarding the delicate balance of inborn aptitudes, if Georgia had inductive reasoning—making decisions on facts—she may have chosen to write; if she had structural visualization—seeing forms in three dimensions—she may have chosen to sculpt. But with a probable lack of both inductive reasoning and structural visualization, she more than likely felt comfortable with painting.[15]

The reliability of the Johnson O'Connor aptitude tests can be confirmed in a letter written by Francesca Calderone-Steichen, granddaughter of famed photographer Edward Steichen:

> My mother, Mary Steichen Calderone, became a public health physician and a pioneer in the field of human sexuality because of the Johnson O'Connor Research Foundation. She often said proudly, "I took my tests from Mr. O'Connor himself!" One story that has since become an amusing family anecdote involved her father, photographer, Edward Steichen, worriedly questioning her about changing careers in her early thirties from acting to medicine. "But Daddy," she replied breezily, "Mr. O'Connor says I have excellent tweezer dexterity!"[16]

Additionally, Georgia had an innate drive and energy, not so much physical strength, but a great desire coupled with a feeling of not wanting to be controlled by others. In a matter of speaking, parents, as the creators, are the owners of their children. With such a role of responsibility, the parent strives to promote the child's development by controlling. With a successful child, parents gain validation as to who they are, with a not-so-successful child, there is an assumption of poor parenting skills or inherited characteristics. The only problem with the

parent's controlling arises when a child has his own agenda to discover his own destiny, which causes alienation between the child and parent.[17]

In *The Mill on the Floss*, George Eliot wrote:

> Nature, that great tragic dramatist, knits us together by bone and muscle, and divides us by subtler web of our brains; blends yearning and repulsion; and ties us by our heartstrings to the beings that jar us at every movement. We hear a voice with the very cadence of our own uttering the thoughts we despise; we see eyes—ah! So like our mother's—averted from us in cold alienation; and our last darling child startles us with the air and gestures of the sister we parted from in bitterness long years ago. The father to whom we owe our best heritage—the mechanical instinct, the keen sensibility to harmony, the unconscious skill of the modelling hand—galls us, and puts us to shame by his daily errors....[18]

Not to be discounted is that regardless of all the inborn traits, the time and feeling have to be right. Georgia had courage in great abundance and luck in knowing she wanted to be an artist.

Years later, a young woman, Carol Merrill, entered Georgia's life in Abiquiu. In her book of poems, *Georgia O'Keeffe, Days in a Life*, she described Georgia's early feelings:

> O'Keeffe remembered
> running away from home
> as a small girl.
> She had forgotten why
> she was angry at the folks
> and decided to leave
> remembered walking
> down the road thick with trees
> on either side
> at the end of the road
> a bright red sun
> setting between the trees
> she had a feeling she was walking into the sun

she will never forget
that feeling.
Her memory reminded me
of the watercolor
she's been working on
in Claudia's big bedroom.
"Yes, but it doesn't come close to what I feel, what I felt
that day I was running away."[19]

Georgia's mother, Ida, continued to expand her daughter's knowledge of
art by asking Sarah Haner Mann to include Georgia, Ida Ten Eyck and Anita in
her art classes. The O'Keeffe sisters traveled the three and one-half mile distance
from their farm to Mann's home/studio at 173 North Street.[20] See figure 3-1.

3-1 Home of Sarah Haner Mann

Georgia recalled years later:

> My two sisters were sent into town to study painting with me. My sister next to me [Ida] always thought she was the talented one. She thought so until she died, a few years ago. My other sister [Anita], though, was the one I thought had the real talent. She was my pupil at the University of Virginia, and I always tried to get her to let go. But she was always rather timid about her painting. She had no fear about contact with people. It was just the painting.[21]

Sarah Mann's parents had recognized Sarah's talent for art and enrolled her in the Art Institute of Chicago. In 1866, a group of Chicago artists founded the Chicago Academy of Design with a modest gift from the French government. The Academy followed the example of the European academies with three types of memberships: academics, who administered the academy; associates, who were the art students; and honorary members, which included financial, cultural and social assistance. The initial facilities were in rented buildings. Its first permanent building at 66 West Adams Street burned in the great Chicago Fire of 1871. The confusion following the fire led to the Academy's bankruptcy. In 1879, a group of businessmen with the community's backing founded the Chicago Academy of Fine Arts, located at the southwest corner of State and Monroe streets. The Academy took the name of The Art Institute of Chicago in 1882 to become the oldest art school in the Midwest. After outgrowing its facility at 280 South Columbus Drive, its present location, since 1988, is at 37 South Wabash Avenue.[22]

The Academy provided a relief from the rough and tumble, free-wheeling profile of Chicago's stockyards and railroads. Its early direction followed the European design: Elementary Form, Preparatory Class, and Top Form. With no entrance examination, the beginning courses consisted of Outline Drawing and Elementary Perspective. The students submitted drawings to progress in the Academy.[23]

Sarah employed the Institute's accepted method of copying the works of well-received artists to learn and improve her own techniques. She became steeped in the fashionable aesthetics of the times. See figure 3-2.

3-2 Painting by Sarah Haner Mann

A likely assumption could be that Georgia's meetings with Sarah Mann placed her further on her way to surrounding herself with powerful, influential women of the times: her mother, Aunt Ollie (who lived to one hundred three years of age), Aunt Lola, Aunt Jenny, both of her grandmothers, and now Sarah Mann.[24]

Misses Blanche Hayden and Elizabeth Belle Hayden taught at Georgia's Town Hall School. Ella, a founder of the Twentieth Century Club, emphasized art and encouraged self-expression. Blanche taught during the fall term of 1893–1894, and Belle taught from October 1894 through January 1895. Both sisters taught at Town Hall School when Georgia began her schooling at five years of age in 1892. Both Hayden teachers experimented with photography and could possibly have been Georgia's first introduction to photography.[25]

Mrs. Zed Edison in 1895 taught at the Town Hall School, which stood near the O'Keeffe farm. Francis served the school well as clerk of the Board and also chaired on at least one occasion an annual school meeting in 1901.[26] On March 1, 1948, at the Sun Prairie Centennial observance at the Sun Prairie High School, Mrs. Wilbur Renk read the following letter by Mrs. Edison:

My first job was school teacher in Sun Prairie township school. Georgia O'Keeffe was in school, at that time about 7 years old, I think. I stayed in her home. Mr. O'Keeffe was a member of the school board, but Mrs. O'Keeffe seemed to take over his duties. Georgia's great aunt Jennie (Mrs. Varney) lived in the home and apparently mothered the whole family. The oldest brother and Georgia were at the unanswerable questions age. I don't believe Georgia thought teacher was very smart, because she wiggled out of real answers to such questions as "When two big, black clouds bump together, is THAT thunder?" or "if Lake Monona rose up, way up, and spilled over, how many people would be drownded?" Georgia was at the tattle-tale age, and repeated anything out of regular routine to her mother. However, she was good, quiet, and had her lessons. She did not mingle with the other children much. In fact, the family rather kept to itself. Many time when questions weren't answers, I was told, "Well, I'll just ask Aunt Lola; she knows everything." Aunt Lola was Aunt Lola Totto, a much loved and respected teacher in Madison schools for years. I think the late Mrs. C. A. Lewis was Georgia's Sunday school teacher some years later. In the home I had more to do with the younger children; Ida, my favorite; Anita, sweet and cute; and Alexius, never in sight. I stayed over weekends many times to help Aunt Jenny with these youngsters when their mother visited her mother.[27]

By the time Georgia reached twelve years of age and entered the eighth grade, many of the aesthetic ideas that she had since her earliest memory of the quilt most likely had not vanished, but had built one upon the other. She had private interpretations that she imposed on her experiences. Georgia's biography would result from over a decade of experiences, including those that occurred in her first two years. Georgia's heredity had mixed with exposure and practice.

During Georgia's formative years, Ida must have spent some time in Madison with Aunt Ollie on Spaight Street because Ida would attend the Grace Episcopal Church where Aunt Ollie attended. For a single day, the trip from Sun Prairie to Madison would have been too long for church on Sunday.[28]

Mrs. Renk quoted a letter by Mrs. Edison:

> My sister Belle (a natural artist) followed me as teacher. The school was small and cold, and on bad winter days would have maybe seven or eight scholars. For busy work, Belle would take a sprig from a tree, a leaf, or if fortunate, a blossom, and arrange it for the pupils to draw and enlarge. I have often wondered if that was Georgia's start in the artist line.[29]

Usually a three year old child succeeds in copying a circle, by age five a square and by age seven a diamond shape. Georgia by the time she was twelve years old in 1899 had mastered other shapes that proved her ability. The year 1899 preceded by fifty-six years Anne Morrow Lindbergh's book, *A Gift From the Sea*, consisting of essays encouraging women to find strength and meaning in their lives by turning inward, to nurture their spirituality, and to express their creativity —and sixty-four years before Betty Friedan's ground breaking feminist book, *The Feminine Mystique*, which addressed the limited vision of what a woman could and should accomplish.

In 1899, Georgia, age twelve, offered a privileged look into her privacy by remarking to her friend, Lena Catherine Bucholz, "I want to be an artist."[30]

Lena, the daughter of the family's washerwoman, known for her dramatic ability as she rendered "The Gypsy Flower Girl" in a declamatory class, graduated from Sun Prairie High School in 1905. The graduation program described Lena: "Her voice was even soft and low—an excellent thing in a woman."[31]

Georgia's remark about wanting to be an artist may have appeared as an odd choice and bewildering to Lena, a girl from a prairie town. Georgia would later admit she didn't know where the idea came from, but perhaps recognition of the influence of her role model mother, Ida, existed as a dim memory. But for Georgia, the declaration simply came like that of an East Texas preacher "getting the call." The declaration allowed herself to feel alive from the inside, a quality she easily recognized. This insightful self-discovery and interest in her

inner life set her apart from the outer world. Indeed, Georgia appeared to be one of a group of young people who became vocationally-anointed at a very young age.

If one visits the lives of musicians, composers and artists, one finds that many knew at an early age what they wanted to be. Accompaning this talent is an awareness, a desire and a love for the talent...almost like an obsession.

Along with Georgia's twelve-year-old declaration, she must have discovered that she couldn't change these natural abilities but only increase her knowledge of them. She found pleasure in her drawings, a sense of attainment of a goal following an effort, and a constant attention to what beauty afforded and a dislike of ugliness.

Georgia had her own agenda which she didn't think necessary to validate to anyone but herself. Georgia did not undergo what so many twelve-year-olds underwent. Other children wanted to be everything. When they met a businesswoman with erect posture who looked self-assured, that was what they wanted to be. When they met an actress who articulated beautifully, that was what they wanted to be. When they met a nurse filled with compassion and caring, that was what they wanted to be. Georgia just wanted to be herself.

Added to Georgia's early vision while sitting on the quilt, coupled with her statement to Lena, was the way her physical attributes affected how she saw herself, how she interacted with others, how she dressed...and how she was perceived by others, which affected how she was. From her Hungarian heritage Georgia gained a seriousness in her looks, not so much masculine as conservative; from the Irish she acquired an impishness which allowed her to express herself when the Irishness came forth. Her attributes tended to affect her appearance, rather than her appearance affecting her attributes or character.

Yet Georgia maintained a sense of normalcy. Georgia's childhood friend, Jessie Flint (Mrs. Williamson), remembered:

> Georgia and I used to play together. My sister [Lillian Flint] taught at the school and boarded with the O'Keeffes. I used to be at their home so often that once her mother asked me if I ever went home.[32]

At age fourteen Georgia probably recognized her inborn aptitudes as a natural, inherited gift as she executed her first known watercolors:

Hanging Up the Clothes, watercolor on moderately thick, beige, moderately textured wove paper, 7 3/4 x 15 in., 1901,

Untitled (Lighthouse), watercolor and graphite on moderately thick, white, moderately textured wove paper, 5 5/8 x 7 3/8 in., 1902.[33]

With this discovery must have come the recognition of an openness in her thoughts and feelings. She parlayed her initial discovery many times in her life to even greater discoveries.

Perhaps for these reasons Georgia's nonconforming attitude, meager interest in school, and merely adequate performance resulted in her recognition of what attributes she possessed and how she wanted to use them.[34]

Art can be defined as having no gender, but the art world did have male dominance in those days—the critics, curators, galleries, and artists. The unspoken language meant that art was created only by men. The reverential term "Old Master" has no meaningful feminine form; "Old Mistress" has a different connotation.

Regardless of gender, early fortitude was required for an artist in Georgia's times. For a woman, fortitude demanded a strong character and imagination to defy and circumvent the rules. Having a successful artist for a relative provided great help. Georgia's help came later in her life when she met Alfred Stieglitz.

However, there was one woman who didn't ignore the women artists. Wilhelmina Cole Holladay, inspired by her maternal grandmother's interest in art, remarked, "She would lift up a flower and say, 'Why do you respond to this? Is it the color? Is it the smell? Is it the garden? Is it its fragility?'"[35]

Holladay began collecting sometime in the 1960s when art scholars noticed that women and ethnic minorities had been grossly overlooked in major collections and art histories. She purchased a still life by Flemish artist Clara Peeters and discovered that there was nothing in the art history books about Peeters or other women artists. Holladay's advice to collect with a focus evolved into collecting women artists.[36]

Until the late 1970s, women were simply ignored in the art books or were

given only a sentence or two. Holladay founded the National Museum of Women's Art in Washington, D. C. in 1981, and opened its doors in 1987.[37] An undiscovered world explored through a woman's eyes included in the permanent collection: the art of Lavinia Fontana, a Renaissance era artist; Vigree-Lebrun, court painter for Marie Antoinette; and the 1977 gift by Wilhelmina and Wallace Holladay from the Georgia O'Keeffe Museum, *Untitled (Alligator Pears)*, charcoal on medium thick, cream, moderately textured laid paper, 24 7/8 x 19 in., 1920/1921.[38]

Georgia's and Holladay's spirit of exploring, discovery and adventure paralleled the development of America. The United States came into being in an era of worldwide discovery. Only the exploration of America's geography allowing contact with its vast ecological systems and varied Native Americans could lay the foundation for the true character of America and all its people. With such a continental exploration, the West took on mythical, bigger-than-life proportions. Americans knew the vastness of the endless plains, the rigid, high mountains, and the rivers that led to the "back of beyond." Out of this mystery the explorers were led to place the West into reality.[39]

Thomas Jefferson had never traveled farther than what is now West Virginia. Yet, when he was President of the United States he pushed his plan for westward expansion into place when he sent James Monroe as a special envoy to France. Jefferson wrote Monroe, "All eyes, all hopes, are now fixed on you." Monroe's mission resulted in the Louisiana Purchase in 1803 which extended the boundaries of the United States and established the doctrine of Manifest Destiny—Americans' belief that to expand into the western territories was their inevitable and divinely ordained right. Planning for an expedition westward had begun in Jefferson's mind years before and culminated in asking his private secretary, Meriwether Lewis, to form an expedition seeking a northwest waterway passage to the Pacific Ocean. Lewis engaged William Clark to form the Lewis and Clark Expedition. Although their personalities differed from calm to volatile, aloof to informal, the two men shared common traits: both were Virginians and Army officers, stood six feet tall, were terrible spellers but competent outdoorsmen, and shared "a passion for such Enlightment sciences as ethnology, paleontology, zoology and botany."[40]

The expedition, known as the "Corp of Discovery," set the stage for American expansion into the West. Thus began the great task of extending American commerce to gain knowledge of the weather conditions, identify wildlife, vegetation and natural resources, befriend the natives, find a suitable

route to the Pacific, and bringing the explorers safely back.[41]

Our young nation already had a workable Constitution but no identity when the party of thirty-one, which included twenty-nine-year-old Lewis and thirty-three-year-old Clark launched their wooden boats in the Ohio River. Their objective of finding a northwest navigable waterway between the Atlantic and Pacific Oceans would claim the land for America. Power was among the chief objectives. The passage existed only in an imaginary form because no such waterway existed. Clark, as shown in their extensive journals, proved to be the better navigator and Lewis the better planner as they used keelboats named the Red Pirogue and the White Pirogue, dugout canoes, horses and their own walking pace as they left the Ohio River and headed up the Missouri River. Skepticism of how the Native Americans would greet the expedition finally resolved itself with Sacagawea, a teenage girl, who helped them cross the rugged mountains. First unnoticed in history, Sacagawea's place later grew with the women's movement. After passing through the western part of the Great Plains of the United States, the explorers didn't find an easy waterway because the Rocky Mountains confronted them in all their glory. Lewis wrote on July 27, 1805, "Country opens suddenly to extensive and beautiful plains... surrounded...with distant and lofty mountains."[42]

Their adventure fostered by a grand hope and significant ignorance, and counterbalanced with determination and a quite recognizable fortune, sustained them for other discoveries—a national identity of discovery that required patience, luck, resourcefulness, resilience and observation.[43]

The Lewis and Clark Expedition secured a place in history when they sighted the Pacific Ocean. Clark's field notes cheered, "Ocian in view! O! The joy." Dramatically, Clark carved on a massive spruce tree "Capt. William Clark December 3rd 1805. By land. From U. States in 1804 and 1805." After a month of further exploring, they settled in for the winter to prepare for the return trip east in the spring of 1806 arriving September 23, 1806 at Saint Louis.[44]

They had experienced a torturous trip with portage of their boats and supplies over land to meet some of America's fiercest terrain. In essence, future explorers learned where not to go. Jefferson, in his political savvy, saved Lewis's and Clark's reputations by changing their objectives to understanding the Native American tribes and gathering specimens of plants and animals to increase the country's knowledge of the West. What is not to be forgotten is that Lewis's and

Clark's legacy included not only discovery but a cartography of the West which brought the American West together, later aiding John Frémont in the Rocky Mountains and John Wesley Powell on the Colorado River.[45]

The expedition's legacy changed through the generations. Through the years, Lewis and Clark have been lauded at first, for industrial expansion, then as conquerors of the forest, then "multicultural diplomats and proto-ecologists." Yet for every aspect of glory came sorrowful upheavals which in its totality became the saga's everlasting power.[46]

The English poet, Lawrence Durrell, wrote, "Journeys, like artists, are born and not made.... They flower spontaneously out of the demands of our natures— and the best of them lead us not only outwards in space but inwards as well."[47]

At about the same time that Lewis and Clark were making their epic journey, James Fenimore Cooper was entering Yale University in 1803. James Cooper, born in Burlington, New Jersey, in 1879, would add the "Fenimore" to this name in 1826. At one year of age, Cooper moved to Cooperstown, New York. The frontier village named for his father stood in the lake region approximately eighty-five miles southwest of Lake George, New York. Cooper experienced a youth of wealth and influential social circles which he freely criticized. At the age of thirteen Cooper entered Yale University. Being expelled in 1805 for a prank set him on a life of adventures. When his father was killed, Cooper left a naval career to manage his father's estate. Marrying in 1811, he was reading a mediocre English romance novel aloud to his wife and supposedly said, "I could write a better book than that myself." She challenged him and after one unsuccessful attempt, Cooper in 1821 published *The Spy*. In 1823, he published *The Pilot* and *The Pioneers*, which became the first of his five published *Leatherstocking Tales*, featuring Natty Bumppo as the main character. By 1826 and 1827 Cooper had composed *The Last of the Mohicans* and *The Prairie*, acknowledged as among his finest works. In 1840 and 1841, he published *The Pathfinder* and *The Deerslayer* to complete his *Leatherstocking Tales*. His writings eventually totaled thirty-two novels and over a dozen volumes of non-fiction.[48]

Cooper's strength lay in narrative and in description of the American forests, Great Lakes and High Plains, through which he communicates his fundamental theme that "nature provided an essential factor in the problem of existence." As he depicted man's relationship with his natural environment he told of a "great religious vision of life." Through Cooper's descriptions of the grand order of the

natural landscape of America he presented "both the principle of divine harmony everywhere apparent in the physical world and the need for humility in men who are dwarfed by the immensity of the God revealed in nature."[49]

The greatest value of a work of art, whether poetry, painting or novel, is its ability to arouse in the mind of the reader or viewer some fundamental truth.

Ida, a great talker, in her own quiet pleasure after dinner, read stories to her children. Georgia's older brother, Francis, Jr., usually chose the stories and all of Ida's children listened intently as she read, among others, of the adventures of Kit Carson, Stanley's adventures in Africa and the *Leatherstocking Tales*.[50]

It is a reasonable assumption that no listener, adult or child, could resist James Fenimore Cooper as Ida more than likely read to her children one of Cooper's best examples of his prose in the first chapter of *The Prairie* set on the Great Plains. Here Natty Bumppo, known by various names, was called only the "trapper" and Cooper made effective use of the frontier by showing the natural landscape and its relationship to those who moved through it.[51]

Cooper wrote:

> In the little valleys, which, in the regular formation of the land, occurred at every mile of their progress, the view was bounded on two of the sides by the gradual and low elevations which give name to the description of prairie we have mentioned; while on the others, the meagre prospect ran off in long, narrow, barren perspectives, but slightly relieved by a pitiful show of coarse, though somewhat luxuriant vegetation. From the summits of the swells, the eye became fatigued with the sameness and chilling dreariness of the landscape. The earth was not unlike the ocean, when its restless waters are heaving heavily, after the agitation and fury of the tempest have begun to lessen. There was the same saving and regular surface, the same absence of foreign objects, and the same boundless extent to the view. Indeed so very striking was the resemblance between the water and the land, that however much the geologist might sneer at so simple a theory, it would have been difficult for a poet not to have felt, that the formation of the one had been produced by the subsiding dominion of the other. Here and there a tall tree rose out of the bottoms, stretching its naked branches abroad, like some solitary vessel; and, to strengthen the delusion,

far in the distance appeared two or three rounded thickets, looming in the misty horizon like islands resting on the waters. It is unnecessary to warn the practised reader, that the sameness of the surface, and the low stands of the spectators, exaggerated the distances; but as swell appeared after swell, and island succeeded island, there was a disheartening assurance that long and seemingly interminable tracts of territory must be passed, before the wishes of the humblest agriculturist could be realized.

Still, the leader of the emigrants steadily pursued his way, with no other guide than the sun, turning his back resolutely on the abodes of civilization, and plunging at each step more deeply, if not irretrievably into the haunts of the barbarous and savage occupants of the country. As the day drew nigher to close, however, his mind, which was perhaps incapable of maturing any connected system of forethought, beyond that which related to the interests of the present moment, became in some slight degree troubled with the care of providing for the wants of the hours of darkness.[52]

Ida's readings of Cooper and others carried a strong message. First, Georgia heard the words which imparted a musical rhythm as the melody rose and fell. Unlike a single musical note with no significance by itself, each word symbolized ideas in a rhythmic sequence of the times in which it was written. She heard not only the more difficult words but the easier words, and she used them all later with great precision. From this listening Georgia could see with her imagination. The readings ignited in Georgia a feeling for the open space, sky and emptiness of land that gestated in her mind for years. Who can really explain why anyone falls in love with something?

Second, one of the most influential results of the readings involved the task her mother regarded as essential. From the beginning of time, mothers have been applauded for seeing into the hearts of their children. Ida assigned roles to her children based not on gender but on their special talents. Ida took the quilt and made a security blanket for Georgia which lasted long enough for Georgia to realize that the security came from Ida, not the quilt. Soon the reading became an everyday event. Ida passed on to Georgia what she had and she never stood between Georgia and the living of her life. Ida allowed Georgia to find her voice by clearing a space for her where her art could find a way to others.

Third, few role models existed in society for the creative woman so Georgia

accepted her mother's role model status more than she realized. Ida, aloof and aristocratic, made sure that her children received a well-rounded education, creating an influence on Georgia that lasted a lifetime.

Georgia in her later years commented on her mother:

> We had violent differences—we were very different kinds of people. I got so that I would not talk with her at all about many things. When I was near her I tried to do what she expected—when I was alone I did as I pleased and she would have often disapproved if she had known—I was not with her very much.[53]

Fourth, Georgia's memory of her birthplace always carried a fondness for the land. Her attachment to the familiarity of the earth and sky, its easily remembered spots, its traditional events and customs, often would create a slight pang of nostalgia, not to be confused with patriotism.

Georgia's brother, Francis Jr.'s, education included a diploma from the common schools in the spring of 1900. Then his father accompanied the young man to Delafield in September 1900, where Francis Jr. enrolled in Saint John's Military Academy.[54]

Georgia's education continued in 1901–1902 while she boarded as a freshman at the Sacred Heart Academy in Madison, a girls-only high school of boarding and day students.[55]

Sacred Heart Academy, an exclusive convent school overlooking Lake Wingra, had been built as Edgewood Villa in 1855 for a New York attorney. A banker bought the property in 1856, then sold its fifty-five acres to Governor Cadwallader C. Washburn in 1873 as the Executive Mansion. When the Governor moved to Minneapolis, he deeded the property in 1881 to the Dominican Sisters of Sinsinawa for educational purposes. It was called Saint Regina's Academy until the facility burned in 1893. Edgewood Academy of the Sacred Heart was erected on the stately site and served as a boarding school, high school, college and convent until 1926. Then the academy became co-educational. In 1969, the facility was razed.[56]

The Sacred Heart Academy boarding students and the sisters lived in the same building to develop a close relationship between them. One teacher, Sister Mary Angelique Sabourin, a thirty-four-year-old born in Wotton, Quebec, in

1867, had only taken her profession of vows on August 4, 1900, a year before assuming her first teaching assignment at Sacred Heart Academy.[57]

The almost fourteen-year-old Georgia took art lessons at an additional cost of $20 above the $80 tuition fee. About 1902, Georgia drew and signed a small hand in profile: *Untitled (Hand)*, graphite moderately thick, cream, moderately textured laid paper, 6 1/2 x 9 1/4 in., ca. 1902.[58]

As an art instructor with some previous experience, Sister Angelique reprimanded Georgia for the smallness of the drawing and Georgia remembered and vowed to always draw bigger. By the end of the term, Georgia had mastered her instructor's advice and Sister Angelique chose one of her drawings to be published in the school catalogue and awarded her an improvement pin.[59]

Sister Angelique remained at Sacred Heart Academy for twelve years. Later, at various assignments throughout the East and Mid-West, Angelique became known as a gifted teacher of drawing and painting. In her fancy needlework she chose to hand-color the thread for a set of needlepoint vestments. She died peacefully in 1957, at the age of ninety years and in the fifty-seventh year of her religious profession.[60]

With the death of Francis O'Keeffe's three brothers from tuberculosis, Francis must have feared for his own health. Rather than move westward, Francis O'Keeffe moved east to a more temperate climate in Williamsburg, Virginia, in the fall of 1902. He sold his Wisconsin land for $12,000. Luis Drunasky bought one hundred sixty acres and a gentleman from Lake Mills purchased the remainder. As part of the payment Francis received eighty-six acres of land in the township of Sun Prairie and eighty acres in Lake Mills from the Lake Mills purchaser. Leaving debts behind in Sun Prairie, Francis took to Williamsburg his wife, Ida, Aunt Jenny, and his three youngest children, Alexius, Catherine and Claudia.[61] They were to settle and be ready for the older children, Francis, Jr., Georgia, Ida and Anita to join them at the end of the school term.

In Williamsburg, the O'Keeffes paid $3,500 for a two-story, eighteen-room white clapboard house on nine acres of land known as Peacock Hill at the southern end of the intersections of Scotland, Boundary and Henry streets. The luxurious grounds stood among neighboring new homes and included oak trees, a stable and tennis court. The house, called "Wheatlands," stood at the end of a pine-tree-lined, long drive. The house featured a front and side porch and the ever-present Southern tradition of an upstairs sleeping porch. A short walk two

blocks east stood the Governor's Palace overlooking the Palace Green, leading to the unpaved Duke of Gloucester Street which was filled with crumbling eighteenth century houses.[62] See figure 3-3.

3-3 *Map of Williamsburg, Virginia*

Francis opened a feed and grocery business when he arrived in Williamsburg which eventually continued his downhill economic slide.[63]

In the summer in Williamsburg, the O'Keeffes rented a rather rough vacant summer home on the river at Yorktown to enjoy swimming and sailing.[64]

Georgia and her brother, Francis, did not go to Williamsburg and Georgia attended Madison High School as a sophomore. Georgia, as always surrounded

by strong women, lived with Aunt Lola, a rather sweet, soft-spoken school teacher whom Georgia considered an authority on most subjects. They lived on Spaight Street which overlooks Lake Monona, a lake about ten miles in circumference with crystal clear water revealing the bottom of the lake covered with white pebbles. The bank sloped gently in a rise and did not look swampy.[65]

Georgia spent her remaining high school years at Madison High School. While attending an art class, Georgia saw a jack-in-the-pulpit and it occurred to her to paint from nature, rather than copy a painting.[66]

Georgia, in June 1903, joined her family in Williamsburg. With a defining sense of her inborn abilities, a reference to her birthplace, the mores of the Sun Prairie neighborhood, the quality of her teachers and role models, and identification with her socioeconomic class, Georgia departed eastward.[67]

4

REACHING FOR EARTH AND SKY

Sixteen year old Georgia in June 1903, left the security of Wisconsin's earth and sky to join her family in Williamsburg, Virginia. The move took her to the peninsula-like lowland between the James and York rivers before the current eases into the Atlantic Ocean from Chesapeake Bay. In her searching mind's eye this foreign terrain at eighty-six feet elevation from sea level must have been miles and miles of the same green.[1]

Centuries earlier in the southeast of the United States the skilled Native American farmers, the Creeks, Chickasaws, Choctaws, Cherokees, Yamasees and Seminoles built their villages in these river valleys similar to the James and York rivers. In Virginia in 1607, the Native American inhabitants numbered in the thousands, mostly living east of the Blue Ridge Mountains, a range that slowed advancement to the West.[2]

The first one hundred forty-four colonial settlers of Virginia came from England in 1606 in three ships, the *Susan Constant*, the *Godspeed* and the *Discovery*. After an uncertain beginning

the colony survived until the king of England in 1624 gained control, bringing settlers to farm the royal colony's land. In 1633, Williamsburg, with the largest population and influence, became the capital and flourished as the political, cultural and educational center of Virginia. Bacon's Rebellion in 1676 protested the British rule. In 1699, Williamsburg, the thriving capital, harbored the dream of American freedom. Then in 1776, Virginia declared itself an independent state. With the excessive taxation, Virginia joined other states to declare its independence from England. After the American Revolution the capital moved up the peninsula to Richmond. For over a century Williamsburg existed as a quiet town, home of the College of William and Mary, until 1926, when John D. Rockefeller began preserving its heritage.[3]

Any persons not born in Williamsburg were "outsiders" in Williamsburg, where the fundamental concepts of America nurtured responsible leadership, public service, self-government and liberty for all. The O'Keeffes, having no pedigreed ancestors, were met with little hospitality in the unpaved, dusty 1903 Williamsburg streets where the eighteenth-century houses showed the remnants of the earlier southern way of life. See figure 3-3.[4]

Georgia, probably not too concerned with being an insider or an outsider, arrived in Williamsburg to begin her more than nine-year "journey of discovery" when, as a twelve year old, she declared she wanted to be an artist. All her natural abilities—which couldn't be measured, seen, heard or felt, but she knew they existed—played into her discovery of how these abilities influenced her behavior.

The O'Keeffes planned the education of their two oldest children and in the fall of 1903, Francis enrolled in the College of William and Mary and Georgia enrolled in Chatham Hall Episcopal Institute. Their younger brother, Alexius, would attend the Academy at William and Mary, a college preparatory school, from 1907 to 1910. A tutor managed the younger children's schooling.[5]

In south central Virginia, approximately one hundred thirty miles southwest of Williamsburg, one hundred miles south of Charlottesville, Virginia, and twenty-five miles north of the North Carolina border, stood Chatham Episcopal Institute (now Chatham Hall) in Chatham, Virginia. The sister school to Woodbury Forest in Orange, Virginia, approximately one hundred twenty miles northeast of Chatham, dated its founding to 1894. An affiliation with the Episcopal Church provided secondary school education for Virginia girls.

As an all-girl boarding school, its mission included preparation for college and leadership in the community by invigorating the student's sense of responsibility and self-respect, leading to a high level of integrity to guide her choices and actions. The uniqueness of the school resided in its appreciation of the individual as each girl matured.[6]

Georgia began her schooling at Chatham Episcopal Institute in the fall of 1903, as a boarder. Elizabeth May Willis, the principal and art teacher who had studied at the Art Students League, recognized and encouraged Georgia. Willis allowed Georgia to follow her natural spirit. During her second year as a senior Georgia became the art editor for the Chatham Hall yearbook, *Mortar Board*. She drew a series of seventeen black and white drawings in 1904/1905. The decidedly Art Nouveau style contained notations:

Untitled Illustration, VI, with the notation: "Racket Club, Colors, Scarlet and white, Flower, Chrysanthemum, Hot Game of Tennis,"

Untitled Illustration, VII, with the caption: "This abominable machine will be the death of me yet,"

Untitled Illustration, VIII, with the caption: "Alice, I wish you would please show me the oil stove if you know where it is,"

Untitled Illustration, IX, with the caption: "Young ladies H_2O has a very disagreeable odor,"

Untitled Illustration, X, with the caption: "I will now read the grades for the week,"

Untitled Illustration, XI, with the caption: "You know how good I want you to be—good as gold,"

Untitled Illustration, XII, with the caption: "It is perfectly ridiculous—the way I hate to demerit the girls,"

Untitled Illustration, XIII, with the caption: "Whoooeee but—this goes pretty well,"

Untitled Illustration, XIV, with the caption: "I see nothing to laugh at, I want perfect silence at once,"

Untitled Illustration, XV, with the caption: "Oh! I want my boys!!"[7]

At the end of the school year, Georgia won the school's art prize. Georgia also participated in the school's activities by playing basketball and was elected

treasurer of the tennis club. She joined Kappa Delta, a national fraternity which had been founded in 1897 at State Female Normal School (now Longwood University) in Farmville, Virginia, approximately sixty-five miles northeast of Chatham. The four founding women of Kappa Delta encouraged college-age women and beyond by preparing them to be all they could be and all they could hope to become. With Kappa Delta's official flower, the white rose, the fraternity expressed itself as a "social experience based on the fundamental right of a free people to form voluntary associations."[8]

Even with the white rose as the Kappa Delta official flower, Georgia painted many different types of flowers but did not paint a white rose until 1928: *White Rose*, oil on canvas, 11 1/8 x 7 1/8 in.[9]

Although Georgia participated in college events, her playfulness, poker playing and inability to master spelling kept her from being a "model student."[10]

While at Chatham Hall, Georgia met Alice Peretta from Laredo, Texas. After Alice announced that she really didn't like Georgia, Georgia made a public bet that she could convince Alice to like her. Consequently, by the end of the school year Georgia and Alice had become friends.[11]

Georgia graduated on Monday, June 5, 1905, and participated in the 10:00 a.m. graduation ceremonies by reading the Class Prophesy.[12]

With few women role models in society for a creative female to follow and seeking such role models, Georgia began absorbing information from her teachers. Sarah Mann adhered strictly to the traditional approach and preferred that Georgia copy the masters. She eventually would encounter those who encouraged her to ignore the masters, to break the rules at any cost and develop her own voice. There would also be teachers who wanted her to combine the best of the traditional and nontraditional approaches.

At age seventeen, Georgia continued collecting pieces of knowledge. Her accumulated knowledge followed Georgia out of the classroom because she included them in anything, simple or complicated, that she did—writing a letter, folding a napkin, and in her art.

An important element not to be discounted was Georgia's optimism, but she knew her self-empowerment would take a while.

With Willis's assurances that art school was proper for a young woman, Georgia in the fall of 1905 returned to her familiar prairie land in Chicago to enroll in the Art Institute of Chicago. She lived with her Aunt Ollie Totto and

Uncle Charles Totto in an apartment on Indiana Street, within walking distance of the Institute. Aunt Ollie showed traits of a determined woman and pursued several careers: schoolteacher, stenographer in Chicago, manager of a shoe store in Madison, and finally settled on being the only female proofreader for the Milwaukee *Sentinel* newspaper. Each career developed further Aunt Ollie's natural independent talents based on her aristocratic presence. Aunt Ollie encouraged Georgia when she enrolled in the Art Institute of Chicago for further art studies and took great pride in Georgia's accomplishments.[13]

For the first time in her life, Georgia was with a group of students whose skills were greater than her skills. But, sensing her amateur standing, her innate desire to achieve drove her to master the classes.

For seventeen-year-old Georgia, copying the classics was the only option at the Art Institute of Chicago. To advance in her studies she chose to study with the Dutch artist, John H. Vanderpoel.

Georgia recalled of the hunchback Vanderpoel:

> As he lectured, he made very large drawings on a sheet of tan paper as high as he could reach. He was very clear...[and] one of the few real teachers I have known.[14]

His emphasis on meticulous draftsmanship impressed Georgia and she would employ such a technique in her future work although she seldom painted the human form. Georgia always identified more with objects than with people.

In Vanderpoel's book, *The Human Figure, Life Drawing for Artists*, published in 1908, he approached nature simply and directly, analyzing the human body in detail and as a whole. In excellent taste, he remained close to nature as he featured each part of the body which was not subject to change with time.

Vanderpoel illustrated each body part by including lines that subtly shaded, foreshortened and proportioned such as the overhang of the upper lip, the pucker at the corners of the mouth, and the tension of the connected body parts.

In his assessment of drawing the human figure, he stated:

> In the making of a thorough drawing of the human body... whether in line, light and shade, or tone, the student goes through two stages of mental activity: first, the period of research, in which

he analyzes the figure in all the large qualities of character, action and construction. In this analysis he acquires an intimacy with the vital facts, and this leads, as the work progresses, to a profound conviction. When thus impressed the student enters upon the second period, which deals with the representation of the effect dependent upon light and shade. Impressed with the facts in regard to the character of the model, understanding the action and construction, his appreciation enhanced by research, his lines become firm and assertive.[15]

As Vanderpoel concluded his instructions on drawing the human figure, he stated:

The minor parts fuse into the greater in the most subtle manner, leaving us in doubt as to the moment of separation or as to which is the more important for pictorial use. So the lines that encompass the smaller parts melt into the larger and become part of them. This is true of every degree of form, from the minutest detail to the largest mass; each form becomes a part of something larger than itself. Even a form, than which locally none is more important, may be so submerged in a strong action as to lose all or a great part of its importance.[16]

At first, Georgia was uneasy in the class because of the nude models. But she overcame this and emerged from Vanderpoel's December class ranking of fifth to first place the following February.

In the summer of 1906, Georgia returned to her family in Williamsburg. In the warm, low-lying land she contracted typhoid fever. By the end of September she had recovered but the fever caused the loss of her hair and she had to wear a lace cap to conceal her baldness. The typhoid endangered her eyesight, making her conscious of the need to see clearly, in sharp focus, and to transpose images to her thoughts. She was too weak to return to the Art Institute of Chicago and spent the following year in Williamsburg recovering from the illness.[17]

Francis's economic troubles forced the sale of Wheatlands in 1907. He retained a strip of land on the corner of Francis and Henry streets that included the "Travis House."[18] See figure 3-3.

With a letter from the Art Institute of Chicago stating, "Miss O'Keeffe is a young lady of attractive personality and I feel that she will be very successful as a teacher of drawing," Georgia in the fall of 1907 added to her accumulated knowledge by enrolling in the Art Students League on West Fifty-seventh Street in New York and living in a rented apartment with her friend, Florence Cooney.[19] In this atmosphere of American art which praised conservativeness and with the European avant-garde artists introduced by Stieglitz, Georgia furthered her artistic career at the Art Students League.

Georgia was nineteen years old when she went to New York. Seven years had passed since she declared that she wanted to participate in the creative world and be an artist.

The inborn abilities that Johnson O'Connor had identified in his aptitude studies were those that emerged early in Georgia's life. Her natural qualities had not drifted away. She was recognizing these traits and stayed focused. She easily accepted her mature memory for design. She was becoming proficient with finger dexterity to handle the tools of her trade. Georgia's flow of ideas allowed her to find places to demonstrate them. Observation played a keen role in selecting her painting subjects. Color perception would always remain essential in her career. She had listened to all the linear processes of thinking such as drawing a line from A to B. As a personality Georgia was a specialist rather than a generalist. She listened to her subconscious feeling of intuition.[20]

Georgia's finances were meager, but the economy of America as a whole was thriving in the early 1900s. New York was the center of the American art world. Not to be overlooked in Georgia's choices were all the random events, that seemed coincidental, which led Georgia to New York.[21]

Georgia studied with William Merritt Chase in the afternoons and with Kenyon Cox and F. Luis Mora in the mornings.[22]

William Merritt Chase came from a prosperous Indiana family dealing in women's shoes, which Chase claimed as the first ladies' shoe store in the West.[23] Born in 1849, Chase expressed an interest in art from the earliest age. When asked how he started painting, Chase replied:

> That would indeed be hard to say. It may have been a natural outcropping...for I do not know of any of my forebears who practised it. About the time I was born, decorative work with colored feathers was

all the fashion among the ladies, and my mother took it up. It may have been that the first thing my infantile eyes saw was a brush and pigments. However, that may be, the desire to draw was born in me, and I believe that my mother still treasures some old school books whose illustrations are fearfully and wonderfully colored by my hands.[24]

When Chase turned twenty years old, his father's business failed and the older Chase experienced disappointment in his son's disinterest in the business. Chase's father finally became resigned to his son's interest in art and directed him to study with a local artist, Barton S. Hays, who provided him with basic training in copying.[25]

Before continuing with his art studies, the 5 feet 4 1/2 inches tall seventeen-year-old with blue eyes, black hair, and dark skin joined the United States Navy in July 1867. He ended three months of duty with a discharge arranged by his father.[26]

Hays then suggested Chase further his studies in New York. Chase attended classes at the National Academy of Design (NAD), founded in 1825 by a group of male artists including painters, engravers, sculptors and architects. The NAD, patterned after the École des Beaux-Arts, sought to improve the artist's life and provided life classes that eventually opened to women in 1871.[27] Like other students, Chase made drawings of plaster casts of antique sculpture. Chase mastered this discipline but many years later remarked:

> I am convinced that the manner in which the study of art has been conducted, by making the beginner draw first from the antique before he knows anything about art is wrong.... I prefer that my pupils begin to draw from life.... For a youngster to go into a classroom filled with casts of the antique is as disheartening as to go to a graveyard.... I know how it was with myself; as much as I appreciate the antique now, I know very well that I do not appreciate it as much as if I had not once hated it, when I knew it was a task that had to be done, something that had to be gone through with.[28]

By 1871, Chase was exhibiting at the Academy's annual exhibition and his more polished paintings represented variations on a single theme which he developed his entire career. His still life paintings, a popular theme of the day, brought needed income when his father's financial support ended.[29]

In 1872, the twenty-three-year-old Chase studied at the Royal Academy in Munich, which by then had established a popularity with American art students comparable to the Paris academies because of its adventurous and less than academic discipline.[30] Besides, the Munich art scene avoided the distractions of Paris.[31]

Previous to Chase's 1872 arrival in Munich, the influence of the German realist, Wilhelm Leibl (1844–1900), had become apparent in the Munich Royal Academy. Leibl sought to reject the sentimental drama in a painting to attain "artistic truth" through technique, with no subject embellishment. Leibl was the first to exhibit paintings that seemed unfinished. Leibl's philosophy maintained that "if a picture is painted well the soul would anyway be present." This to Leibl represented artistic truth.[32]

In Munich Chase began his final and most rewarding artistic training, as advised by his instructors, studying the Old Masters at Munich's principal art gallery, Alte Pinakothek. The Munich teachers praised the works of Diego Velázquez and Frans Hals as the ideals. At first Chase dismissed the dark paintings as nonsense and confessed:

> When I first reached Munich I went first to the old gallery where the "old masters" were; and I distinctly remember that at that day I thought it was all nonsense—that these dark, terrible things were not all they were claimed to be....Then the next thought I had was: "There must be a reason why all these things are here, and so cherished and so placed and so guarded as they are." And I thought. "I think, William, it would be wise for you to keep a hold upon your counsel, and not to say this out loud, or even whisper such a thought."[33]

As a common practice the students were to select a painting at the museum, study it and paint a copy from memory. Eventually reversing his opinion, Chase admitted their influence. He shifted his preference from still lifes to portraits and figure studies using dark, lush colors, and broad brush strokes.[34]

The study course in Munich involved three stages: drawing, painting and composition. In the drawing classes the students copied casts of ancient sculpture. The painting class involved painting the nude. Composition class required composing elaborate historical paintings.[35]

The rigorous Munich Academy doctrine exposed Chase to Karl von Piloty (1826–1886), whose style "has been described as 'coloristic realism,' characterized by vigorously applied broad brush strokes that capture the coloristic properties and appearances of objects." As the foremost representative of the realistic school of painting in Germany, Piloty specialized in melodramatic historical scenes.[36]

Liebl, working with Piloty, taught Chase to paint directly with little retouching, using dense surfaces and a dark palette with minimum embellishing of ordinary subjects. His instinct for color enabled him to paint broadly, yet reveal detail delicately. Leibl's direct, careful recording was in direct opposition to the prevailing German romantic idealism.[37]

Chase also spent time in Venice with American friends Frank Duveneck and John Henry Twachtman.

Duveneck, born Frank Decker in Covington, Kentucky, in 1848, assumed the name of his stepfather. As a young boy, Duveneck apprenticed to two church decorators in Kentucky. He studied at the Munich Royal Academy from 1870 to 1873. In 1874, Duveneck returned to America to settle for a year in Cincinnati. He returned to live and paint in Munich, Venice, Florence and Paris. In 1877, Duveneck painted with Chase and Twachtman in Venice and by 1879 he called Venice his home and became a highly successful teacher. His most enthusiastic American students became "The Duveneck Boys." His wife, the artist Elizabeth Boott Duveneck (born in Boston in 1846), died in Paris in 1888. One of his best works of sculpture, a memorial to his wife, is in the English cemetery in Florence. Returning to America that same year, Duveneck taught briefly in Boston and then taught summer classes in Gloucester, Massachusetts, before joining the faculty of the Cincinnati Art Academy, where he became dean in 1905. As an art teacher, Duveneck helped America become interested in European naturalism. Duveneck died in Cincinnati, January 3, 1919, and bequeathed his collection to the Cincinnati Art Museum.[38]

Duveneck's work showed the influence of the works of Franz Hals, Rembrandt and Peter Paul Rubens, which resulted in his use of dark, earthy colors, and broad brushstrokes.[39]

Twachtman, the son of German immigrant farmer's, was born in Cincinnati, Ohio, in 1853, and as a young boy decorated window shades. At fifteen years of age he studied at night at the Ohio Mechanics Institute. When he was eighteen years old, Twachtman studied with Duveneck at the McMicken

School of Design in Cincinnati. In 1875, at age twenty-two, Twachtman traveled with Duveneck to the Royal Academy in Munich to begin formal art training. In 1876, he painted in Bavaria. In 1877, he went to Venice with Duveneck and Chase. Returning to Cincinnati, Twachtman, too, adopted the broad brush strokes and dark warm colors of the Munich School and Duveneck. In studying at the Académie Julian in Paris from 1883 to 1885 with the Impressionists, he would be influenced to paint with broken dabs of color, resulting in his formal construction of scenes veiled in delicate high-key coloring. A more abstract style with Whistlerian overtones was formed in Paris. Economically successful as a painter, Twachtman bought a seventeen-acre farm near Greenwich, Connecticut, where his personalized landscapes became decorative and poetic. After 1889, he taught at the Art Students League, where his landscapes attained a maturity. His best known works are of a delicate nature with high-keyed color and a strong composition always veiled in "cool, shimmering light." As one of America's leading Impressionists, he belonged to the Ten American Painters group who exhibited independently of the National Academy of Design. He died in 1902 in Glouchester, Massachusetts, known as a landscape painter, etcher and teacher. His teaching position at the Art Students League was filled by Chase.[40]

Chase declined the offer to teach at the Munich Academy and returned to the United States. He explained, "I was young: American art was young; I had faith in it." He was prompted by Piloty's advice:

> Yours will yet be a great country of artists and art lovers...everything points to it; you have the subjects, and you have the great inspriation of the place where life is being lived. Italy, France, Germany, Spain, England, these have had their day, the future is to America.[41]

Chase's reputation in Munich preceded him in America as he had sent paintings to American exhibitions to gain notoriety and needed income. But during Chase's absence from the United States, the art climate had changed.

A group of students unhappy with the restrictive discipline at the National Academy of Design and the École des Beaux-Arts broke away from both to form the Art Students League in 1875. The instruction was difficult, but a student could enter any class of his choosing with approval of the instructor. The school accepted

women, allowed student participation in preparing the curriculum, regulations, and the staff. And most important, the student's ability was paramount, rather than his advancement in class.[42]

As Chase's career gained momentum, he began his career at the Art Students League in 1878 where, except for one year, he would teach for a quarter of a century until 1896. Chase arrived at the right time in the United States although he doubted his ability to teach. There were thirteen art schools in New York and Chase joined the most active and progressive of them.[43] He later became involved with the Society of American Artists which formed from the National Academy of Design because of a dispute over wall space being allotted to younger artists and dissatisfaction with the National Academy's conservatism. He joined the Society of Painters in Pastel to establish pastel as a legitimate medium with his painting, *Pure*. Member Kenyon Cox commented on Chase's answer to critics suspicious of his direct means of painting the female nude in *Pure*:

> Within a short time some of us have seen a few lovely pastels of the nude female form from his hand. The delicate feeling for color and for values, the masterly handling of the material, the charm of texture in skin or stuffs—these things we were prepared for; but we were not quite prepared for the fine and delicate drawing, the grace of undulating contour, the solid constructive merit which seemed to us a new element in his work.[44]

Chase also became associated with the Tile Club, formed in 1877. Its members included their era's prominent painters and sculptors. They produced art work of a decorative nature. Chase's interest in *plein-air* (outdoor daylight) dated from his summer excursions with the Tile Club.[45]

His reputation as a gregarious personality made Chase a popular teacher. His leadership melded with vitality, his talent with ingenuity, and his strong beliefs with wit.

Aside from teaching his students to paint quickly, to use bravura brushwork, to use color and textures, and to focus on a beautiful subject matter, Chase personifed the value of an impressive image by his attire and in his studio. Because few art dealers showed an interest in representing American artists, Chase's attire and studio contributed to his aura and became his "salesroom."[46]

He valued the theatrical self-promotion of his status as an artist to present himself as different from the rest of society. When he walked down the street or into a room, he wanted others to notice his rather eccentric artistic bearing. He didn't allow his small town beginnings to command attention. Chase dressed elegantly: cutaway coat and trousers, flat-brimmed French silk hat, broad black ribbon that hung from his glasses, always a flower in his lapel, and often he was accompanied by a large white Russian wolfhound.[47] His flamboyant attire was not unlike that of Stanford White, the New York architect.[48]

In 1878, Chase's studio suite in the Tenth Street Studio Building in New York featured a two-story gallery. The inclination to elaborate studio decorating began in the late 1850s as New York's Tenth Street Studio Building exemplified artists' artistic and financial successes. Chase's had been formerly occupied by Albert Bierstadt, who decorated his studio with western travel relics such as Indian wampum and feathers as he painted his enormous landscapes of the West.[49]

Chase followed Bierstadts's lead and filled the same suite with mementoes from his travels around the world. Duplicating the European studios, Chase displayed countless bric-a-brac such as Japanese fans, East Indian drums, Phoenician glass, Russian samovars, a bust of Voltaire, a large stuffed flamingo, and a plethora of fine paintings to give the aura of a show studio, all of which justified his studio as the talk of New York.[50]

Chase's gentlemanly manners appealed to his women students who were finally being offered a higher level of training than the self-study women's clubs. American women were not offered a substantial role in the beginning days of America's first museums, art unions and galleries. They entered the American artistic world through the decorative arts and the minor arts because in their role of homemaker a properly appointed home would uplift and build character. In the antebellum era of the 1850s, studio life belonged strictly to the men. Then New York artists, to increase their sales, began opening their studios to the public, which included women. This eventually led to women being admitted to male dominated art classes, including life drawing from nude models.[51]

Chase began a series of travels for teaching purposes, the first being to eastern Long Island, which introduced him to broad land expanses and skies always changing, then to European cities where he met with John Singer Sargent, Carolus Duran, and Alfred Stevens, a Belgium painter. Stevens advised, "Chase,

it is good work, but don't try to make your pictures look as if they had been done by the old masters." From then forward, Chase lightened his palette and painted modern subjects.[52]

Chase's abandonment of the dark palette of the Munich school and his conversion to Impressionism began in the 1890s when he moved to Shinnecock Hills, Long Island, and set up a school after the New York schools closed for the summer. The house sat on a parcel of land with the sea all around and this became a favorite subject. Chase again and again painted the gray-shingled walls, crystalline light, blond beaches, and blue sky full of windswept clouds. He hinted that for artists to paint over and over the same scene was simply a way to reveal themselves.[53]

Categorized as an American impressionist in 1898, Chase accepted his election to the American Institute of Arts and Letters along with Childe Hassam and John H. Twachtman.[54]

Eventually, in 1902, Chase discontinued his summer classes at Shinnecock and by 1903 was taking summer students to study in Europe because he still believed that to view the old masters provided a broadened perspective for all young artists and particularly for the next generation of painters.[55]

In the summer of 1907, Chase escorted a group of students to Italy where he emphasized art history and appreciation. That fall, Georgia enrolled at the Art Students League in New York.[56] By now Chase had become fascinated with the sheen of the skin of dead fish. He painted another of his variations of a theme, *Still Life, Fish*, oil on canvas, 32 1/8 x 39 9/16 in., 1912, which is now in the Brooklyn Museum.[57]

Georgia adhered to the prominent method of teaching which was to draw from antiquity, then from life. The similarities seem recognizable in Chase's *Still Life: Fish*, and Georgia's *Untitled, (Dead Rabbit with Copper Pot)*, oil on canvas, 20 x 24 in., 1908, for which Georgia was awarded the Art Students League's 1907–1908 Still Life Scholarship of $100, and the opportunity to attend the ASL summer outdoor workshop at Amitola, conducted at the Crosbyside Hotel on Lake George.[58]

When Georgia studied with Chase, she remembered:

I think that Chase as a personality encouraged individuality and gave a sense of style and freedom to his students... I thought that he was a

very good teacher. I had no desire to follow him, but he taught me a good deal.[59] There was something fresh and energetic and fierce and exciting about him that made him fun.[60]

In 1908, Chase's election to the American Academy of Arts and Letters accompanied the election of Kenyon Cox and Julia Ward Howe, the first woman elected to the American Institute of Arts and Letters.[61]

Chase, often criticized as taking too much time from his painting to teach, countered:

> The association with my pupils, most of them young people, has, I may say, kept me always young in my work, and my interest in painting fresh and ever renewed. The analysis of my pupils' work and the incidental formulating of correct principles, keep me artistically speaking, healthy and my point of view clear.... If you as Art students or as artists, paint with the idea of truckling to possible buyers...you degrade the art and yourself. If you paint with the desire of pleasing the vulgar taste, of tickling the fancy of the ignorant, if your aim is to produce what will sell, I beg of you to put up your canvas and brushes and leave them forever.[62]

Chase painted what he saw and often told his students, "When the outside is rightly seen, the thing that lies under the surface will be found on your canvas."[63]

Chase taught his students to study fine art, to emulate it, to receive advice from a teacher but not to become dependent on the teacher, and to develop a style relating to the strong elements of others' art in your own refreshing original way because "originality is found in the greatest composite which you can bring together."[64]

Often, originality is forgetting where you found it. Chase admitted borrowing from many only to develop his own style. Of his eclectic style, Chase commented:

> The most original painters are those who have stolen here a little and there a little from everyone. When they arrive at the level of the masters they have sought to imitate, they will find they can do so much better work themselves that they can't help being original.[65]

In teaching, Chase thought of the individual foremost. His criticisms were bold, yet enthusiastic, to foster the idea of a next painting; he encouraged persistence in that if your work on one particular day is not as good as the previous day...you are not losing ground; paint to leave a record because millions die without a trace of their having been here; study for the stimulation; and avoid specializing in one subject matter. He insisted that a painting did not have to tell a story, have a moral, or be poetic. He recommended simple subjects.[66]

Chase thought of teaching as an obligation and advised his students to become teachers. "It is good for the teacher and good for the pupil to repeat the creed."[67]

He was among the first to profess that art training should last no more than three years. "Shake the influence of the school as quickly as you can. Cultivate individuality. Strive to express your own environment according to your own lights, in your own way."[68]

His teaching career culminated in the formation of his own school in New York at Fifty-seventh Street and Sixth Avenue, the William Merritt Chase School of Art, which later became the New York School of Art.[69] After eleven years, Chase abandoned teaching at his school due to conflict with Robert Henri, stating, "I have warned the students...that there was danger is mistaking violence for strength...." In 1907, as the conflict between conservatists and progressives heightened, Henri, with five other artists formed The Eight, a secessionist group of painters.[70] In 1914, Chase commented to his students, "A certain group of painters in New York paint the gruesome. They go to the wretched part of the city and paint the worst people."[71]

Chase gave young, aspiring artists the proper technique, encouragement and inspiration to become future modernist painters in spite of his disdain for modern art.

A national spirit prompted attempts to define an American art for our country based on the work of Thomas Eakins, Winslow Homer, and Albert Pinkham Ryder, in addition to James Abbott McNeill Whistler, John Singer Sargent and Mary Cassatt. Chase's reputation ranks between all others who fall in these categories. To measure all by European standards ensured mistakes.

During the late nineteenth century, Chase dominated the American art scene, being one of the first to paint Impressionist landscapes in the United States. His portraits and still lifes only added to his reputation as a leader in

the society of artists, a connoisseur of European painting, a person who knew everyone of importance in American art, and above all through his renowned reputation as a teacher.

Chase ended his life as a frail and weak man and his family buried him abruptly without ceremony or tribute, perhaps to allow his friends and public to remember his dynamic personality.[72]

In essence, Chase was the most influential American art teacher of his time and until his death in 1916 he promoted a greater appreciation of American art. The one exception was modern art, which he decried as opposed to everything he stood for and fought for in maintaining truthfulness for American art.[73] In 1930, critics credited him with paving the way for modern art with his abstract qualities, a concept Chase had not intended.[74]

Duncan Phillips (1886–1966), later regarded as an important patron of modern American artists such as Arthur Dove and John Marin, commented after Chase's death:

> Time was when William M. Chase was regarded by his fellow countrymen as a radical artist.... Today, they call Chase reactionary, they who fight sham battles, brandishing paper pistols. And yet the position where he held his own against all comers marks the battle front of forty years ago, where the victory was won which made possible the present and the future of American painting.[75]

Kenyon Cox said in 1916 that Chase's "place in American art is fixed, and as long and as widely as that art may interest mankind so long and so widely, will his name be remembered."[76]

Another of Georgia's teachers at the Art Students League was Kenyon Cox. His politically prominent father encouraged his son's artistic ability and interest when Kenyon, born in 1856, experienced a frail childhood. His artistic career began crystallizing when Kenyon realized he would not be successful without European training. Paris offered not only museums, ateliers and academies, but hopes and prospects of success. The fully enrolled École des Beaux-Arts prompted Kenyon to study with the elaborately dressed and controversial painter Carolus Duran, who taught as a means of furthering his art, acquiring disciples for his teachings and methods.[77] Duran rejected the academic drawing of casts of famous

works in favor of drawing directly on the canvas with a brush, not only modeling, realistic representation, and form, but emphasizing surface, texture, color, and motion.[78] His teachings stirred the enthusiasm of the most skeptical student.

Kenyon realized that Duran's methods were successful only for the talented. Years later, though, Kenyon praised Duran, who, in his modernism, allowed light and color to become painting. Yet Cox desired the drawing expertise absent in the atelier of Duran, which forced him to apply to, enroll in, and be accepted at the École des Beaux-Arts to study drawing with Alexandre Cabanel.[79]

Among the better artists of the École des Beau-Arts, Cox matured as he saw the effects of experience and education. He broadened his knowledge with travel to Italy which demonstrated that the art tradition existed behind all the academic training. He saw how a painter executed his skills in a personal style. He studied in the private atelier of Rodolphe Julian, then with Jean-Léon Gérôme.[80]

Cox's ability led to his developing an intellectual side to his art. Skill was important, but ideas were paramount. H. Wayne Morgan stated in his biography, *Kenyon Cox, 1856–1919, A Life in American Art*:

> Above all, art communicated between a special creator and an audience of like-minded people. The artist selected from his experience and intensified with his skill and special personality those attributes of life that would enhance the experience of others. The artist was "not to invent something not in nature, but to choose from nature those truths which come home to the individual mind, so making you see, not nature, but the artist's view of nature."[81]

Cox further stated in 1878:

> Then, as I conceive it, his business as an artist is not to reproduce the landscape just as it is, which if it were possible, would leave everyone free to be impressed or not, as nature would; but to choose from the scene those aspects and forms which should convey perforce to any beholder of his work the same impression which nature herself conveyed to him. And he is the noblest artist who succeeds in reproducing the greatest and truest feelings and conveying to the beholder the noblest emotions, and in this,

I think, is [the] true morality of art, which has no business to instruct but only to move.[82]

In Europe, Cox worked hard to return to America in 1882 with his reputation in good standing. He had his own identity, although Duran had taught him breadth of style, his drawing technique came from Cabanel, and Gérôme had taught him truthfulness to nature. Cox became an academic modernist when he discovered symbolism in nature.[83]

Like most American artists, Cox earned a living drawing illustrations in New York, which also required critical comment. Cox established a reputation as a critic which remained with him throughout his career and which led to writing about art. After an uncertain start, Cox took the advice of his father. "'Slashing criticism' is very tempting, but it does not teach the public, nor does it impress the knowing, as more temperate and kindly criticism will do."[84]

In 1884, Cox taught at the Art Students League.[85] Cox, cognizant of teaching as "that great resource of the impecunious painter in America," gratefully accepted the offer to teach there.[86]

Cox's position as an illustrator, critic, muralist and painter gained him recognition at the Art Students League. His gruff, caustic tone caused William Merritt Chase to say, when Cox commented on a friend's speaking so rudely, "For God's sake, Cox, don't you know that you always speak like that?" However, Cox resisted criticism because "he has energy of intellect sufficient for a whole company."[87]

Cox's reputation and teaching skills at the Art Students League in 1884 were at their height when Georgia attended in fall of 1907 through spring 1908.[88] She benefitted from Cox's twenty-three years of teaching before he retired in 1909.

Cox entered a classroom as a rather tall, bearded man who was caustic, disciplined, traditional and formal. He taught that drawing was the most basic aspect of art because it focused the artist's eye to perceive as well as interpret nature.[89]

He held to his classic point of view by stating late in his teaching career:

Drawing as a training of eye and hand is a kind of physical culture. It shapes the senses, broadens the powers and stimulates the observation

and the intelligence, making of the student a finer and in every way more efficient being than he could become without it.[90]

He taught drawing from life classes, insisting students master the myriad of details, not merely copy. His teaching included an innovative procedure of having his students meet in one classroom, pose a model in another classroom, and then force the students back and forth between classrooms until they drew from memory.[91] He did insist on controlled expression, but he encouraged individualism.

In Paris Cox had learned well his training in figure work. Parisians did not think of drawing the nude as anything but an artistic endeavor. The energy and motion of the human figure were synonymous with the workings of life experiences.

Cox's family, in particular his mother, questioned his advocacy of the female nude form. Cox responded:

> It seems as if no one would ever understand that an artist's models are tools, like his palette and easel, equally indispensable to his work and of as little importance to his life.... [Models had] no more to do with the feeling of the artist than so many paintbrushes.... Do you suppose painting and drawing such easy things and so little absorbing that one can think of anything else while carrying them on?... When I am working on anything serious and difficult, I haven't a word to throw at a dog and would absolutely forget that the model was human were it not that her fatigue and inability to hold still any longer reminds me that she is not a plaster cast.[92]

Perhaps Georgia, in a burst of creative energy, thought of nothing else as she executed her enlarged flowers between 1920 and 1930, which claimed startlingly vivid colors and a clarity of design.

Most of Cox's teaching at the Art Students League involved supervising large classes in drawing. In early March 1908, Cox showed his women's life class his six-foot clay model of his statue, *Greek Sciences*, commissioned for the Brooklyn Institute of Arts and Sciences.[93] The Institute had awarded commissions for thirty monumental figures for a frieze below the roof line of the building.

The sculptures represented stages in human thought and culture, with strong Greco-Roman ties signifying linear progress. Cox, not liking the rough and impressionistic sculpture of Auguste Rodin, presented his sculpture of the Greek scientific thought as an ideal woman with emphasis on the folds in her cloak and drapery and the curves of her form, rather than explicit details. He symbolized the soft, curved female form to lessen scientific complexities.[94] He could easily be called an academic modernist as he dealt with contemporary life and saw symbolism in nature.[95]

Earlier in 1898, Cox had been elected to the National Institute of Arts and Letters and the year before Cox retired from the Art Students League in 1909, he was elected to the American Academy of Arts and Letters.[96]

Francis Luis Mora, one of Chase's teachers at his New York Art Academy, was born in Montivideo, Uruguay, in 1874, the son of Spanish sculptor Domingo Mora, who emigrated to the United States in 1880. F. Luis's education consisted of Manning's Seminary in Perth Amboy, New Jersey, and the public schools in Boston and New York. He studied with his father, F. Benson and E. Tarbell at the Boston Museum of Fine Art, and the Art Students League with H. S. Mowbray. F. Luis began his art career as an illustrator for leading magazines, then branched out to murals. Recognition came quickly with inclusion in major fine arts exhibitions. F. Luis traveled in the West with his brother, artist Joseph Jacinto Mora (1876-1947), who made a four-year trip through the Southwest sketching the Navajo and Hopi. Then F. Luis worked as a Works Progess Administration (WPA) artist. He died in 1940 in New York City, well-known as an illustrator, painter, muralist, etcher and teacher.[97]

While studying at the Art Students League with Chase, Cox and Mora, a fellow student, Eugene Speicher, insisted on painting Georgia's portrait. After Speicher blocked her way to class, Georgia, completely annoyed, demanded that he let her pass. He declared, "It doesn't matter what you do. I'm going to be a great painter and you will probably end up teaching painting in some girls' school." Georgia consented with Speicher's promise to give her the portrait.

Anita wrote in October 1916, to Georgia of the portrait hanging in the Art Students League building: "Oh I saw Speicher's portrait of you—Its very funny—I talked to it at length. It hangs in the Member's room beside an early Arthur Wesley Dow...Irony of Fate."[98]

In the late summer of 1908 at Amitola, an artist's retreat on Lake George,

New York, the portrait of Georgia by Speicher was submitted in a painting exhibition. The art work won first prize and $50 from the judges, Edward Stieglitz and his son, Alfred.[99]

MEETING ALFRED STIEGLITZ

"If all my photographs were lost and I were represented only by The Steerage that would be quite alright."
—Alfred Stieglitz

As early as November 1906, Alfred Stieglitz had exhibited pictorial photographs by Edward Steichen, Frank Eugene, Gertrude Käsebier, Clarence White, and his own work in his Little Galleries of the Photo-Secession at 291 Fifth Avenue in New York City. A series of one-man exhibitions followed featuring pictorial photography as Stieglitz continued promoting photography as fine art. Then in 1907, Stieglitz, again on the cutting edge, promoted modern art as a metaphor for individual freedom, six years before the International Exhibition of Modern Art held February 17–March 15, 1913, at New York's Sixty-ninth Regiment Armory. Subsequently known as the Armory Show, it startled the American art world. Stieglitz had already exhibited Henri Matisse, Marius de Zayas, John Marin, Henri de Toulouse-Lautrec, Henri Rousseau, Paul Cézanne, Pablo Picasso, Arthur Dove, Francis Picabia and Auguste Rodin.[1]

The most impressive modern art exhibition in 1908 at 291 displayed Rodin's drawings as selected by Rodin and Steichen. Rodin at first had considered the drawings only sketches and studio aids until they were published in an 1897 portfolio. Gradually the drawings found their way into American and European collections. Finally, fifty-eight unframed Rodin drawings under glass lined the exhibition walls at Stieglitz's gallery.[2]

William Merritt Chase at the Art Students League suggested that his students should see the drawings of the French master. He complained, however, that on seeing the drawings, they would question all he had taught them.[3]

Interestingly, while Georgia was sitting for her portrait by Eugene Speicher, some Art Students League students interrupted the sitting and suggested they go to Stieglitz's 291 to see Rodin's abstract sketches.[4] Earlier Georgia had frequented 291, often called a seminar in aesthetics because the exhibition space served as a less interesting statement than the art. But Georgia always found Stieglitz intimidating and kept a low profile where he was concerned. Unbeknownst to Georgia, at these visits she and Stieglitz had a background of similar European parentage.[5]

Armed with Chase's insistence and the students' suggestion, Georgia went on January 2, 1908, to see the drawings. The collection of nudes ranged from pencil sketches to drawings with shadings of red, blue and gold washes. Among the line drawings was *Female Nude from Behind, A Scarf Around Her Shoulders*.[6] See figure 5-1.

During Georgia's visit to the gallery, the forty-four-year-old Stieglitz defended the art against the group of students. Retreating to a corner to wait out the "storm," Georgia claimed the Rodins provided a good laugh. She, like others, dismissed the drawings as curved lines and scratches with a few watercolor brush strokes. She later came to appreciate the drawings.[7]

She also commented later that she went to see what modern art was doing in America instead of seeing what had been done and that she didn't quite understand Rodin's work. But the thought did linger that art did not have to follow a set pattern but rather that it could reflect what a person experienced. From this perspective the new age of modern art had been brought forth by Stieglitz's genius.[8]

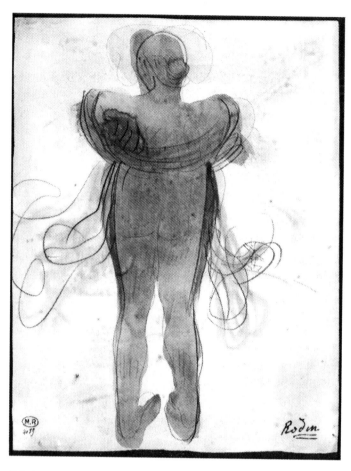

5-1 Auguste Rodin's Female Nude from Behind, A Scarf Around Her Shoulders

Alfred Stieglitz, the first-born and oldest son of Edward and Hedwig Ann (Werner) Stieglitz, arrived in this world on January 1, 1864, in middle-class Hoboken, New Jersey. Edward, born in Germany in 1833, ran away from home in 1849 at age sixteen and emigrated to America. He joined the great German exodus which began in 1845 because of crop failures, famine and political unrest, and which led to depression in 1849. At least one-third of the immigrants to America were Jewish. During this time Karl Marx and Friedrich Engels wrote *Manifest de Kommunistischen Partei*, which encouraged the German revolutionists, but their credo served no purpose as the revolutionaries wanted more capitalism.[9]

Edward's first business endeavor in America was as an apprentice in making mechanical drawing instruments, but this ended unsuccessfully. After a brief service in the Civil War, Edward eventually partnered with Herman Hahlo in a wool business and became a successful woolen merchant. His business success allowed him to enjoy a civilized style of living. With his finances secure at the age of forty, Edward became an amateur painter. However, he lacked the means to buy great art, instead surrounding himself with creative people.[10]

Alfred's mother, Hedwig, German-born in 1844, and the eldest child of the proprietor of a clothing business, emigrated to New York in 1852. Hedwig brought to her union with Edward on December 21, 1861, a love of music, visual arts and literature. Edward and Hedwig led a life of fishing, horse racing, riding, and association with people in the arts and literature, such as Friedrich Nietzsche (1844-1900) and Johann Wolfgang Von Goethe (1749-1832).[11] Their house was constantly filled with creative quests which gave Alfred a sense that he could follow his natural sense of self. Two parental elements affected Alfred: Edward's temper rose and fell with the slightest irritation, which caused Stieglitz to fear his father; and there was constant stress over financial matters, due to Hedwig's inability to manage money, which left Alfred with a distaste for discussing money matters.[12]

Alfred Stieglitz's childhood memories included a photograph of a cousin that mesmerized him in 1866. He often thought of that single event as his predestination to master photography. At the same age he met a woman friend of his mother's who always dressed in black. This captivated him and prompted Stieglitz to claim black as his favorite color.[13]

As a frail, delicate young boy, Stieglitz felt unworthy of his parents' or twin brother's love. As Stieglitz recognized the tension between his parents and became envious of his twin brother, this could have been the beginning of his hypochondriac tendencies which would remain his entire life. His need to seek approval and his inability to express his rage probably led him to think, "Love me more because I am sick."[14]

After an 1866 family trip to Europe, Stieglitz returned to America and began his schooling in 1868. In 1871, Stieglitz started school at Charlier Institute, a private school, and graduated from Townsend Harris High School in 1879. He continued his education at the City College of New York where he rose academically from tenth in his class to sixth.[15]

Starting in the summer of 1868, and for several years fter that, Stieglitz accompanied his father while the elder Stieglitz searched for a family summer resort in the White Mountains, Highland Falls or at the beach. In 1872, the family visited Lake George in the Green Mountains and stayed at the Grand View Hotel. The overnight introduction to Lake George showed it to be the place the Stieglitz family wanted.[16]

Lake George lies in northern New York State west of Lake Champlain. For many centuries the Native Americans roamed this land and during the summer months enjoyed the hunting and fishing. For their protection they often camped "where the mountains touch the water." During the French and Indian War of 1754–1763, the French and English fought over control of this vital waterway. With the end of the Revolutionary War in 1783, a few pioneers settled along the shores of Lake George. Its beauty, hunting and fishing, and the rolling hills, provided opportunities for farming, lumbering and cattle grazing along with early tourist adventurers. As the tourists returned home with great fish stories the locals began offering rooms, then small hotels. Eventually, the ten mile stretch between the village of Lake George and the village of Bolton Landing on Lakeshore Drive housed vast estates and became known soon after the Civil War as "Millionaires' Row." The head of Lake George was the site of Fort William Henry Hotel; the Sagamore Hotel anchored the opposite end of Lakeshore Drive. Like James Fenimore Cooper's character, Uncas, in *The Last of the Mohicans*, the Sagamore Hotel still stands today as the last of the grand hotels.[17]

In 1873 the Stieglitz family returned to Lake George and on one summer day Stieglitz and a group of young boys played a game that Stieglitz had invented by moving miniature horses on a playing board. With the adults' enthusiasm the game became a success. The young boys went to the local tintyper for a photograph of the board and of the boys. Stieglitz became fascinated with the tintyper's photographic process. Later Stieglitz frequently visited the tintyper and received permission to enter the developing booth. With such unplanned moments Stieglitz's career choice of photography became inevitable.[18]

Alfred Stieglitz's pale-skinned face as a young man added to his sensitive intenseness and has been described as:

> a sensitive face with deeply set, piercing eyes. A large brush mustache
> sprouted above what [Theodore] Dreiser described as his "firm mouth,

and sharp, forceful chin." Long but carefully combed wavy black hair covered the tips of his ears. In his expressions one could read fire, sadness, disappointment, fatigue, but also a twinkle of mischievousness.[19]

As the years passed, the same intensity could be seen in Stieglitz's face in 1929, at age fifty-five. See figure 5-2.

5-2 Alfred Stieglitz, 1929

In 1881, Edward and Hedwig moved to Europe to further their children's education. While attempting to study engineering at Berlin's Polytechnikum from 1882 to 1883, Alfred impulsively purchased a camera. The purchase revived his recent interest in photography and triggered his study of photo-chemistry with the German researcher, Dr. Herman Wilhelm Vogel. While still in Germany, Stieglitz won over one hundred fifty prizes and wrote his first photography article, "A Word or Two about Amateur Photography in Germany." He decided to fight for photography's recognition as a creative art medium equal to painting. Stieglitz abandoned his studies, and to advance his cause strove to become a photography authority by making his own photographic prints to the highest standards. In 1887, he won recognition from *The Amateur Photographer* with a first prize by Peter Henry Emerson.[20]

With Stieglitz's father's finances quite secure upon returning from Europe, in the late spring of 1886 his father rented the Oaklawn summer home at Lake George. In the fall Edward Stieglitz bought Oaklawn with its twelve acres. In the summer of 1891, Edward purchased 36.6 acres of the neighboring Price estate and Smith homestead and named the new estate The Hill. Now the family was assured of a permanent place to retreat from the city on Millionaires' Row at Lake George, overlooking Lakeshore Drive.[21] See figure 5-3.

Returning to America in 1890, Stieglitz worked for John Foord's Heliochrome Company. Stieglitz's photographs reflected advanced technical innovations such as making the first photographs in rain, snow and at night with a hand-held camera.[22]

Photographers Peter Henry Emerson and Henry Peach Robinson in the late 1880s advocated, respectively, naturalism and attention to detail and focus. As Emerson produced an expressive body of work, he changed the concept of photography as an independent art form. Emerson asked Stieglitz to translate into German his 1889 book, *Naturalistic Photography for Students of the Art*, which advocated the return to natural subjects with respect for the photographic process. The two men bonded with this translation and Emerson, the British correspondent for the *American Amateur Photographer*, asked Stieglitz in 1892 to be the Berlin correspondent.[23]

Stieglitz had known sixteen-year-old Emmeline Obermeyer, who was eight years younger, since 1889. He thought of her as "hopelessly spoiled and selfish, frivolous and materialistic, obnoxiously pushy, and far from beautiful."[24]

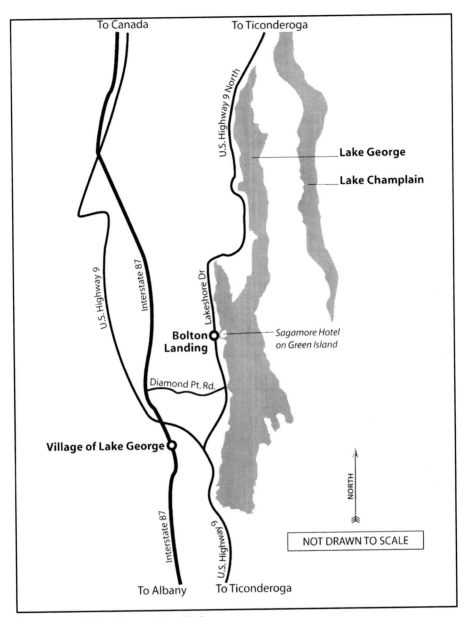

To Canada

To Ticonderoga

U.S. Highway 9 North

Lake George

Lake Champlain

U.S. Highway 9

Interstate 87

Lakeshore Dr

Bolton Landing

Sagamore Hotel on Green Island

Diamond Pt. Rd.

Village of Lake George

NORTH

NOT DRAWN TO SCALE

Interstate 87

U.S. Highway 9

To Albany

To Ticonderoga

5-3 Route to Lake George, New York

The Stieglitz complex at Lake George became known as Oaklawn and The Hill. See figure 5-4.

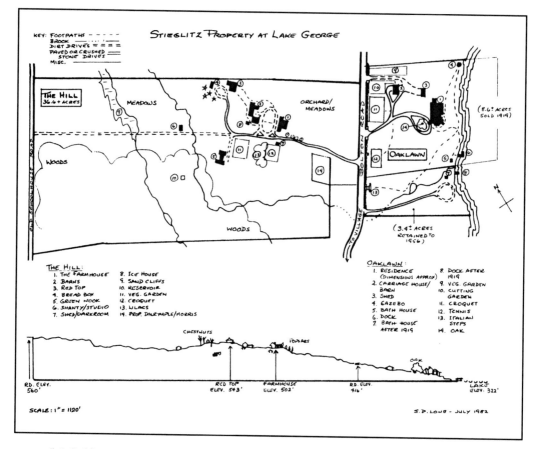

KEY: FOOTPATHS - - - -
BROOK
DIRT DRIVES = = = =
PAVED OR CRUSHED
STONE DRIVES
MISC.

STIEGLITZ PROPERTY AT LAKE GEORGE

THE HILL
36.6+ ACRES

MEADOWS

ORCHARD/
MEADOWS

(8.6+ ACRES
SOLD 1919)

WOODS

OAKLAWN

WOODS

(3.4± ACRES
RETAINED TO
1956)

THE HILL:
1. THE FARMHOUSE
2. BARNS
3. RED TOP
4. BREAD BOX
5. GREEN NOOK
6. SHANTY/STUDIO
7. SHED/DARKROOM
8. ICE HOUSE
9. SAND CLIFFS
10. RESERVOIR
11. VEG. GARDEN
12. CROQUET
13. LILACS
14. PROP. DALRYMPLE/MORRIS

OAKLAWN:
1. RESIDENCE
(DIMENSIONS APPROX)
2. CARRIAGE HOUSE/
BARN
3. SHED
4. GAZEBO
5. BATH HOUSE
6. DOCK
7. BATH HOUSE
AFTER 1919
8. DOCK AFTER
1919
9. VEG. GARDEN
10. CUTTING
GARDEN
11. CROQUET
12. TENNIS
13. ITALIAN
STEPS
14. OAK

CHESTNUTS

POPLARS

OAK

RD. ELEV.
560'

RED TOP
ELEV. 543'

FARMHOUSE
ELEV. 502'

RD. ELEV.
416'

LAKE
ELEV. 322'

SCALE: 1" = 1120'

S. D. LOWE - JULY 1982

5-4 *Oaklawn and The Hill at Lake George, New York*

In 1893, twenty-year-old Emmeline, impressed by Stieglitz and his status as a photographer, during an innocent boat ride on the Hudson River with her family, fell asleep with her head on Stieglitz's shoulder. He did not consider this a serious breach of etiquette. Emmeline's brother later informed an appalled Stieglitz that he considered marriage the only way to maintain his sister's reputation. Coupled with Stieglitz's honor-bound intentions, and with the knowledge that his father had experienced financial failings and could not contribute to Stieglitz's love of photography, Emmeline and Stieglitz married on November 16, 1893. Their marriage suffered because the times demanded prudishness of women. Emmeline rebuked Stieglitz's sexual advances and his request to photograph her

nude. Stieglitz worked on the concept of a portrait being a "composite." He thought the only true portrait should be a photographic diary, with almost daily entries from birth to death. His concept consisted not of a specific woman, but of all women projected through one woman.[25]

Uncompromising in his self-righteousness, Stieglitz focused his energies on his work and his attitude toward his marriage suffered because he did not feel that marriage was a loving display of compromise intended to better each other.[26]

In 1893, Stieglitz showed his first widely exhibited photograph, *Winter, Fifth Avenue*. The exposure, made on a raging snowy day that blurred the building lines and softened the edges of the horse-drawn carriage, considered a single event of real time and place.[27] Though it was considered out of focus, Stieglitz recalled, "I knew [it] was a piece of work quite out of the ordinary." With such efforts Stieglitz added judging his own work to that of judging others' works which resulted in a conflict between author, promoter and soon-to-be collector.[28]

In 1894, Stieglitz became co-editor of *American Amateur Photographer* and the following year withdrew from the Heliochrome Company to dedicate his efforts to photography.[29]

In 1895, Stieglitz developed pneumonia, adding to his hypochondria. The illness hastened his resignation as editor and general manager of *American Amateur Photographer*. Consequently, he was instrumental in the merging of the Society of Amateur Photographers with the Camera Club to form the Camera Club of New York. One year later Stieglitz became vice-president of that club, which published *Camera Notes*.[30]

The first issue measured 10 3/4 x 7 inches with a green cover featuring an Art Nouveau sunflower. Stieglitz stated, "The utmost care will be exercised to publishing nothing but what is the development of an organic idea, the evolution of an inward principle; a picture rather than a photograph, though photography must be the method of graphic representation."[31]

With the second issue, Stieglitz stressed his belief that photography was a fine art. In doing so, soft-focus pictorial photographs featured compositional simplicity and a limited number of easily recognized subjects.[32]

Camera Notes's twenty-four issues provided images and words such as exhibition reviews, foreign press reprints, technical expertise, club news, book reviews, an occasional poem, and the importance of subjectivity or emotion in making photographs.[33]

Despite Alfred and Emmeline's uneasy first years of marriage, an only child, Katherine, was born in 1897. Soon after her birth Stieglitz began a series of photographs of his newborn child in his quest to record photographically an entire life span, which he again considered the only true portrait of anyone. His attention to the project was spasmodic and eventually abandoned.[34]

With the years full of photographing New York street scenes, the timing was right when in 1900 Steiglitz met Edward Steichen, who had submitted ten prints to the First Chicago Photographic Salon for Stieglitz's judgment.[35]

Steichen, born in 1879 in Luxembourg, had a sister, Lillian, who married the poet, Carl Sandberg, in 1910. Steichen moved with his parents to America in 1882, and at age fifteen worked as an apprentice to a commercial lithographer. He studied painting but photography held his interest. His early photographs retained the influence of his painterly training as he achieved prints that resembled "soft, fuzzy mezzotints or loose wash drawings," then considered the highest achievement in photography.[36]

By the spring of 1900, Steichen had saved enough money to study in France. On his way to Europe he stopped by the Camera Club in New York. Stieglitz was busy hanging an exhibition, but found time to recognize the excitement in Steichen's work. Stieglitz bought three of Steichen's photographs with the remark, "I am robbing you, at that." Later that evening, Stieglitz announced to his wife, Emmy, "I think I've found my man."[37]

Arriving in Paris, Steichen began a project that employed all his interests in painting, sculpture, literature, music and photography: a series of portraits of accomplished artists. In 1901, Steichen met Auguste Rodin in Paris. Every Saturday for an entire year, Steichen visited Rodin before attempting to photograph this most important artist.[38]

François-Auguste-René Rodin, the celebrated artist, began his life in 1840 in the Rue de l'Arbalète in Paris. The shy young boy entertained himself with daydreams. Rodin recalled:

> When I was very young, as long ago as I can remember, I used to draw. At a grocer's where my mother did her shopping, they used to wrap their prunes in paper cones made from the pages of illustrated magazines, and even engravings. I used to copy them. They were my first models.[39]

Rodin had difficulty reading, writing and counting. At fourteen, the age

when all young boys started learning their trade, his father had no idea of his son's future. While at the Bibliothèque Sainte-Geneviève, Rodin looked at the Michelangelo books of engravings. This exposure influenced Rodin for his entire life. He convinced his father of his artistic ability and enrolled in 1854 in the École Impériale de Dessin (Petite École), not the more prestigious École des Beaux-Arts.[40]

Rodin's days overflowed with drawing before class, reading to enhance his career, attending morning drawing classes copying the Old Masters, copying antique sculpture at the Louvre in the afternoon, and visiting the Bibliothèque Impériale for the reference works. By accident one day, he opened the door to a modeling room—which in Rodin's day equated to sculpture—and discovered his life's vocation.[41]

Three times Rodin applied to the École des Beaux-Arts and rejections resulted because his work did not resemble the work of Jacques-Louis David, the prevailing sculptor at the École des Beaux-Arts. Saddened by his lack of sculpture commissions and the death of his sister, Rodin joined the Fathers of the Holy Sacrament for a short time. Returning to his secular life, Rodin rented his first studio.[42]

While working on the caryatids for the facade of the Théâter des Gobelins in 1864, Rodin met Rose Beuret. He fathered a child with her but did not legally acknowledge the child. Beuret became Rodin's devoted companion for fifty-three years. Rodin married Beuret in 1917, only two weeks before she died.[43]

Rodin joined the studio of Albert-Ernest Carrier-Belleuse where he discovered that "the aim is to appeal to the masses, to the detriment of true sculpture." He did not agree with this but from Carrier-Belleuse Rodin learned how to organize a large studio and how to create many variations of a single figure.[44]

After a few years of turmoil due to rejection of his work and of being drafted into the army during the Franco-Prussian War, Rodin settled in Belgium again with Carrier-Belleuse. Difficulties arose and Carrier-Belleuse returned to Paris, leaving Rodin in Brussels. In this land far away from Paris, Rodin exhibited his mastery over the body with the *Age of Bronze* sculpture at the Salon of 1877. He received a notoriously bad press, claiming he had cast from life. In 1880 Rodin exhibited *St. John the Baptist* and eventually became highly sought after in Paris. By 1900 his reputation was assured throughout Europe.[45]

About that time, Rodin began a provocative series of line drawings that would eventually number fifteen hundred. He drew constantly, walking around the model, making loose outline pencil drawings and completed them sometimes with a colored wash. The drawings included erotic nudes and lesbian couples.[46]

In *Personal Reminiscences of Auguste Rodin* by Anthony Ludovici, Rodin stated:

> Don't you see that, for my work of modeling, I have not only to possess a complete *knowledge* of the human form, but also a deep *feeling* for every aspect of it? I have, as it were to *incorporate* the lines of the human body, and they must become part of myself, deeply seated in my instincts. I must feel them at the end of my fingers. All this must flow naturally from my eye to my hand. Only then can I be certain that I understand. Now look! What is this drawing? Not once in describing the shape of that mass did I shift my eyes from the model. Why? Because I wanted to make sure that nothing evaded my grasp of it. Not a thought about the technical problem of representing it on paper could be allowed to arrest the flow of my feelings about it, from my eye to my hand. The moment I drop my eyes that flow stops. That is why my drawings are only my way of testing myself.... My object is to test to what extent my hands already feel what my eyes see.[47]

Steichen's meeting with Rodin in 1901 developed into a friendship which resulted in Rodin posing for Steichen's photographs. Steichen's famous artistic portrait, *Rodin-Le Penseur*, emerged when Steichen combined two exposures taken in Rodin's studio, one of Rodin with his *Le Penseur* and the second with his bust of Victor Hugo, a combination that would not have fit into the image if photographed together.[48]

Steichen made studies of Rodin's sculpture, among them *Balzac*, photographed by moonlight. His photography greatly impressed Rodin. Steichen recalled, "The prints seemed to give him more pleasure than anything I had ever done. He said 'You will make the world understand my *Balzac* through these pictures. They are like Christ walking in the desert.'"[49]

Rodin, along with other sculptors, was not threatened by photography because a sculptor's work, like a photographer's, involved instruments and a

workforce to produce copies. The functions common to sculpture and photography hint at an industrial nature. As Baudelaire stated, "The true art lover never confuses art with industry."[50]

When Steichen returned to New York in 1902, Stieglitz had met with difficulties with the Camera Club and *Camera Notes*. Its members preferred a more domestic journal rather than Stieglitz's attempt to internationalize its content. Its last issue included an exhibition of "American Pictorial Photography Arranged by the 'Photo-Secession'" which stepped out of the Camera Club boundaries.[51]

After becoming disenchanted with several organizations, Stieglitz realized his early reputation as a photographer did not forward the recognition of photography as an art. Stieglitz believed that photographers would be more effective in a group than as individuals. Stieglitz invited Steichen in 1902, with eleven other talented photographers dedicated to the same ideals, to create Photo-Secession. The group, a protest against conventional photography of the day, adapted their name from the German Secessionist painters who revolted against traditional art. These Photo-Secessionists succeeded in adding to the transformation of photography from a craft to an art form.[52]

By now *Camera Notes* had become a trial run for the Photo-Secessionist's journal, *Camera Work*, which Stieglitz had already planned. Its first issue appeared in January 1903. An average issue had ten articles dealing with individuals, aesthetics, and exhibition reviews, and a limited number of technical articles. The quarterly magazine, beautiful with a cover designed by Steichen, yet radical, published 1,000 copies for its six hundred fifty subscribers. Steichen was given an entire issue along with Alvin Langdon, Clarence H. White and David Octavius Hill. Stieglitz only came close to an issue devoted to his photographs with number twelve in October 1905. Its last issue was published for thirty-seven subscribers in April 1917 as America's entry into World War I approached. The planned June 1917 issue was to have featured Georgia.[53]

Stieglitz recognized the lack of gallery space for photographs. Steichen urged Stieglitz to agree that the Photo-Secession should have its own space in Steichen's former studio at 291 Fifth Avenue. Steichen designed the space and Stieglitz became the first director. Initially called the Little Galleries of the Photo-Secession because of its limited space, the gallery soon became known simply as 291. The gallery would last until 1917, when World War I brought talk of an

act to prohibit alcoholic beverages, which would certainly affect Stieglitz's income from his in-laws' breweries.[54]

At first, Stieglitz began collecting modern art rather haphazardly because he didn't quite understand the modern movement but recognized the artist's ability to express reality differently. Sometimes he added to his collection to help a needful artist or to acquire a document for "The Record." As the idea of a record surfaced he began to collect with a purpose, to show how artists evolved by collecting the best examples of their work.[55]

With Stieglitz's interest in modern art, Steichen became his conduit concerning all the latest modern art developments in Europe. Upon Steichen's return to New York in 1902, he promoted Rodin's art. When Steichen returned to Paris, he informed Rodin that he wanted his drawings to be the first non-photographic exhibition at 291. Unbeknownst to Steichen, when Pamela Colman Smith presented her work in January 1907, Stieglitz exhibited her seventy-two drawings and watercolors to become the first non-photographic artist to exhibit at his Little Galleries of the Photo-Secession.[56] Her exhibition roused the New York critics and instigated serious discussions about art and its direction.

Smith was born in London in 1878 and raised in Manchester and in Kingston, Jamaica. In those days, Manchester was a hotbed of women voicing their political views disguised as spiritualism. Smith received her art training at Pratt Institute. She studied with Arthur Wesley Dow who advocated his belief that painting was "visual music" and that musical forms could be adapted to painting to charge the emotions abstractly. To the avant-garde artists, this form related to "transcendent and anti-materialistic." After a few years accompanying the Lyceum Theater Company on its tours and developing a career as a freelance book illustrator, Smith settled in London in 1899. By now she had become deeply involved in her Manchester roots of mysticism, socialism and feminism, painting of such beliefs in subtle visual messages, and claiming that she painted them in a trance-like, unconscious state. In 1903–1904 in London, Smith edited and published *The Green Sheaf* with poems by, among others, W. B. Yeats. In 1907, Stieglitz exhibited seventy-two of Smith's watercolors which gave ample examples of ideas normally barred from women's expression. In 1909, Smith designed the lithographs for A. E. Waite's tarot cards. By 1911, Smith had converted to Catholicism, combining her musical visions with Catholic imagery.[57]

Steichen fumed for years as the exhibition gave the impression that the idea of showing modern art at 291 originated as Stieglitz's idea.[58]

Stieglitz in 1907 photographed *The Steerage*, located near Southampton or the harbor of London. Repelled by the people in his first class level, Stieglitz peered into the lower steerage level and witnessed the mass of immigrant people returning to Europe, crowded on a ship's deck surrounded by the ship's rails and masts. He related his emotions to the composition, "a round straw hat, the funnel leaning left, the stairway leaning right, the white draw-bridge with its railings made of circular chains, white suspenders crossing on the back of a man...below, round shapes of iron machinery, a mast cutting into the sky, making a triangular shape." His recognition of the beauty and importance of the work brought forth his remark, "If all my photographs were lost and I were represented only by *The Steerage* that would be quite all right."[59]

As word spread of the new modern-art gallery, a young copyeditor, Agnes Ernst Meyer, who married Eugene Meyer, came in one day and was smitten with the rebellious work of Stieglitz and Steichen. Eugene would buy *The Washington Post* in 1933, and his daughter, Katherine Graham, would eventually assume its helm as publisher. Agnes became instrumental in the periodical published by 291 and became its first editor.[60] The periodical met with conflicting approval and disapproval. Charles Caffin, the English art critic, wrote, "Uncouth in shape, its whole make-up is one of self-assertion and self-assured superiority, while it bristles with antagonism." Georgia would write a friend that she was "crazy about it."[61]

But in 1908, Georgia O'Keeffe walked into 291 and saw Rodin's sketches and met the born leader, Alfred Stieglitz, with an infallible eye, a flexible, inquiring mind, and a temper conducive to battling for his revolutionary beliefs.[62]

6

INFLUENTIAL TEACHERS

"...direct the thoughts,
awaken a sense of power
and point to ways of
controlling it."
—Arthur Wesley Dow

In 1907, Francis moved his family to the Travis House, located on the northeast corner of South Henry and Francis streets in Williamsburg, one block south of Duke of Gloucester Street. See figure 3-3. By 1908, Francis O'Keeffe's financial situation had worsened. All his efforts had failed —real estate, pier rental, creamery, and feed and grocery business. His latest endeavors involved a cement-block manufacturing business using material from abandoned pavement mixed with clamshells hauled from the river. On a strip of land he retained from Wheatlands in Williamsburg, Francis built a speculative concrete block house near the northwest corner of Scotland and North Henry streets and facing Scotland Street, two blocks north of Duke of Gloucester Street. See figure 3-3. Its hard-edged lines with concrete block columns, intended to duplicate the softer-lined colonial homes, stood out as an obtrusive eyesore. Unable to sell the house, the O'Keeffe family moved into it themselves.[1]

Sometime in 1909, Ida, seeking a better climate for her early signs of tuberculosis and disappointed in Francis's business maneuvers, moved with her daughters from Williamsburg to Charlottesville, Virginia.[2]

Charlottesville, approximately one hundred fifteen miles northwest of Williamsburg, lies at an elevation of four hundred to six hundred feet in an immense natural bowl in the foothills of the Blue Ridge Mountains. In Colonial days, Charlottesville served as a stopping point on the main trail from the Tidewater to the West. Thomas Jefferson's father settled there in 1737. Overlooking the town is Monticello, Jefferson's red brick home with white porticoes and an octagonal clerestory topped by a dome.[3]

Ida and her children rented a house and took in boarders at 1212 Wertland Street. The house is located between Thirteenth Street and Twelve and One-half Street, north of the railroad track and the junction of West Main Street, University Drive, and Jefferson Park Avenue, and east of the University of Virginia.[4] See figure 6-1.

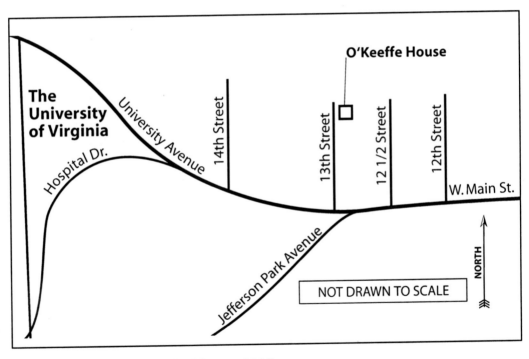

6-1 *Map of Charlottesville, Virginia, 2005*

The large two-story red brick house, built ca. 1900 in the Victorian style, features two-story, triple-wide bays on all four sides with gables projecting over each bay. The gables, covered with tin, once housed small attic windows but today they are boarded up. Four interior chimneys pierce the roof. The front houses a centered pediment dormer with a small porch with bracketed square pillars and sawn slat balustrade. In 1957 the house was extensively renovated and divided into apartments. Today an iron fence surrounds the property. In 2001 the Department of Historic Resources placed a historical marker on the corner.[5] See figure 6-2.

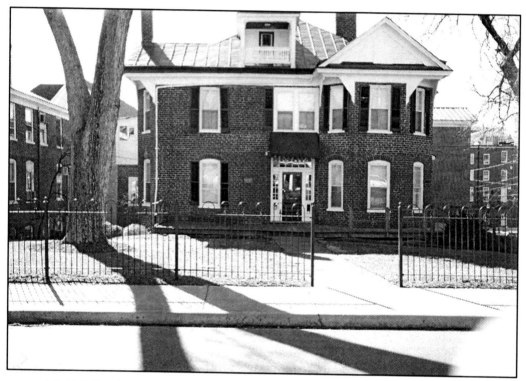

6-2 *1212 Wertland Street, Charlottesville, Virginia*

Francis remained in Williamsburg to sell the concrete block house and for three years did not join the family full time. When he finally permanently moved to Charlottesville he opened another creamery.[6]

After Georgia's years at New York's Art Students League, the disillusionment of studying academic realism, coupled with her family's financial situation, encouraged her, in the fall of 1908, to move to Chicago. She abandoned the desire to be a professional artist to work as a commercial artist designing lace and embroidery for dress advertisements. Additional work included drawing the symbol for the Little Dutch Girl cleaning product.[7]

Again Georgia lived with her mother's sister and brother, Aunt Ollie Totto and Uncle Charles Totto. Her kinship with Aunt Ollie provided specialness for Georgia, with Aunt Ollie placing Georgia's needs above hers, a theme that resurfaced throughout Georgia's life. In working for the advertising firm which featured the ads in the daily newspapers, Georgia learned one of her most important lessons, to work quickly, the gauge of a good commercial artist. But the effect produced not more commercial art but a sincere dislike of it.[8]

Sometime in 1910, Georgia's unhappiness with her commercial work probably lowered her physical resistance and she contracted measles. Her damaged eyesight forced her to resign from design work for the advertising company, a decision she did not regret because of her dislike of the commercial work.[9] To recuperate, Georgia moved to Charlottesville, Virginia, to live with her mother, Ida, and her sisters and brothers.[10]

In an attempt for financial independence, Georgia in May 1911, applied for a teaching position in the Williamsburg public schools but was rejected.[11]

The timing fell right because in the fall of 1911, Elizabeth May Willis arranged a leave of absence for a few weeks from her teaching position at Chatham Episcopal Institute.[12] Twenty-three-year-old Georgia assumed Willis's position. An easy assumption could be that Georgia considered her first teaching position as a generous act, one that teaches the teacher how little the teacher knows. Perhaps this teaching job provided a prelude to a default career of teaching, rather than a career as an artist in New York City.[13] Georgia's interest in art in 1912 provided an awareness of the New York scene through her studies with William Merritt Chase, F. Luis Mora and Kenyon Cox at the Art Students League.[14] But Georgia needed more artistic experiences to conquer New York.

In 1912, New York reigned as the center of the American art scene, with Stieglitz involved in promoting photography as visual representational art and painting as an emotional response to what is seen.[15]

At the same time, from 1912 to 1915, at 23 Fifth Avenue at the northeast corner of Ninth Street, Mabel Ganson Evans Dodge presided over the most famous New York salon, which began at the end of November 1912. Known as a gathering place for the "movers and shakers" of the pre-World War I times, Hutchins Hapgood, Walter Lippmann, Max Eastman, Margaret Sanger, Alfred Stieglitz or Emma Goldman could be heard speaking their views and exchanging avante-garde thoughts on politics, art and society in general.[16]

Mabel Ganson's life began in 1879 in Buffalo, New York, as the daughter of Sara (Cook) and Charles Ganson. Her affluent rearing, featuring nursemaids, resulted from the more-than-comfortable fortune possessed by her Buffalo banking family. The Gansons, often emotionally cold, self-centered and absent, left Mabel with a feeling of abandonment. She often looked to others to define her and to escape her feeling of being an "orphan." To escape, Mabel's defenses became restlessness, a desire for thrills, a fear of purposelessness, control over all, and a desire to experience everything. At school she learned little about discipline but a great deal about emotional and intellectual self-exploration. A friendship with Violet Shillito instilled a lust for "art for life's sake"—an attitude which Mabel used to turn her natural energy into a fine art that she would use later to inspire artists. After Mabel's marriage to Karl Evans she experienced conflict between seeking autonomy and frustration that her identity came from a man. After the birth of their son, John Evans, in 1902, Karl Evans died accidentally, in 1903.[17]

Mabel married Edwin Dodge later in 1904 and lived a luxurious life in Europe where she gave birth to her talents by entertaining notable aesthetes, and in doing so discovered her real talent, that of being a muse. Tiring of the European scene, the Dodges returned to New York and moved into an apartment at 23 Fifth Avenue. Mabel completed decorating the fashionable apartment that was at the heart of the 1912 American avante-garde Greenwich Village. Edwin recognized Mabel's struggle with the boredom of being a wife, her constant searching for a home so she could end her feeling of being orphaned, and her disillusionment with the United States entering World War I, all the while searching for new systems to believe in and new modes of living. Dodge introduced Mabel to Hutchins Hapgood and other important personalities of the times. She visited Stieglitz's 291, only a few blocks from her Fifth Avenue apartment, where she found him the center of avante-garde art. He further helped

her to "See—both in art and in life." Mabel had arrived at the right time to find a new spirit of art in America.[18]

In the same time period, far from New York, Georgia's sisters, Ida Ten Eyck and Anita, had enrolled in summer art courses at the nearby University of Virginia, and encouraged Georgia to take art classes at the University.[19]

Thomas Jefferson, in founding the University of Virginia, declared that his version of the college experience should mirror his philosophical vision and be set within an "academical village." In such an atmosphere, shared learning could be infused into everyday life. The University of Virginia opened its doors in March 1825, to one hundred twenty-three students studying philosophy, arts, foreign languages, science, law and medicine. In the beginning the students came from the plantations of the middle Atlantic and Southern states. These students lived a rowdy life, resulting in strict laws governing student behavior instead of student self-government. The "pride of Virginia" remained open during the Civil War, with engineering courses added. In 1895, a fire destroyed the building known as the Jefferson Rotunda which echoed the design of the Pantheon in Rome. Stanford White redesigned the buildings. At the turn of the century the university's growth required that Jefferson's plan of a faculty counseled by a Board of Visitors be abandoned and the university hired its first president. In the early twentieth century few questioned the fact of an all-male, all-white student body. Females and black students were denied enrollment but were allowed to attend summer teaching institutes as early as the 1890s.[20]

In this environment Georgia enrolled in the summer of 1912. The timing seemed perfect because Georgia had completed her apprenticeship in learning technical art skills, commercial art had proved a disappointment, and a sabbatical provided a new perspective to learn more and teach better. Georgia readied herself for her teacher, Alon Bement, an assistant professor of fine arts at Teachers College, Columbia University.[21]

Bement, born in Ashfield, Massachusetts, in 1876, studied at the École des Beaux-Arts and the Académie Julian in Paris with J. P. Laurens and Benjamin Jean Joseph Constant in 1900. A professorship at Teacher's College, Columbia University, lasted from 1908 to 1920. Bement later became director of the Maryland Institute from 1920 to 1925 and held directorial titles in various institutions. He served as dean of the Traphagen School of Fashion in New York in 1946 until his death in 1954 in New York City.[22]

Known as an educator, designer, painter, lecturer and writer, Bement exhibited at the Art Institute of Chicago, among other institutions. His contributions to national magazines complemented his 1921 book, *Figure Construction, A Brief Treatise on Drawing the Human Figure, For Art Students, Costume Designers and Teachers*.[23]

In an introduction to the book, Arthur Wesley Dow asked, "What is life drawing?" He answered that life drawing "is the 'tool' of the trade" and that Bement presented another way to learn rather than in anatomy classes.[24]

Dow stated further:

> Accuracy in itself is not art...for in figure drawing the important things to appreciate are *life* and *action*.... Action is expressed by the *direction* of the lines and life lies in the *quality* of the drawn line. In Japanese sketch books of the last century are line drawings of figures and animals where life and action are given by one or two lines...by seeing the subject as a *whole*. After that is realized it is easy to add details.
>
> Freehand drawing would progress farther if we looked upon it as *expression* rather than *imitation*.[25]

Bement's preface to his treatise begins with four assumptions:

- drawing the figure in action is easier than from life classes or from drawing books or anatomy
- the body's action, except in the front view, is drawn with two lines—convex and concave curves
- the beginning artist should first draw the body as a whole rather than its parts
- the drawing of each stroke should be with speed.[26]

Bement suggested that each beginning student use at least six pencils varying in degree of softness and hardness and to use paper of each kind and variety. Such use of various pencils and papers provides an adequate experience for choosing the preferred material. Bement followed his preface with thirty lessons and fifty-six detailed four-minute student's illustrations showing attitudes

of the body in the arm, head, hand and profile. He concluded with photographs and drawing plates by the Old Masters.[27]

Later Georgia related many times that Bement had introduced Dow's theory: "to fill a space in a beautiful way."[28]

Bement introduced Georgia to the composition ideas of his mentor, Arthur Wesley Dow (1857–1922), head of the art department at Columbia University Teacher's College in New York. Dow, influenced by Oriental art and Art Nouveau, worked in abstract, two-dimensional styles. Bement followed Dow with "encouraged invention and self-expression with Oriental patterning, simplification and harmony."[29]

By now, Georgia's skills had reached maturity. Dow gave her a method of using her skills with design rather than representation. Her concentration now focused on color and shapes to match her feelings.[30]

Dow began life in Ipswich, Massachusetts, as the son of an established New England weaver. As a refined, solitary intelligent student, Dow's interest centered on languages and history but he lacked the funds for Amherst College. He employed a tutor to teach him Latin, Greek and mathematics while he supported himself teaching in an elementary school in Linebrook Parish. Dow co-produced a local history journal, the *Ipswich Antiquarian Paper*, which featured his woodprint illustrations. This foray into art encouraged him, at age twenty-one, to try painting. His first art training began in 1880 in Worcester, then in Boston with a former student of Frank Duveneck. After an effort of four years, Dow attended the Académie Julian in Paris with fellow student, J. H. Twatchman. Dow enrolled in the evening classes of the École Nationale des Arts Decoratifs in 1884–1885 where he became interested in decorative arts. Being older than most of the Parisian art students, Dow quickly tired of the academic system and moved to Pont-Aven in 1885 to paint *plein-air*. Then, in 1886, in Brittany, he boarded at Pension Gloanec at the same time as Paul Gauguin. Dow, wavering between Tonalism and the Barbizon School, rejected Gauguin's rough manners and bold ideas. He eventually returned to the United States in 1887, completely unaffected by radical art but aware that his own efforts had become stale. After another summer in Pont-Aven, Dow returned to Ipswich in 1899 and began to teach private art lessons in which he urged the students to strive for beauty in their chosen field.[31]

With exhibitions in Chicago, Boston and New York, Dow moved to

Boston and sought a viable alternative to the strict rules of academic training. He spent hours reading in the Boston Public Library, founded in 1848 as the first metropolitan library for the public. The sculptor for the Lincoln Memorial, Daniel Chester French, fashioned the enormous bronze doors that represent Music and Poetry, Knowledge and Wisdom, and Truth and Romance. In this building of an Italian *palazzo*-style atmosphere, Dow discovered the work of the Japanese *ukiyo-e* printmaker, Katsushika Hokusai (1760–1849). Dow wrote, "One evening with Hokusai gave me more light on composition and decorative effect than years of study of pictures. I surely ought to compose in an entirely different manner and paint better." [32]

Ukiyo-e means "the pictures of the floating world" and in the seventh to nineteenth centuries this was the most popular art form in Japan. The concept eventually became "the fleeting pleasures of everyday life" and incorporated into wood block prints the common man's daily pleasures, such as theater, women, landscapes, nature and erotica. Its style began in the seventeenth century with simple drawings that developed into black-and-white prints, then occasionally hand-tinted. As color blocks were added, the process became full-colored with shading colors, metallic pigments and embossing. [33]

Hokusai, born in Edo, now Tokyo, from age fifteen to eighteen apprenticed with a wood-block engraver. The exposure to printmaking led the eighteen-year-old Hokusai to become the pupil of the leading *ukiyo-e* master, Katsukawa Shunsho. In his mature years, Hokusai ran the gamut of *ukiyo-e* art. His *Thirty-six Views of Mt. Fuji*, published about 1826 to 1833, ranks as the summit in the history of Japanese landscape prints. In his seventy years of productive work, Hokusai served as the prototype of the single-minded artist striving to complete a given task. [34]

Dow's discovery of Hokusai led him to the Boston Museum of Fine Arts, which opened in 1876 on Copley Square and moved to the Fenway in 1909 in a classical style building. "A beautiful stairway adorned with carved lions and a portal of a dragon in the clouds announces the entrance to the main Chinese and Japanese Galleries on the second floor." [35]

In this setting Dow sought out Ernest Francisco Fenollosa (1853–1908), the curator of the Japanese collection. [36] Fenollosa, born in Salem, Massachusetts, studied philosophy and sociology at Harvard University and graduated in 1874. As a student Fenollosa began painting and an invitation by Edward Sylvester

Morse, who was teaching at the Imperial University in Tokyo, guided him to join Morse in lecturing on political science, philosophy and economics. From 1878 to 1886 Fenollosa taught at the Imperial University where he saw the deterioration of many of Japan's ancient temples and shrines with their art treasurers falling into disrepair. His interest led to his becoming a student of the themes and techniques of traditional Chinese and Japanese art and an advocate for their preservation.[37]

In 1886, Fenollosa and the art critic, Okakura Kakuzo, toured Europe studying methods of teaching and preserving the fine arts, including the preservation of the Japanese Noh Theater dramas. The Emperor challenged Fenollosa to teach Americans about Japanese art when he declared, "You have taught my people to know their own art." After Fenollosa's death the Noh dramas were turned over to Ezra Pound who reworked them into English poetic form to much acclaim in 1915-1917.[38]

For five years beginning in 1890, Fenollosa was director of the Oriental department of the Boston Museum of Fine Arts. He did much to further the American appreciation of Oriental art before being rebuffed by the Japanese who wanted to control the preservation of their art. He saved Buddhist temple art when the Japanese imperial government canceled subsidies. The Boston Museum featured a Buddhist Temple Room as a space to contemplate Buddhist art.[39]

In 1912, Fenollosa's two-volume *Epochs of Chinese and Japanese Art: An Outline History of East Asiatic Design* that Dow used in his classes was posthumously published. Fenollosa put forth his argument, "At creative periods all forms of Art will be found to interact. From the building of a great temple to the outline of a bowl...."[40]

With Dow's exposure to Oriental art, he developed an all-consuming interest in Japanese art. He concluded that tonal forms suggested perspective. He started flattening forms and patterns became important.[41]

In 1893, Dow assumed the assistant curatorship under Fenollosa, who exposed Dow to such Chinese and Japanese aesthetics as line, form, color, and notan, which is a tonal-contrasted method of light and dark similar to chiaroscuro. Fenollosa likened poetry to painting because both contained "thought, sentiment, analogy, symbolism, the interpenetration of meaning, plane behind plane, sphere within sphere; the organic union of parts.... even the spiritual significance of trees and rocks; and mountains and water...."[42]

Dow, who shared Fenollosa's view that art should be pictorial and decorative, developed a method for making woodcuts that reflected Japanese techniques.[43]

Fenollosa concurred with Dow that art teaching methods were inadequate. "Art education was intent on discovering the nature of the plastic arts and on the methods of using that knowledge in teaching." Two years later Dow lectured his Boston classes with a series of exercises on his ideas of Japanese art.[44] "Fenollosa believed that beauty, not realism, was the true aim of art."[45]

In 1899, Dow compiled all his theories, lectures and experiences into *Composition: A Series of Exercises in Art Structure for the Use of Students and Teachers*. Although commonly called *Composition*, its contents included all steps in creation of an art work and stressed that none should suffer discrimination. Dow's philosophy furthered Fenollosa's concept by stating that composition was the essence of beauty. The book, widespread in its appeal as a text for public schools, appeared in *Prang Education Magazine*.[46]

There were many subsequent editions of *Composition*. Dow wrote in the introduction of the 1912 edition that his purpose consisted of establishing a way of thinking of art. The book should "...direct the thoughts, awaken a sense of power and point to ways of controlling it."[47]

As an educator more than an artist, Dow claimed that painting in a two-dimensional medium is to achieve perfection of the whole. "Composition, building up of harmony, is the fundamental process in all fine art. I hold that art should be approached through composition rather than imitative drawing."[48]

Dow believed that the many processes in a work of art can be mastered one by one and united harmoniously. With appreciation, the artist recognizes the harmony. To insure appreciation, a series of progressive exercises leads to the best composition.[49]

Dow added that Fenollosa:

> ...vigorously advocated a radically different idea, based as in music, upon synthetic principles. He believed music to be, in a sense, the key to the other fine arts, since its essence is pure beauty; that space art may be called "visual music," and may be studied and criticised [sic] from this point of view.[50]

Dow in his text stated, "It is not the province of the landscape painter to represent so much topography, but to express an emotion; and this he must do by art."[51] His route to perfecting expression simply combined the Western and Eastern composition forms.[52]

Dow based his compositional elements on three interrelated elements:

- Line is the "boundaries of shapes and the interrelations of lines and spaces." Line is where colors join and divide. Line drawing is best accomplished with a Japanese brush, ink and paper. Depending on the desired line, various type brushes are used: long brushes for long lines; short brushes for sharp corners; for lettering, clip the long line brush to a point. Japanese paper is made from the bark of a mulberry tree with sizing of glue and alum. Japanese ink is made by grinding an ink stick on a slate slab.
- Notan, a Japanese word, describes value as the relationship of light and dark. His illustrations began with black-and-white spaces graduating to middle gray values, all at right angles. He advanced to geometrical forms and concluded with curved plant and flower motifs, then landscapes, all in two dimensions.
- Color is "the quality of light." Its hue, value and intensity is introduced by the Munsell system of color.

In the 1913 edition of *Composition*, Dow incorporates five principles designed to stimulate the artist's imagination, give the artist free choice and bring forth the essence:

- Opposition is where the vertical and horizontal lines meet.
- Transition is when the two lines meet and a third line is added to soften and produce unity.
- Subordination is to form a whole with a single dominating element which determines the whole's character.
- Repetition is the rhythmic repeating of the same equal or unequal lines.
- Symmetry is the placing of two equal lines in exact balance. Japanese art suggests that perfect symmetry is to be avoided.

With the composition system in place, Dow included an amazing array of illustrations from lines in squares, circles and rectangles, landscape composition, and representational drawing. He discussed notan as building harmony with dark and light in designs and landscape, patterns, Gothic sculpture and Japanese design books. He furthered his treatise on notan with a third value, gray, and with more than three values.

Color is discussed with the usual hue and intensity and their relationship to notan (value).

Dow dealt with composition in the last section with design in wood-block printing, printing on paper and cloth, picture painting, stenciling, colored charcoal, painting in full color, watercolor and oil color. However, Dow stressed —sometimes at odds with all he had learned in his formal art training—that the artist should make choices not so much for truth to nature or fact, but to teach the viewer to feel harmonies and the quality of work. "The power is within—the question is how to reach it and use it."[53]

Dow staked his claim as a teacher when he began the Ipswich Summer School of Art in 1891 to integrate design and composition into all mediums of art, such as painting and photography, and the crafts he considered art, such as ceramics, furniture making, candle making and weaving. The school was located in one of the oldest towns in the United States, founded in 1633, on the north shore of Massachusetts only twenty-eight miles from Boston. The town encompasses seven hills; the Ipswich River runs through the heart of the town in a landscape of marshes, dunes, beaches, uplands, forests fields and farmland. The school ran successfully under other instructors until 1907. Tiring of the Ipswich School, in 1895 Dow joined Pratt Institute in Brooklyn and finished his woodcut prints, *Ipswich Prints*, which did not imitate *ukiyo-e* works, but he created modernist prints. At Pratt he wrote articles for the *Pratt Institute Monthly* in which he explored the thoughts he had developed with Ernest Fenollosa that encouraged students to learn from the decorative principles of design of every culture. Dow discovered that Japanese people, even as young children, had an innate appreciation of good design and art that rested on their use of everyday objects made with beauty in mind as well as practicality. This theory resulted in a way for the art student to forge a discipline of hand and mind working in unison, thus making creativity available to everyone.[54]

Dow lectured in 1898 at the Art Students League. In a later lecture, he said:

> Teach the child to know beauty when he sees it, to *create* it, to love it, and when he grows up he will not tolerate the ugly. In the relations of lines to each other he may learn the relation of lives to each other; as he perceives color harmonies, he may also perceive the fitness of things.[55]

Dow continued teaching in 1904 as director of the art department at Columbia University's Teachers College in New York. His once radical concepts gained acceptance as artists focused not on copying physical objects, but on composition placed harmoniously to convey ideas. In other words, beauty reigned as choice and judgment reflecting the artist's thoughts and emotions.[56]

Dow stated:

> Art is the most useful thing in the world, and the most valued thing. The most useful is always that which is made as finely as possible and completely adapted to its purpose; the most valued because it is the expression of the highest form of human energy, the creative power which is nearest the divine.[57]

In 1904, John Dewey joined the faculty at Columbia's Teachers College. He had been instrumental at Chicago University and the Laboratory School in assuming leadership in the art work of school children. The children's drawings and craft work displayed social, historical, literary or geographical importance as much as they expressed honest emotions. Dewey saw the promise of the children evolving into a maturity of art powers rather than just the copying of adult art.

Dow recognized Dewey's concepts that children rarely have mature drawing abilities, but rather that they can easily organize lines, shapes and colors into a distinct composition.[58]

In 1908, Dow published *The Theory and Practice of Teaching Art*.[59] Dow began with the principle: "The true purpose of art teaching is the education of the whole people for appreciation."[60] With a variety of illustrations, Dow repeated his composition principles with some noticeable references to applying

his concepts to children's work. In essence, Dow changed the general objectives of art education in the United States.

As so often happens, artists who become teachers relegate their own art to a secondary status and teaching supplies their basic vocation and income. A remarkable network of teachers and students carried Dow's theories into all corners of the American art world, such as arts and crafts and photography, and gave a definite direction to American modernism.[61]

THE INFLUENTIAL YEARS
1912–1918

7

TEXAS PLAINS AND SKY

"I was hugely excited about going to Texas, because of all those stories that Mother had read to us."

—Georgia O'Keeffe

In 1912, Georgia had been invited to teach in the art department of the University of Virginia providing she acquired experience in public school teaching. To meet the requirement she readied herself to accept a teaching job in Roanoke, Virginia.[1]

Georgia had been corresponding with her Chatham Episcopal Institute friend from Laredo, Alice Peretta, who taught school on the open plains of Amarillo, Texas. Alice knew S. M. Boyd, the superintendent of the Amarillo High School, and suggested to him that Georgia's qualifications were sufficient for her to fill a vacant art teacher's position. Alice telegraphed Georgia of the opening and Georgia accepted the teaching offer in 1912.[2]

Perhaps Georgia remembered Chase's advice about teaching as an obligation: "I consider the office of teacher to be one of the highest honor and I am doing what I can to help those who come after me to tread the path which I have pursued for many years."

He explained that all who were involved in art would benefit. After eleven years Chase abandoned teaching at his school due to the conflict with Robert Henri, stating, "I have warned the students...that there was danger is mistaking violence for strength...."

In 1907, as the conflict between conservatives and progressives heightened, Henri, with five other artists formed The Eight, a secessionist group of painters.[3] In 1914, Chase commented to his students, "A certain group of painters in New York paint the gruesome. They go to the wretched part of the city and paint the worst people."[4]

As supervisor of penmanship and drawing, Georgia would teach in Grades One through Eight in the Amarillo school at East Fourteenth Street and South Polk Street. She didn't know much about teaching, but she wanted to go the great distance to Texas. During these years she would not only teach, but discover concepts and themes that stayed with her until she was no longer able to paint.[5]

Ever mindful of the beginning entry in her grandmother, Isabella Wyckoff's, journal, "I Came West, April 1854," Georgia's acceptance of the Amarillo teaching position must have seemed a natural means of showing emotional independence. As a necessary condition Georgia also sought economic independence, but her economic independence did not guarantee her emotional independence. In Amarillo Georgia could easily unite the interest in the West that she had known since her Mother's readings with her quest for financial independence.[6]

As Georgia emphasized in 1974, "I was hugely excited about going to Texas, because of all those stories that Mother had read to us. Texas was the great place in the world as far as I was concerned."[7]

She commented later, "I was very young when I came to Amarillo. Frankly, I knew very little about teaching school."[8]

Charles Franklin (Frank) Reaugh (1860-1945), the Texas artist, observed the Panhandle in its pristine state and recalled, "illimitable distance...skies that were beautiful, grand or awe-inspiring...all around was open range; wild and free."[9]

The open Great Plains of the United States, covering twenty degrees of latitude, easily defined metaphorically as an ocean serve as a corridor to other worlds. Eastward, the plains lead to the Mississippi River, westward to the Rocky Mountains, northward from Texas some 1,600 miles to Canada, and southward through Texas to the Edwards Plateau, which includes Amarillo.[10]

The Great Plains rest upon a marine rock sheet, the Permian red beds, which emerged from swampy plains as the Rocky Mountains were thrust upward.... Because of their great elevation, the mountains caught immense amounts of moisture that formed large streams. Charging eastward toward the marine rock sheet, these rivers eroded the mountains and carried their loads of eroded materials into the lower elevations. Here, deprived of steep gradient and moisture supply, the streams spread out, dropped the debris washed from the mountains, and choked their beds. As their beds became choked, the streams sought new ones, which in turn were similarly choked. As the process continued, stream beds crossed and recrossed, and a network of interlacing, aggrading streams built up a fast flat debris apron or alluvial deposit about three hundred feet thick stretching eastward from the foot of the mountains for hundreds of miles, and from Texas' Edwards Plateau, in the south, northward to Canada. But even as nature's forces were at work building up the Great Plains, the forces of erosion began to modify the landscape, and to produce a most startling feature, the High Plains.[11]

East of the High Plains, the humid climate encouraged the growth of tall grasses, yet they were unable to stop the erosion. As the water eroded the land and reduced its elevation, a severe escarpment appeared. West of the High Plains the Pecos River, flowing north from the Rio Grande, did away with all the rivers except the either dry or raging Canadian River, which became the only river to flow completely across the Texas Plains and to cut down the surface of the alluvial deposits standing in the West. With erosion from the east and west of the Great Plains, a section in between stood higher: the High Plains. Three-fourths of the Texas Panhandle lies in the High Plains of the Great Plains with its most distinct features—its escarpment and its flatness.[12] See figure 7-1.

The original inhabitants of the High Plains, as they discovered a land bridge to a new world, claimed their origin mythically, "We are real from the beginning of time." Acting on their discovery, they came, unchallenged by others, into this vast sweep of Texas located in the shadow of the Rocky Mountains. A small tribe of Native Americans known as the *Tejas* discovered and named the land, *Tejas*, meaning friends or allies. These natives roamed the grassland

and found the key to their survival in their resourcefulness and adaptation to the large, dry region. The Native American civilization, living close to the soil of the earth, found perfection in harmony with Nature, which produced great yields from the earth.[13] From humble beginnings as hunters they developed into a flourishing culture.[14]

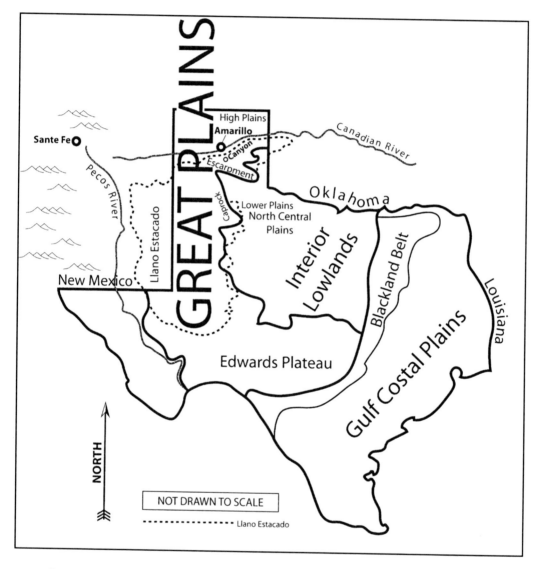

7-1 Amarillo and the Escarpment

Elsewhere on the continent, with the dawn of seafaring discoveries, North America became the destination of the Norsemen who lived by the sea. In the 900s, one Norseman, Bjarni Herjulfson, reached the coastline of this new land, but without the curiosity of a man of vision sailed back to Greenland. His discovery, six hundred years before Christopher Columbus, could have led to other discoveries.[15] The discovery of something unknown without the vision to act on it provides no worthwhile results.

Another discoverer, the Icelandic explorer, Leif Ericsson, became one of the first to visit North American soil when his father, Eric the Red, sent him to bring Christianity to Norwegian King Olaf Tryggvesson's settlement in Greenland. Ericsson sailed off course and is believed to have landed in what is now New England. The eleventh-century discoverer made maps, but the news of the misguided discovery did not reach other lands, again voiding related discoveries.[16]

In 1492, some five hundred years later, Christopher Columbus left Spain when Spain felt the need to extend their Christian faith to other lands.

God, the Father Almighty, Creator of heaven and earth; and in Jesus Christ His only Son their Lord, Who was conceived by the Holy Ghost, born of the Virgin Mary, suffered under Pontius Pilate, was crucified, died and buried. He descended into hell; the third day He rose again from the dead; He ascended into heaven to sit at the right hand of God the Father Almighty from thence to come to judge the living and the dead. They believed in the Holy Ghost, the Holy Catholic Church, the communion of saints, the forgiveness of sins, the resurrection of the body, and life everlasting, Amen.[17]

Columbus wrote in a letter to Ferdinand and Isabella in 1501:

I went to sea at an early age, and there I have continued to this day; the same art inclines those who follow it to wish to know the secrets of this world.... I have sailed everywhere that is navigable.... Our Lord found this my desire very proper.... [He]...opened my understanding with his hand, so that I became capable of sailing from here to the Indies.

Columbus knew his ship and men. Experienced seaman understood how much Columbus knew before he embarked. He was confident in himself and in his burning vision for his voyage of discovery, even as the debate raged about the size of the globe. Had he not thought the globe much smaller than other contemporary scholars, perhaps his discovery would not have occurred.[18]

At 10:00 p.m., just before the moon rose on October 11, 1492, Columbus saw a light, "...like a little wax candle rising and falling." Not certain of his sighting, Columbus did not declare the light as land.[19]

"Lumbre! Tierra!" (Light! Land!), were the two words shouted by one of Columbus's seamen at midnight on October 11, 1492, as he sighted land off an island in the Bahamas. Daybreak revealed what Columbus called San Salvador.[20]

Columbus's astounding vision and first voyage, often called the most important discovery by the Old World, impacted the destinies of the Eastern and Western Hemispheres.[21] His discovery remains a link between the Middle Ages and the Renaissance. When Columbus returned to Europe in 1493, his follow-through vision enabled him to unload a bounty of goods, livestock and men to form the nucleus of Spain's claim to the New World.[22]

On his last voyage in 1502, Columbus discovered Central America where he described people "of very handsome bodies and fine faces, 'los Indios.'"[23]

Soon other Spanish explorers made their way to the Americas, not only pursuing gold and riches but always accompanied by Dominican friars who had difficulty explaining the Native Americans's origin within the context of the Bible and who set out to convert them to Christianity.[24]

Alvar Núñez Cabeza de Vaca (ca. 1490-ca. 1560), was treasurer of the ill-fated expedition of Pánfilo de Narváez to Florida in 1527-1528, which was shipwrecked on the Gulf Coast. Only four survived the shipwreck, including Cabeza de Vaca. The four men wandered for eight years across Texas, passed south of the Texas Panhandle, and traveled to other southwestern points. Although their exact route has been debated, they returned to civilization with tales of what they had seen and heard. These stories aroused interest and inspired others to explore and discover.[25]

Cabeza de Vaca's discoveries inspired Hernando De Soto's (ca. 1496-1542) 1538 expedition and Francisco Vázquez De Coronado's 1540 expedition, both leading deeper into the areas that later formed the United States.[26]

Taking his cue from Cabeza de Vaca's explorations, De Soto sailed for Florida and subsequently discovered the Mississippi River in 1541. His other discoveries also presented a first view of Indian cultures from Georgia to Texas.[27]

Coronado (1510-1554), raised as a properly educated, prominent Spaniard, rose quickly in the imperial hierarchy and by 1540 reached the governorship of New Galicia, New Spain's northwestern province. As the leading candidate to lead an expedition, Coronado arrived at the last outpost of civilization, Culiacán, accompanied by three hundred Spanish cavalrymen, 1,000 Native American allies, and Fray Marcos de Niza. They found no riches in the Seven Cities of Cíbola, now known as Zuni, New Mexico. Then Coronado sent out expeditions to the Hopi villages and the Grand Canyon of the Colorado, and dispatched Hernando de Alvarado to the Rio Grande. Coronado set up headquarters at Tiguex, north of today's Albuquerque. A Native American told Coronado of land to the east beside which the Seven Cities of Cíbola paled. Coronado's man, Alvarado, headed eastward to Acoma, fifty miles west of Albuquerque, and Tiguex. With the advice of an Native American slave called the "Turk," Alvarado traveled along the Canadian River nearly to the Texas Panhandle some eighty years before the Pilgrims landed at Plymouth Rock. Returning to Tiguex, where Coronado was now quartered, Alvarado expounded on Turk's story. Coronado's fascination led him to cross the *Llano Estacado* (staked plains or stockaded plains) where he camped in a ravine on the eastern edge. According to written records, when Coronado's men encountered the *Llano Estacado*, as experienced explorers, the semi-arid, desert-like *Llano Estacado* did not faze them. But the eastern edge of the *Llano Estacado* bewildered the explorers as they encountered land that harbored no landmarks and the unending flatness of the grassy plains, home to buffalo herds and the Native Americans.[28]

Not finding great wealth, Coronado sent his men back to Tiguex and traveled until he found some squalid Native American pueblos in central Kansas. Disillusioned, Coronado turned homeward to Tiguex and upon learning of Turk's stories to lure the men into desolate land and starvation, sentenced Turk to death. Coronado returned to Spain, never to find Cíbola.[29]

De Soto's and Coronado's expeditions presented an insight into an unknown vast interior of the North American continent to provide the basis of the area's cartography.[30]

Acting on previous discoveries, Juan de Oñate (ca. 1550-ca. 1630), the first Spanish governor of New Mexico, led a force of four hundred, including eight Franciscan friars, into the Rio Grande valley in 1598. He established his headquarters twenty-five miles south of Abiquiu at the confluence of the Rio Grande and Chama River for the purpose of converting the Pueblo Native Americans.[31]

In 1685, René-Robert Cavelier, Sieur de La Salle, explored the Mississippi River and claimed part of Texas with an outpost at Nacogdoches. The Spanish sent Ponce de Leon to expel the French from Texas, only to discover that the French had already left.[32]

Although fifteen thousand years exist of Texas's prehistory, Texas's recorded early history began with the Spanish explorers when Cabeza de Vaca claimed Texas as Spanish property. After 1690, Texas officially became a Spanish province with the seat of government established in San Antonio in 1718. In 1821, when Mexico broke away from Spain, Texas fell under the rule of Mexico from 1821 to 1836. American colonists led by Stephen F. Austin began settling the land in 1821. Benjamin Rush Milam was among those who followed and soon over 30,000 Americans lived in Texas which drew no favor with Mexico's dictator, General Antonio López de Santa Anna (1794-1876). The colonists became unhappy with the Mexican rule of no schools, difficult trade, and no religious freedom. On March 2, 1836, the Texans drafted a Declaration of Independence which resulted in a war with Mexico. Shortly afterwards, on April 21, 1836, the American colonists under General Sam Houston cried "Remember the Alamo," the holiest land in Texas, and defeated Santa Anna. After the Mexican army surrendered, Texas became an independent republic with Houston its first elected president. In 1845, the Republic became the twenty-eighth state of the United States of America. Between 1846 and 1848, the United States warred with Mexico, and the Texans again fought Mexico as United States citizens in the Mexican War. Mexico then relinquished all rights to Texas. After a brief period in the Confederacy in 1861-1865, Texas was readmitted to the United States in 1870. The raising of the United States flag over the state ended the rule of the Spanish, French, Mexicans, Confederates, and the Republic of Texas, six flags over Texas that became "more than symbols but the focus of many great events." Beneath the United States flag flies the Texas flag, three equal segments with the third nearest the staff with blue with a white star in the center; the remaining segment is divided horizontally

with the top half white and the bottom half red. Its lone star is intended to create a simplification of the United States flag, making it more similar than unique. Today the Texas flag is viewed by Texans as a symbol of uncompromising individualism, setting it apart from the other forty-nine states.[33]

With each discovery, from the earliest inhabitants to the latest explorers, not only did the heirs receive land, but they received character and vision built on the previous discovery. The noble phrase about English explorers by the British geographer, Richard Hakluyt (ca. 1552–1616), "men full of activity, stirrers abroad, and seekers of remote parts of the world," applied to all who instigated voyages of discovery. The explorers who discovered far off lands and followed through managed quite well with simple maps and determination.[34]

Before Georgia's arrival and discovery of Texas, art in Texas had developed slowly in its first centuries. In one of two early standard references on Texas art, *Art and Artists of Texas*, Esse Forrester-O'Brien wrote in 1928, "In the days when the Indians ruled the land…an unknown artisan was yet carving on the great door to La Salle's fort, Fort St. Louis, on Lavaca Bay, Texas, the Indians smote him down. Art is especially slow where scalping is in style."[35]

The Native Americas left their artistic legacy on cliff walls, using their own dyes, with the early explorers offering their interpretation. The surviving cliff paintings are prized for their beauty and historic value. After the original discoverers of Texas came the artist-explorers and military survey artists to record the vast Texas landscape. Next to arrive in Central Texas were the academically trained European artists.[36]

For nearly the entire nineteenth century, Texas produced few artists because Texas's main focus was in material resources, not aesthetically pleasing objects. In 1884, as the state became more settled and leisure time became available for cultural pursuits, the Fort Worth Art Association, commanded by women, began art leagues and associations all through the vast state of Texas. Bursting on the scene, the Fort Worth Art Association's initial exhibitions included some Texas art, and by the 1890s the exhibitions favored Texas art.[37]

Texas's art history began about 1888, when portraitists arrived after the Texas legislature, expressing patriotism, commissioned portraits and statues of the Republic's presidents.[38]

Texas artist and author Williamson Gerald "Jerry" Bywaters (1906–1989) wrote in 1936:

As a result of the rough and vigorous energy of pioneering in Texas, wealth began to accumulate, and with it came cultural pretensions—pretensions parallel to those of the wealthy New England ship-builder and trader, the Colonial planter, the Southern plantation-owner, and the California silver king. This was the Roman pride which, wishing itself preserved for posterity, turned to art for portraits of the grandees and their ladies.[39]

This early period, which lasted from about 1888 to 1900, featured the works of Harry Arthur McArdle (1836-1908), William Henry Huddle (1861-1951) and Robert Jenkins Onderdonk (1852-1917).[40]

McArdle, an Irishman, was born the same year Texas gained its independence. Orphaned at eleven years of age, he came to America, possibly studying at the Peabody Institute, where he excelled in drawing. He eventually moved to Texas for his wife's health. While a professor in the art department at the Baylor Female College in Waco, McArdle painted historical battle paintings at Washington, the seat of the government of the Republic of Texas. *Dawn of the Alamo*, oil on canvas, 84 1/4 x 144 3/4 in., 1905, depicts the dawn of Texas's freedom and *The Battle of San Jacinto*, oil on canvas, 95 x 167 1/2 in., 1898, depicts General Sam Houston leading the charge against the Mexicans with Santa Anna in full retreat. The two paintings, loaned to the capitol in Austin to inspire patriotism rather than art, eventually hung permanently in the state capitol.[41]

Huddle, Virginia-born in 1847, moved with his parents to Texas. In his leisure time, Huddle studied the principles of art. Moving to Nashville, Tennessee, to study with his cousin, J. F. Fisher, portrait painter for the White House, he solidified his desire for an artistic career. After studying three years at the National Academy of Design, Huddle and other Academy scholars established the Art Students League in 1874. He returned to Austin, where he saw the distinct possibilities of art at the capitol. After a few years studying with the Munich masters, Huddle returned to Texas where he began producing portraits of the many men who made Texas history. Huddle's gallery of five presidents of the Republic of Texas and seventeen governors hangs in the capitol rotunda.[42]

Onderdonk, from Maryland, showed considerable artistic talent at an early age. At twenty, Onderdonk spent two years at the National Academy studying with, among others, William Merritt Chase and at the Art Students League. In 1878, Onderdonk went to Texas to earn enough money painting portraits

to travel to Europe for study. However, few portrait commissions came his way because Texans' interest laid in adventure rather than art. He earned his living by starting an art class and painting a few commissioned portraits. After a brief stay in Dallas, Onderdonk returned to San Antonio where his portrait commissions included the most illustrious Texas citizens. His monumental masterpiece, the 1903 commissioned oil on canvas, *The Fall of the Alamo*, portrays the spirit of the battle in the early morning of March 6, 1836. If Onderdonk had spent most of his time painting rather than teaching he would easily be ranked one of America's finest.[43]

By 1900, a few years before Georgia arrived in Amarillo, Texas native artists had come to the forefront. Texas's art history from 1900 to 1917 included the Texas landscape with Charles Franklin (Frank) Reaugh, Harvey Wallace Caylor (1867–1932) and the first art school in Texas, Aunspaugh at Dallas.[44]

Reaugh, an adopted Texan, was born in Illinois in 1860 and came to the Lone Star State as a young boy. Living in Terrell on the East Texas blackland prairie, Reaugh received most of his schooling from his educated mother. She instructed him in the beauty of botany and animals which led to his sketching with the crudest of materials. As his hobby grew into a passion, he attended the St. Louis School of Fine Art. Frank returned to Texas to teach, then went to the Académie Julian. A final move to Dallas led to his becoming the finest landscape and cattle painter. His studio full of cattle skulls and horns even attracted the artist, F. Luis Mora, to witness the man's talent. Reaugh's love of cattle and the fenceless Texas landscape with its "free grass," became the mainstay of his artistic subjects. Praise came in the form of a *Chicago Examiner* reporter's remark, "We need men brave enough to love and paint beauty which lies around them."[45]

Caylor's life began in 1867 in Indiana. As early as at seven years of age Caylor showed an interest in drawing, soon followed by his first instruction in black and white, using charcoal and crayon. Caylor left home at age fourteen and while in Kansas herding cattle lost his portfolio of sketches, only to begin again. He returned to Indiana and studied with Jacob Cox, William Merritt Chase's first teacher. Traveling through the West, Caylor learned of the Native Americans and studied the horses, cattle and plain life before the railroad transported the cattle. Caylor settled in Big Spring, Texas, where he painted when the creative desire surfaced, not by commissions, scenes familiar to all as "he has interpreted these men of the plains, not as wild, lawless creatures but as many of them really

were—strong, manly, heroic, yet gentle with hearts of gold, that in moments of tremendous crises could in humility and trust hold intercourse with their creator." Caylor died in 1932 in Big Spring.[46]

Vivian Louise Aunspaugh, born in Virginia in 1869, moved to Texas with her family. She studied at the Art Students League with Twachtman and in Chicago with Cecile Payne, the painter of miniatures. Continuing studies in Paris at the Carlarossi School and in Rome, she then returned to the United States. Her specialties included landscapes, flowers, figures, portraits and miniatures—all in oils, watercolors and pastels. As early as 1868, Dallas had its first art school but its name, the Aunspaugh School, named after its founder, became official in 1902. As Aunspaugh promoted the study of art in Texas, the Aunspaugh School used the nude model or life model to teach its students. Not only did Aunspaugh paint to win awards, but her teaching reached far and wide.[47]

In 1910, the Fort Worth Art Association organized its first annual exhibition strictly for Texas artists with their own genre. Gradually, as Texas became less of a frontier, Texas art paralleled the art in the rest of the United States.[48]

Georgia's arrival in Texas occurred not long after Texas artists had come into their own Texas style. As Texas art emerged, Georgia reached her 1912 destination, Amarillo, a frontier town in the Texas Panhandle which occupies the southern terminus of the table-flat Great Plains of the central United States and is full of the romance of a forgotten people.

B. Byron Price and Frederick W. Rathjen wrote in their book, *The Golden Spread*:

> Politically, the Panhandle, which had been a part of the vast Bexar Land District created by the Legislature in 1846, (during the first year Texas was a state) received a more specific identity in 1876 when the twenty-six Panhandle counties were created by legislative enactment to provide the framework for organized local government. With preparations thus made, a wave of pioneers rolled into the Texas Panhandle.[49]

The Panhandle comprises 25,610 square miles and among these twenty-six northernmost counties, Potter and Randall occupy the near center, with each county attaining a dramatic eight-hundred-foot elevation gain from the escarpment.[50] See figure 7-2.

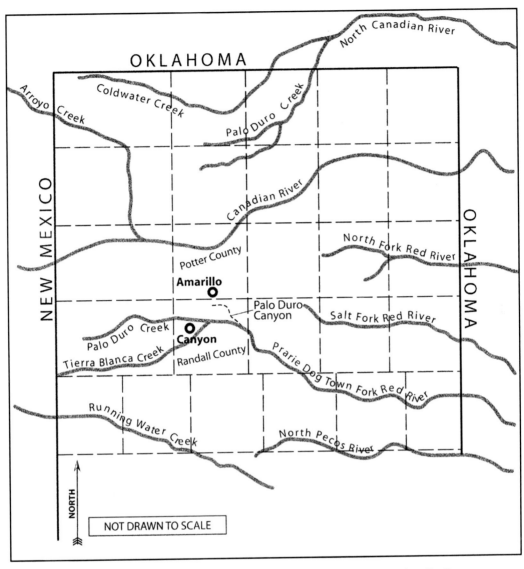

Within the map:

OKLAHOMA

North Canadian River

Arroyo Creek

Coldwater Creek

Palo Duro Creek

NEW MEXICO

OKLAHOMA

Canadian River

North Fork Red River

Potter County

Amarillo

Palo Duro Canyon

Salt Fork Red River

Palo Duro Creek

Canyon

Tierra Blanca Creek

Randall County

Prarie Dog Town Fork Red River

Running Water Creek

North Pecos River

NORTH

NOT DRAWN TO SCALE

7-2 Texas Panhandle Counties

Within the Great Plains lies an area of some 30,000 square miles in western Texas and eastern New Mexico known as the *Llano Estacado*, mentioned earlier, sometimes referred to as the "Great American Desert."[51]

In 1820, the first Anglo-American explorer to cross the Texas Panhandle was Major Stephen Harriman Long. One of his men described the "Great American Desert:"

> In regard to this extensive section of country, I do not hesitate in giving the opinion, that it is almost wholly unfit for civilization, and of course uninhabitable by a people depending upon agriculture for their subsistence. Although tracts of fertile land considerably extensive are occasionally to be met with, yet the scarcity of wood and water, almost uniformly prevalent, will prove an insuperable obstacle in the way of settling the country.[52]

The origin of the name *Llano Estacado* varies: Coronado in 1541 gazed in awe as he discovered the wind-struck vastness and left white stone *mojoneras* (mound or stake landmarks) across the mile after boundless mile of the tall red and golden grass—sparkling in the sun, rippling in the wind—to trace their return and, just as important, to indicate nearby water; or, the distant sight of the stalks of yucca without flowers in the winter resembled stakes driven into the center of the plant; or, the travelers tethered their horses at stakes to keep them from wandering off at night into the sea of grass blowing in the wind.[53]

In geological terms this land south of the Canadian River known as the *Llano Estacado* means "palisaded plains" because of the way the edge of the plains appear when looking at them from below the spectacular Caprock Escarpment—a two hundred fifty mile ridge marking the geological divide between the High Plains on the west and the Lower Plains on the east. The *Llano Estacado* marks the end of the coastal plains and the beginning of the great American West. Here the erosion of the limestone by the Red, Brazos and Colorado rivers lifts the earth and becomes easily identifiable as the brown swath on today's maps.[54]

A native of the *Llano Estacado* in eastern New Mexico best described the land: "This country will promise you less and give you more, and promise you more and give you less, than any place you'll find."[55]

Within the *Llano Estacado* lies the Texas High Plains comprised of the Texas South Plains and the northernmost plains called the Texas Panhandle, an almost square block of wasteland deemed "the chunk that evil cartographers like to lop off and stick in the corner of the map."[56] The Panhandle further

divides into the western High Plains and the eastern Lower Plains, divided east and west by the Caprock Escarpment. To the eye, the Panhandle may appear flat, but it doesn't lie horizontal because the northwest slopes from 4,000 feet above sea level to 2,400 feet above sea level at the southeast end in the Edwards Plateau.[57]

For about three hundred years the Spanish controlled the *Llano Estacado*, but discovered nothing in the flat land to interest them. It served only as a passageway for the Spanish and similarly the French and English. Their main interests remained to the east and west.[58]

Amarillo sits atop the *Llano Estacado* and Caprock Escarpment at an elevation of 3,671 feet above sea level.[59] Amarillo claims to be almost equidistant from the east coast and west coast, serving as a crossroads for travelers on the old highway Route 66 which is 2,448 miles from Chicago to Los Angeles. Adrian, Texas, a small town west of Amarillo claims to be the exact center of the highway which actually ends in Santa Monica, California. Commercialization began in the late eighteenth century when *El Camino Real* (The King's Highway), used by European settlers for exploration and trade, passed through the Texas Panhandle on its way from San Antonio to Santa Fe.[60]

Travel remained the same until 1869, when the completion of the transcontinental railway changed forever the experience of traveling west.[61] The hazards of the overland journey on horseback were exchanged for the comfortable Pullman car rolling over the steel rails. The passengers endured the monotony of the Plains for days rather than weeks.

In 1874, approximately twelve miles southeast of Amarillo in Palo Duro Canyon, columns of United States Army troops converged from five different directions and harassed the Indians for six months. On a path on the south rim of the canyon the Army descended to the floor of the canyon. Realizing they could not overcome the natives as they fired from the canyon walls, they retreated but burned the Indian camp and captured 1,400 horses. The natives realized the loss of their supplies, horses and shelters and fled to their Oklahoma reservations at Fort Sill and Fort Reno.[62]

The Battle of Palo Duro in 1874 signaled the demise of the Native Americans, who had lived in the Amarillo area for 12,000 years. Cattlemen and sheep herders from all directions came looking for fresh grazing. They found short grass, prairie blue grass and buffalo grass. In 1878, the introduction of

Longhorn cattle came, then in 1883 Hereford and Shorthorn cattle replaced the Longhorn. In 1885 over 3,000,000 acres of public land along the western Texas Panhandle entered the deed books as payment to the contractor by the State of Texas to build the state capitol in Austin. The builders accepted the land and established the now famous XIT Ranch. In 1886, the XIT Ranch, valued at more than $1,500,000, extended into ten counties and ran 150,000 head of cattle.[63]

When the Fort Worth and Denver City Railway (FW&DC) began laying its tracks across the Panhandle in 1887, a Colorado City, Texas, merchant, namely Colonel James T. Berry, chose a bald prairie with a large *playa* (basin) known as Amarillo Lake in the northwestern quarter of the section. He platted this site along the FW&DC right-of-way for a town and established stores, now known as "Old Town" in Amarillo. Berry's efforts to make the new town site the county seat involved enticing the qualified voters, mainly the Boston-owned LX Ranch employees in Potter County, to vote for the site as the county seat by promising each a business lot and home lot if the vote carried. A successful vote ended with the seat at a settlement originally called Oneida. Soon the name gave way to Amarillo, for the color of yellow as seen in the nearby yellow clay deposits. The renaming of the town resulted in a celebration to paint most of the houses yellow.[64]

A logical assumption can be made that, based on her memories of Amarillo's yellow houses, Georgia painted *Yellow House*, watercolor on paper, 8 7/8 x 11 7/8 in., 1917.[65]

Georgia easily painted her symmetrical composition with rectangles, repetition and opposition forming a harmonious whole. The grouping of lines drawn with no foreground or background demonstrated Dow's principles that Georgia taught to her students.[66]

Amarillo began in 1887, the year of Georgia's birth, and only twenty-four years before Georgia arrived, as a railroad construction camp on a vast sheet of silts, sands and gravels that originated in the Rocky Mountains to settle on the smooth surface of Amarillo. In time, the engine's whistles either comforted the nearby residents or disturbed their dreams. But for some the sounds provided good company and guarded against isolation, while others felt a lonesomeness. Either way, the engine's whistle represented the city's history.[67]

Not content that the original site sat on low ground and flooded, Henry B. Sanborn, part owner of the Flying Pan Ranch, and Joseph P. Glidden, who owned one of the two patents on barbed wire, purchased land to the east in

1888 enticing people to move. Soon people gravitated to the new site and the merchants opened their businesses on Polk Street. The new developers built in 1889 the three-story, yellow frame Amarillo Hotel at Third and Polk streets. See figure 7-3.

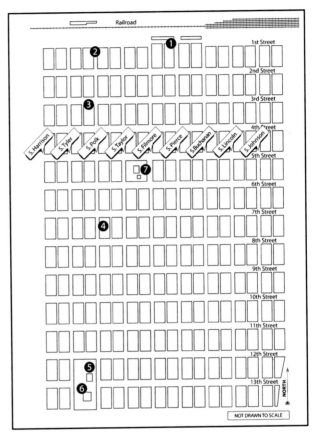

7-3 Map of Amarillo, Texas, March, 1913
1. Railroad Passenger Depot
2. Hotel Southern
3. Amarillo Hotel
4. Magnolia Hotel at 706 South Polk Street
5. Amarillo Grammar School
6. Amarillo High School between Thirteenth and Fourteenth streets on South Polk Street
7. Potter County Court House

The Victorian-style hotel, complete with an adjacent landscaped park, became headquarters for all the cattle buyers. Prosperity followed as a cattle town complete with holding grounds and pens sprang up near the railway tracks. By 1893, the city's population listed "between 500-600 humans and 50,000 head of cattle."[68]

Electricity arrived in Amarillo in 1902, the Amarillo Independent School District was formed in 1905, and electric streetcars arrived in 1908. The year 1909 brought the Grand Opera House into existence. The sudden influx of more railroads increased the population from 1,442 in 1900 to 9,957 in 1910, and included the Bowery district notorious for saloons, brothels, crime and desperados. But with the imposition of prohibition in 1911, the Bowery soon faded in its activity.[69] By 1912, several blocks of Polk, Taylor, Third, Fourth, Fifth and Sixth streets had been paved with bricks, easier driving for Amarillo's one hundred fifty automobiles.[70]

In 1918, four years after Georgia left her teaching position in Amarillo, the discovery of natural gas provided further reasons to migrate to the Texas Panhandle. Then came the oil boom in 1921 when "black gold" created fortunes overnight.[71]

After a few weeks in the summer of 1912 at the University of Virginia, armed with Alon Bement's teaching, twenty-four-year-old Georgia stepped off the train in the blistering August Amarillo heat.[72] Amarillo at the time held the honor of being the biggest cattle shipping depot in the Southwest, regardless of few paved or even graveled roads, no fences and few cars.[73]

The West Texas horizon with its sky punctuated by the sun or moon dwarfed the earth. Georgia commented, "Amarillo was a brown, barren place."[74] Easily, she may have related to the known fable:

> It was one of those days when God was creating the earth... He was working on Texas as darkness fell at the end of the day, and as he prepared to quit He gave the Great Plains of West Texas a smoothing stroke and said to Himself, "In the morning I'll come back and make it pretty like the rest of the world, with lakes and streams and mountains and trees." But the next morning when he returned, it had hardened like concrete. As He thought about having to tear it all down and make it over, He had a happy

thought: "I know what I'll do," He said, "I'll just make some people who like it that way." And that is how it came about that the people who live in the Panhandle like it this way.[75]

On the high, flat Texas Panhandle plains with few paved roads, Georgia stood her full height of 5' 4" and discovered, as if she were the very first to discover, her new land, the purple haze strewn across the plains interrupted only by canyons. To her, the find must have seemed like no other explorers, such as Cabeza de Vaca, De Soto, Coronado and Oñate, had set foot in this inherent beauty that symbolized time stood still. Soon, surely, in Georgia's mind, she and only she had discovered the round saucer-like depressions from several inches to several tens of feet deep and ranging in diameter from several feet to a mile that gather rainfall to form grayish, flat-bottomed ponds known as *playas*. The many *playas* have lee-side dunes of wind-blown lake sediment on their east and southeast sides; the water that does not evaporate sinks to the High Plains Ogallala Aquifer beneath the surface (the largest underground water supply in America) and flows southeastward for natural storage.[76] This aquifer transformed the arid land into a productive farming region.[77]

Georgia could not help but notice at first, regardless of the year, even with the absence of natural beauty, that Amarillo possessed the privilege of a climate with few days of extreme temperatures, yet possessing all four seasons. The high elevation and low humidity brought appreciation for any summer afternoon highs of over ninety degrees. Relief came in contradictory nights that cooled down quickly.

The advancing of Georgia's days as a "newcomer" brought not only the discovery of the cold, clear night, but of the wind. Whether described as a breeze or wind, coming from any direction, the wind ruffled the hair and clothes. The wind averaged fourteen miles per hour with gusts of thirty to forty miles per hour in the late winter and spring. A wind that moved large chunks of the land also provided the power to move the windmill blades to lift underground water to the surface. Yet, the ill wind robbed the land of its moisture, and smothered the land with gargantuan dust storms, and dust devils danced their way across the plains. Acceptance arrived as everything displayed a thin coating of dust and an attitude that the wind provided inspiration as everyone leaned hard into the wind.[78]

Georgia observed an overpowering sweep of concave sky that allowed the silence of great space to linger forever, signifying time remained still and permitting possession of her ever-important freedom, a freedom she easily recognized from her Sun Prairie sky, a link with her childhood home. For the Amarillo "old timers," this open space prompted the claim that during an Amarillo sunrise and sunset you could see the curvature of the earth.[79]

The unplowed vastness surrounding Amarillo in 1912 endured without being chopped up with too many roads and barbed wire, and remained one of the last places where the Old West was just a few miles away.[80] Georgia easily accepted Amarillo as truly the Wild West. She could not have imagined much more.

Georgia had discovered her first muse, Amarillo. She vowed to overcome the land with a limitless horizon that reminded her of the ongoing horizon of an ocean.[81] Now she must decide how to place herself in a receptive frame of mind to court this muse and assimilate into her life its awesome mystery, a mystery she would investigate but not interpret literally. In Amarillo she learned that her artistic expression related to the environment in which she placed herself. Her subject chose her, she did not choose her subject. She had lots of thinking to do before putting brush to canvas, all part of the painting process.

Arriving in high summer when all of Texas was under the influence of a southerly wind, she had not met anyone who had seen Amarillo when the city existed only as open grassland. Georgia arrived in time for a teachers meeting on August 31, 1912. She was elated about the school's expectations, and her qualifications met the demands of the day. She would teach the fall-spring semesters through the spring of 1914 in the town that by 1920 would expand to 15,000 in population.[82]

With her position of art supervisor and a salary of $150, Georgia did not have to live in a boarding house. She chose as her first residence the Magnolia Hotel at 706 South Polk Street on the west side of the street, only a few blocks south of the two railroad lines curving through town. Her window faced the open plains.[83] See figure 7-4.

Georgia described the Magnolia Hotel by forming a circle with her thumb and middle finger saying, "There wasn't a tree bigger than that. There were two scraggly lilac bushes on either side of the Magnolia house steps, but they were having a hard time of it."[84]

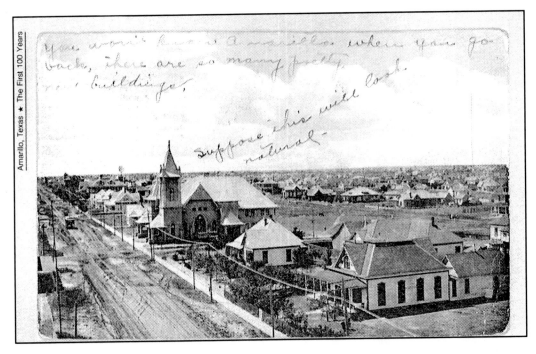

7-4 Magnolia Hotel

Georgia saw the clouds of dust indicating the cowboys' herds of cattle ranging at a distance. She also noticed their nightly campfires. Each day the herds came closer to town until she could hear their bawling. After they herded the cattle into stock pens, the dirty, leathery-skinned cowboys knew that Mollie Turner, the proprietor of the Magnolia Hotel, hosted a popular dining room. They barged into the hotel to eat and eat and eat. An incident of a shooting in the hotel where Georgia was playing dominoes in the back room prompted her to find more suitable dining facilities.[85]

Shortly after Georgia arrived in Amarillo she learned that Alice Peretta had died. About the same time she witnessed a black-bearded murderer with a gun on his arm walk past her on his way to surrender to the local sheriff. The murderer Beal Snead, a rancher and cattle trader, had shot his wife's lover, Albert Boyce, Jr., in an ambush as Boyce walked past the Polk Street Methodist Church, a block from Georgia's hotel.[86] Such an experience topped anything her mother had read to her about the West.

Texas Plains and Sky 153

Georgia's teaching career began in a small house on school property because the high school between Thirteenth and Fourteenth streets on South Polk Street was still incomplete.[87] See figure 7-5.

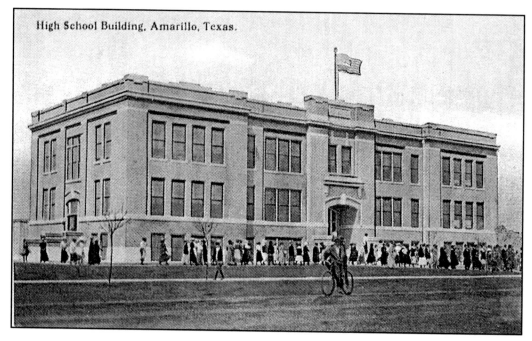

High School Building, Amarillo, Texas.

7-5 Amarillo High School Upon Completion

Except for a brief period in the fall of 1911, at Chatham Episcopal Institute temporarily teaching Miss Willis's class, Georgia had spent her years being the student.[88] Now the prospect of supervising the teaching stirred her as nothing ever had.

Teaching is a craft, but also an art in itself. Its purpose is to produce whatever the student can do. The teacher's task is to give constant attention to hundreds of details while allowing freedom of the student's creativity.

Early that September, Georgia's assignment included buying textbooks because her predecessor had only used the standard Prang books. In her first year of teaching she struggled with the administration over the use of certain textbooks which Georgia found stifling. Not vested with the authority to act

as she wished, Georgia confronted the high school by not ordering any of the designated textbooks.[89]

Georgia wrote to her friend, Anita Pollitzer, in New York City to send teaching aids such as photographs of textiles, and Greek and Persian pottery which she hung on her classroom walls.[90] As a young woman struggling to make the most of her teaching skills, Georgia insisted that art demanded creativity, not statements in a book. As the year progressed, Georgia became involved with more than the mere presentation of the teaching material.

She easily recognized that teaching evolved simply into the art of assisting discovery. She learned of her students' capabilities, their backgrounds, what they had accomplished, and even their interests. Along with her evaluation of her students came her long- and short-term teaching objectives so she would know what to teach them. A single lesson became part of the complex sequence and lasted months. The alternating phases of Georgia's instructing activity became quite noticeable in her students. Georgia must have realized that she had to select and arrange the material to maintain curiosity and interest for the learner to set for himself realistic goals of achievement.

Georgia preferred to teach the children by her own methods: teaching art registered better if taught with action, not with reading. She became determined not to back down or give up. As she won the battle over the textbooks, she encouraged her students in simplicity, to draw and paint from life and nature. She found an approach that suited her which included new adventures. In her effort to bring shapes to the class and with no flowers blooming on the plains, Georgia's walks on the plains brought cow skulls and bones to class for the students to draw.[91] The bones, classified as dead, resembled other dead material such as glass, stone and metal. The drawing of these subjects brought them to life.[92]

Georgia must have remembered William Merritt Chase's discipline that the life casts, as required, existed as dead. Perhaps the drawing of the dead bones became Georgia's way to refute "cast" drawings.

With more than three-fourths of Amarillo's year radiant with sunshine and no more than twenty inches of rain a year, Georgia blissfully took her students on walks on the plains to see great eye-dazzling expanses of the striking panorama of earth. She didn't even have to look up to see the blue sky.[93]

One of Georgia's students, an Amarillo teenager, Margaret Seewald (Mrs. Ed Roberts), showed much promise. Georgia selected Margaret's pictures as

outstanding, giving them prime space on the classroom blackboard.[94] The young artist's ability was easily recognized by her father, Phil, a fifth-generation jeweler, who prospered with the cattle people in nearby Tascosa and who, when the railroad came to Amarillo, settled at Fifth Street and Buchanan Street across the street from the Sanborns. Seewald said, "I always drew when I was a kid. That's how I knew I was interested in art...it's rather like a disease." Recognized by Georgia, Seewald's art career continued. Beginning in 1918, Seewald studied at the Art Institute of Chicago with Allen Philbrick, Forest Byrd, and Elmer Foresberg to become an etcher, printmaker and muralist. Offered a greeting card job, Seewald refused, on the advice of her father. Successful in her career, Seewald's work was featured in the 1931 Tri-State Fair in Amarillo and the Panhandle Plains Historical Museum and Chicago Society Etchers in 1933.[95]

A guest at the Magnolia Hotel, Mr. McGregor, entertained Georgia with his tales of the Alaskan gold rush and took her on her first visit to Palo Duro Canyon.[96] Georgia in the autumn of 1912, rode to the Palo Duro (hard wood) Canyon in one of the dozen or so cars in Amarillo at that time.[97] As the bottom dropped out of the plains into the sandstone depression, this brought the realization that the West harbored color. The golden glow of the coming autumn sun, the canyon's colors as they slipped into nighttime, and the clear, calm nights with bands of light that ebbed, pulsed and even danced, belonged now only for the memory because she had little time to paint for herself.

Barbara Buhler Lynes documented in *Georgia O'Keeffe, Catalogue Raisonné* that from her arrival in Amarillo in 1912 to her departure in the spring of 1914 Georgia painted five paintings, three of which were portraits:

> *Untitled (Catherine O'Keeffe)*, graphite and oil on medium, thick, cream, slightly textured wove paper, face of illustration board, 18 1/2 x 10 1/8 in., ca. 1912/1914,
> *Untitled (Fashion Design)*, watercolor and graphite on medium, thick, brown, slightly textured wove paper, illustration board, 18 1/2 x 10 1/8 in., ca. 1912/1914,
> *Untitled (Horse)*, oil on cardboard, 12 1/2 x 11 1/2 in., 1914,
> *Untitled (Horse)*, oil and graphite on cardboard, 11 1/2 x 10 1/2 in., 1914,
> *Untitled (Portrait of Dorothy True)*, linoleum block print, 7 5/8 x 6 3/4 in., 1914/1915.[98]

Georgia turned down an opportunity to teach for more money in another state. Instead, before moving to the next cycle in her teaching career, she assessed her teaching results and returned in the summer of 1913 to Charlottesville to work as Alon Bement's assistant at the University of Virginia, where she had taught. She would do so through the summer of 1916.[99]

As the percentage of children attending school increased and more came into the secondary schools, the Texas Legislature, in the spring of 1913, raised the standards by requiring a state commission to approve textbooks.[100]

Georgia returned to Amarillo in the fall of 1913, again confronted by the strict use of the conforming textbooks. Georgia thought such precise, rigid art training did not produce enjoyment and convinced the authorities that the children would learn much more about art in the environment she discovered.[101] Again Georgia was victorious in the battle by leaving the textbooks on the shelves and permitting the students to draw and paint from life and nature which surrounded them.[102]

Georgia won her fight, although she didn't enjoy the fight. She said:

> I could not let those children, some of them so poor that their toes were sticking out of their shoes, be forced to pay 75 cents or a dollar for a drawing book, when fine things that were part of their lives were growing at their very door in Amarillo.[103]

Georgia's intent to become economically independent seemed on the right track and her emotional independence, in its formative stages, allowed her to leave Amarillo in the spring of 1914. Why she left is part speculation because she had mastered the textbook situation. Perhaps she left over a salary dispute. Perhaps she wanted to study more, paint her own paintings, and work toward a college degree.[104]

Whatever the reason, the memory of the Texas plains and sky stayed with Georgia forever. Her sister, Catherine, commented, "Georgia seemed to be drawing just for herself, and her work was like that of no one else."[105]

INFLUENTIAL BOOKS

Georgia returned to the University of Virginia in Charlottesville for the summer of 1914 as Alon Bement's assistant teacher. Bement probably recognized that an artist's journey could not be called a "short journey" through the cultural offerings of the times. As an established, prestigious teacher, Bement exposed Georgia to a powerful flow of knowledge. He suggested, for artistic stimulation, that Georgia read books by Arthur Jerome Eddy and Wassily Kandinsky.[1]

Eddy (1859–1920), born in Chicago, prided himself on being the first Chicagoan to ride a bicycle and later the first to own a car. He was a self-made man. In the early twentieth century, Eddy pioneered the modern trade association. He played a central role in the organization of American capitalism—and all this separate from his treatises. As a pioneering corporate lawyer, Eddy authored two books in economics. The first, about trusts, preceded the 1912 *The New Competition: An Examination of the Conditions Underlying the Radical Change That Is Taking Place in the Commercial and Industrial World*, which has had a lasting importance.[2]

Besides being known as an economist, Chicagoans recognized Eddy as "the man that Whistler painted." James McNeill Whistler (1834–1903) in 1894 painted *Arrangement in Flesh Color and Brown: Portrait of Arthur Jerome Eddy*, oil on canvas, 82 6/10 x 36 3/10 in.[3]

Whistler called his works harmonies, studies or arrangements rather than choosing names to emphasize the subject that might detract the viewer from the painting. Eddy, an outspoken advocate of Whistler, recognized that Whistler produced harmonies with line and color similar to what a musician does with sound.[4]

Eddy's interest in art centered on collecting and his name became associated with collectors of modern art such as Alfred Stieglitz, John Quinn and Walter Arensberg. His finances did not match those of the Eastern millionaires and his interests focused on abstract artists such as Kandinsky and Arthur Garfield Dove. In a quest to educate the general public about modern art, he surpassed Stieglitz and Quinn. As an influential member of the Art Institute of Chicago, Eddy encouraged the institute to bring to Chicago several hundred paintings from the famous Armory Show. His purchase of twenty-seven paintings from the Chicago exhibition included *Pasture*, oil, 28 5/8 x 36 in., 1912, by André Dunoyer de Segonzac, and *The Leap of the Rabbit*, oil, 19 5/8 x 24 1/8 in., 1911, by Amadeo de Souza Cardoso.[5]

After the Armory Show in Chicago, Eddy's interest in art increased with lengthy written critiques supporting the new art and attacks on the established art theories and ideals. Although highly controversial, Eddy influenced modernist artists. Eddy's efforts to educate the public about modern art rivaled Stieglitz's efforts and led to his authoring in 1914, *Cubists and Post-Impressionism*. In this book, Eddy explained the latest trends in painting and sculpture.

Within the book, the illustrations were glued on a separate brown page. Eddy included two paintings by Albert Gleizes, which were not well received by everyone, *Original Drawing for Man on Balcony* and *Man on Balcony*, oil on canvas, 77 x 45 in., 1912.[6]

Gleizes, in his attempt to distinguish his painting from Picasso and Braque, kept the subject's unity recognizable by depicting the man's head resting on his shoulders, his torso on his legs and the figure leaning on a balcony with the street behind him in unrecognizable disarray.[7]

Stieglitz's copy of Eddy's book contained this marginal notation by the German artist, Oscar Bluemner, about Gleizes' cubist painting:

> This picture is not art. It clearly renders a motif or an idea of reality. But no emotion or feeling—vision is discernible in the commonplace subject. Instead artificial transformations of irrelevant natural things.[8]

Georgia probably saw in Eddy's 1914 book her first Dove painting and abstraction, *Based on Leaf Forms and Spaces*, pastel with support not verified, 23 x 18 in., 19211/1912.[9]

Dove wrote about this piece, "It is a choice of three colors, red, yellow, and green and three forms selected from trees and the spaces between them that to me were expressive of the movement of the thing which I felt."[10]

Dove explained to Eddy in a 1912 letter:

> You have asked me to "explain as I would talk to any intelligent friend, the idea behind the picture," or in other words, "what I am driving at."
>
> One of these principles which seemed the most evident was the choice of the simple motif. This same law held in nature, a few forms and a few colors sufficed for the creation of an object. Consequently I gave up my more disorderly methods (impressionism). In other words I gave up trying to express an idea by stating innumerable little facts, the statement of facts having no more to do with the art of painting than statistics with literature....
>
> The first step was to choose from nature a motif in color and with that motif to paint from nature, the forms still being objective.
>
> The second step was to apply this same principle to form, the actual dependence upon the object (representation) disappearing, and the means of expression becoming purely subjective. After working for some time in this way, I no longer observed in the old way, and, not only began to think subjectively but also to remember certain sensations purely through their form and color, that is by certain shapes, planes of light, or character lines determined by the meeting of such planes.

With the introduction of the line motif the expression grew more plastic and the struggle with the means less evident.[11]

Dove (1880-1946), the son of a wealthy contractor, was born and raised in upstate New York and was influenced by living close to nature during his formative years. One of his childhood friends, a farmer, naturalist and painter, introduced Dove to living off the land and encouraged him to follow his instincts about outdoor life and art. At his father's insistence, Dove studied law at Cornell University before his 1903 decision to pursue a career in art. Taking advantage of the golden age of illustrators, such as Maxfield Parrish and Charles Dana Gibson, Dove illustrated for magazines such as *McClure's*, *Century* and *Collier's*. He married Florence Dorsey, his next door neighbor in Geneva, New York, in 1904. In 1908 they traveled to Paris, where he gained exposure to the vivid color and decorative patterning of Henri Matisse and the Fauves, and the orderly structures of Cézanne. Returning to the United States in July 1909, Dove linked with Alfred Stieglitz and began a series of bold non-representational paintings, always in response to nature: a radiant sunrise, sensuously shaped tree trunks, the color of autumn leaves and the waving grain fields. These various abstractions, first exhibited in 1912 at Stieglitz's 291, blended his love of nature with his interest in the ideas and philosophies of modern art and life. He called his paintings "extractions," basing them on the "pulsating energy of nature" in order to make the invisible visible. New Yorkers thought of Dove's work as nonsense but when the exhibition traveled to Chicago, one Chicagoan who bought Dove's work, Arthur Jerome Eddy, shortly afterwards wrote the book, *Cubists and Post-Impressionism.*[12]

In the opening chapter, Eddy declares that the first stimulation in the art world since the Columbian Exposition in 1893, with the exception of Alfred Stieglitz's 291, arrived with the sensational International Exhibition of Modern Art in 1913. The 1913 exhibition contained work that was "fresh, new, original— eccentric,...that it gave our art-world food for thought—and heated controversy." Further, "Art thrives on controversy—like every human endeavor. The fiercer the controversy the *surer*, the *sounder*, the *saner* the outcome."[13]

Eddy continued, "The old and the new are not rivals; the new is simply a departure from the old, simply an attempt to do something different with line

and color." Eddy declared that a good reason for change is that the times were ready for a change:

> Broadly speaking we are changing from the *perfections* of Impressionism to the *imperfections* of Post-Impressionism; from the *achievements* of a school, a movement, that has done the best it could, to the attempts, the *experiments*, the *gropings*, of new men along new lines.[14]

In his book, Eddy described some of the changes as they occurred. He stressed that Post-Impressionism contained not more of Impressionism with its painting of "light," but a reaction. Similarly, when the romantic Barbizon School, known for its nineteenth century French painting, exhausted itself, the realistic artists, such as Gustave Courbet and Édouard Manet, painted "things" quite brutally and realistically. After the painting of things and light came the painting of "emotions" with color and line to express the artist's inner self.[15]

Eddy wrote that each artistic era had artists who created works ahead of their time and that only a short time ago Rodin's *Balzac* had been condemned. Each era also contained the seeds of "its dissolution and the germs of its succession." No one could predict when one era would end and another began. Eddy expanded on the changes brought forth by the successors of Impressionism such as the Fauves with their brilliant colors used constructively and decoratively instead of imitatively, the Cubists who drew objects into the basic shapes of cubes, spheres, cylinders and cones to redesign them into planes, and the new art in Munich.[16]

Of color, Eddy wrote:

> Color force is a feature of the new inspiration.
>
> The painters of today have discovered anew the world's coloring. We now recognize everywhere the power and vivaciousness, the thousandfold freshness, and the infinite changefulness of color. To us colors now talk directly; they are not drowned by covering tints, not hide-bound by a preconceived harmony. An instrument has thus been given, wherein innumerable melodies still slumber.
>
> Color is a means of representation not only of what is colored, but also of the thick and the thin; of the solid and the liquid; of the light

and of the heavy; of the hard and of the soft; of the corporeal and of the spacious. Cézanne models with color; with tinted color surfaces he builds a landscape. The proper couching of colored planes can force upon us the impression of depth; colored transitions call forth the impression of ascent and of motion; spots scattered here and there give the impression of sprightly vivaciousness.

Color is a means of expression talking directly to the soul. Deep mourning and soft glowing, warmth of heart and cold clarity, confused dumbness, flames of passion, sweet devotion—all conditions and all outbursts of the soul—what can communicate them to us more forcefully and more directly than a few colors with their effect exerted through the eye? As tones draw us with them without our will and without meeting resistance, so does color subjugate us: now it fills us with deepest sorrow, then again we are all glowing under its influence.

Color is a means of composition. The force of sensuous designation, the expressive power of the soul, both must combine and make for an always new, always original, and always unique harmony. The law of color beauty has not as yet been fathomed by the intellect. It is being created by feeling and by subconscious experience.[17]

Eddy quoted Cézanne, realistically a Fauve, who defined line and color:

Everything in nature is modelled on the lines of the *sphere*, the *cone*, and the *cylinder*, and one must understand how to paint these simple figures, one can then paint anything. Design and color are not distinct; to precisely the extent that one paints, one draws; the more the color harmonizes, the clearer and purer the design. When the color is at its finest, the form also attains its perfection. Contrasts and harmonies of tones—that is the secret of drawing and modelling.[18]

Eddy elaborated on cubism:

In the suggestion of the lines of the *sphere*, the *cone*, and the *cylinder*, as the elements of all art, one recognizes the *alphabet of cubism*. But in

reducing drawing to these elements Cézanne, without knowing it, simply repeated what Albert Dürer printed in book form nearly four hundred years ago, and what the Chinese and Japanese had discovered centuries earlier.[19]

Eddy described cubism:

In a sense, "Cubism" is a misleading term, for, in the first place, "Cubist" pictures are not painted in cubes, but in all sorts or angles and curves; in the second place, the theory does not call for angles.

The theory being the expression of emotion in line and color, there is no conceivable reason why cubes and angles should be used to the exclusion of curves, swirls, sweeps, dashes. On the contrary, of all forms, cubes and angles would seem to be the most inappropriate for emotional expression, since they are peculiarly suggestive of the geometrical and the matter of fact.[20]

The long lines form the structure of the picture. They decide how the picture is to be constructed from its parts, and how the parts are to be interlocked in order to become a whole. The long lines define the measure and rhythm of the work. Lines are the vibrations of the soul; lines are reflections of the will, the rigidity of that which endures. Like currents of forces they flow against each other and unite into one. The smaller ones accompany them with playful gambols, like a multiple echo, the sounds of which melt away in the distance.

The picture is not a nicely divided plane. It is like a world arising from chaos. Its essence is the law of order working itself out. The picture is an agglomeration of agitated members, an agglomeration of planes pulsating with blood, enlivened by breath.

The planes may be stratified, parallel and similar to each other; they may rear and pile themselves against each other, or they may interlock like cogs. They may liquefy and melt away, or they may double up and form themselves into balls. They may, more quietly, rest within themselves, becoming effective through the contrast of their essence and yet maintaining themselves. Out of them originates the picture's spaciousness, out of them the living force of the picture.[21]

The very high aesthetic value of drawing and painting in planes, and with small regard to the so—called laws of perspective, is illustrated in the rare beauty of Chinese and Japanese paintings. From the point of view of their greatest painters, we carry perspective and imitation to extremes that destroy art.

In oriental art, in archaic art, in primitive Italian art, in not a little modern decorative work, we have long recognized the beauty of drawing in planes and of the use of color arbitrarily. The Cubists are showing us— perhaps too violently and imperfectly—that it is possible to paint pictures and portraits in planes and masses without imitation. That is possible we know, for the orientals have done it for two thousand years; nevertheless, we stubbornly resist the attempt in western art.[22]

The fact that one may get nothing out of it as yet in the way of tangible or even vaguely experienced emotions is beside the point. The interest in this whole matter rests on the fact that here is revealed a new form of aesthetic expression as yet only tentative and groping perhaps, but reaching out in new directions. And it must not be forgotten that the pioneer is usually misunderstood; he is so far in advance of current ideas as to be out of touch with his fellow men who might appropriately be called follow-men, they lag so far behind the progress of new ideas. Cézanne and Picasso—they mark the parting of the ways: a fulfilment and a promise. Quo Vadis?[23]

Eddy summarized Cubism: "One value of the Cubist movement lies in arousing a sense of the strength possessed by the simple and elemental."[24]

He wrote of the art movement in Munich, "The key-note of the modern movement in art is *expression of self*; that is, the expression of one's *inner self*, as distinguished from the representation of the outer world."[25]

Eddy refers to three of the Kandinskys in his book as masters of color combinations and his work as exemplary of the Munich art. The London Exhibition in Albert Hall in July 1913 featured three Kandinskys and a critic said, "By far the best pictures there seemed to me to be the three works by Kandinsky."[26]

Georgia probably saw these illustrations while reading *Cubists and Post-Impressionism*.

Eddy wrote that a critic said of the three Kandinskys:

They are of peculiar interest, because one is a landscape in which the disposition of the forms is clearly prompted by a thing seen, while the other two are improvisations. In these the forms and colors have no possible justification, except the rightness of their relations. This, of course, is really true of all art, but where representation of natural form comes in, the senses are apt to be tricked into acquiescence by the intelligence. In these improvisations, therefore, the form has to stand the test without any adventitious aids. It seemed to me that they did this, and established their right to be what they were. In fact, these seemed to me the most complete pictures in the exhibition, to be those which had the most definite and coherent expressive power. Undoubtedly representation, besides the evocative power which it has through association of ideas, has also a value in assisting us to coordinate forms, and, until Picasso and Kandinsky tried to do without it, this function at least was always regarded as a necessity. That is why of the three pictures by Kandinsky, the landscape strikes one most at first. Even if one does not recognize it as a landscape, it is easier to find one's way about in it, because the forms have the same sort of relations as the forms of nature, whereas in the two others there is no reminiscence of the general structure of the visible world. The landscape is easier, but that is all. As one contemplates the three, one finds that after a time the improvisations become more definite, more logical and more closely knit in structure, more surprisingly beautiful in their color oppositions, more exact in their equilibrium. *They are pure visual music.*[27]

To Eddy, "*the important question is whether the form has grown out of the inner, spiritual necessity.*"[28]

He claimed that he had little knowledge of how compositional painting would be accepted by the public, but that the number of appreciative viewers would increase and that they would collect only the more abstract art.[29]

He briefly discussed "color music," whereby an artist paints a canvas with only color harmonies when there is not even a suggestion of object or form to produce an even more abstract work.[30]

Eddy carefully discussed *esoragoto*, a Japanese canon which literally means "an invented picture or a picture into which certain fictions are painted." The Japanese artists are not bound by literal presentation but take certain artistic liberties to present *kokoro*, a moving spirit.[31]

He reminded his readers of the Chinese wisdom that warns the modern painter of four points:

Ja, Kan, Zoku, Rai.

Ja refers to attempted originality in a painting without the ability to give it character, departing from all law to produce something not reducible to any law or principle.

Kan is producing only superficial pleasing effect without any *power* in the brush stroke—a characterless painting, to charm only the ignorant.

Zoku refers to the fault of painting from a mercenary motive only—thinking of money instead of art.

Rai is the base imitation of or copying or cribbing from others.[32]

He concluded *Cubists and Post-Impressionism* with a discussion of ugliness, futurism, virile impressionism and sculpture.

Eddy declares that one's first impression of forceful modern art is that it is ugly, but with continued viewing the "exceeding vitality" becomes dominant. He concludes that there is danger in labeling a painting ugly because past history indicates that what might at first be considered ugly would later become a classic. He added that the time could arrive when paintings would be bought for offices in addition to homes instead of lying in the graveyards of art, the private galleries.[33]

Futurism, as mentioned by Eddy, had its beginnings in Italy in 1912. Its main premise concerned the painting not of "a moment of immobility of the universal force that surrounds us, *but the sensation of that force.*" In other words, the artist does not limit himself to just what he sees in the rectangular window frame, but includes what he would see from all directions. The artist is showing "both the *eye* and the *mind's eye.*"[34]

In his earlier 1902 book, *Delight, the Soul of Art*, Eddy claimed that art is delight in thought and symbol. Delight is the soul of the artist. No artist

must work without the initial impulse, without pure and serene enthusiasm, the spiritual element. Lose this delight and one produces lifeless work. Delight in thought is the subjective element, the conception, message, conviction, sincerity, and inspiration. Delight in symbol is the objective element, the expression, how technically executed by the line, form or structure. If a work of art falls short in any one—delight, thought and symbol—the work is inferior. Perfection in art is obtained in one combination: "A pure and serene delight...; noble and profound thought...; the most perfect freedom and facility in technique...; all so pre-eminently combined in one man at one time that great achievement is absolutely compelled."[35]

Along with Eddy's book, *Cubists and Post-Impressionism*, Bement encouraged Georgia for an immediate experience to read Kandinsky's 1911 book, *The Art of Spiritual Harmony*. Kandinsky's writings first appeared as an essay and had been translated into English by his friend, Michael T. H. Sadler, in 1914 to become *Concerning the Spiritual in Art*. Kandinsky's reputation was as the most important artist in nonrepresentational painting in the first half of the twentieth century.[36]

On December 4, 1866, a cold day in Moscow, Wassily Vasilyevich Kandinsky began his Russian life, born into an aristocratic, well-to-do family with a European and Asian cultural heritage. His father, a tea merchant, provided him at an early age with travels to Venice, Rome, Florence, the Caucasus and the Crimean Peninsula. The family settled in Odessa, where he finished his secondary schooling. A calm, studious boy, he painted and played the piano and cello. After his parents separated in 1871, his aunt raised him in Odessa in the Russian Orthodox faith. Kandinsky visited his father every winter in Moscow where they attended art exhibitions. At age thirteen, Kandinsky acquired a box of paints and a set of watercolor tubes. Years later he recalled that he formed an adolescent theory that "each color had a mysterious life of its own." In childlike fashion Kandinsky sketched, attended exhibitions and collected art in a small way.[37]

Traveling frequently to Moscow, Kandinsky returned in 1886 to study political economy, ethnology and law at the University of Moscow. Kandinsky's exposure to the city's architecture, icons and color interested him and he often thought of these elements as the beginning of his own art, which eliminated nature, retained an emotional expression, and originated from a specific event.

In 1889, the University sent him on an ethnographic field trip approximately seven hundred fifty miles northeast of Moscow to the forested province of Vologda which resulted in a profound interest in garish, nonrealistic Russian folk art painting.[38]

In 1893, Kandinsky received an academic degree similar to a doctorate and his career gravitated toward academia when in 1895 he saw Claude Monet's (1840–1926) *Haystack at Giverny*, oil on canvas, 31 9/10 x 23 6/10 in., 1886. He described his confusion at seeing the painting:

> It was from the catalogue I learned this was a haystack. I was upset I had not recognized it. I also thought the painter had no right to paint in such an imprecise fashion. Dimly I was aware too that the object did not appear in the picture....[39]

He was shocked by the absence of structure and construction in an object that existed only in the composition of its colors. Undecided about his career, the decision to paint festered for years because Kandinsky liked painting with strong colors but he also enjoyed playing the cello and piano. To Kandinsky music possessed color and shape. The rich tapestries of piano, woodwinds, horns and especially the strings evoked a sensorium of yellows, reds, blues and a myriad other colors that formed into mental shapes with rigid angles, smooth edges, curves and a myriad shapes, just like painting.[40]

In 1896, Kandinsky, a tall, large-framed, immaculately dressed, thirty-year-old man wearing pince-nez glasses and with the habit of holding his head up high as if he were a prince, turned down a professorship in jurisprudence. In a "now or never" mood and with his father's financial support, Kandinsky boarded the train to Munich to study painting instead of law. Munich was well-suited to Kandinsky because the Munich Secession of 1892 allowed the younger artists to break from academic rules, explore avante-garde art, and study Impressionist color and Art Nouveau form. Kandinsky received a Munich Academy diploma in 1900 and achieved some success with his paintings, which leaned toward modernism. From a nineteenth-century realism foundation in his work can be seen the influence of the Impressionists, Art Nouveau, Pointillism, the shadows of Moscow icons and Vologda folk art, the patterns of forceful

Asian hues, and the strong colors of central European Expressionism and French Fauvism. Kandinsky recalled:

> In my studies I let myself go. I didn't think much about houses, or trees, I applied streaks and blobs of colours onto the canvas with a palette knife and I made them sing with all the intensity I could....[41]

This placed him in vanguard groups all over Europe, culminating in his first one-man show in 1903 in Moscow which showcased his interest in fantasy.

8-1 Blue Mountain by Wassily Kandinsky

Traveling extensively to become acquainted with all of Europe, Kandinsky lived in Paris in 1906-1907 where he saw the exhibitions of the Fauves. In these paintings he saw the liberation of color which influenced him the remainder of his life.[42]

Kandinsky's *Blue Mountain*, oil on canvas, 42 x 38 1/2, in., 1908, indicated that his direction toward nonrepresentational art progressed with the schematic forms, unnatural colors, and the effect of a dreamlike landscape.[43] See figure 8-1.

In the painting, with very simple, primary colors, Kandinsky expressed his belief that:

> Form, in the narrow sense, is nothing but the separating line between surfaces of colour. That is its outer meaning. But it has also an inner meaning, of varying intensity, and, properly speaking, *form is the outward expression of this inner meaning.*[44]

Form using blue provided a spiritual conduit for the viewer. Kandinsky claimed that blue retreated from the viewer and turned "in upon its own center, expressing profound meaning, depth and coolness."[45] He further claimed:

> Blue is the typical heavenly colour. The ultimate feeling it creates is one of rest. When it sinks almost to black, it echoes a grief that is hardly human. When it rises towards white, a movement little suited to it, its appeal to men grows weaker and more distant. In music a light blue is like a flute, a darker blue a cello; a still darker a thunderous double bass; and the darkest blue of all—an organ.[46]

In 1909, discarding his early marriage at age twenty-six to a cousin, Kandinsky and Gabriele Münter, his mistress since 1902, moved to southern Bavaria where he worked part-time and part-time in Munich. Kandinsky's desire to eliminate realistic subject matter revolved around his wanting the colors, lines and shapes to be free from the objects so that the colors, lines and shapes would form a visual language much like the language of music. In other words, Kandinsky cared what the colors meant and how they resembled a certain sound, taste, smell, touch or emotion. He wanted to free his work from any reference to an object so it could express pure sensation, much as music expresses without

any words. Of course, analogies between music and painting have existed before Kandinsky. The Cubists by 1909 had codified colors, lines and shapes. During this time all the influential facets came together and his personal style emerged as purely abstract painting. Although not the founder of abstract art, Kandinsky ranks among the first of the pioneers.[47]

During Kandinsky's Munich period he divided his paintings into three categories: "Impressions," which show some representation; "Improvisations," which include spontaneous emotional reactions; and "Compositions," the ultimate works of art after much preparation.[48]

In 1909, Kandinsky helped found the New Artists' Association of Munich (Neue Künstlervereinigung) as a revolt against the Munich Secession from which the Expressionist movement originated. The association's doctrine, which could have been written by Kandinsky, stated:

> We start out from the idea that the artist, over and above the impressions he receives from the external world, from Nature, also at all times experiences the tumultuous activity of his inner world...the search for forms free of all superfluity and capable of expressing the essential, the hope for an artistic synthesis, that is our watchword, which commands the support of a growing number of artists....[49]

The president of the New Artists' Association in a memo to all members requested that all entries for an exhibition should be "as comprehensible as possible." Kandinsky recognized the thinly veiled attack on his work and sent a large abstract, Composition V, which resulted in a great conflict.[50]

When he was rejected from the exhibition of the New Artists' Association, Kandinsky and Franz Marc, the German painter, broke away and formed an important modern art association Der Blaue Reiter (The Blue Rider), so named because Marc liked horses, Kandinsky liked to ride horses, and they both liked blue. The sky-blue rider "represented a departure towards a destination, energy directed towards an end."[51]

The Blue Riders believed in the birth of a new spiritual epoch and published Der Blaue Reiter with fourteen major articles in which they reproduced art from all ages because of its spiritual rendering. Kandinsky contributed to the almanac

with his concept of "inner necessity" which he revised in 1912 to become *On the Spiritual in Art, Especially in Painting.*[52]

Kandinsky became friends with the artist-composer, Arnold Schoenberg (born in Vienna, 1874, died in Los Angeles, 1951), who exhibited his art with the Blue Riders. Kandinsky in 1911 attended a concert and heard Schoenberg 's music, a new method of composition consisting of a row, or series, of twelve tones called atonality. Later, in 1913, the Chicago Symphony Orchestra performed five short pieces by Schoenberg and reactions included ridicule. This music opened up unexplored fields of expression that threatened to undermine the traditional major-minor tonal system.[53]

Schoenberg stated, "Every combination of notes, every advance is possible, but I am beginning to feel that there are also definite rules and conditions which incline me to the use of this or that dissonance." In other words, Schoenberg realized freedom can never be absolute. Even a genius had boundaries but each age must enlarge these boundaries.[54]

During this time, Kandinsky elaborated on a theory of abstract art using color and form to reject materialism in favor of an abstract concept of spirituality founded in metaphor. In his desire to help others understand this creative process and "to raise art to a metaphysical dimension," he wrote *The Art of Spiritual Harmony*. He divided it into two sections: "Part I. About General Aesthetic" and "Part II. About Painting." His writings stressed a departure from the objective world to a place he called the artist's "inner necessity."[55]

In Part I, the introduction stated:

> Every work of art is the child of its age and, in many cases, the mother of our emotions. It follows that each period of culture produces an art of its own which can never be repeated. Efforts to revive the art-principles of the past will at best produce an art that is still-born.

He added that when a similarity of inner feeling of any period relates to another period, a revival of the external forms will appear, expressing the inner feelings of the earlier age. That inner spark has been awakening from materialism. Now that the external form has no future, the inner form awakening subtle emotions holds the future with those artists possessing "a secret power of vision."[56]

The second chapter of Part I dealt with the "life of the spirit" as represented by a horizontally divided triangle of unequal parts. Its upper segment is the narrowest part, the lower segment the widest. Each segment contains artists; often the one person standing at the uppermost, narrowest segment is the one regarded as eccentric, the one who can see beyond the limits of the triangle. In the lower segment reside more artists who understand each other and supply each other with spiritual food. In time, those in the broader, lower segment will stretch their hands to drag upward those who strive upward. Yet, with all the chaos, the entire spiritual triangle moves slowly upwards.[57]

The third chapter, in Part I states:

> When religion, science and morality are shaken, the two last by the strong hand of Nietzsche, and when the outer supports threaten to fall, man turns his gaze from the externals in on to himself. Literature, music and art are the first and most sensitive spheres in which this spiritual revolution makes itself felt....the various arts of today learn from each other and often resemble each other.[58]

In a succeeding chapter Kandinsky briefly wrote on the spiritual development of all the arts as they draw together. Music has devoted itself to the expression of the artist's soul. A painter must envy the musician as he expresses his inner life in musical sound. A painter attempts to apply music to his painting to find "rhythm in painting, for mathematical, abstract construction, for repeated notes of colour, for setting colour in motion."[59]

In Part II, Kandinsky wrote briefly of "The Psychological Working of Colour." Many colors splashed over a palette produce a physical impression which becomes the beginning of related sensations that produce spiritual vibrations. Kandinsky again used music to illustrate his ideas because the music spoke to the senses and directly to the soul.[60] He declared:

> Color is the keyboard, the eyes are the hammers, the soul is the piano with many strings. The artist is the hand which plays, touching one key or another, to cause vibrations in the soul.... *It is evident therefore that colour harmony must rest only on a corresponding vibration in the human soul; and this is one of the guiding principles of the inner need.*[61]

The most extensive subject addressed by Kandinsky surfaced in Part II with "The Language of Form and Colour." Form stands alone as a representation of the object or as an abstraction and has the power of "inner suggestion." As to form, Kandinsky stated:

> One of the first steps in the turning away from material objects into the realm of the abstract was, to use the technical artistic term, the rejection of the third dimension, that is to say, the attempt to keep a picture on a single plane.[62]

Color does not stand alone and can't function without boundaries. A color must have a definite shade and its neighboring color lends an additional effect. Kandinsky believed that to study color is to know of its effect on man. Colors are warm and cold and light and dark with all their interplaying combinations. He emphasized the expressiveness of color: yellow to the aggressive trumpet sound, almost disturbing; red, powerful; blue, to the pipe organ; gray, immovable; green, spiritual movement.[63]

To combine color and form the artist must select forms and color suited to each other. He advised:

> Keen colours are well suited by sharp forms (e.g., a yellow triangle), and soft, deep colours by round forms (e.g., a blue circle)...an unsuitable combination of form and colour is not necessarily discordant, but may, with manipulation, show the way to fresh possibilities of harmony.[64]

Kandinsky continued his thoughts about form and color with a discussion on all colors, including black as dead silence and white as nothingness awaiting birth.[65]

Next Kandinsky discussed theory: "There are no basic principles nor firm rules in painting, or that a search for them leads inevitable to academism....That art is above nature is no new discovery...appeals less to the eye and more to the soul."[66]

The last chapter in Kandinsky's book was titled "Art and Artists." He stated:

The work of art is born of the artist in a mysterious and secret way. From him it gains life and being....The artist is not born to a life of pleasure. He must not live idle; he has a hard work to perform, and one which often proves a cross to be borne. He must realize that his every deed, feeling, and thought are raw but sure material from which his work is to arise, that he is free in art but not in life.[67]

Kandinsky concluded, "We are fast approaching the time of reasoned and conscious composition, when the painter will be proud to declare his work constructive.... this new spirit is going hand in hand with the spirit of thought towards an epoch of great spiritual leaders."[68]

By 1910, Kandinsky had divorced his wife and after publishing *Concerning the Spiritual in Art*, he separated from Münter and moved to Russia. With the beginning of World War I in 1914, the Russian government received avant-garde artists enthusiastically and Kandinsky's work abandoned its earlier spontaneous, lyrical style in favor of a more hard-edged form with biomorphic and geometrical approaches.[69]

In 1917, Kandinsky married a younger woman, Nina Andreevskaya, which resulted in a successful marriage. In Moscow Kandinsky thrived as an influential professor, author, and creator of the Institute of Artistic Culture, and organized twenty-two museums in the Soviet Union. By 1921, avant-garde art became "bourgeois," a criminal offense, and fell into disfavor with the Soviet government, prompting Kandinsky's move to Berlin where he taught at *Das Staatliche Bauhaus Weimar*. The school of design's name derived from the German *bau*, meaning structure. It started in 1919 to revolutionize the teaching of painting, sculpture, industrial arts and architecture by eliminating the gap between the artist and the technically expert craftsman so that each could flourish. Its basic course listed experience, perception and ability as its principles. Kandinsky lectured on form and color while his artistic direction evolved into a "geometric abstraction of points, bundles of lines, circle and triangles."[70]

The Germans, in 1933, forced the *Bauhaus*, as a reputed center of communist intelligentsia, to close and Kandinsky went into exile in Paris. The visual language he had "spoken" since 1910 now turned into "collections of signs that look almost–decipherable messages written in pictographs and hieroglyphs;

many of the signs resemble aquatic larvae, and now and then there is a figurative hand or a lunar human face."[71]

Kandinsky documented his artistic development in his oil paintings, watercolors, woodcuts, drawings, glass paintings, sculpture and furniture— up to his departure toward abstraction in 1914 and his leaving Munich. His detailed records and theoretical reflections give an overview of his development. He developed an awareness of his artistic life and often offered his reflections in texts. His classification of his own development: his childhood and youth of uncertainty, painful emotions, and incomprehensible longing; a time after schooling in which emotions took form; a time of conscious application of the materials relating to painting which progressed to abstract painting. Each phase built on the previous phase as he observed:

> Objects did not want to, and were not to, disappear altogether from my pictures.... It is impossible to conjure up maturity artificially at any particular time. And nothing is more damaging and more sinful than to seek one's forms by force. One's inner impulse, i.e., the creating spirit, will inexorably create at the right moment the form it finds necessary. One can philosophize about form, it can be analyzed, even calculated. It must, however, enter into the work of art on its own accord, and moreover, at that level of completeness which corresponds to the development of the creative spirit. Thus, I was obliged to wait patiently for the hour that would lead my hand to create abstract form.[72]

Kandinsky's remarkable patience in waiting for his destiny as an artist and author derived from his response to his own spirit, his love of color and his visionary powers. In his writing he attempted to parallel the rules for painting with the rules involved in music but conceded that no inflexible art theory is possible. Yet the value of his writing resides in being a secondary response to his painting as he attempted to free himself from nature.[73]

Kandinsky died December 13, 1944, in Paris. Whether Kandinsky was the first person to paint non-objectively remains subject to debate. He could easily be called a discoverer because he made known something previously unknown. His importance lies in his complete dedication from age thirty to ridding the artistic world of external appearances to discover an essence.[74]

9

INFLUENTIAL FRIENDS

"They are at your mercy, do as you please with them."
—Georgia O'Keeffe

During the summer with Alon Bement in Charlottesville, while she was reading Eddy and Kandinsky, an event occurred halfway across the world on June 28, 1914. Gavrilo Princip, a nineteen-year-old, romantically courting immortality as a Serb nationalist by advocating socialism, jumped on the running board of the royal touring car and shot the Austrian archduke Franz Ferdinand, heir to the throne of the Austro-Hungarian Empire. This one act was the defining moment that sparked declarations of war amongst the Eastern Europe countries with their many overlapping alliances. The assassination of the then suzerain or overlord must have brought back Georgia's memories of her Hungarian grandfather who participated in the Hungarian Revolution led by Louis Kossuth, declaring Hungary's independence from the Austrian Hapsburg rule. His decision to live in America eventually changed and he left Sun Prairie for Hungary, never to return. Georgia noted that a war that would place a generation of Europe's best in the trenches never really solved anything. To Georgia, history simply repeated itself.[1]

Arthur Jerome Eddy wrote in the second edition of *New Competition*, published in 1914, six months before Europe began to experience war:

> For a time the nations are content within their borders... Suddenly there comes a change, due, perhaps, to some great invention or discovery, or perhaps, to the restless personality of some mighty leader, who reflects the spirit of his times. The period of intense development is at an end; as if moved by one impulse the nations embark on a period of conquest, of discovery, of colonization; a period wherein local barriers are annihilated and countries come together in one grand clash, one supreme struggle either on the field of battle or in the more bloodless but none the less fierce rivalry for commercial and industrial victories.
>
> The world has gone mad over trade and the problems of trade. Financiers and diplomats exhaust their energies trying to devise new schemes, new treaties, new tariffs whereby one nation can sell the world more than it buys, whereby the "balance of trade" can be turned hither and thither at the will of man—this is the era of "dollar diplomacy."[2]

In the midst of these turbulent years Georgia met two people who would influence her life: Arthur Whittier Macmahon, who would influence her decision to place art in the forefront of her life and Anita Pollitzer, who would put Georgia's art in the forefront for Stieglitz to discover.

In June 1914, twenty-seven-year-old Georgia met a fellow teacher at the University of Virginia, Arthur Macmahon, a Brooklynite. His birth, three years after Georgia's, added to a family of clergy and academics who cherished their free-thinking. His education as a political scholar at Columbia University in New York City entitled him to membership in Phi Beta Kappa. Macmahohn, who could easily be called extremely handsome with his clean-cut appearance, benefitted from his roommate, Randolph Bourne's, progressive political philosophy, which included pacifism.[3]

Randolph Silliman Bourne, born in 1886 in Bloomfield, New Jersey, graduated from Columbia University in 1912. As a critic of the American way of life he became a spokesman for his generation. He opposed the United States entering World War I and made his pacifist and noninterventionist views known in his articles.[4]

Georgia admired Macmahon's friendship with Bourne and suspected that Bourne's ideas originated with Macmahon.[5] Perhaps the beginning of Georgia's pacifist views began with this assimilation of Macmahon and Bourne's pacifism.

Georgia noted that Arthur possessed a delightful way of saying things, avoided slushy feelings, and did not take offense when Georgia boldly wrote to him first. She put herself at risk of rejection by placing her needs beyond society's control. Her unconventional actions stayed with her the remainder of her life.[6]

Georgia's attempt to balance herself with falling in love or not falling in love heightened her emotions and led her to declare, "I want to love as hard as I can and I can't let myself." Georgia and Arthur's relationship escalated to the point where Georgia decided serious art and social life were competing directly for her time. As she would throughout her life, Georgia chose work as the central theme of her life.[7]

Still building on her teaching credentials, Georgia enrolled in the School of Practical Arts at Teachers College, Columbia University in New York City in the fall of 1914. Here she met Anita Pollitzer, a twenty-year-old woman who came from a privileged Jewish community in Charleston, South Carolina.[8] Pollitzer was described by her nephew, William S. Pollitzer:

> I can see her now, small in stature, big in brains and spirit, a whirlwind of energy, brushing her dark hair from her face. Sometimes hasty and domineering, yet always kindhearted, Anita was easily moved by beauty everywhere, in a painting or in nature; and she was deeply touched by sadness or injustice in the lives of others. Somehow she was always a patrician and yet a democrat.[9]

On June 10, 1915, from Charleston, South Carolina, Anita Pollitzer instigated a correspondence with Georgia:

> Dear Miss O'Keeffe, I feel just like writing to you.... I've got lots to tell you.... I had a brilliant idea—I went to the Photo Secession and asked Mr. S [Alfred Stieglitz] to show me some old numbers of Camera Work— He said "why?"—I said "I want to buy one"—He said—"Let me pick out the

most wonderful one we have"—and it was an old Rodin number—the most exquisite thing you can possibly imagine—Oh I wish you might see it. It has four fine Steichen photographs in the front & then marvelous color reproductions of about 8 or 9 of Rodins colored drawings—Magnificent nudes with color touched in—So I bought it—It was three dollars but worth a million—I didn't know they sold back numbers for what ever price they wanted to, did you?... I hope I can show it to you next year.... Do you know yet if youre going to Texas? But you never know do you ahead of time.[10]

Georgia replied to Anita's letter that same June from Charlottesville:

Dear litttle Pollitzer—Don't you like little spelled with three t's—but you are little you know and I like you little but I also like you a lot.

I can't begin to tell you how much I enjoyed your letter—write me another—won't you? I'm sure the Camera Work was great—why don't you lend me yours for a few days. I"ll be very good to it.

I sent you the things I have done that would roll—I have painted three portraits...tell me do you like my music—didn't make it to music—it is just my own tune—tis something I wanted very much to tell someone—and what I wanted to express has a feeling like wonderful music gives me...[11]

With these reciprocal letters an intense correspondence began between Georgia and Anita that lasted until sometime in 1919 and continued intermittently until 1968. These two first letters introduced Georgia to *Camera Work* and *291* magazines.

Georgia wrote Anita, July 1915, from Charlottesville:

So far the events of the summer have been weekend camping trips and long walks and a very good friend—an interesting person is always a great event to me—the good friend is professor of Political Science here and at Columbia—and he is even very much interested in new art—A great find really—[12]

In August 1915, Georgia again wrote Anita:

> The professor [Arthur Macmahon] was very much interested in Feminism—that was why I read it [Floyd Dell's *Women as World Builders*]— and I have been slaving on war books trying to catch up with some of the things he started me on....We had a great time—I have almost a mania for walking and he did too so we just tramped—and tramped and tramped. He gave me so many new things to think about and we never fussed and never got slushy so I had a beautiful time and guess he did too—He stayed over four days after School was over just for some extra walks—[13]

Two years before, in 1913, Floyd Dell had written *Women as World Builders, Studies in Modern Feminism*. Dell declared that the feminist movement could be considered in two ways: as a sociological abstraction, or as insight into the individual women who are acting. He chose to write about the individuals: Charlotte Perkins Gilman, Jane Addams, Emmeline Pankhurst, Olive Schreiner, Isadora Duncan, Beatrice Webb, Emma Goldman, Margaret Dreier Robins and Ellen Key. Among these ten Dell thought the soul of modern feminism could be found.[14]

Dell believed that to address the changes of any social status amounted to not adjusting to feminism but adjusting to common sense, that the concern remained about woman as producer rather than lover. The woman who focused not on love but on her work would discover her love.

In September, 1915, Georgia wrote Anita from Charlottesville:

> I have been reading a book of essays–"Life and Youth" [*Youth and Life*] by Randolph Bourne—...he wrote them for the Atlantic Monthly during his senior year in college—He is a cripple—they [Bourne and Macmahon] had traveled in Europe together of some time last summer so the essays were interesting to me because he sent them to me—and I think friends like that thrash things out together till they are some what alike.[15]

Bourne in *Youth and Life*, published in 1913, discusses youth from the perspective of two generations, virtues and the seasons of life, irony, friendship, the

adventure of life, religion, mysticism, seeing, experimental life, dodging pressures, radicals, college life and in a last chapter, the philosophy of the handicap.[16]

Twenty-eight-year-old Georgia would have read of Bourne's writing on youth:

> Youth, the time of contradictions and anomalies... it clearly is: a great, rich rush and flood of energy... We are still on probation... A virtuous life should be responsive to its power and its opportunities, a life not of inhibitions, but of a straining up to the limit of its strengths.[17]

An ironist, according to Bourne, is born, not made. "This critical attitude towards life, this delicious sense of contrasts that we call irony, is not a pose or an amusement. It is something that colors every idea and every feeling of the man who is so happy as to be endowed with it." On friendship, which Bourne deems necessary to his being, he states that the difference in his friends is their response to him. "The adventure of life is always fraught with real peril, but it is peril which gives us the sense of adventure."[18]

On religion, Bourne stated:

> If we accept whole-heartedly the spiritual world, we seem to be false to the imposing new knowledge of science which is rapidly making the world comprehensible to us; if we accept all the claims and implications of science we seem to trample on our souls. Yet we feel instinctively the validity of both aspects of the world. Our solution will seem to be, then to be content with remaining something less than monists....The only view of religion and science that will satisfy us is one that makes them each the contemplation of a different aspect of the universe, —one, an aspect of quantities and relations, the other, an aspect of qualities, ideals, and values.... Scientific and intuitive knowledge are simply different ways of appreciating an infinite universe.[19]

Seeing was discussed as not lingering on the past, but on the present. Bourne added that "Life works in a series of surprises. One's powers are given in order that one may be alert and ready, resourceful and keen. The interest

of life lies largely in its adventurousness, and not in its susceptibility to orderly mapping."[20]

Georgia probably read Bourne's chapter, "The Dodging of Pressures," with particular interest as he stated: "For a truly sincere life one talent is needed, —the ability to steer clear of the forces that would warp and conventionalize and harden the personality and its own free choices and bents." Bourne said that youth ask about radicalness, "What is to be done?" and "What must I do?" and he answered, "It would be good for them to know that they cannot hope to accomplish very much in radiating their ideals without the skill and personality which gives impetus to that radiation." Bourne then said of college life that the student comes to college to learn from men, not from books.[21]

Bourne's final chapter dealt with "A Philosophy of Handicap." As a crippled person, he wrote:

> The doors of the handicapped man are always locked and the key is on the outside.
>
> The world of youth is a world of so many conventions, and the abnormal in any direction is so glaringly...abnormal.... For I was older, and I had acquired a lively interest in all the social politics; I would get so interested in watching how people behaved, and in sizing them up, that only at rare intervals would I remember that I was really having no hand in the game.[22]

Bourne's *Youth and Life* called for self-expression and the virtues of experimental living.

In the Fall of 1915, Georgia moved to Columbia, South Carolina, to teach art at Columbia College.

In February 1854, representatives of the South Carolina Methodist Conference established Columbia Female College in Columbia, South Carolina. Such a vote constituted a bold action because the education of females remained controversial. A year before, in 1853, the Phi Beta Kappas were told, "The best diploma for a woman is a large family and a happy husband." Simultaneously the *Southern Christian Advocate* stated, "the yoke matrimonial sits heavily upon those between whom there exists a marked intellectual disparity." The college opened its doors on Plain Street (now Hampton Street) in downtown Columbia in 1859,

with one hundred eighty-eight students and sixteen faculty members. Courses for a diploma included the basics and for an additional fee students could enroll in music, drawing and painting classes. The college grew until 1865, when General Sherman's troops marched on Columbia. The school escaped torching because a professor heard that all unoccupied buildings would be burned and stood in the college doorway to notify Sherman's troops of the occupied building. By 1873, the college had reopened and by 1880 the tuition was $100 per year. The students' dress requirements: black during the winter, plain white muslin during the spring and summer and white or colors during night exhibitions and other occasions (unless in mourning). An 1895 fire damaged the college but didn't destroy the facilities. The college moved to its present site in 1904 when F. H. Hyatt gave land and in 1905 the word "Female" was dropped from its name.[23]

Another fire in 1909 forced the college to operate from its former downtown location until the North Columbia site could be reworked. In 1910 the college operated at its present site on Columbia College Drive. In 1964 a third fire destroyed "Old Main" and its columns, the only things remaining after the fire, became the symbol of Columbia College's strength and endurance.[24]

From Columbia Georgia wrote Anita in September 1915:

It is going to take such a tremendous effort to keep from stagnating down here that I don't know whether I am going to be equal to it or not. I have been painting a lot of canvases and boards white—getting read for work—I think I am going to have lots of time to work but bless you—Anita—one can't work with nothing to express. I never felt such a vacancy in my life—Everything is so mediocre—I don't dislike it—I don't like it—It is existing—not living—and absolutely—I just wish some one would take hold of me and shake me out of my wits—I feel that insanity might be a luxury. All the people I've meet are all right to exist with—and it is awful when you are in the habit of living.

I'll be better for having told you and tomorrow can get out and take a long walk—that will probably help—[25]

Anita, who had been doing some work for suffrage, responded to Georgia's predicament: "You can do both right where you are in Colombia if you buckle down—& grit your teeth and bear it Pat—"[26]

Bement's advice to Georgia to read Kandinsky's *Concerning the Spiritual in Art* must have been slow, difficult reading because she wrote from Charlottesville in September 1915: "Kandinsky is reading much better this time than last time too."[27]

From Columbia, in October 1915, Georgia wrote Anita:

> With an abundance of time on my hands—and little inclination to work when every thing felt so mixed up—and some very nice letters from Arthur [Macmahon]—I got rather out of gear. He is the sort of person who seems to say nice things in the very nicest way they could be said—and Anita—I found I was just going on like a fool—and—was nearer being in love with him than I wanted to be—It was disgusting—simply because I hadn't anything else to work off my energy on—to think that I would be liking anyone more than usual—simply because I had nothing else that demanded my attention—I felt that I was insulting him.
>
> I know it was only a notion—but it made me furious with myself—I know I like him very much—and he likes me as much—I think—or Id not like him—Im sure—but there is no earthly reason why I should let him trail around in my mind like he was trailing.
>
> So—I thank you and Dorothy for giving me a jolt that started me at work—Maybe you can understand better—now—how *much* I thank you.[28]

In October 1915, Georgia, as a mature artist, started working and charted a new course for her art. The long-term process of career development that began in childhood with its many influences extended forward with her learning and seasoning years, and ended by her own choosing.

Georgia's accumulated knowledge, which equaled power, arrived from many sources: Sarah Haner Mann in Sun Prairie, Sister Angelique at Sacred Heart Academy in Madison, Elizabeth Mae Willis at Chatham Episcopal Institute, John Vanderpoel at the Art Institute of Chicago, William Merritt Chase, Kenyon Cox and F. Luis Mora at the Art Students League, Alon Bement, Arthur Wesley Dow, Wassily Kandinsky and Arthur Jerome Eddy.

Georgia's reading advanced her long artistic journey with Kandinsky's theories. She applied her love of music, which had remained constant from her

early life when she learned to play the violin and wrote about her violin playing to Anita, in October, 1915:

> I've labored on the violin till all my fingers are sore—you never in your wildest dreams imagined anything worse than the noises I get out of it—That was before supper Now I imagine I could tell about the sky tonight if I could only get the noises I want to out of it.[29]

That same year Georgia further wrote to Anita of her love of music:

> You asked me about music—I like it better than anything in the world—Color gives me the same thrill once in a long long time—I can almost remember and count the times—it is usually just the outdoors of the flowers—or a person—sometimes a story—or something that will call a picture to my mind—will affect me like music—
>
> Do you think we can get much of it in art—I don't know—anything about anything— and Anita Im afraid I never will.[30]

Georgia knew of color, which brush worked best for an approach, how much drying time was required, what the colors looked like when wet and dry, and the feel for intensity, luminosity and richness.

The inventory of her aptitudes favored her artistic knowledge. She needed to duplicate what she saw on canvas, and in her own way strip away all the basics of her beloved color. She must have adopted Michelangelo's theory that the painting lives within the canvas and that the painter's task is to free it, rather than create it.

Drawing on her exposure to symbolism, oriental art, Dow and Fenollosa, she employed a guideline of using balance between line, form and color.

Georgia's introduction to line, form and color as related to music started to have importance in her long journey as an artist. Line surfaced as "nothing more than length without thickness and specifies that the boundaries of a line are points and that lines define the boundaries of a surface."[31] A line includes curves where the more sharply it bends, the smaller is the circle, and this can evolve into spirals. Within these lines the form originates. Color added a rhythm not

unlike music which could be free, yet harmonious. These values and influential facts, learned from various sources and her expression of emotion rather than a literal translation provided Georgia a catalyst for her October 1915 series of charcoal drawings of various sizes called *Specials*, which would chart her lifetime course.[32]

Georgia drew these *Specials* from October to December. She used the charred black sticks of wood with a soft drawing edge to favor broad, vigorous diagonal, curved and straight strokes emphasizing mass and movement. The black with all its varying edges echoed simplification as she rejected the usual set formula for painting and her expression created its own unique path.[33]

Throughout art history artists used the charcoal medium for preliminary sketches to quickly record ideas. An assumption could be entertained that in the broad scheme of Georgia's drive to break away from what she had been taught of traditional art, the charcoal drawings were preliminary sketches for what would eventually follow in color.

The *Specials*:

No. 2 Special, charcoal on medium, thick, cream, moderately textured laid paper, 23 5/8 x 18 1/4 in., 1915,

No. 5 Special, charcoal on medium thick, cream, moderately textured laid paper, 24 x 18 1/2 in., 1915,

No. 7 Special, charcoal on medium thick, cream, moderately textured laid paper, 24 x 18 1/2 in., 1915,

No. 3 Special, charcoal on medium thick, cream, moderately textured laid paper, 24 x 18 1/2 in., 1915,

No. 4 Special, charcoal on medium thick, cream, moderately textured laid paper, 24 1/4 x 18 1/2 in., 1915,

Early Abstraction, charcoal on medium thick, cream, moderately textured laid paper, 23 3/4 x 18 3/8 in., 1915,

Early No. 2, charcoal on medium thick, light blue, moderately textured laid paper, 23 3/4 x 18 5/8 in., 1915,

No. 12 Special, charcoal on medium thick, cream, moderately textured laid paper, 24 1/8 x 18 1/2 in., 1915,

No. 20 From Music - Special, charcoal on medium thick, cream moderately textured laid paper, 13 1/2 x 11 in., 1915,

No. 9 Special, charcoal on moderately thick, cream, slight textured laid paper, 25 x 19 in., 1915,

Untitled, charcoal on medium, thick, cream, moderately textured laid paper, 24 1/4 x 18 3/4 in., 1915,

Second, Out of my Head, charcoal on medium thick, cream, moderately textured laid paper, 24 x 18 1/2 in., 1915.[34]

These *Specials* were quite abstract for their time in American art and were simple compared to the urban art scene. Most originated from Georgia's yearning for isolation, her efforts to express what she felt at the time, and her longing for nearness to nature. She drew their playful gray lines with detailed shading to suggest nature's space with an unbounded light. *Special No. 2* depicted a shiny black egg riding in a symmetrical fountain of water. *Special No. 4* and *Special No. 5* showed rhythmic vertical forms suggesting liquid sounds. *Special No. 9* expressed writhing waves erupting from the lower edge while soft, dripping forms fell into softness; like wind, fire and rain similar to Texas weather extremes.[35]

Georgia, who early in her career did not consider herself a female artist or even a regional artist, sent Anita some of the black and white charcoal drawings that she produced from her newly charted course of drawing what she felt rather than what she saw. To Georgia, these drawings dealt with visual issues that transcended gender and geography. With Georgia's innate sense of her direction, it is not unimaginable that she sensed what Anita would do with her drawings. She had planted the seed when she wrote that she'd rather Stieglitz see them than anyone else. She instructed Anita, "They are at your mercy, do as you please with them."[36]

Georgia wrote Anita in November 1915 from Columbia:

If I told you that I am so glad about something that Im almost afraid Im going to die—I wonder if you could imagine how glad I am. I just cant imagine anyone being any more pleased and still able to live.

Arthur is coming down to spend Thanksgiving with me—His letter this afternoon was like a thunderbolt out of a clear sky—nothing could have astonished me more—and Anita—even yet—I can scarcely believe it—

Do you really suppose its true! He even tells me the train he is coming on so it must be. That's all I can write tonight. Love Pat[37]

Georgia wrote in November 1915 from Columbia:

He has been here and has gone. What can I say about it —I don't seem to have anything to say—We had a wonderful time—and Anita—today I feel stunned—I don't seem to be able to collect my wits—and the world looks all new to me. He couldn't get off till Thanksgiving day so didn't get here 'till Friday morning—and left last night—Monday—.

This is the best picture I have of him—we spent about an hour—up on a mountain top unraveling rope and fixing things to take ourselves—last summer. We took some more time—when he sends them to me if they are any good I will send them to you to look at—I want this back—you know—it isn't good of me and you don't care about keeping him. "I don't mean that I feel depressed over his being gone.[38]

Georgia wrote Anita, December 4, 1915, from Columbia, South Carolina:

I want to tell you about Arthur and still I want to keep it to myself...

He has the nicest way of saying things—and making you feel that he loves you—all the way round—not just in spots

Anita—we have made the greatest plans you ever heard of—We will be both out of school the end of May—and have planned to go to the Carolina Mountains—...He is going to have his mother and brother down and take a cottage—...and maybe we will have some other people—We talked up some great things—it seems too much to come true—when ever we talked about it we always said particularly that we were only talking—not planning—because if we didn't really plan we wouldn't be so disappointed if it didn't happen.

But Anita it is all air castles—...I never plan you know, Anita—he laughs about it.[39]

Georgia wrote again in December 1915 to Anita:

Anita—I was very happy when he left—just because he makes me happy—then for several days I was miserable—no not exactly that—only I had such a hard time making myself think right about it. It is alright now 'though and I feel as if I will never get mixed up again.[40]

Anita wrote Georgia from New York City, January 1, 1916:

Astounded and awfully happy were my feelings today when I opened the batch of drawings. I tell you I felt them!...Then I flew down to the Empire Theater with them under my arm & saw Maude Adams in Peter Pan—I hope you've seen her & if you haven't I hope you will. Theater was over at 5 and Pat—I had to do, I'm glad I did it, it was the only thing to do—I'd have—well I had to that's all. I walked up to 291...He came in. We spoke. We were feeling alike anyway and I said "Mr. Stieglitz would you like to see what I have under my arm." He said "I would—Come in the back room"—I went with your feelings & your emotions tied up & showed them to a giant of a man who reacted—I unrolled them—I had them all there—...He looked Pat—and thoroughly absorbed & got them—he looked again—the room was quiet—one small light—His hair was mussed—It was a long while before his lips opened—"Finally a woman on paper"—he said.... "Why they're genuinely fine things—you say a woman did these—She's an unusual woman—She's broad minded, She's bigger than most women, but she's got the sensitive emotion—I'd know she was a woman—Look at that line—"...Then Stieglitz said "Are you writing to this girl soon?"—I said "Yes"—"Well tell her," he said "They're the purest, finest sincerest things that have entered 291 in a long while"—and he said— "I wouldn't mind showing them in one of these rooms one bit...thank you, he said—for letting me see them now."

Pat I hold your hand I think you wrote to me once—"I would rather have Stieglitz like something I'd done than anyone else."[41]

Georgia replied to Anita from Columbia on January 4, 1916:

Dear Anita:
There seems to be nothing for me to say except thank you—very calmly and quietly.[42]

On January 14, 1916, Georgia wrote Anita from Columbia, South Carolina:

What am I doing down here—Why Anita—at times Im glad and at times I have a Hell of a time—Id pack my trunk and leave for half a cent—I never was so disgusted with such a lot of people and their ways of doing—I halfway have a new job out in Texas—hope I get—Ill have a cat and a dog and a horse to ride if I want it—and the wind blows like mad—and there is nothing after the last house of town as far as you can see—there is something wonderful about the bigness and the lonelyness and the windyness of it all—mirages people it with all sorts of things at times—sometimes I've seen the most wonderful sunsets over what seemed to be the ocean—It is great—I would like to go today—Next to New York it is the finest thing I know—here I feel like Im in a shoe that doesn't fit. So far I've forgotten it by dreaming I guess—and Im disgusted with dreams now—I want real things—live people to take hold of—to see—and talk to—Music that makes holes in the sky—and Anita—I want to love as hard as I can and I cant let myself—When he is far away I can't feel sure that he wants me to—even though I know it—so Im only feeling luke warm when I want to be hot and cant let myself—It's damnable—but it doesn't matter—so long as its just me—[43]

Anita replied from New York City on January 22, 1916:

You do keep people going. Thats part of why you're you. I move in leaps after your letters. So you may really go—to Texas. Pat I don't know what to think. Distance doesn't matter Pat you know that...but just a minute. to be disappointingly sane and practical. How can you leave Columbia?(SC)—I don't understand.[44]

By February 16, Georgia had not heard about her Canyon position and wrote Anita:

> Its that darned Texas job—Id rather not have it than haggle over it almost.
>
> If I get it—Ill have to give up so many things that I like that I almost hate to think about it.[45]

Georgia wrote a few days later:

> Dear Anita
>
> This afternoon I met a woman who knows one of my sisters and my mother—She knows Arthur too—and something she said—makes me—Oh—just sort of think—that—...Why Anita—I can hardly get it into words—I am no more disappointed in him than in myself—but I seem to have just seen my bubble burst—and don't even mind...[46]

Again in February, Georgia wrote Anita:

> I don't know about Texas yet for sure—we are haggeling and tearing the air about it—I"ll probably know soon—I don't know—I may not go—I really don't care like ought to...I think if they decide that they want me in spite of my short comings—They asked to apply for it you know—I think now it is very probable that I will not go till June if I go at all—and I am thinking I will just pick up and leave here—if I find I am going to desert in June—I don't know—I really have no plans beyond today.[47]

Georgia exclaimed to Anita on a Sunday night:

> Texas—we are still jawing at one another. It all riles me up till I feel that I simply must do something rash. Now he wants to know if I will go up and take Pa Dows class in Methods next summer if I am elected to go to Texas in September. Well—I told him I would go right now—so I may be up. I seem to be hunting madly for an excuse to leave here.

I was going to ask if you thought Pa Dow would let me enter his Methods class now—but it is a useless question—Ill just write and ask him. I imagine it would come about as near killing me as this place does—Anita—I seem to be a misfit—But it doesn't matter—I don't care

I am about out of the notion to go to Texas now—[48]

In February 1916, Georgia received word in Columbia, South Carolina, that she had secured a position in charge of the art department at West Texas State Normal College, "A Training School for Public School Teachers" (WTSNC) in Canyon, Texas. It was situated some fifteen miles south of Georgia's first teaching position in Amarillo. The college, known today as West Texas A&M University (WTAMU), became the first state college in the western part of Texas. The campus included the largest college building in the state and its enrollment was just under three hundred. Exhilarated with optimism, Georgia wrote Anita of her new adventure.[49]

Kick up your heels in the air! Im elected to go to Texas and will probably be up next week. I am Two hundred dollars short of what I need to finance me through the time I want to spend in N.Y. but if I can't scratch around and chase it up somewhere I'll go without it—because I'm going. Im chasing it—hunting for it at a great rate—

I just had a tellagram from the man this morning telling me my election is certain but he wants me to go to T. C. For this term as I understand it—...the place is certain...and I like the condition better than the place—

My head is about to pop open so guess I'll not write any more.

Isn't it exciting!

I can't believe it will come true

Can you?[50]

The college had requested that Georgia take the Arthur Dow course in teaching methods in New York. Georgia asked Olive Denman to take over her teaching responsibilities at Columbia Teachers College. In March 1916, Georgia accepted the teaching position for the fall term at WTSNC in Randall County.[51]

Georgia wrote Anita, February 1916:

> I heard from Pa Dow—he will let us in his Methods class for the rest of the year so—if the letter I am expecting warrents my doing so—I'll go up this week—I don't blame you for not believeing it—I don't believe it myself—but I know it—and that is better—Its great to be a fool—it makes me laugh that I should have to come to this half dead place—to get such luck with my drawings—and at the same time—run down the position I would rather have than most any I know of—I am crazy about living out there in Texas you know.[52]

In her mid-twenty-ninth year Georgia returned as a student to attend the Dow course at Columbia College in New York. She lived at 51 East Sixtieth Street with relatives of Anita Pollitzer.[53]

On May 1, 1916, Georgia learned that her mother, Ida, in meager surroundings, died of a lung hemorrhage. Her mother's death and burial in Forest Lawn Cemetery in Madison shocked all the children, and afterwards, as is true of so many families, when the mother is gone, the family no longer stays together. Each child began going his or her separate ways.[54]

Although Georgia vividly remembered the colored quilt when she was two years old, perhaps, in addition to the colors, she remembered the security stemming from her mother's desire to give Georgia a voice.

Ida, probably possessed, like so many mothers, insight into the heart of her child. When Ida read the tales of the West to Georgia as an infant, she planted the seed for the ability to achieve. Maybe Ida wanted Georgia and her children to be her wings, to fly with the opportunities she had longed for and been denied. Ida treated the birth of each child with unhurried support, not intervention.

In that same May, Stieglitz included some of Georgia's charcoal drawings in a group show at his 291 gallery. From May 23 to July 5, 1916, Stieglitz executed at 291 an "Exhibition of Drawings by Georgia O'Keeffe, of Virginia; Water-Colors and Drawings, by C. Duncan, of New York; and Oils, by Réné Lafferty, of Philadelphia."[55]

With an arranged trip to New York upon hearing of the exhibition of her drawings, she demanded that he take them down. Georgia relented when Stieglitz

pointed out to her that they illustrated the thrust of the woman artist going her own way. Not only did they agree on her art, but they began writing to each other and the letters filled a void within each.

Georgia, in the early summer after her mother's death in 1916, began working in color by executing:

> *First Drawing of the Blue Lines*, charcoal on moderately thick, cream, slightly textured laid paper, 24 3/4 x 18 7/8 in., 1916,
>
> *Black Lines*, watercolor on medium thick, cream, moderately textured laid paper, 24 1/2 x 18 1/2 in., 1916,
>
> *Blue Lines*, watercolor and graphite on moderately thick, cream, slightly textured laid paper, 25 x 19 in., 1916.[56]

The series of *Blue Lines* used Dow's technique of Japanese brush and ink, almost like calligraphy. These expressive lines would resurface from time to time in her art as she interpreted natural forms into abstract forms in paintings of roads and rivers.[57]

Pollitzer wrote of Georgia and Stieglitz, "[Your're] two independent on each other yet perfectly separate individual lines of fine dark blue [refering to the *Blue Lines* watercolor]." Probably still not satisfied that her career might be in teaching, however, Georgia traveled to Charlottesville to again teach with Bement. Her classes, held from 8:30 a.m. to 10:30 a.m., gave her plenty of time to rest, read and work.[58]

Georgia did not plan to return to Charlottesville for the next semester because "I can make 150 more in Texas and car fare mounts to 100—so it doesn't seem practical." When Georgia left Charlottesville she recommended Anita for her position, which she would eventually accept.[59]

With Georgia's feelings about Arthur Macmahon subsiding and her feelings toward Steiglitz intensifying, Georgia wrote Anita on a Wednesday in July 1916:

> Stieglitz asked about you—I think I never had more wonderful letters than he has been writing me—and isnt it funny that I have you to thank— Yesterday—no day before—he told me he had taken my things down and that the place is empty.

But his letters Anita—they have been like fine cold water when you are terribly thirsty.

I would like you to read them but some way or other—they seem to be just mine."[60]

Just before leaving Virginia to resume her teaching career in Canyon in late August 1916, Georgia sent Stieglitz more of her art. This action, combined with Pollitzer's actions, a disinterest in Macmahon, and Stieglitz's favorable reaction, charted Georgia's course forever.

THE RETURN TO TEXAS PLAINS AND SKY

"It seems so funny, that a week ago it was the mountains I thought the most wonderful—today it's the plains—I guess it's the feeling of bigness in both that carries me away."

—Georgia O'Keeffe

Georgia's going in 1916 to Canyon in the Texas Panhandle didn't resemble her 1912 trip when she first encountered an unknown Amarillo. That earlier, singular discovery, perhaps in search of an enchantment, put in motion a series of discoveries leading to Georgia's recognition of the West as a place she wanted to be. She sensed what other discoverers had experienced, that discoveries need to be followed through. She knew what she wanted to do with her discovery.

Canyon, a land of low esteem in the Great American Desert, played its part in America's development as the connecting link between the Mississippi River and the Rocky Mountains. While Georgia's move to the West demonstrated her emotional and economic independence, others ventured further west than Canyon to the rugged mesas and mountains of New Mexico. These pioneers accepted their time in New Mexico as the gift of a muse, one that Georgia would eventually discover and develop.

In March 1916, Alice Corbin Henderson (1881–1949), a modernist writer, arrived in Santa Fe, New Mexico, to join her husband, the artist William Penhallow Henderson. Suffering from tuberculosis, Alice quickly made the connection between the physical and spiritual healing powers of the New Mexico landscape. She compared the city and desert as male and female. In her 1920 poem, "Red Earth," Alice wrote of the city as "strident, aggressive, gigantic, and noisy," as man seeking to shape the land to his vision. She wrote of the desert as "ancient, peaceful, and religious, its habitats scaled for survival," as woman recognizing the land could not be mastered. This womanly view appealed to many women as they strove to make their own nondestructive mark on the land with individual terms.[1]

Mabel Ganson Evans Dodge Sterne, the Buffalo, New York, heiress, arrived in New Mexico in December 1917 because she sought, "change" from her Eastern lifestyle. She commented, "My life broke in two right then, and I entered into the second half, a new world that replaced all the ways I had known with others, more strange and terrible and sweet than any I had ever been able to imagine." She described her arrival: "There was no disturbance in the scene, nothing to complicate the forms, no trees or houses, or any detail to confuse one. It was like a simple phrase in music or a single line of poetry, essential and reduced to the barest meaning." Needless to say, Mabel's first impressions included the clarity of the blue sky, the gray-green looming on the Sangre de Cristo Mountains and the high plateau of the Rio Grande, all mingling with the aroma of piñon and uncomplicated by human endeavors.[2]

Years before these twentieth-century women pioneers arrived in the West, young Charles Goodnight with his family headed for Texas in 1845. Goodnight, of German heritage, began his life in 1836 on the family farm in the prairie country near the Macoupin and Madison County lines in Illinois only three days after Texas declared its independence from Mexico on March 2. During Goodnight's early boyhood years, the news of the Republic of Texas spread like a prairie fire. Caught in the migratory craze, Goodnight's family set out for Texas in 1845 with nine-year-old Charles riding a horse bareback the eight hundred miles to Nashville-on-the-Brazos in Milam County, Texas.[3] Passing through Dallas, which consisted of a ferryboat and one log cabin, the wilderness lands hastened his manhood. As a young man, Goodnight acquired hunting and trailing skills, learned how to live in the wilderness, and developed a natural talent as

a Texas cattleman. His keen observation and visionary energy heightened his accomplishments with every outdoor experience. A dislike of urban life and having a roof over his head remained with Goodnight forever.[4]

Eventually Goodnight met up with Oliver Loving, an experienced cowman. When the gold rush to Colorado began, the two men sent a herd through unspoiled, grassy Indian territory and Kansas to the Rocky Mountains mining camps.[5]

As the Indian troubles escalated, Goodnight served as a twenty-four-year-old scout and guide to the Texas Rangers. He guided the Rangers to the Comanche Indian camp for the recapture of Cynthia Ann Parker, the girl stolen to become the wife of a Comanche chief and mother of the famous Quanah Parker.[6]

Goodnight's discovery that his knowledge of the prairies, his expertise at not only finding tracks but knowing how old they were, and his trained ear that human voices echo more than an animal's voice, became talented gifts upon which he acted. A seasoned scout, he spent most of the Civil War chasing marauding Indians. This knowledge of the prairies and the *Llano Estacado* would serve him later.[7]

After the war Goodnight returned to Texas where he tried to salvage his cattle business by hunting a market rather than a home for his cattle. At age thirty, Goodnight and Loving blazed a cattle trail from west of Fort Worth at Fort Belknap, Texas, through New Mexico to Denver, Colorado. The trail later known as the Goodnight-Loving Trail extended into Wyoming. The trail at its height bore only hoof prints in a dusty land, but embodied the spirit of the West's cattle industry. Its romance fueled songs, novels and a few motion pictures.[8]

Goodnight, who became a character in Larry McMurtry's novel, *Streets of Laredo*, bought a government wagon and outfitted the back with a chuck-box with a hinged lid that let down on a swinging leg to form a cook's work table, thus introducing the first chuck wagon.[9] The chuck wagon ruts, wide on the trails, left the principles of handling the cattle the same but changed the cowboy's etiquette forever.[10]

When Loving died, Goodnight honored his wishes not to be buried "in foreign soil," and packed the casket in charcoal inside a large metal box which he soldered and nailed together from oil cans. He then placed the metal box in a huge wooden box. Goodnight accompanied the mule-driven wagon carrying the cargo over the Goodnight-Loving Trail to its final resting place, Weatherford,

Texas. As Goodnight's biographer said, this was "the strangest and most touching funeral cavalcade in the history of cow country." This overland journey formed the basis for Larry McMurtry's novel, *Lonesome Dove*, which was adapted for a 1989 television miniseries filmed partly in Abiquiu, New Mexico.[11]

After Loving's death, Goodnight settled on a ranch near Pueblo, Colorado, to become a wealthy cattleman. The ranges overstocked with cattle and the Panic of 1873 nearly ruined Goodnight financially but revived his desire to return to Texas's virgin grasslands.[12]

A survey of Goodnight's career as a distinct individualist who lived close to the soil provided standards for others to follow as he discovered the *Llano Estacado*, captured the vision of the prairie and acted on this vision.

The history of the prairie town of Canyon, then known as Canyon City, began when Lincoln Guy Conner, a cattleman from Clay County, Texas, envisioned a land better suited for his cattle. He moved with his wife, Queenie Victoria Younger (her uncle, Cole Younger's, involvement with the outlaw Jesse James brought fame) and a small herd of cattle to the Texas Panhandle searching for well-watered land. Conner, about to relinquish his search, met a sheepherder who told him of land between the Tierra Blanca (white soil) and Palo Duro creeks in Randall County. Conner located the land in Section 34, Block 5 on Christmas Day, 1887, and purchased the land for $3 an acre in 1888. The Conners lived in a dugout, herded cattle, and established the first real estate office. In the spring of 1888 the surveyors marked off the prairie into orderly squares. They called the site Canyon City after the canyon to the east. To attract other settlers to the area, the Conners hosted a picnic featuring a drawing that offered a town lot to anyone who wished to build a home or business building. Ranchers, investors and settlers came from all parts. With Conner's success, he donated lots for the courthouse, land for the railway station and thirty acres for cattle pens and shipping grounds.[13]

Because of the survey work begun by the railways in the 1880s, by 1898 the railroads ran from Amarillo to Canyon City with a large stockyard built near the present day WTAMU. As the new railways arrived, a small community arose every six to ten miles, allowing for easier access to the land.[14]

By the close of the twentieth century, the huge Panhandle ranches had developed serious problems due to droughts, blizzards, too many cattle, and falling cattle prices. The disillusioned ranchers sold off small parcels of the land

to small farmers who were arriving and plowing the land, to the ranchers' dismay. The ranchers made life difficult for the farmers encroaching on their territory. One farmer not scared by the ranchers made his living picking up bones on the prairie and hauling them to Amarillo at $7 per ton.[15]

Another visionary man of German lineage, ahead of his times, Charles O. Keiser from Keota, Iowa, left Drake University in his junior year. Listening to the call of the West, Keiser worked on a Wyoming ranch. Returning to Iowa, Keiser became prominent by importing Percheron horses from France. When the Dakotas opened for immigration Keiser pursued his interest in land, reacted to the Germans complaining of high-priced land in the Midwest, and brought farmers to the Dakotas. In 1906, only six years before Georgia went to Amarillo, he ventured into the Texas Panhandle because of the rich top soil, and set up a real estate office.[16]

Keiser, teaming with his brothers and with George Phillips of Indiana, formed the Keiser Brothers and Phillips Land and Cattle Company. They bought a considerable amount of land, planning to bring immigrants from other sections of the United States. In these early years the sparsely populated land held fears of the Indians, the rough cowboys and the desert-like land itself. Targeting these settlers, the railroad advertised to bring people to live near the railroads. Keiser's ads in newspapers declared, "Get a valuable home in the Panhandle for little money by buying directly from us." Word of mouth brought in the majority of these early pioneers who came by train. The Keisers brought a big influx of German farmers first from Iowa, then Wisner, Nebraska, with their last excursion train in 1912.[17]

A 1906 description of Canyon City described it as "a small typical western town, with no sidewalks, no roads, no conveniences and a shortage of the very necessities of life. They had to haul the water in the town from a well outside of town about a mile and three quarters."[18] As other developers came to the area, the schools, churches and a cemetery gave a sense of community.[19]

The Keiser Brothers and Phillips Land and Cattle Company in mid-December 1907, continued its plans of bringing in immigrants from other parts of the United States and bought nine sections of land, three miles by three miles, containing 5,927.53 acres for $8.77 an acre, beginning four miles east of Canyon City. Their original purchase, part of the T-Anchor Ranch, included section numbers 84, 85, 86, 107, 108, 109, 116, 117, and 118 for a total of

$52,160. Later purchases included: in 1908 sections 73, 74, 75, 76, 77, 87, 88, 106, and 119 and in 1909 sections 69, 70, 71, 72, 89, 90, 91, and 92, for a total of twenty-six sections.[20]

This purchase of prairie land devoid of any obstructions such as fences, full of waving blue gramma and Buffalo grass, scattered with meadow larks, snakes, antelope, deer, quail and buffalo, all under a blue, blue sky, became known as "The Block," because the acreage made a square block.[21] See figure 10-1.

10-1 "The Block"

Keiser built in 1911 a large two-story home at 1214 Fifth Avenue with high ceilings, beautiful woodwork, and an innovative hot water radiator system. Situated near West Texas State Normal College, the Keiser home served as a place for entertaining college visitors.[22]

Texas's frontier marched forward by increasing its railroads and mapping out a road system. The 1901 discovery of oil in Beaumont brought a new vital industry to Texas.[23]

Canyon boasted a population of 2,500 when Georgia arrived at the Santa Fe Railroad Station. Henry Ford's Model T had changed the automobile from

a luxury and toy into a necessity. Since one of the first cars arrived in Canyon City in 1906 with the Keisers, Georgia's Saturday midnight arrival may have been met by one of the faculty members in a buggy or automobile.[24]

In the first week of September 1916, Georgia took up her position as head of the art department, teaching at a salary of $150 per month.[25]

She discovered mocassined feet that left no trails, the same wind drifts that cause a dusty fragrance, the same trails through the scanty grass, and the same land that Goodnight found. Albert Pike (1809-1891), a self-taught Massachusetts educator and teacher who would one day write the dogma for the American Freemasonry, joined expeditions into the *Llano Estacado* and found the same land some forty-three years before, and explained so aptly:

> No man can form an idea of the prairie, from anything which he sees to the east of the Cross Timbers. Broad, level, grey and barren, the immense desert which extends thence westwardly almost to the shadow of the mountains, is too grand and too sublime to be imaged by the narrow contracted, undulating plains to be found nearer the bounds of civilization.
>
> Imagine yourself....standing in a plain to which your eye can see no bounds. Not a tree, nor a bush, not a scrub, not a tall weed lifts its head above the barren grandeur of the desert; not a stone is to be seen on its hard beaten surface; no undulation, no abruptness, no break to relieve the monotony; nothing...Its sublimity arises from its unbounded extent, its barren monotony and desolation, its still, unmoved, calm, stern, almost self-confident, grandeur, its strange power of deception, its want of echo, and in fine, its power of throwing a man back upon himself and giving him a feeling of lone helplessness, strangely mingled at the same time with a feeling of liberty and freedom from restraint.[26]

Georgia had now encountered her second muse, Canyon. She commented:

> I couldn't believe Texas was real. When I arrived out there, there wasn't a blade of green grass or a leaf to be seen, but I was absolutely

crazy about it. There wasn't a tree six inches in diameter at that time. For me Texas is the same big wonderful thing that oceans and the highest mountains are.[27]

Surely, the land reminded her of growing up in Sun Prairie with its open spaces, broad rolling hills and the presence of great nature.

Georgia wrote Stieglitz from Canyon on September 4, 1916:

> I have been here less than 12 hours—slept eight of them—have talked to possibly 10 people—mostly educators—*think* quick for me—of a bad word to apply to them—the *little* things they forced on me—they are so just like folks get the depraved notion they ought to be—that I feel it's a pity to disfigure such wonderful country with people of any kind—I wonder if I am going to allow myself to be paid 1800 dollars a year to get like that—I never felt so much like kicking holes in the world in my life—till there is something great about wading into this particular kind of slime that I've never tried before—alone—wondering—if I can keep my head up above these little houses and know more of the plains and the big country than the little people....[28]

Georgia continued:

> Your letter makes me want to just shake all this place off—and go to you and the lake—but—there is really more exhilaration in the fight here than there could possibly be in leaving it before it's begun—like I want to—...
>
> It seems so funny, that a week ago it was the mountains I thought the most wonderful—today it's the plains—I guess it's the feeling of bigness in both that carries me away.[29]

In this raw element of the Panhandle blossomed the college that resulted from the passage of a bill in early 1909 by the Thirty-first Texas Legislature to establish a "State normal school for the education of white teachers" located somewhere "west of the ninety-eighth meridian." After a bidding war of some twenty-five West Texas towns, the location committee selected Canyon City. Aiding in the selection process, the city's citizens pledged $100,000 in cash and

Lincoln Guy Connor donated forty acres of land which was once a part of the T-Anchor Ranch. Not mentioned in an official report was the town's lack of saloons.[30]

Almost a year after the announcement of the location for the school, President R. B. Cousins on September 20, 1910, welcomed a faculty of sixteen and one hundred fifty-two students to the single yellow-brick school building which would become the northernmost four-year public university in Texas. The next year, 1911, Canyon City became simply Canyon.[31]

Three years later on March 25, 1914, a fire that started over the library destroyed most of the campus. Not thinking the building would burn completely, the librarian cautioned the boys as they tried to save the books by throwing them out the window, "Please, please boys don't treat my books that way." After the fire, the students and faculty pledged support for the school. With the exception of the capitol building in Austin, architects designed a building described as the "greatest building in Texas."[32] On September 16, 1915, the cornerstone was laid and a barbecue for 1,500 people climaxed the event.[33] See figure 10-2.

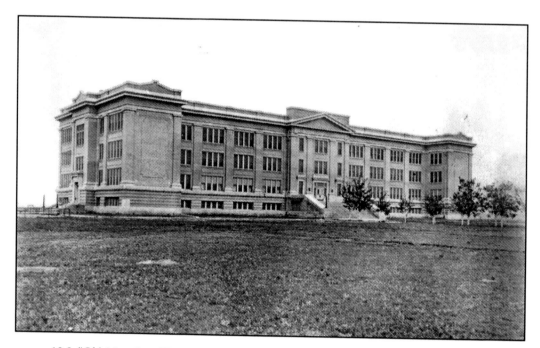

10-2 "Old Main" at West Texas State Normal College

The school opened again on April 16, 1916, with "Old Main" located between blocks 2400 and 2500 on the north side of Fourth Avenue.[34]

Georgia's first impression came shortly after she arrived when she wrote Anita Pollitzer:

> My first impression was that it is a shame to disfigure anything as wonderful as these plains with anything as little as some of these darned educators—but—I'm not quite as wrathy at them as I was the first 24 hours.[35]

Georgia's living arrangements for one and one-half years in Canyon began with the B. A. Stafford family.[36] See figure 10-3.

10-3 B. A. Stafford

Stafford, the college's Latin teacher, lived in a white two-story house at 1911 Fifth Avenue on the corner of Fifth Avenue and Twentieth Street, later known as the Kirby home.[37] See figure 10-4.

10-4 B. A. Stafford Home

Georgia abhorred her lodging in this house, staying only two nights, and wrote Anita:

> Don't mind what I said on the other side of this—I'm a pink pill with wheels on my head—but if you had waked up Sunday morning and found pink roses in squares hitting you from all over the walls—pale grey

ground—dark green square lines—tails gold—rose *pink*.... There were pink roses in the centers of the 2 rugs too—I moved the next day....My work is going to be great—I think—The building is all new—the best in the state they say—everything looks fine to work with—I'll tell you when it's started how it works—

It seems so queer to be here—it doesn't seem far away from the world like it used to.[38]

Georgia wrote Stieglitz:

The sound of the wind is great—but the pink roses on my rugs! And the little squares with three pink roses in each one—dark lined squares—I have half a notion to count them so you will know how many are hitting me—give me flies and mosquitoes and ticks—even fleas—every time in preference to three pink roses in a square with another rose on top of it.[39]

Georgia managed to rent rooms in various homes and learned of a neighbor across the street from the Staffords' house, Douglas A. Shirley, a physics professor who later became a dean at the college.[40] Shirley had come to Canyon from his position as president and coach at Hereford College where he had distinguished himself with a football team that often defeated WTSNC during the period around 1910. WTSNC President R. B. Cousins brought Shirley to Canyon to teach physics and to coach.[41] See figure 10-5.

Shirley bought lots from L. G. Conner, the founder of Canyon. In 1916, Shirley was building a new house at 500 Twentieth Street on the south side of the street across from the Stafford house. The house was constructed from plans supplied by the Craftsman-Bungalow Company of Seattle, Washington. The plans were inverted because Mrs. Shirley did not want the bedrooms on the north side of the house. Sterling Coffee and Brothers built the dark brown house with white trim on the windows and eaves.[42] See figure 10-6.

10-5 Douglas A. Shirley

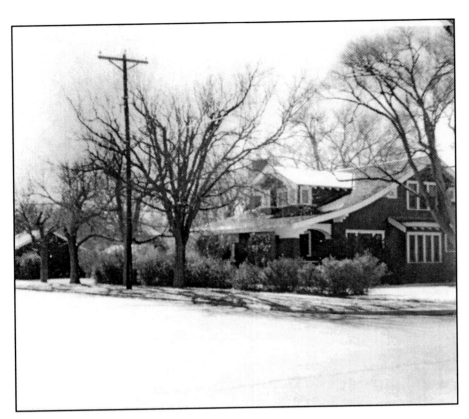

10-6 *Douglas A. Shirley Home*

The Shirleys' daughter, Louise, related that as a small child, "their large brown house was quite new and my mother, Willena, did not really want to rent a room."[43]

The Shirleys reminded Georgia that there were no curtains or furniture and they really didn't plan to rent the room. Georgia's preference for minimal furniture and no curtains fit in with the Shirleys' accommodation. Mrs. Shirley relented and allowed Georgia to rent the room.[44]

Georgia commented, "It is the only steam heated one in this end of town— the only place I could find where the walls wouldnt drive you to drink—"[45]

Out the Shirleys' window across the street stood a Victorian gingerbread house known as the Kimbrough house. See figure 10-7.

10-7 Kimbrough House

In winter the house's roof, covered with snow, appeared pink in the fading sunset. In 1916, Georgia painted three versions of the house:

> *Untitled (Roof with Snow Study Sketch)*, watercolor and graphite on medium
> thick, white, smooth wove paper, 4 x 5 1/2 in., 1916,
> *Untitled (Roof with Snow Study Sketch)*, watercolor and graphite on medium
> thick, white, smooth wove paper; 4 1/2 x 5 5/8 in., 1916,
> *Roof with Snow*, watercolor on moderately thick, cream, smooth wove paper
> with a slightly fuzzy feel, 8 7/8 x 11 7/8 in., 1916.[46]

From this eastern view of the Shirley house in 1916, Georgia painted: *Sunrise*, watercolor on paper, 8 7/8 x 12 in., 1916.[47]

The same year she painted:

Morning Sky, watercolor on paper, 8 7/8 x 12 in., 1916,
Sunrise and Little Clouds No. I, watercolor on paper, 9 x 12 in., 1916,
Sunrise and Little Clouds No. II, watercolor on moderately thick, cream
 slightly textured wove paper, 8 7/8 x 12 in., 1916.[48]

Before Ida O'Keeffe's death, Georgia promised to take care of her seventeen-year-old-sister, Claudia. The younger sister joined Georgia at the Shirleys' house in Canyon. Claudia enrolled in WTSNC as a junior and her photograph appeared in the WTSNC year book of 1916–1917.[49] See figure 10-8.

*10-8 Claudia O'Keeffe at West
Texas State Normal College*

Georgia's photograph also appeared in the WTSNC year book of 1916–1917. See figure 10-9.

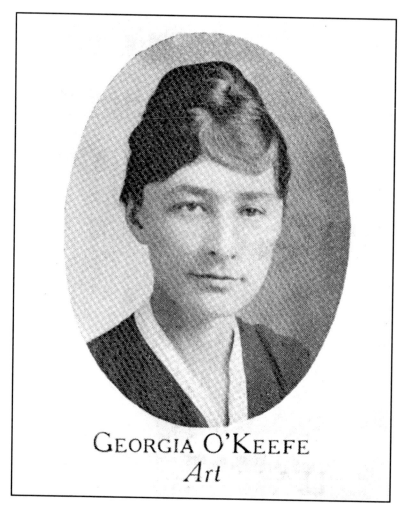

GEORGIA O'KEEFE
Art

10-9 *Georgia O'Keeffe at West Texas State Normal College*

Georgia's room, looking out of the gable on Twentieth Street, contained an iron bed and one wooden storage crate, a plainness which Georgia admired. Georgia wanted to paint the wooden trim black, but Mrs. Shirley vetoed such a decorating scheme on the bird's-eye maple woodwork without further discussion.

But she permitted Georgia to have black curtains by tacking black cloth over the windows.[50]

The room tucked into the attic commanded an eastern view of the beautiful rising sun with no significant natural or man-made interruptions to obscure the bright sun rising above the plains.[51] As Louise Shirley later commented, "In those days you could see to hell and gone. My mother, who was from Granbury, [Texas,] used to look out the window and say, with sarcasm, 'Isn't this a wonderful view.'"[52]

Shortly before arriving in Canyon, while teaching the summer session at the University of Virginia, Georgia probably became more knowledgeable about ambient light, which affected every object whether the lighting was backlighting, sidelighting or frontlighting.[53] She noticed that in the early pre-dawn lighting the third dimension narrowed into flat lighting with no shadows. Then the dawn lighting from the clean atmosphere molded and shaped any objects with its harsh, intense yellow to orange light. The mid-morning light lightened the colors of the shapes, contours and shadows of any objects to obtain a three-dimensional perspective. The midday lighting caused by the sun being perpendicular to the earth produced harsh "down lighting." Mid-afternoon lighting produced a reddish glow and long shadows. The red to rosy-orange setting of the sun created a drier quietness of nostalgia, and finally the dim light of a quiet, cool dusk portrayed no third dimension.[54]

The western sky, with all its variations, impressed Georgia because on September 11, 1916, Georgia wrote Anita:

> Tonight I walked into the sunset—to mail some letters—the whole sky—and there is so much of it out here—was just blazing—and grey blue clouds were riding all through the holiness of it—and the ugly little buildings and windmills looked great against it
>
> But some way or other I didn't seem to like the redness much so after I mailed the letters I walked home—and kept walking—
>
> The Eastern sky was all grey blue—bunches of clouds—different kinds of clouds—ticking around everywhere and the whole thing—lit up—first in one place—then in another with flashes of lighting—sometimes just sheet lighting—and some times sheet lighting with a sharp bright zigzag flashing across it—. I walked out past the last house—past the last locust tree—and sat

on the fence for a long time—looking—just looking at—the lighting—you see there was nothing but sky and flat prairie land—land that seems more like the ocean than anything else I know—There was a wonderful moon.

Well I just sat there and had a great time all by myself—Not even many night noises—just the wind—

It is absurd the way I love this country—Then when I came back—it was funny—roads just shoot across blocks anywhere—all the houses looked alike—and I almost got lost—I had to laugh at myself—I couldnt tell which house was home—

I am loving the plains more than ever it seems—and the SKY—Anita you have never seen SKY—tis wonderful—[55]

Georgia remembered Louise as "an ethereal, delicate blond child whose every movement was a delight to watch."[56]

Louise recalled, "Georgia was as different as they come." Georgia, trying to keep her creative instincts alive, spent many hours sitting on the floor drawing, which didn't allow her much time with the Shirleys. But she managed a good relationship with them. In later years they visited Georgia in Abiquiu.[57]

Another WTSNC teacher, Mary Elizabeth Hudspeth (1874-1943), taught Spanish and eventually became chairman of the Modern Languages Department.[58] See figure 10-10.

At the same time as Georgia, Hudspeth also needed a place to live. The Turk Brothers in 1909 ordered a house out of the Sears, Roebuck and Company catalog and for $2,500 built a ten-bedroom and ten-bathroom house of over 8,000 square feet at 402 Palo Duro Street (now First Street) west of the Canyon Town Square. Like most large homes in Canyon, the family took in boarders. Mary Elizabeth boarded with the Turks and helped them financially with the completion of the house with the promise of being repaid. The 1912 Canyon drought forced the Turks' dry goods store into bankruptcy and the deed to the house paid the debt to Miss Hudspeth, who rented rooms to faculty and students. She then moved the house on railroad ties attached to wheels and steam-tractored down Fourth Avenue to its present location at 1905 Fourth Avenue on the north side of the street.[59]

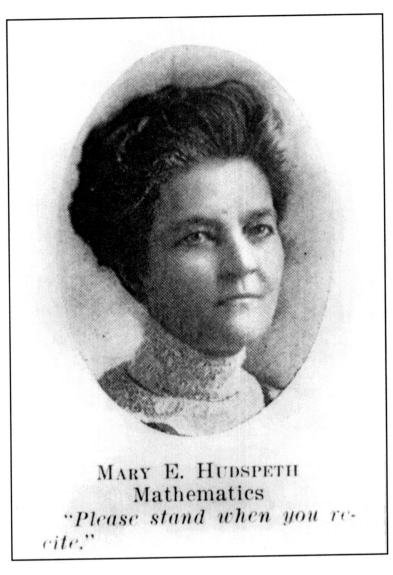

MARY E. HUDSPETH
Mathematics
*"Please stand when you re-
cite."*

10-10 Mary Elizabeth Hudspeth

The Shirley house had no cooking facilities for Georgia so she often ate her meals about a block away at the Hudspeth house with Mary Elizabeth.[60]

Georgia often shared her latest art projects with the group that met for dinner at today's Hudspeth House Bed and Breakfast.[61] See figure 10-11.

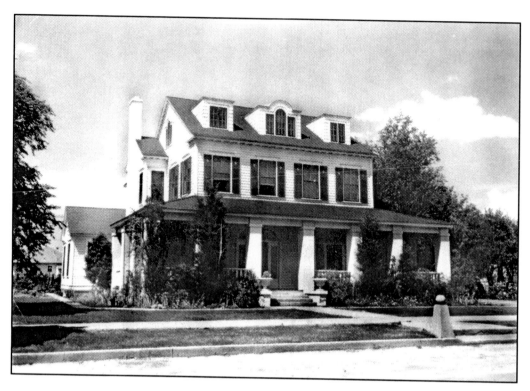

10-11 Hudspeth House

From the Hudspeth House, Georgia had no more than 0.4 of a mile to walk to the Old Main building on the campus. That year, as President Cousins greeted the students to the new campus, Georgia stood among the faculty welcoming the students.[62] See figure 10-12.

Georgia joined the thirty-member faculty with five visiting faculty members. As she prepared for her first classes in November, she had begun reading Clive Bell's *Art* and Willard Huntington Wright's *The Creative Will*, both in preparation for her 1916 and 1917 classes.[63]

According to the "Bulletin of The West Texas State Normal College, Catalog for 1917–1918," as the only member of and head of the Department of Drawing in the College, Georgia taught design, drawing, costume design, advanced design, advanced drawing, methods of teaching drawing in public schools, interior decoration, beginning drawing and industrial art.

With the new school building complete, except that not all the furniture had arrived, Georgia searched the premises for boxes to use as chairs.[64]

With Georgia's room, meals, classroom and class schedule in place, she began teaching.

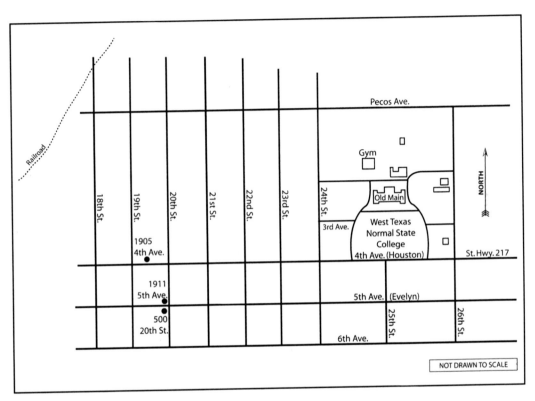

10-12 Map of Canyon, Texas, 1920

11

A TEACHING CAREER

"The painter's joy lies in the rapture of creation, in the knowledge that he is carrying forward the banner of a high ideal."

—Willard Huntington Wright

In one of Georgia's WTSNC courses she set up a small wooden table in the front of the class to display examples of color in a piece of fabric bunched up on the table and to demonstrate lines of design in the ceramic pieces sitting on the table. See figure 11-1.

Beside the table stood an easel displaying Guido Reni's (1575–1642) *Phoebus and the Hours, Preceded by Aurora*. Reinach featured this Reni fresco in *Apollo, an Illustrated Manual of the History of Art throughout the Ages* and claimed his work "a little strident in its high-toned colour, and over-facile in drawing, is one of the great achievements." He declared Reni a clever and prolific decorator unduly depreciated.[1]

Saloman Reinach, a member of the French Institute, wrote the book in 1904 and as a companion to his 1889 publication, *Minerva*, an introduction to the Greek and Latin classics.

Apollo was derived from a series of lectures given at the École du Louvre in 1902–1903.[2]

11-1 Georgia's Class at West Texas State Normal College

The book begins with a history of art from the Stone and Bronze Ages to the art of the nineteenth century, with his thoughts on the origin of art. He felt that man, out of necessity to survive, fashioned tools, weapons and clothing. Art "*superadded* to that of utility" and was set apart to provide not a need but a sentiment. As such, art, a luxury and diversion, became a social phenomenon. The earliest man designed a tool for his needs and decorated the implement to please himself and his neighbor.[3]

Reinach claimed:

> Art manifests itself first in the desire for symmetry, which is analogous to the rhythm of poetry and music, and the taste for colour, not so arranged as to produce images, but applied or exhibited to please the eye. It goes on to trace ornaments composed of straight or curved, parallel or broken lines.[4]

The book concluded that the future of art would not be primarily realistic because photography had made reality familiar to all. He thought that future art would be idealistic and poetical as it translates man's eternal aspirations toward what he lacks in daily life.[5]

Georgia must have known that the student is more than just a reservoir of information accumulated from her and many others, but contains a growing power to create.

During this time she was reading Willard Huntington Wright's *The Creative Will* (1916) and Clive Bell's *Art* (1913).

Georgia wrote to Anita in September 1916 that she was reading Willard Wright again. Anita responded in an October, 1916 letter:

> By all means buy Huntington Wright and Clive Bell—get this last even if not Wright—to give your people some pt. of view.[6]

Willard Huntington Wright's (1888-1939) younger brother, Stanton MacDonald-Wright (1890-1973), known as "the other Wright brother," was born in Virginia. Each brother distinguished himself as an author and painter respectively. Willard attended Pomona College and later Harvard University dismissed him for drinking absinthe in class. From college, he traveled to Paris and Munich to study art. At age twenty-one in 1909, Willard returned to the United States and became a book reviewer and reporter for the *Los Angeles Times*. His insulting, scornful assaults on Los Angeles, such as "Hypocrisy, like a vast fungus, has spread over the city's surface," earned him the title "the boy iconoclast of Southern California." In 1912, he became editor of the sophisticated New York magazine, *The Smart Set*, before H. L. Mencken's editorship.[7]

Willard traveled to Paris and Munich in 1913 where his brother exhibited his Synchronist paintings. Fired in 1914 from *The Smart Set* for controversial writings, he in 1915 edited an anthology, *What Nietzsche Taught*, which added to his pro-German views of the times.[8]

In 1915 Willard wrote the first of his books on subjects intended for a select few, *Modern Painting, Its Tendency and Meaning*, and in 1916 wrote *Creative Will*. In both books he championed Synchronism which creates forms and images exclusively with color. Synchronistic theory, as instituted by Stanton, stated that modern art would be successful only through "form by means of color."[9]

In 1916, Wright wrote his only novel, *Man of Promise*. He also organized the Forum Exhibition of American Artists, mounted at the Anderson Galleries and aimed at promoting his brother's art.[10] Later, Willard, after bouts of drug addiction and a nervous breakdown, reinvented himself as he convalesced in bed for two years by writing fiction and mystery novels under the pseudonym S. S. Van Dine.[11]

In his earlier writings, "Forum" and "New Age," Willard stated his hypothesis that "any art can arouse pleasing sentiments. Only great art can give us intellectual rapture." In an attempt to broaden the scope of understanding by those not trained in the aesthetics, Willard, in *Modern Painting, Its Tendency and Meaning*, collected and explored the function and psychology of the world's great art to produce a fuller understanding of modern painting. He attempted to explain the difference between ancient and modern art, stressing the superiority of the latter. In doing so, he tried to answer the questions:

What men and movements mark the milestone in the development of the new idea? What have been the motivating forces of each of these schools? To what extent are their innovations significant; what ones touch organically on the vital problems of aesthetics; and what was their influence on the men who came later? Out of what did the individual men spring; what forces and circumstances came together to make their existence possible? What were their aims, and what were their actual achievement? What relation did they bear to one another, and in what way did they advance on one another? Where has modern art led, and what inspirational possibilities lie ahead?[12]

Willard's discussion of the new era included Édouard Manet, Auguste Renoir, Paul Cézanne, Paul Gauguin, Edgar Degas, Henri Matisse and Pablo Picasso, ending with Futurism, Synchronism and the lesser moderns. Willard considered Kandinsky a lesser modern based on the claim that art does not rest on transcendental terms. Willard concludes, "The painter's joy lies in the rapture of creation, in the knowledge that he is carrying forward the banner of a high ideal."[13]

Creative Will was dedicated to Willard's brother and consisted of a series of

two hundred fifty-one essays under the chapter headings "Art and Life," "Problems of Aesthetics," "Art and the Artist" and "Art and the Individual."[14]

Georgia commented, upon reading his *Creative Will*, "It has been great to me.... He gets me so excited that sometimes I think I must be crazy." She later wrote that she labored on aesthetics.[15]

Willard stated in essay number sixty-seven, "The medium of painting is colour. The medium of music is sound. The medium of literature is document. Aesthetic form is produced by an arrangement and co-ordination of the differentiations of these media."[16]

In essay number seventy-eight Willard wrote:

> Do not consider the arts as isolated and independent, each governed by its own laws. The laws which apply to one art will apply with equal fitness to any other art. What is basically true of one art is true of all the others: seek for the aesthetic analogy. Precisely the same reactions are expressed by painting, music and literature; and these reactions are expressed in the same aesthetic manner. Only the media differ. You cannot know one art *à fond* without knowing all the others; or, to state the proposition conversely, it is necessary to know all the arts fundamentally before you can truly grasp one of them. The emotional effects of the various arts are superficially dissimilar; but the principles do not vary.[17]

Clive Bell (1881–1964), an English art critic who promoted acceptance of the Post-Impressionists in England during the early twentieth century, graduated from Trinity College, Cambridge, in 1902. In 1907, Bell married Vanessa Stephen, the sister of Virginia Stephen, who became Virginia Woolf after her marriage to Leonard Woolf. These four formed the nucleus of the Bloomsbury Group, a collection of English writers and artists. As a member of the Bloomsbury Group, Bell joined those who discussed "artistic and philosophical questions in a spirit of honest agnosticism." They "searched for definitions of the good, the true, the beautiful and questioned accepted ideas with a 'comprehensive irreverence' for all types of shams." Their sharing of ideas did not originate a school, but its significance was the great number of talented people assembled.[18]

Bell's most significant contribution to art criticism was that art that provokes one's aesthetic emotions involves line and color combined in a certain

way which he called "significant form." He claimed:

> That purely formal qualities, i.e., the relationships and combinations of lines and colours, are the most important elements in works of art. The aesthetic emotion aroused viewing a painting springs primarily from his apprehension of its significant form, rather from his "reading" of its subject matter.[19]

Georgia also read *Interior Decoration, Its Principles and Practice*, (1915) by Frank Alvah Parsons, president of the New York School of Fine and Applied Art. Parsons felt that mass-produced consumer products allowed the middle class to buy goods which provided an identity. Parsons wrote that the house is the "normal expression of one's intellectual concept of fitness and his aesthetic ideal of what is beautiful." He claimed that the house exists as the externalized man expressed in color, form, line and texture.[20] He also established a school in New York City, The Parsons School of Design.

Parsons emphasized that color is a language, like music and words, and that color has three qualities: hue (the name of a color), intensity (vitality or individual strength of a color) and value (degree of lightness and darkness).

Meanwhile, Georgia had discovered in the devastating WTSNC fire that the 1904 edition of *How to Study Pictures*, by Charles H. Caffin, had been saved.[21]

Charles Henry Caffin (1854–1918), English-born, graduated from Magdalen College, Oxford, with a finely honed sense of aesthetics. His pursuits in theater and teaching developed his observation and descriptive powers. His arrival in the United States led him to the decoration department of the Chicago Exposition in 1892. From Chicago, Caffin moved to New York where he became an art critic. His essays led him to publish a series of books which greatly influenced the layman.[22]

Caffin claimed that to properly see a picture "is to try and see it through the eyes of the artist who painted it."[23]

As Georgia settled into her teaching career in Canyon, she discovered Palo Duro Canyon and acted on her discovery.

12

PALO DURO CANYON

"*Last night couldnt sleep til after four in the morning—I had been out to the canyon all afternoon-till late at night—'wonderful color'*"
—*Georgia O'Keeffe*

The Palo Duro and Tierra Blanca creeks rise in eastern New Mexico to flow through the Texas Panhandle. At their Texas confluence, northeast of Canyon, the Prairie Dog Town Fork is formed. In its formative years the larger river, as compared to today's seemingly low-water stream, sought its way east into the *Llano Estacado* to become the Prairie Dog Town Fork of the Red River. Its eastward meandering provided the headwaters of the Red River which forms the boundary between Texas and Oklahoma. The Red River winds southeast eventually to the Gulf of Mexico.[1]

The Prairie Dog Town Fork of the Red River met resistance from the *Llano Estacado* in varying degrees to form a massive formation, the Caprock Escarpment, which is much harder than the soil above or sedimentary rock below. The canyon formed by the Caprock Escarpment broke the seemingly almost endless vision of flat land, offered stands of twisting cottonwood trees to signal the life of the river, provided hackberry trees for shade and made the sky appear bigger and closer.[2]

The canyon extends one hundred twenty miles in length and one-half to two miles wide. The highest elevation is at 3,463 feet above sea level while the lowest stands at 2,775 feet above sea level.[3] Insight into the formation is obtained from examining the canyon walls, from the oldest on the canyon floor to the youngest on the canyon rim. Its existence from an endless landscape into a sharply contrasting terrain began slowly to sculpt the six-hundred to eight-hundred foot canyon walls. Timewise the canyon's formation of orange, red, lavender, gray, white, brown and yellow rocks lasted approximately one million years, making the canyon relatively young. The stratified, layered and exposed sedimentary rock formations in the canyon walls reveal units of time and deposition.[4] See figure 12-1.

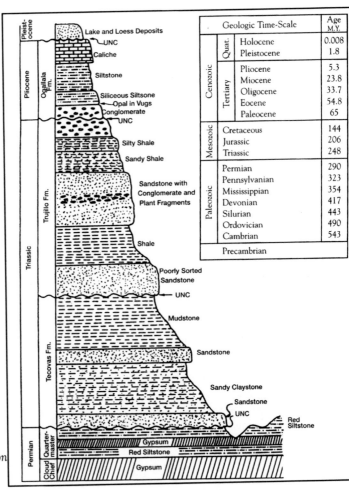

12-1 *Palo Duro Canyon Geological Column*

The oldest formations in Palo Duro Canyon are the Cloud Chief Gypsum and the overlaying Quartermaster during the Permian Period. They were deposited near the edge of a shallow sea from two hundred sixty to two hundred fifty million years ago. The Cloud Chief Gypsum Formation is seen as "thick horizontal and folded white layers of alabaster...and as seams of fibrous white satin spar criss-crossing the red beds in the Quartermaster Formation...which is mostly siltstone and shale with a distinctive red color...with bedded gray zones."[5]

"Stratigraphically, the Palo Duro Canyon would sit on top of the Grand Canyon, because the upper rim of the Grand Canyon matches the lowest exposed layer of the Palo Duro Canyon."[6]

As the Permian Period closed, the Panhandle uplifted with massive erosion leaving no sediments.[7]

The next layer, the Tecovas Formation, was deposited in swamps, lakes and streams about two hundred thirty million years ago, leaving lavender, yellow, orange and buff siltstone and shale. The shale forms less-steep canyon walls often covered with plant growth. The upper Tecovas consists of boulders from the overlying sandstone of the Trujillo Formation. Within the Tecovas Formation stand irregular-shaped, weathered rocks as a result of the sediments hardening around a nucleus. The Tecovas Formations, combined with the Quartermaster, form triangular slopes called "Spanish Skirts," so called because when Coronado came through seeking Cíbola, he thought the formations resembled Mexican ladies' skirts.[8]

Overlying the Tecovas Formation, the Trujillo Formation's was probably deposited by streams beginning in an ancient highland southeast of the Panhandle some two hundred twenty million years ago. The upper Trujillo Formation forms much of the upper canyon walls. Sandstones layer alternately with dark maroon shale and marl-pebble conglomerate. With well-developed cross bedding, their gray color became obscured by a crust of red mud or iron stain.[9]

About two to ten million years ago the Rocky Mountains uplifted again and sediments were deposited on the surface of the Trujillo Formation to form the Ogallala Formation.[10]

The next-to-the-top layer is the Ogallala Formation, a siltstone and a tan conglomerate of sandstone with white caliche. The Ogallala Formation has often been cemented by silica which erupted from the groundwater. The Ogallala's importance lies in supplying water for the region.[11]

Scattered on the Ogallala Formation are the Late Pliocene and Pleistocene *playa* lake deposits consisting of fresh water lake deposits of silt, limestone and wind-transported sediments. Below these sediments, caliche forms a caprock along the canyon rim.[12]

Throughout the canyon, "hoodoos," or pedestals, formed from different erosions provide a hard cap of sandstone to protect a pedestal underneath.[13]

Human habitation of Palo Duro Canyon began about twelve thousand years ago. The Comanche, Kiowa, Cheyenne and Apache called the crater "the canyon of the hardwood." The Spanish named the canyon *Palo Duro* after the strong, long-grained cedars used by the Native Americans to make their bows and after the rot-resistant junipers.[14]

As later pioneers arrived, Mrs. Clyde Warwick, wife of the early and longtime editor of *The Canyon News*, in *The Randall County Story*, described Charles Goodnight's return to Texas after serving in the U. S. Army as a scout during the Indian wars of 1870:

> He remembered that a Mexican cattle pilot, Nicholas (Cola) Martinez, had spoken in glowing terms of a great and colorful canyon that cut a great gash in the Staked Plains of Texas. The dream would not go away! Finally he asked the Mexican to show him this great place. Goodnight and Martinez rode southward to find it. After days of searching disappointment and near defeat they found it! A great gash in the *Llano Estacado*; water, timber, protected. A cowman's dream! So colorful it dazzled the eyes! Like the outstretched palm of Heaven it lay before them! The Palo Duro![15]

Goodnight discovered for himself the erosion, out of the gentleness of the Staked Plains, that shimmered in the horizon like a sea with no boundaries. Refusing an echo, the escarpments of high and colorful abutments, swept by the wind into figures, broke away from the flatness into flashing reds, yellows and browns leading into purple.

Ready to return to Texas in 1876, Goodnight drove his herd of 1,800 Durham cattle to graze in Palo Duro Canyon. When Goodnight reached the rim of the canyon he saw 10,000 to 20,000 grazing buffalo. He herded the buffalo in a cloud of red dust fifteen miles out of the canyon to make room for his cattle. In this canyon, forty-five-year-old Goodnight established the first

cattle industry and the first recorded ranch in the *Llano Estacado*.[16]

Goodnight partnered with John George Adair and his wife, Cornelia Ritchie Adair of England, in 1877 to form the JA Ranch, which eventually reached 1,325,000 acres and over 100,000 head of cattle.[17] The beginning of the big ranches in the Panhandle, a land known as a "man's country," followed and included the T-Anchor Ranch, which by its end in 1902 owned almost all of the eastern half of Randall County. The Frying Pan Ranch, so-called when a cowboy branding cattle said as he studied the brand, "Hell, this ain't no Panhandle. This here is a skillet. It's a damn frying pan." This ranch, owned by a man who held one of the two patents for barbed wire, Joseph F. Glidden, and with his sales representative, Henry B. Sanborn, became the first Western Plains ranch completely enclosed by barbed wire, a showcase for barbed wire.[18]

The barbed wire fences contained the cattle but not the wind. Goodnight described the wind:

> Wild animals always range into the wind; so do wild cattle, unless in a storm. A herd driven with the wind may be nervous and ill at ease. One pointed into the breeze steps out with assurance and a right free will not altogether due to lessened heat, dust, and flies. A stampeding herd circles into the wind to know what is ahead. In working a roundup, cattle should always be cut into the wind—they work easier that way. And a cowboy, loping into the breeze, feels an exhilaration that stirs his blood like old wine.[19]

In an old joke, a stranger asked, "Does the wind blow this way here all the time?" A cowboy's response, "No, mister, it will maybe blow this way for a week or ten days; then it'll change and blow like hell for awhile."[20] As a pioneer plainsmen commented about the wind, "You get to where you never notice it."[21]

As the nineteenth century closed, and before Georgia's arrival in Canyon in 1912, the big ranches dissolved and the farmers arrived. The railway connected Amarillo to Canyon City in 1898. By 1908, work had begun on making the area east of Canyon City a national park. An early discoverer and settler, Herman Kuhlman, came with a trainload of people from Wisner, Nebraska, in 1909. The German settlers were encouraged to come because they were good land developers and farmers. They were thrifty, had money, were content to stay put,

were not afraid of hardships, and were even clannish. These settlers came just as Theodore Roosevelt's last presidential days ended and his adventurous western life continued, possibly influencing their move to the west.[22]

The Nebraskans loaded all their possessions, including their animals, into twenty-one wooden box cars on which they had written, "From Icy North to Sunny Texas, 21 Cars Bound for Homes Near Canyon City, Texas." The railroads notified most of the towns along the route to announce the tide of immigration. Some purchased land east of Canyon and began breaking it up for farming. They built barns in the German tradition, with the house and barn under the same roof. The German settlers west of Canyon City belonged to the Catholic Church and those east of town belonged to the Lutheran church. In 1909, Keenan School, built nearby in the extreme northwest corner of Section 109 as a one-room schoolhouse, also served as the Lutheran church. Here a candidate for the ministry found German-speaking members in the church who had banded together in a sense of community. The St. Paul's Lutheran cemetery, eight miles east of Canyon in the northeast quarter of Section 108, had its first burial on February 9, 1916. Anna Marie Kuhlman, Herman's first wife, whom he had married in May 1913, died from complications of childbirth.[23]

In the very land that Georgia would explore, in the northwest corner of the northwest quarter of Section 106, stood a windmill, a dugout for temporary shelter, and a granary. In 1909, Herman Kuhlman, a bachelor, lived in a one-room granary located by a windmill in Section 106. He declared, "Breaking the sod was a difficult task because the thick grass was a foot to eighteen inches high, with a heavy root structure." Yet, by 1914 Kuhlman bought 165.43 acres in the northwest quarter of Section 109 for $23.50 an acre. Later, he bought more land four miles east of Canyon on today's State Highway 217.[24]

The road to Palo Duro Canyon originally ran straight east of Canyon for four miles, dividing in half sections 110, 111 and 112. The road then turned north one-third mile to pass by the Kuhlman farm, then turned east by the side of the north side of Section 109, then on to Palo Duro Canyon.[25]

Later in the 1930s, the Civilian Conservation Corps created a road through the north half of Section 110, which curved beginning from the old road to the northeast and connecting at the northwest corner of Section 109. This created thirty-nine acres surrounded by roads and designated as "Kuhlman Park."[26] See figure 12-2.

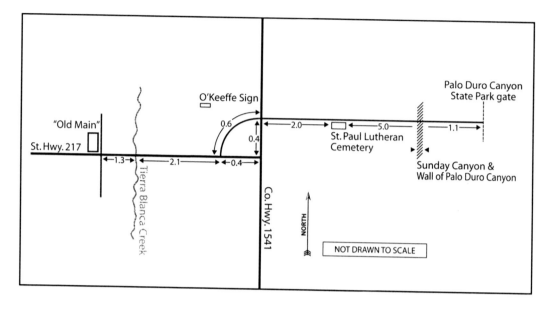

12-2 Route from Canyon to Palo Duo Canyon State Park

In Georgia's time, on her way from WTSNC to Palo Duro Canyon, she followed the approximate same route taken by Charles Goodnight in 1876 on the old Comanche Indian Trail. She would pass the site of an 1881 barbed wire fence built to enclose a 240,000-acre horse pasture and a "drift" fence to hold cattle back from wandering south when "blue northers" descended upon Canyon. Georgia then forded Tierra Blanca Creek before continuing east across the High Plains. She would have passed the site of the feast of the first Thanksgiving, seventy-nine years before the Pilgrims, as Pedro Fray Juan de Padillo celebrated for Coronado's troops. Georgia would have seen the wind-waving grass spreading to the horizon on both sides of the road as the road turned toward the canyon.[27]

Herman Kuhlman's son, Jim W., born in 1937 to Herman's second wife, Alma Marie, recalled:

> In 1916-1918 when Georgia was in Canyon the Kuhlman land did have a fence around the perimeter. When Georgia walked east to Palo Duro Canyon on now State Highway 217 she would have hiked through

the very heart of The Block. Three miles from town she would have met a hill the old timers called Stone Hill. In the earlier days when the road existed as a trail people at this four mile point jogged square north on the road for one third of a mile, then square turn east over eight miles to Palo Duro Canyon. The trail curved around the Stone Hill making it easier with their horses and wagons to get up the hill. Georgia would have had to walk past my father's home on the west side of Section 109, then along the north side of 109, heading towards the canyon. Georgia might have cut across the pasture, later purchased by my father in 1922, if there wasn't a bull in the pasture...a small bull but nevertheless a challenge. Until the square in the road was made into a curve in the 1930s by the WPA [Work Projects Administration] Georgia most likely would stop for a drink of water at the windmill on the Kuhlman land which was about the first one east of Canyon, which is shown below the row of trees planted along the road in 1939 and over four miles from where she lived.[28]

Kuhlman added, "Along the way she would pass the cemetery with its lone occupant."[29] See figure 12-3.

Kuhlman elaborated on Georgia's walk. "Another well was about two miles down the road from our well where Georgia again could have gotten water. There was even another well further down the road for her long walk and most welcome on a hot summer Panhandle day."[30] See figure 12-4.

"Just before you get to the entrance is a small, less colorful canyon that is named Sunday Canyon on the south side of State Highway 217. Neat, but not as impressive as the Palo Duro Canyon."[31]

Georgia could have entered the canyon at Sunday Canyon or she could have walked past that southern chasm another mile until she came to the rim of the colorful Palo Duro Canyon erupting in its full glory.

Kuhlman added, "My guess is Georgia entered the Palo Duro Canyon about where the entrance is today or slightly to the east."[32] See figure 12-5.

From the vantage of this entry point, Georgia would begin seeing the magnificent views of the full canyon.[33] (See illustration number 2 on the dust jacket of the book, Palo Duro Canyon State Park.)

The most famous landmark is a pedestal rock formed by erosion and known as the Lighthouse. The formation stands three hundred ten feet high

above the canyon floor. The pinnacle showcases its soft mudstone topped by a layer of sandstone that avoided the ongoing erosion.[34] (See illustration number 3 on the dust jacket of the book, Lighthouse, Palo Duro Canyon State Park.)

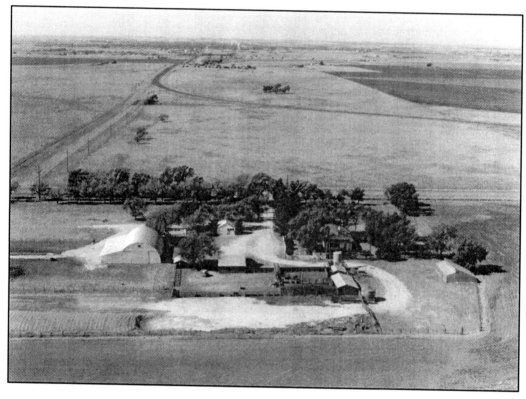

12-3 Kuhlman Land With Windmill

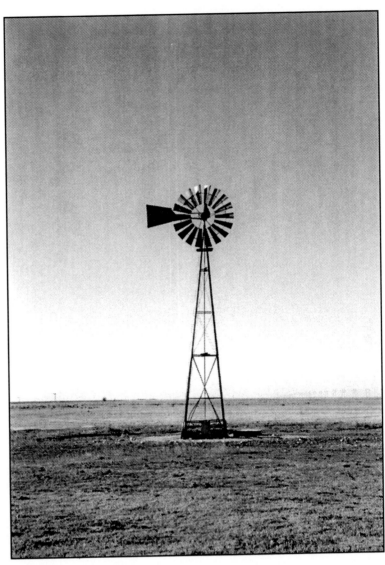

12-4 A Lone Windmill, 2003

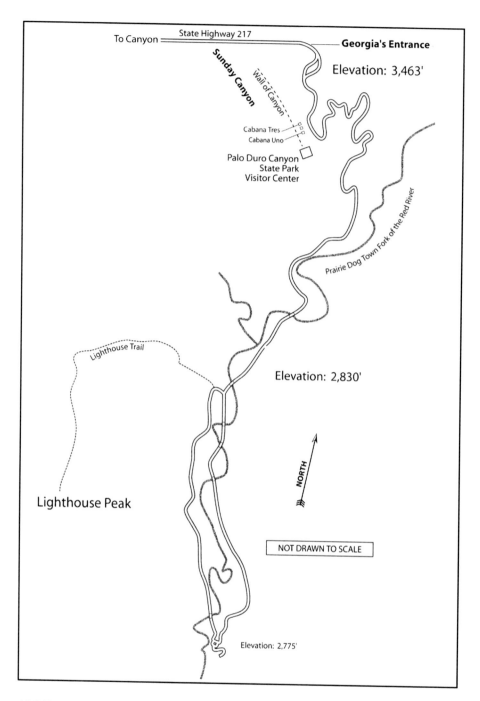

12-5 Route in Palo Duro Canyon State Park

Often with Claudia as her companion, she descended into Palo Duro Canyon by holding onto opposite ends of a long stick for balance as they maneuvered the "narrow winding cow paths, hidden in the golden sandstone walls by banked earth whose edges rose so steeply you couldn't see the bottom." Georgia claimed, "Those perilous climbs were frightening but it was wonderful to me and not like anything I had known before."[35]

Georgia said Palo Duro Canyon was "a burning, seething cauldron, filled with dramatic light and color."[36]

Georgia wrote Anita from Canyon in September 1916:

> Last night couldnt sleep til after four in the morning—I had been out to the canyon all afternoon—till late at night—wonderful color—I wish I could tell you how big—and with the night the colors deeper and darker—cattle on the pastures in the bottom looked like little pinheads—
>
> Then the moon rose right up out of the ground after we got out on the plains again—battered a little where he bumped his head but enormous—There was no wind—it was just big and still—so very big and still—long legged jack rabbits hopping across in front of the light as we passed—A great place to see the night time because there is nothing else.—Then I came home—not sleepy so I made a pattern of some flowers I had picked—They were like water lillies—white ones—with the quality of smoothness gone...[37]

Jim Kuhlman added, "The trip would be over twelve miles one way from the town of Canyon east to the Palo Duro Canyon, no easy trek, then to take time to paint and return home it would have been a very long tiring day. Hopefully, someone came along with a buggy or wagon and gave them a ride at least part way. But she truly loved painting the Palo Duro Canyon...."[38]

Walking through the acres and acres of grassland at dusk when searching for her way home, Georgia often depended on the lights of Canyon to guide her. The dusk lighting and the city lights highlighted the evening star.

In 1916 and 1917, using vibrant colors to indicate the evening star's importance, Georgia produced ten watercolors featuring the vast evening sunset with its star. Of the ten, only eight are known:

Evening Star No. I, watercolor on moderately thick, cream, smooth wove paper with a slightly fuzzy feel, 8 7/8 x 11 7/8 in., 1917,

Evening Star No. II, watercolor on paper, 8 3/4 x 12 in., 1917,

Evening Star No. III, watercolor on moderately thick, cream, slightly textured wove paper, 8 7/8 x 11 7/8 in., 1917,

Evening Star No. IV, watercolor on moderately thick, cream, smooth wove paper with a slightly fuzzy feel, 8 7/8 x 12 in., 1917,

Evening Star No. V, watercolor on moderately thick, cream, smooth wove paper with a slightly fuzzy feel, 8 3/4 x 11 7/8 in., 1917,

Evening Star No. VI, watercolor on moderately thick, cream, smooth wove paper with a slightly fuzzy feel, 8 7/8 x 12 in., 1917,

Evening Star No. VII, watercolor on moderately thick, cream, smooth wove paper with a slightly fuzzy feel, 8 7/8 x 11 7/8 in., 1917,

Evening Star, watercolor on paper, 13 3/8 x 17 3/4 in., 1917.[39]

Dr. John Freemont Mead, attending WTSNC and a critic teacher, commented:

> Miss O'Keeffe often returned from her walks, flushed and excited about her sketches, and showed them to people interested in art. A few liked them, but many were shocked by animal bones and skulls in a picture. Art, according to local standards, should be pretty, something to go well with the color scheme of one's room, and not, as Georgia O'Keeffe's pictures were, a magnifying glass with which to view the world, a reflection of man's image of God, a search for the meaning of life and death.[40]

Canyon people at the time had great difficulty appreciating Georgia's portrayal of Canyon's natural surroundings. Mr. Shirley, on viewing Georgia's abstract rendition of Palo Duro Canyon as a bright red and orange ball, remarked, "Well, you must have had a stomachache when you painted it."[41]

Georgia's appreciation for the local people was minimal. With such a full and varied curriculum of teaching, it is easy to understand that Georgia, with her propensity for nonconforming, did not have the time and did not take much time to develop friendships with the local people.

In Canyon, Georgia never attended church. Although the college expected

her to attend church and to teach Sunday School, she considered the weekends her domain. She accepted few invitations, preferring to spend her time looking at nature and drawing and painting. Organized social interaction became a waste of time for Georgia.[42]

Georgia painted only four known oil on board paintings while in Canyon:

No. 21 Special, oil on board, 13 1/2 x 16 1/4 in., 1916/1917,

No. 20 Special, oil on board, 17 3/8 x 13 1/2 in., 1916/1917,

Red Landscape, oil on board, 24 1/2 x 18 1/2 in., 1916/1917,

No. 22 Special, oil on board, 13 1/8 x 17 1/4 in., 1916/1917.[43]

But she became most helpful and enthusiastic with her students and fellow faculty members. She worked with the students in many capacities.[44] Georgia diligently taught them to observe nature by using all their senses. She probably ordered books and paid for them herself and even gathered up furniture for the classes. The students enjoyed her and her sense of humor. One day she became disgruntled with her students and wrote in large letters on the chalk board, "Will all fools leave the room." After the class quieted one student said, "Who will teach this class?" After Georgia and the students had a hearty laugh their studies continued.[45]

Mattie Swayne Mack, a student in two of Georgia's classes, remembered years later, "She was a good teacher. There was strength in her teaching—she knew what she thought and expressed it." Several years later Mack visited with Georgia at a New York exhibition and asked her what her painting in the exhibition represented. Georgia responded, "Do you like it?" Mack answered that she did. Georgia tartly said, "Then what difference does it make what it is?"[46]

After preparing for and giving a talk to the faculty, Georgia wrote Anita in January 1917:

You know that kind of reading and thinking takes one very much off the earth—So imagine my astonishment to have a mere—ordinary—everyday man pull me out of the clouds with two or three good yanks and knock me down on the earth so hard that I waked up....

I met him at a party Xmas time—Next time I went to town he

followed me around till I was alone then asked if he could come up–I said–No–thinking we had absolutely no interests in common–but he look so queer–I changed my mind right quick and said he could–then held up my hands in holy horror wondering what I'd do–So–The first time he came because I didn't want to hurt his feelings–and the next time because I wanted to explain something I had said the first time–And then my landlady [Willena Shirley, wife of physics professor, Douglas A. Shirley] informed me that she objected to my having any one come to see me at all–and I nearly died laughing because–I had begun to enjoy the problem of trying to talk to him.[47]

Mrs. Shirley had adhered to the propriety of the day and informed Georgia that such behavior was prohibited in her home. Georgia agreed to not pursue the activity again.[48]

Georgia served as guardian of the local Camp Fire Girls. Ura Shotwell, a member of that group, recalled that Georgia invited the girls to her room, which was acceptable. Regardless of Georgia's simple way of dressing, she advised young women on manners, charm, dress and simplicity of dress. Georgia knew the rudiments of such graces but did not adhere to them for herself. Not surprisingly, her teaching of charm and dress was questioned by many.[49]

Emma Jean McClesky Smith, another teacher, ate meals with Georgia at Mary Elizabeth Hudspeth's home. On pleasant weather evenings the girls would take long walks in the neighborhood. To enliven the walking they often imitated the walk of a particular faculty member, with the others trying to guess the identity of the victim.[50]

Georgia recalled in 1965, "Oh, I was a trial to the Normal administrators. I was always doing something unorthodox, but since I was on the faculty they felt they had to support me."[51]

While Georgia taught in Canyon the landscape she saw on her visits to Palo Duro Canyon would have been the same as those seen by the Spanish explorers in 1541, and written about by Captain Randolph Marcy in 1852. With the help of Margaret Seewald, who rode horseback all day long in the canyon to pick out the different spots and name them, the area would become in 1934 the Palo Duro Canyon State Park, and be known as Texas's "best kept secret." Hollywood

discovered Palo Duro Canyon in 1950 with the movie, *The Sundowners*, starring Robert Preston and Robert Sterling.[52]

Today, Palo Duro Canyon State Park consists of 16,402 acres with an additional 7,837 acres added in 2005. Over sixteen miles of winding paved roads join with approximately twenty miles of hiking and horseback-riding trails.[53]

Margaret Harper envisioned an outdoor drama staged in Palo Duro Canyon which would allow people to participate in the arts. Aware of the effect of music on her students and intrigued by an article in *Reader's Digest*, Margaret invited Paul Green, who had written several outdoor dramas, to visit Canyon.[54]

A board of directors formed to include Harper and Margaret Seewald and in July 1966, Paul Green, the Pulitzer Prize winning author, presented his outdoor musical drama, "Texas," in Palo Duro Canyon's Pioneer Amphitheater to showcase the history of the Palo Duro country.[55]

Set amidst the powerful cliffs of the canyon, the drama tells of the early Panhandle settlers symbolically through two men, a rancher and a farmer. As the sun sets, a lone rider appears above the stage on the six-hundred-foot cliff which serves as a backdrop for the presentation. With the audience's gasp, the rider and his horse gallop along the edge of the canyon with the Texas flag rippling behind them to embody the Texas spirit. The stage below fills with singers and dancers who invite "you all to come to Texas." Their welcome precedes cowboys on horses, Native Americans atop rocks, ballerinas enacting a prairie fire, and a Texas-size thunder-and-lightning storm zig-zagging down the canyon. The drama bringing the past to life ends with a grand finale of blazing fireworks.[56]

Georgia's heart would forever belong to the canyon, her third muse. The unexplainable magnetism of the canyon established her sense of place which can be explained as her sense of spirit.

ENRICHMENT

Georgia continued her enrichment at WTSNC by reading and developing friendships. No matter how unconcerned Georgia's reaction to the times, the cultural forces influenced, provoked thought of, and provided a catalyst for accomplishment.

She read, among others, *The Forerunner: A Monthly Magazine*, edited by Charlotte Perkins Gilman, excerpts from Gilman's lengthy essay, "Dress of Women, a Critical Introduction to the Symbolism and Sociology of Clothing," and the writings of Friedrich Nietzsche.[1]

Georgia inscribed the date October 19, 1916, on her 1915 bound set of *Forerunner*, Volume 6, numbers 1–12.[2]

She wrote Anita, October 30, 1916:

Do you ever read the Forerunner? I remember asking you last year–It isn't going to be published after December–but I've been having a great time with the 1915 volume. There is an article "The Dress of Women" in it that is great.[3]

The Forerunner was founded and edited by Charlotte Anna Perkins Stetson Gilman (1860-1935). Gilman, the great-granddaughter of theologian Lyman Beecher, began her life in Hartford, Connecticut. Her father abandoned the family and poverty dominated her early years. Her irregular education, due to frequent moves, led her to attend the Rhode Island School of Design. She started her literary life in the 1890s with the publication of her poetry, short stories, social analysis, and as a lecturer. Her book, *Yellow Wallpaper*, published in 1892, related her personal depression in a journalistic style of nine short entries. She described her treatment as harmful because of the existing social structure that aborted women's growth to keep them submissive. She followed this by writing three other books on related topics of feminist views. Her 1898 book, *Women and Economics*, encouraged women's financial independence from men by supporting day-care programs and community kitchens. Gilman explored other feminist ideas when she founded the magazine.[4]

The Forerunner stressed the need for social reorganization. As a leading theorist of the women's movement, Gilman proposed that the maternal and sexual role of females had long been overemphasized to the point where their social and economic abilities were hampered. She reasoned that only economic independence could result in true freedom for women.[5]

Floyd Dell, in *Women as World Builders*, described Perkins:

> Of the women who represent and carry on this many-sided movement today,...she is, to a superficial view, the most intransigent feminist of them all, the one most exclusively concerned with the improvement of the lot of women, the least likely to compromise at the instance of man, child, church, state, or devil.[6]

Then in November 1916, Georgia wrote Anita:

> Charlotte Perkins Gilman on "The Dress of Women" its in Volume VI of The Forerunner—Its absurd—I sit here trying to think what I've read—and—I don't know—it seems that it has been poetry—but I don't know—[7]

Georgia's additional reading involved Friedrich Nietzsche's works which introduced her to the way art and music related. One appeals to the eye, the

other to the ear, both leading to the heart under the power of creativity.

Music as symbolism progressed under the tutelage of two German philosophers, Arthur Schopenhauer (1788-1860) and Friedrich Nietzsche (1844-1900). Each in separate theories remained faithful to the same principle of dynamism, the theory that all phenomena of matter or motion can be revealed in variation and contrast in force or intensity.[8]

To know a "modern thinker," the setting within which he developed must be explored. Friedrich Nietzsche, the nineteenth-century German philosopher, had a fine education in a strong tradition of clerical ancestors. After his father's death in 1849, Nietzsche, at age five, was raised in a household of mostly women. In 1864, at the University of Bonn, he began studying theology and classical philology, the study of historical linquistics. At Bonn he sought refuge in music from the ongoing quarrels between his two classics professors, Otto Jahn and Friedrich Wilhelm Ritschl.[9]

In 1865 Nietzsche transferred to the University of Leipzig where he met again with Ritschl who had joined the Leipzig faculty. He prospered under Ritschl's tutelage. Here he discovered Arthur Schopenhauer's philosophy and the music of composer, Richard Wagner.[10]

In 1867 Nietzsche embarked on a military career but in 1868 suffered serious chest injury. He continued his studies at Leipzig while on extended military leave. In 1869, Ritschl recommended Nietzsche to a professorship at the University of Basel which featured classical philology. An interruption in 1870 to serve in the Franco-Prussian War led to his contracting dysentery and diphtheria, which ruined his health. Returning to Basel to continue his relationship with Wagner opened his eyes to the great possibilities existing in human nature. From Wagner's greatness he observed that Wagner's artworks were derived from the composer's need to dominate others. Nietzsche concluded that even the most sincere person remains an actor; that pettiness and greatness can exist simultaneously in the same soul; that love and hate exist as opposites of the same emotion. During these years his friendship with Wagner ripened until Wagner's exploiting of Christian motifs, chauvinism, and anti-Semitism became too much for Nietzsche.[11]

Nietzsche also believed that real philosophers create new values with foresight to dominate the future, thereby being responsible for the destiny of man. This

distinguishes them from those who claim to be philosophers but deal only with the past. In former times those who dealt with the past removed themselves from responsibility by transferring the deeds to a supernatural authority. Nietzsche's major theme is that there is no evidence for the Christian God.[12]

Nietzsche's beliefs summed up: all life evidences a will to power which enables the better understanding of human behavior; men want power over themselves and their creative mastery; more brutal forms of power are only substitutes; hopes for a life after death is compensation for failures in life on earth; heaven is an illusion and god worship in the beyond should be eliminated and man should concentrate on his own elevation which he calls superman which is the man of passion who uses his passions creatively instead of destroying them.[13]

Nietzsche's first book, *The Birth of Tragedy from the Spirit of Music*, published in 1872, freed him from classical scholarship as he anticipated the twentieth century discovery that the making of symbols in dreams, myths and art evolved into a needed, even an automatic human endeavor.[14]

The true value of Georgia's probable reading of *The Birth of Tragedy* was in Nietzsche's philosophy as a whole: that creation is produced by contest, and the creative force is passion, controlled and redirected.[15]

Throughout the history of music, its emotional aspect embraces the proposition that music is capable of sparking a variety of specific emotions within the listener. By using a variety of music forms, the composer can elicit involuntary emotional responses from the listener. Large intervals bring joy, small intervals relate to sadness, while a rough harmony with a rapid melody arouses fury and obstinacy is evoked by highly independent melodies.[16]

The design and structure of such musical elements can be compared to painting elements, such as balance, harmony, contrast, dominance, rhythm, center of interest, progression, repetition and unity. The conceptualizing of music into art became unadulterated joy for Georgia.

After Nietzsche's death in 1897, preceded by a mental collapse in 1889, his sister, Elizabeth, was responsible for associating Nietzsche's name with Adolf Hitler. After the death of Elizabeth's husband's, Bernhard Förster, a leading exponent of chauvinism and anti-Semiticism, she worked tirelessly to fashion Nietzsche into Förster's image. Her enthusiasm for Hitler linked Nietzsche's name in the public's mind with the dictator.[17]

From this concept probably arose the episode at a WTSNC service where Dr. R. B. Cousins, president of the college, addressed the faculty and students by speaking quite negatively about Nietzsche's philosophy. Georgia's reputation with the faculty evolved into conflicting attitudes as she interrupted Cousins to ask if he had ever read Nietzsche. Cousins replied that he had not read any of the philosopher's work and did not intend to do so. It became obvious to Georgia that Cousins knew only enough about Nietzsche to side with the sister's representation of the philosopher's work. This uncordial reported event obviously did not endear Georgia to the president.[18]

In October 1916, Georgia wrote Anita,

We had faculty meeting this afternoon and it was great—You would die laughing—I wanted to say some things so bad that I almost died. The president is a nice little man—I'm going in and tell him the things I wanted so much to say today—next Tuesday. Anita—he is Methodist—I seem to be doomed to work with them—he is really nice though—I like him—[19]

In a speech to the faculty, Georgia's explanation of art received a positive reception. Afterwards she answered many questions which indicated the faculty's appreciation of her knowledge and passion for art.[20]

Interspersed with her own drawing, sending drawings to Stieglitz, teaching and developing friendships, Georgia recognized the need to help all the students when the activity related to art. She even lent her skills in preparing backdrops for the student-produced senior play.[21]

According to the 1916-1917 yearbook, Le Mirage, the Dramatic Club, with James Warren (Ted) Reid as president for the fall quarter, presented on November 6, 1916 two plays: The Obstinate Family, by Werner, and The Nettle, by Ernest Warren, with Reid as the leading man. A senior girl wrote of Reid in Le Mirage, "Stars in our midst."[22] See figure 13-1.

Georgia wrote Anita in November 1916:

I've been making scenery and stage stuff all day it seems—no it almost seems always—

The stage is big—dark purple red velvet curtain—and Ive had the darndest time to make it hitch with some dirty tan scenery for a room—The

principal girl is wearing the brightest red dress you can imagine—

I have had about six boys and three girls slaving like mad all afternoon— we made long windows that open out with little panes—curtains—table covers-flower pots—bags—pillow tops—really great fun and they all work so hard—Two short plays—one mostly in red—the other green—[23]

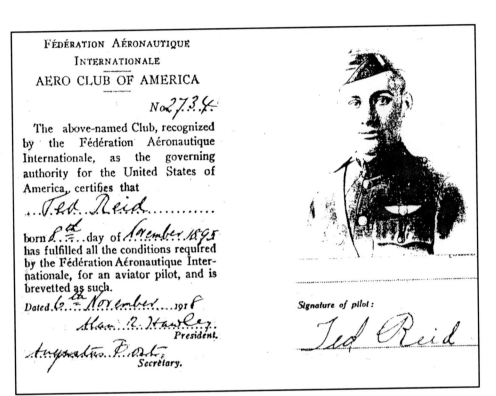

13-1 *Ted Reid*

One day while working the backdrops she stood by a window looking at the rain falling as the six-foot-tall, lanky Ted Reid stood by. Ted was from Tulia, Texas, near the Briscoe-Swisher County line. Reid's father had followed the westward movement from Wise County, Texas, when the big ranchers owned all the land. Among them was the Four Sixes Ranch, founded ca. 1870 by Samuel "Burk" Burnett as a nineteen-year-old cowboy with one hundred cattle, which eventually amassed 448,000 acres. Today the cattle and horse ranches

with their oil royalties are owned and operated by Burnett's great-granddaughter, Ann Burnett Windfohr Marion, who founded and funded the Georgia O'Keeffe Museum in Santa Fe. The Land Law of 1887 prompted Reid's father to file on a section of land for a $16 filing fee with forty years to pay. The Reids raised enough feed for their livestock to be called stock-farmers. Ted commented, "If within one hundred miles of George Reid, you worked...." Ted busied his youth shipping cattle for his family and taking them on long drives, which gave him first hand knowledge of the plains, how the wind blew, how the rain fell, and an appreciation of its beauty.[24]

Reid, who had been elected vice-president of the senior class in the fall of 1916 and was in charge of the play's lighting, saw Georgia standing there by the window. He approached her silently and placed his arm around her, indicating that he, too, enjoyed watching the rain. Instead, startled, Georgia pulled away and left the room.[25]

Years later Reid commented, "Did you ever see her watch a great storm? There was never anyone in the world like her in her appreciation of such things."[26]

Georgia would recall these great storms on the Texas prairie with her bold zigzags. Georgia commented later,

Color out of the tube—red and orange to lemon—It shocks me so that Im rather struck with it—I don't know what it will get to.[27]

Georgia's interest in the plains revealed itself later in her painting as she presented her concept of "visual music," when she attempted to convey the sound of cows lowing in the cattle pens by the railroad tracks: *Series I–From the Plains,* oil on canvas, 27 x 23 in., 1919.[28]

Recalling from memory, she revisited the storms seen at Canyon when she painted:

From the Plains, oil on canvas, 48 x 84 in., 1952/1954,
From the Plains, II, oil on canvas, 48 x 72 in., 1954.[29]

Georgia later became better acquainted with Ted, whom she soon discovered

shared her sensitivity for the natural setting. Ted was one of a few students having a car at college, and Georgia, not having a car, enjoyed Ted's driving them into the country to see first-hand the colorful scenery and to paint.[30]

The mores of the times did not permit such student-faculty relationships. Some faculty members reminded Ted of the appearance of their conduct. Ted, fearful that his conduct would be reported and his graduation canceled, and fearing for Georgia's dismissal from the college, ended their friendship. He graduated from WTSNC in 1918, and on June 18, 1918, after four hours and forty-eight minutes of instruction, made his first solo airplane flight. No one then received a pilot's license. Someone just showed him how to fly and he took off when he could. Ted was commissioned a Second Lieutenant on August 20, 1918, and served as a pilot in World War I and World War II. Some thirty years later, on May 14, 1946, at her Museum of Modern Art (MoMA) exhibition in New York, Ted explained to Georgia the abrupt ending of their friendship.[31]

13-2 Ruby Fowler

The talk of a romance between thirty-year-old Georgia and twenty-three-year old Ted Reid was most unlikely according to his son, J. W. Reid, because at the time Ted presented himself as going steady with his future wife, Ruby Fowler, a student at WTSNC, whom he married in 1918.[32] See figure 13-2.

Ruby took a course with Georgia in interior decoration in 1916 or 1917.[33] Many years later, she visited Georgia in New Mexico. See figure 13-3.

Ruby recalled, "Miss O'Keeffe as always dressed in black with her hair pulled back. Her shoes were flat, mannish, heavy walking shoes." Ruby recalled the "freedom of creativity Georgia allowed and encouraged" and "that some faculty and townspeople were highly critical of Miss O'Keeffe's nonconformity and Bohemian ways."[34]

13-3 Georgia and Ruby Fowler

Georgia's exposure to reading continued when in November 1916 Stieglitz sent her a copy of Clive Bell's 1914 book, Art. She was already familiar with the book, which promoted abstract art. Georgia, however, had already embarked on abstraction.[35]

Along with reading, Georgia often rode to Palo Duro Canyon in a car, but she didn't hesitate to walk anywhere, buffeted by the wind in Canyon, to the admiration of the townspeople.[36] She was not afraid to interpret the wind as inspiration, not irritation, as the gusts ruffled her hair and shook her clothes. Georgia adjusted by accepting the wind as another part of her life and, like everyone else, simply leaned hard into the wind.[37] The wind swept away her Virginia hollyhock sketches one day while she was walking in Canyon.[38]

Georgia discovered, with her students, that if she ran against the wind with some pine branches in her hand, she could hear the branches sing—music to her ears.[39]

She later told her friend Anita Pollitzer:

> I belonged. That was my country—terrible winds and a wonderful emptiness.[40]

The winter months brought Georgia's recollection that the snow falling in Palo Duro Canyon never hit the canyon floor because of the ferocious wind.[41] Georgia wrote Anita in December 1916:

> Last Sunday went to the Canyon in a tearing norther—snow flying and bitter cold—It was terrible—but great.[42]

Enamored with the bleak, uninhabitable plains full of sand, wind, blue northers, extreme heat and cold, Georgia often awakened before dawn to watch the sunrise. Many times she walked to the train station to watch the trains arrive and depart, loaded with mournful, rhythmic lowing cattle, which she related to music. She often walked to the west for the radiant light of the evening sunset. The evening star, Venus, would always hold her attention. Even the town lights provided a sight to see. Many of these sights became subject matter for her abstract paintings as she simplified nature's forms. [43]

In January 1917, Georgia endeared herself to the faculty when she spoke on modern art. Using her readings of Willard Huntington Wright, Clive Bell, Wassily Kandinsky and Arthur Jerome Eddy, she presented a talk, to her surprise, to a receptive audience, which ignited a spark of interest in modern art. Afterwards the faculty asked many questions, showing their appreciation of her knowledge. They asked for another talk. Although that talk consisted of different subject matter, the speech to the faculty must have reminded Georgia of Ida's speeches to the Twentieth Century Club in Sun Prairie, reminiscent of a mind eager to read, discover, absorb and interact.[44]

Georgia to Anita, January 1917:

> I had to give a talk at the Faculty Circle last Monday night—a week ago yesterday—So I had been laboring on Aesthetics—Wright—Bell—DeZayas—Eddy—All I could find—everywhere—have been slaving on it since in November—even read a lot of Caffin—lots of stupid stuff—and other stuff too—Having to get my material into shape—Modern Art—to give it in an interesting 3/4 of an hour to folks who know nothing about any kind of Art—Wed—I worked like the devil—and it was a great success—You see—I hadn't talked to the Faculty at all and I was determined to get them going—They kept me going all through the time allotted to the man who was to come after me and an hour after it was time to go home—and some of them wanted me to talk again next time—It was fun—I planned to say things that would make them ask questions—Really—I had a circus. It was so funny to see them get so excited over something they had doubts about the value of—[45]

Georgia again wrote Anita, February 19, 1917, Sunday afternoon:

> One of my boys—told me yesterday that Art—meaning—Painting—Sculpture—Architecture—A fine pattern—a fine chair or a table—is just another way of expressing yourself—saying what Life is and means to you—I asked the class—about 20 freshmen—the end of three months work—he is bashful about 19—green eyed—such a nice smile—held up his hand and volunteered that—Had I taught him anything? I was astonished—and wondered if what I had taught him was right.[46]

In February 1917, Georgia sent Stieglitz more of her work that she thought of as landscapes, she would later reinsert the same forms into other work:

No. 12 Special, charcoal drawing on medium thick, cream, moderately textured laid paper, 24 1/8 x 18 1/2 in., 1915 of mostly circular lines,

No. 14 Special, charcoal drawing on medium thick, cream, moderately textured laid paper, 24 3/4 x 18 3/4 in., 1916 of strong diagonal lines.[47]

Steiglitz began promoting Georgia by submitting these two works of art to the First Annual Exhibition of the Society of Independent Artists, which opened April 10, 1917, at Grand Central Palace in New York.[48]

Stieglitz's dedication to Georgia was not sidetracked by the threatening world events that had been looming since May 1915, with the sinking of the *Lusitania.* President Woodrow Wilson had held to his neutrality position until Germany attempted to convince Mexico to take action against the United States. On April 6, 1917, the United States declared war on Germany.[49]

On April 3, 1917, three days before Wilson's declaration, Stieglitz opened the first solo exhibition of Georgia's oils, charcoals, one sculpture and her Texas watercolors [50]

Included in the exhibition was: *Blue I,* watercolor on moderately thick, cream, slightly textured laid paper, 30 7/8 x 22 1/4 in., 1916."[51]

Georgia painted *Blue I,* in Texas or Virginia. This swirling mass of blue that turned into a spiraled center, later evolved into other configurations such as:

Abstraction, Blue, oil on canvas, 40 x 30 in., 1927,

Pink Abstraction, oil on canvas, 36 x 30 in., 1929,

Dark Iris, oil on canvas, 32 x 12 in., 1927.[52]

In May 1917, Georgia visited New York to see her exhibition, "Georgia O'Keeffe," but Stieglitz had already dismantled the exhibition. He kindly rehung the paintings for her precisely as they had been in the exhibition.[53]

The gallery was in its last days because its pioneering work of recognizing artists had been accomplished. Immediately after the exhibition, Stieglitz closed 291. Not to be overlooked was the looming war and the depletion of Emmeline's finances.[54]

During Georgia's June 1917 visit to New York, Stieglitz began photographing Georgia's angular body. He made four photographs: the first in a dark dress with a white collar, wearing a dark hat and posed in front of her painting, *Blue I*; the second in the same dress without the hat, posed again in front of *Blue I*; the third showed only her two forearms and hands, again in front of *Blue I*; the fourth in the same dress, showing only her torso with her two hands posed delicately in front of her.[55] These photographs were the beginning of what he had hoped to accomplish with his wife, Emmeline, and then with his daughter, Kitty. Stieglitz's idea of a true portrait, as mentioned earlier, involved not one portrait but a series of portraits beginning at the birth of a child and continuing through the subject's adult life.[56]

When Georgia returned to Canyon in June 1917, Stieglitz sent her the photographs he had made of her. Her students were privileged to see the master photographer's earliest portraits of Georgia.[57]

Through Stieglitz's legendary photography series that numbered over five hundred and which ended in 1937, Georgia gave only what she wanted to give and gave what could be considered a still photography performance showing the masks of a clown, a madonna, a waif and a romantic (cleverly concealing sexiness, intelligence, aloofness and style), all as an object or subject in various states of dress and undress and all in a mood only surface-deep. They could be called "poetic pinups."[58]

Shortly after the opening of the May exhibition, the wife of one of Steiglitz's investors in his gallery, Mrs. Jacob Dewald, bought for $400 from Stieglitz one of the drawings Anita had shown him in 1916, unbeknownst to Georgia: *Train at Night in the Desert*, charcoal drawing on moderately textured paper, 24 1/4 x 18 1/2 in., 1916.[59]

An easy assumption can be made that when Georgia sold her first piece of art, eighteen years after she declared that she wanted to be an artist, her work was taken seriously. As others were to invest in her, she now wanted to invest in herself by learning more skills.

In June 1917, Georgia returned to teach summer school in Canyon. According to the "Bulletin of The West Texas State Normal College, Summer Session for the College and Summer Normal for the Teachers, 1917," Georgia taught:

21. Design (One unit. W. Th. F. S.) Simple exercises in space-filling: line, tone, and color are given with the aim of developing an appreciation of the qualities that all great works of art have in common. Readings required in Dow's *Composition* and Rheinach's *Apollo*, with references on *Primitive Art*.

33. Public School Drawing. (One unit. T. Th. F. S.) This course is a study of public school drawing and the means of presenting it. Required reading in Dow's *Theory and Practice of Teaching Art* and Dow's *Composition*.

41. Costume Design. (One unit. T. Th. F. S.) Line, tone and color will be studied in relation to costume. Some *History of Costume* and Dow's *Composition* will be required readings.[60]

The Bulletin scheduled Georgia to teach Drawing 33 from 9:30 a.m to 10:15 a.m. and Drawing 21 from 11:45 a.m. to 12:30 p.m. There was no listed schedule for Costume Design.[61]

Georgia is also listed as teaching for the Normal College: Drawing 44 from 12:30 p.m. to 1:55 p.m. and Reading 11 from 2:50 p.m. to 3:35 p.m.[62]

With such a full course of teaching, a natural conclusion to the summer was a vacation—time to refresh the spirit.

DISCOVERING NEW MEXICO EARTH AND SKY

"The desert, the ocean, high mountains–these are my world."
–Georgia O'Keeffe.

Anita Pollitzer wrote Georgia from New York City on February 14, 1917, "I don't know why I am so very tired. I want to go West." Five days later Georgia wrote Anita, "Why dont you come West this summer. Come in August when I have my vacation and we will go to Colorado–Wish you would–"[1]

When Anita did not come, Georgia fulfilled her promise to her sister, Claudia, for a trip of Claudia's choice. Before the fall semester, Claudia declared Colorado their destination. Due to the unusually heavy rains, the bridges north of Canyon were washed away the very day they planned to depart. To get to Denver they routed themselves west through New Mexico which allowed Georgia her first sighting of New Mexico, "The Land of Enchantment."[2]

Georgia's liking for the West came not only from her background but perhaps from following the travels of Arthur Wesley Dow. In 1911, Dow, on a leave of absence from his position at Teacher's College, traveled to the Grand Canyon.

From this dramatic, inspirational landscape, Dow's painting became more masculine and more grand and his palette brightened. In his sketchbook, which served as his diary, he wrote, "The Grand Cañon and the old pines and cedars should not be painted for themselves but to express emotion. Express this emotion by mystery of line and Notan." He continued:

> You asked what attracted me most to the Grand Canyon so far from my New England marshes. Color, first of all—color, "burning bright"; or smoldering under ash-grays. Then, line—for the color lies in rhythmic ranges, pile on pile, a geologic Babylon. This high, thin air is iridescent from cosmic dust; shapes and shadows seen in these vast distances and fearful deeps, are now blue, now vibrating with spectral hues. At sunset the "temples" are flaming, red-orange—glorified like the Egyptian god in his sanctuary.[3]

Dow executed thirteen paintings from this trip to the Grand Canyon. Of his experience, he wrote Kenyon Cox, "At the Grand Canyon...I wanted to paint alone every morning.... I simply had to be alone when I tried to paint such overpowering tone and color."[4]

By coincidence, in 1917, the same year Georgia discovered New Mexico, Dow again visited the West and followed his advice, "The art lies in the *fine choices*, not the truth, likeness to nature, meaning story-telling or finish."[5]

This New Mexico land, Georgia's fourth muse, began its history as a prehistoric sea which over millions of years invaded and retreated to form volcanos, deltas, deserts, mountains and faulting. All these changes of uplifts, folds, erosion, drainage and faults built one upon the other to evolve into today's landscape.[6]

About 10,000 years ago the Native Americans discovered New Mexico. Two groups touched the land forms: the agrarian, earlier groups and the later, aggressive, nomadic Navajo and Apache peoples. Through the centuries each established settlements.[7]

The recorded history of New Mexico began with the same explorers as in Texas when Alvar Núñez Cabeza de Vaca and his expedition followed the Indian trails on foot and made their 10,000 mile journey, ending in Mexico City in 1536. Legend is uncertain as to whether they reached New Mexico. But their tales of the Seven Cities of Cíbola inspired the Spanish Coronado

Expedition in 1540. Coronado discovered not cities of gold, but pueblos of earth-colored adobe mud. These farming communities experienced the life along the river as a continuing thread for all of the peaceful natives living on the Rio Grande.[8]

Juan de Oñate (ca. 1550–ca. 1630), brought Spanish settlers accompanied by the Spanish language, crucifix, missionaries and priests. Settling in 1598 at the confluence of the Chama River and Rio Grande, they renamed the existing Tewa village from Yungue to San Gabriel del Yungue.[9] Their capital was later relocated in 1610 to Santa Fe, the present capital of New Mexico.[10]

Oñate's second expedition led him to the plains surrounding the Canadian River where he attempted unsuccessfully to capture specimens of buffalo. He found the Native Americans quite hospitable and trudged as far as Wichita, Kansas. Oñate ended his explorations peacefully for the time being in New Mexico and deemed the Texas Panhandle as "hinterland."[11]

Spanish government affairs originated at *El Palacio* (the Palace of the Governors) and did not treat the Native Americans well as they were told to relinquish their own beliefs. In 1680 a Pueblo revolt drove the Spanish from New Mexico. Twelve years later the Spanish, with Diego de Vargas, reconquered New Mexico. The Spanish confirmed the Native Americans' land ownership with royal grants which still today form the basis of ownership. The Spanish empire disintegrated and in 1821 Mexico, with New Mexico as a political entity, broke with Spain. The Mexican government legalized trade with Missouri River towns and shortly afterwards the first annual caravan left Missouri for Santa Fe resulting in the Santa Fe Trail.[12]

The Republic of Texas claimed the Rio Grande as its western boundary. Encouraged by the lucrative Santa Fe trade, Texas invaded New Mexico in 1841, only to be defeated.[13]

When the United States declared war on Mexico in 1846, General Stephen Watts Kearney captured Santa Fe. The citizens of Santa Fe were pleased to become United States citizens. Kearney organized New Mexico as a territory of the United States in 1850, with Governor Bent its first territorial governor. The United States admitted New Mexico to the Union as the forty-seventh state with Santa Fe as its capital in 1912, a mere five years before Georgia's arrival.[14]

Santa Fe lies east of the southern end of the Sangre de Cristo Mountains that extend southward from Colorado and west of the Rio Grande as the flow

meanders from Colorado, well marked by a line of cottonwood trees, through New Mexico, and borders Texas to the Gulf of Mexico.

With their stop in Santa Fe, Claudia saw what she had studied in history class and Georgia discovered her fifth muse, Santa Fe.[15]

Georgia had taken a giant step when she placed all her experiences together end to end into her future when she discovered this unknown territory. Again, an awakening jolt triggered her sense of place, her true place, where life made sense and she didn't ask why. Georgia's connection to the place became evident, but certainly she didn't expect her heart to rejoice so. The heartfelt celebration moved her forward. This curiosity and knowledge at the first sighting of Santa Fe and its environs was valued because of its usefulness—the fertile soil translated into a fertile mind.

Georgia became fascinated with New Mexico's sky, the ever-present intense light, the contrasting scale, and the varied earth colors so intense that the colors had no choice but to soften at sunset, all an entrancing sight. The passionate attraction to the colors, forms, and bigness, which meant no visual limits of a beginning or ending, remained unexplainable to anyone who had not actually been in this country.

Georgia recognized that she had been presented with a mental map, a mental guide that would structure how she perceived the world. This map was a result of her childhood, her education, where she lived, and the times in which she lived. It provided the borders of how to get where she wanted to go and showed her what roads to take. With a certain amount of hope and some ignorance of what she had seen, she added her determination and was aided by good fortune to be in the right place at the right time.

Her first trip to see the multicolored land began innocently as a way of arousing emotional invigoration. Many more journeys of leaving and returning to New Mexico passed before this delight turned into her recognition of New Mexico as the way. The simple transposed enjoyment closed her mind and heart to other options. Georgia was one of those people who excelled at returning to the simple pleasure of living in New Mexico, rather than leaving.

Although Georgia never embraced the Spanish language, an old Spanish term applies, *querencia*, meaning affection, fondness, and favorite spot. *Querencia* could easily mean the place that Georgia was mysteriously drawn to, where she felt at home, where her soul felt comforted and where her heart felt joy. Many

recognized the quality of light, the colors, the land forms, but it's the feeling that captured her heart and soul—*the querencia*.[16]

Georgia and Claudia's arrival in Santa Fe gave them easy access to the Palace of the Governors which had been the center of activity in Santa Fe since its erection in 1610-1612. Built by the Spanish as the seat of their frontier government, the building included four-foot-thick adobe walls, long galleries, small rooms and a secure courtyard. The original Territorial architecture had been transformed in 1913 into its current Pueblo Revival style of architecture. Through the doors of this oldest continually occupied public building in the United States had passed Spanish soldiers, Native Americans, Mexican governors, United States military men, Confederate soldiers, New Mexico territorial governors and travelers on the Santa Fe Trail.[17]

Georgia and Claudia missed by several months the formal opening of the Museum of Fine Arts in November 1917. Before the opening, the Museum housed its art and relics of the past at the Palace of the Governors. Dr. Edgar L. Hewett, founder and first director of the museum, realized the need for more space as artists arrived from foreign countries and from the United States such as Robert Henri and William Penhallow Henderson. In 1915, the Panama-California Exposition in San Diego, commemorating the opening of the Panama Canal, featured the New Mexico Building as a replica of the Mission Church at Acoma, approximately seventy miles southwest of Santa Fe. A replica of this San Diego building provided the basis for the architecture of the Museum of New Mexico Fine Arts building. The "Old Barracks Site" which had been part of Fort Marcy in Santa Fe, became the preferred site. The selected site and style led Colonel José D. Sena to make an impassioned speech opposing the proposed new museum:

> How many of the children of our city would become artists and derive material benefit from the art gallery? Are you not aware that an exceedingly small percentage of the citizens of this great government of ours can and do dedicate themselves to art, and then those that dedicate themselves to that profession, many become subjects of the poor house?[18]

As the opposition subsided and the site was prepared, the discovered relics at the "Old Barracks Site" provided proof that it had been a Native American pueblo. Despite the beginning of the United States participation in World War I

in April 1917, and the delay of building materials, the museum's dedication on November 25, 1917, attracted 1,200 people. "It was a solemn moment when Dr. David R. Boyd, president of the University of New Mexico, invoked the divine blessing upon the house that had been builded, upon the builders and the donors, upon the commonwealth and its people, upon the young men fighting the nation's battles and the leader in the White House standing watch in the tower. The audience remained standing and joined in the singing of 'America' with a fervor that came from the heart...." Dr. Hewitt spoke at the opening reflecting on his pride in the museum during the frightful World War I years. He said, "We feel that our people here in the Southwest do have a life in keeping with the soil, the skies, winds, clouds, spaces—that they have ordered their lives in honest, simple harmonious ways." The opening featured three hundred canvases of important New Mexico artists, such as Henry Balink, George Bellows, Oscar E. Berninghaus, Paul Burlin, Robert Henri and Carlos Vierra. Gerald Cassidy's *Cui Bono*, oil on canvas, 93 1/2 x 48 in., ca. 1911, was displayed at the opening and today still hangs in the museum.[19]

That August 1917, Georgia and Claudia traveled from Santa Fe to the southwest corner of Colorado. Their stop: Silverton, in San Juan County, deeply ringed by the mighty San Juan Moutains, known as America's Alps, towering at 14,000 feet elevation.[20]

Southwestern Colorado, before the explorers arrived, was occupied by Native Americans who lived in cliff dwellings known today as the Mesa Verde National Park. In 1776, the Utes owned no horses and lived in small clans. After acquiring horses, the Utes became nomadic and warlike. By 1873, the shrinking Ute nation numbered only 3,500 to 4,000. Fredrick W. Pitkin, a Silverton prospector who would become Governor of Colorado, led a campaign to rid the area of the Utes. The resulting 1874 Brunot Agreement with the Utes opened this land where "the miles stand on end" to mining prospectors. At that time, roads that led to Silverton weren't passable for wagons or stage coaches. When the toll roads, the first important innovation in transportation to the area, pushed through the passes, the miners came in droves from Denver and Abiquiu to extract the silver ore at the rigorous elevations over 12,000 feet above sea level. The second transportation innovation arrived in 1882 when the Denver and Rio Grande Railway extended from Durango to Silverton. By the turn of the century, Silverton had become the destination of four separate narrow-gauge railroads.[21]

The same year that the railroads came into Silverton, W. S. Thomson, an Englishman, visited Silverton to check on his mining interests. With his unlimited vision of a hotel in this raw land, and with his own financing from a fortune made supplying the royal family with perfume, Thomson began construction on the Thomson Block, known as the Grand Hotel in Silverton. The four-story stone and native brick building, with its handsome entrance door with a knob bearing the Colorado state seal, had its grand opening on July 1, 1883. "The Home of the Silver Kings" brought the comforts of the metropolitan East to the Western Slope. The fine example of Victorian architecture complete with French plate-glass shop windows on the street level, round-top windows on the second floor, and a mansard roof, housed on the ground floor an emporium, haberdashery, dry goods shop and two hardware stores. The lobby featured chocolate- and cream-colored woodwork. The cherry-wood bar in the saloon came around Cape Horn on a windjammer to San Francisco, then to Silverton in three pieces by train and covered wagon. The dining room, adjacent to the lobby, seated one hundred people and provided an inviting appearance to the fashionable guests. The first floor consisted of public rooms, the second floor had eighteen large rooms, and the third floor had thirty-eight sleeping rooms with three bathrooms. The basement featured a ballroom.[22]

Silverton and the nearby boom towns mined millions and millions of the earth's richest ore out of the treasure house of mines clinging to the mountain sides. Almost everyone living in Silverton owned a mine claim or a mine. Between 1895 and 1908 the population of the San Juan County peaked at 5,000 and mine production averaged $2,500,000 each year. The boom continued at a slower pace, $1,800,000 through 1918.[23]

When the Silver Bust of 1893 hit, the surrounding mining towns turned into ghost towns. Silverton survived the bust as the "mining community that never quit." Hollywood eventually discovered Silverton with the motion pictures, *Ticket to Tomahawk* in 1949, and *Around the World in 80 Days* in 1956.[24] One narrow-gauge railroad remained and today makes the same run, bringing hundreds of tourists through the canyon of the *Rio de Las Animas*.[25]

Among the "Swiss Alps of America," Georgia and Claudia arrived to escape the Texas heat. They probably stayed at the Grand Hotel and as the owners changed and renovations continued, in 1920 it became the Imperial Hotel, and finally in 1952 the Grand Imperial Hotel.[26]

As the vacation continued in the mountain coolness, Georgia traveled as far north as Ward, approximately forty miles northwest of Denver.[27] See figure 14-1.

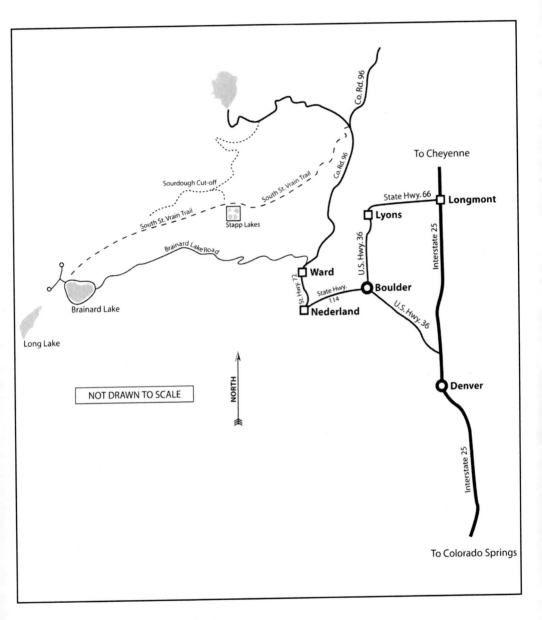

14-1 Map of Ward, Colorado, Area

Ward, named after Calvin Ward who located the first silver claim in 1860, boomed with the discovery of the Columbia silver vein which produced more than five million dollars in its heyday with a population varying from four hundred to one thousand over the next forty years. The first train known as the "Whiplash and Switzerland Trail," arrived in 1898 with "wild celebration, lasting for days." It was so named because of its twisting, steep twenty-six-mile climb from 4,100 feet above sea level at Boulder to an elevation of 9,450 feet. As access to the silver mines became easier, as many as two hundred fifty people rode the train every day to and from Ward. In 1901 a fire burned fifty buildings, causing $90,000 in damage. The residents drenched the schoolhouse and the Congregational Church with water to save the buildings. Ward was quickly rebuilt. In 1911, the Stanley Steamer Mountain Wagons brought tourists to Ward.[28]

Georgia painted the Congregational Church in Ward: *Church Bell, Ward, Colorado*, oil on board, 17 x 14 in., 1917.[29]

In this same locale she painted: *Untitled (Colorado Landscape)*, watercolor on moderately thick, cream, rough laid paper, 11 1/8 x 7 1/2 in., 1917.[30]

While in Colorado, Georgia also painted a series of watercolors:

Pink and Green Mountains No. I, watercolor on paper, 9 x 12 in., 1917,

Pink and Green Mountains No. II, watercolor on paper, 9 x 12 in., 1917,

Pink and Green Mountains No. III, watercolor on moderately thick, cream, smooth wove paper with a slightly fuzzy feel, 8 3/4 x 12 in., probably painted August 23, 1917,

Pink and Green Mountain No. IV, watercolor on paper, 9 x 12 in., 1917,

Pink and Green Mountains No. V, watercolor on paper, 9 x 12 in., dated August 23 and noted as Stapp Lake near Ward.[31]

At Long Lake in 1917, Georgia painted:

Untitled (Long Lake, Colorado), watercolor and graphite on moderately thick, cream rough laid paper, 11 1/4 x 7 5/8 in., 1917,

Untitled (Long Lake, Colorado), watercolor on paper, 8 1/2 x 11 1/2 in., 1917.[32]

Leaving Colorado, Georgia and Claudia entered northern New Mexico. Miles into the state they could easily see Black Mesa, a volcanic table of a thin, horizontal lava flow at the southern end of the Taos Plateau. As they reached the top of the alluvial fans that form the foothills of the western side of the Sangre de Cristo range, the light-colored, sandy hills appeared deeply channeled by mountain streams.[33] Again, they reached Santa Fe to enjoy its culture.[34]

From Georgia's birth, the combination of circumstances stimulated her to always seek new routes. Whatever her motives—to escape the Texas heat, to take care of Claudia, to feed her curiosity—these new expeditions presented new lands that filled her mind. The bigness Georgia felt in Texas now joined with the discovery of the vastness of New Mexico, her fourth muse.

A similar muse existed for Virginia-born Willa Sibert Cather (1873-1947) when she visited the Southwest from 1912 onward. Cather, as a young child when offered assistance, insisted, "Self-alone, self-alone." At ten years of age, Cather moved from a traditional lifestyle in Virginia to Nebraska where the houses "clung to the prairie sod." Cather's visits with the pioneer women revealed to her that "they told me so much more than they said—as if I had actually got inside another person's skin." By thirteen, Cather was an active writer which eventually led her to become a professional. She graduated from the University of Nebraska in 1895. After some successful teaching and writing, she moved to New York to become the managing editor of *McClure's Magazine* from 1906 to 1912. Cather visited New Mexico in 1912, and her discovery of not only the terrain but the pioneering spirit led her to write of the courage of early pioneers who reminded her of her youth in Red Cloud, Nebraska. With simplicity and charm through so many of her novels, she speaks of the courageous spirit of the pioneers and her struggle to emerge with her talent intact from her conforming life on the prairie and in small towns. She returned to her New York home with enough material for many novels on the pioneers who were mastering the soil, among them *O Pioneers!* and the Pulitzer Prize winner, *One of Ours*, the story of a Nebraska boy who served in World War I. After World War I, disillusionment resulted in her writing about the pioneering spirit of years ago. *Death Comes to the Archbishop*, written in 1927, describes the Southwestern scenes as if an Impressionistic landscape painting. Cather's election to the American Academy of Arts and Letters in 1938 preceded her receiving in 1944 the Gold Medal from the National Institute of Arts and Letters.[35]

Georgia returned to Canyon for the fall semester, 1917. By now the college had changed its concept of normal school work in Texas which was "that it should prepare teachers for the country schools, and the function of the country school was to teach only the 'three Rs.'" In 1917 "the normal schools lay emphasis on the preparation of teachers for the grades in city and town schools.... Special departments of expression, music and drawing, for the fine arts, in addition to agriculture, manual training, domestic science art are maintained."[36]

With the U. S. entering World War I in 1917, Georgia drew on her patriotic and pacifist views, learned in Sun Prairie and the East. Georgia's roots in Sun Prairie were patriotic as the Sun Prairie people aided the war effort by knitting socks and sweaters for the troops, bought Liberty Bonds to show their loyalty, and adhered to the rationing coupons. But World War I affected the German-speaking community in Sun Prairie and it felt the tension of being suspected of aiding the German war effort.[37]

In the East, Georgia's association with and admiration for Stieglitz probably provided food for thought. He refused to believe that Germany's position had caused all the warring, that France and England shared equal responsibility, and that the United States had "inaugurated an epoch of conspicuous waste." Deeply involved in his 291, Stieglitz witnessed, as a result of World War I, a decline in enthusiasm for his gallery and lessened subscriptions to his *Camera Work*. As a pacifist, Stieglitz did not turn 291 into a political forum because he stood alone in thinking that the universal 291 should not be confused with political agendas, either right or wrong.[38]

Georgia, far removed from Sun Prairie by 1917, developed a tolerance for pacifism. The common usage of pacifism in 1917 included those who refused and were unwilling to bear arms for any purpose because of their conscientious beliefs and those who encouraged others to refuse. The Draft Act of 1917 relieved from serving only those whose conscientious objections derived from a recognizable religion or organization. Pacifism due to sociological, political, philosophical or personal opinion was not mentioned in the Draft Act of 1917. The issue in 1917 read very "cut and dried" and one registered as a pacifist or not a pacifist.[39]

Georgia remained in favor of the United States's position in World War I. Her version of pacifism included opposition to the excessive military build-up and aggressive nature of war. She handled the war situation by ignoring the war. Her desire to be left alone outweighed any pacifist ideas. Georgia's leaning in

1917 provided a guide to what would transpire in the coming years.

Canyon's patriotism reached its height when the college granted the men students graduation diplomas if they enlisted in the U. S. Army. In the fall of 1917, Georgia struggled with her teaching in Canyon and when she saw students leaving to fight in World War I, she advised them, Ted Reid among them, not to leave school but to stay and receive their education. There would be plenty of time after college to fight the war.[40]

Yet, the 1917 WTSNC annual, dedicated "To the Volunteers," included Mead and John Crudgington, her former students in Amarillo. The 1918 WTSNC yearbook contained a dedication "To our Boys in Khaki," and listed again Mead, Crudgington and added Ted Reid.[41]

Ted joined the Air Force Signal Corps in 1917 and eventually went to West Point, Mississippi, where their planes were shipped from Long Island and the men assembled their own flying machines, even applying the pure linen to the wooden wings with a varnish of banana oil. After seven hours of flying instruction, Ted again flew solo and said, "No parachutes, no runway, just took off, no radio." At the war's end Ted married Ruby Fowler. With the cattle industry gone, Ted taught school in various Texas communities and served in the Reserves in World War II.[42]

In the spring of 1917, two military companies of about seventy men each in the school, were drilled by the college professors. By October 1 1918, WTSNC continued to support the war program when a Student Army Training Corps of one hundred men moved to the campus to train.[43] See figure 14-2.

When the men began to leave the campus for military duty, the women stepped in and assumed whatever jobs were available to help the war effort. More than one hundred girls took a Red Cross course and made bandages and garments. Nearly every faculty member assisted in mobilizing the people and gathering money for support.[44]

Regardless of the war, winter descended on the Texas Panhandle in November 1917, with Amarillo receiving 0.59 inches of moisture, 0.04 inches in December, 1.01 inches in January 1918, 0.26 inches in February, and 1.06 inches in March 1918. "The 1.01 inches in January translated to ten to fifteen inches of snow, a snow so deep that the Herman Kuhlman family in The Block ran a twine string from the house to the windmill and barn so they would not get lost when they got water from the well or went to take care of the cows in the barn."[45]

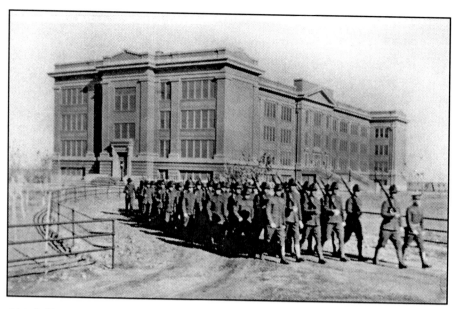

14-2 Soldiers Training on West Texas State Normal College Campus

That Thanksgiving of 1917, Georgia interrupted her teaching at WTSNC to attend a teachers conference in Waco, Texas, to speak on teaching art.[46] The thirty-ninth annual convention of the Texas State Teachers' Association began its meetings on Thursday, November 29, 1917, in Waco with its general sessions in the First Baptist Church. Miss Blanton, the president, assured the enormous crowd that each speaker would be heard when she refused to permit ingress and egress from the hall during the numerous talks welcoming the group. After several welcoming speeches, Blanton, the first woman officer, addressed the issue:

> I ask you, in fairness, not to draw the conclusion that a woman can't make a satisfactory presiding officer, until you have had equal opportunities for judging.... Isn't this a hopeful sign for democracy.... If democracy is good for a nation, it's good for a teachers' organization.[47]

Blanton stressed that the meetings were for members, but with a fifty-cent fee a single meeting could be attended and for one dollar admittance would include the public.[48]

Topics for discussions included: Constructive Program of Public School Work, Music, Equal Pay for Equal Work, and The Immeasurable in Education. Meetings of the different sessions were held in various sites in the city with topics: home economics, mathematics, industrial arts and geography.[49]

It is a likely assumption that Georgia spoke to the industrial arts group. Georgia recognized freedom as the crucial foundation in teaching art. She claimed that art couldn't really be taught, but that she could help the students bring forth the expressions that already existed within them and could assist with the materials and technique to give form to their expressions. This required a great sensitivity to the student.

Governor William P. Hobby of Texas made a speech at the closing session on December 1 with the remark, "Education is first and foremost in the cause of free government."[50]

After Christmas 1917, Georgia became ill with influenza, perhaps a preview of the coming epidemic. During the final days of World War I, when peace loomed on the horizon, a deadly influenza virus erupted in far-off China. Circling the globe, the first known virus entered the United States at Fort Riley, Kansas, on Monday, March 11, 1918. Its first casualties were barely noticed, due to the wartime effort, but the dominoes began to fall and would not cease until a second wave of influenza came in September 1918. Before the influenza epidemic ended, more people had died of influenza in one year, twenty to forty million people, than during the Black Death from 1347 to 1351.[51]

In early 1918, Georgia, as head of the Art Department, helped secure an art exhibit for the college and Canyon. Although active, Georgia attempted to remain in Canyon but in February 1918 she asked for a leave of absence from her teaching.[52]

In February 1918 Gerogia traveled to San Antonio, Texas, where, true to her inclination "to paint where she stood," she painted eighteen watercolors.[53]

Untitled (Tree with Green Shade), watercolor and graphite on moderately thick, cream, smooth wove paper with a slightly fuzzy feel, 8 7/8 x 6 in., 1918,

Figures Under Rooftop, watercolor on moderately thick, cream, smooth wove paper with a slightly fuzzy feel, 12 x 9 in., 1918,

Window–Red and Blue Sill, watercolor on moderately thick, cream, smooth wove paper with a slightly fuzzy feel, 12 x 9 in., 1918,

House with Picket Fence, watercolor and graphite, 9 x 6 in., 1918,

House with Tree–Green, watercolor and graphite on medium thick, cream moderately textured laid paper, 19 x 13 1/8 in., 1918,

House with Tree–Red, watercolor on thin, beige, very smooth laid paper, Japanese gampi, 16 x 11 in., 1918,

Figure in Black, watercolor and graphite on moderately thick, cream, smooth wove paper with a slightly fuzzy feel, 8 7/8 x 6 in., 1918,

Woman with Apron, watercolor and graphite on moderately thick, cream, smooth wove paper with a slightly fuzzy feel, 8 3/4 x 6 in., 1918,

Three Women, watercolor and graphite on moderately thick, cream smooth wove paper with a slightly fuzzy feel, 8 7/8 x 6 in., 1918,

Untitled (Woman with Black Shawl), watercolor and graphite on moderately thick, cream, slightly textured wove paper with a slightly fuzzy feel, 8 7/8 x 6 in., 1918,

Woman with Blue Shawl, watercolor, graphite, and charcoal on moderately thick, cream, smooth wove paper with a slightly fuzzy feel, 8 7/8 x 6 in., 1918,

Untitled (Leah), watercolor on medium thick, cream, moderately textured paper, 15 x 11 1/8 in., 1918,

Untitled (Bowl of Fruit), watercolor and graphite on medium thick, white, smooth wove paper, 4 1/2 x 3 5/8 in., 1918,

Tree and Picket Fence, watercolor on medium thick, cream, smooth wove paper, 17 7/8 x 11 7/8 in., 1918,

The Park at Night, watercolor on moderately thick, cream, smooth wove paper with a slightly fuzzy feel, 17 7/8 x 11 7/8 in., 1918,

Lavender Hill with Trees, watercolor on paper, 8 3/4 x 12 in., 1918,

Trees, watercolor on thin, beige, very smooth laid paper, Japanese gampi, attached to another undescribed sheet, 19 1/2 x 14 1/2 in., 1918,

Spring, watercolor on paper, 17 3/4 x 11 3/4 in., 1918,

Tree and Earth, watercolor on moderately thick, cream, smooth wove paper with a slightly fuzzy feel, 11 7/8 x 8 3/4 in., 1918.[54]

Among the San Antonio watercolors, Georgia painted an answer to the patriotic/pacificist issue with *The Flag*, watercolor and graphite on moderately thick, cream smooth wove paper with a slightly fuzzy feel, 12 x 8 3/4 in., 1918.[55]

Earlier, while in Amarillo, Georgia had met Leah Harris. In March 1918, to recuperate, Georgia traveled to Leah's home in Waring, Texas, where Leah's recuperation from tuberculosis continued. Waring, a small town north of Boerne in Kendall County, was situated on the bank of the Guadalupe River. Founded in 1887, the population of Waring remained between one hundred and one hundred fifty from 1890 until 1914, when the population peaked at three hundred people. The town consisted of two general stores, a corn and grist mill, gin, stone quarry, lumberyard, hotel, boarding house and several stores. Georgia more than likely got off the train at the railroad station and would have seen the little white church which today boasts a Texas Historical Commission Official Historical Medallion reading, "Anglo pioneers in a predominantly German-settled area built the west wing of this building in 1891. Land for this first public school was given by Robert Percival Maxwell Waring, a native of Ireland for whom the town had been named in 1888. Citizens volunteered labor, funds and materials for the building and paid their children's tuition of $1.00 to $1.50 per month. The east wing was added in 1903, and exterior braces were applied in the 1930s. The school closed in 1954."[56]

In Waring, Georgia painted what are believed to be nude portraits of Leah or self-portraits in a style similar to Rodin's work that she had seen earlier in New York. Whether these eleven watercolors were painted in numerical order or not, they possess common characteristics of colors of tan, blue, reddish brown and dark brown with dashes of black tone:

> *Nude No. I*, watercolor on moderately thick, cream, smooth wove paper with a slightly fuzzy feel, 12 x 8 7/8 in., 1917,
>
> *Nude Series II*, watercolor on moderately thick, cream, smooth wove paper with a slightly fuzzy feel, 12 x 8 7/8 in., 1917,
>
> *Nude No. III*, watercolor on moderately thick, cream, smooth wove paper with a slightly fuzzy feel, 12 x 8 7/8 in., 1917,
>
> *Nude No. IV*, watercolor on moderately thick, cream smooth wove paper with a slightly fuzzy feel, 11 7/8 x 8 7/8 in., 1917,
>
> *Nude Series V*, watercolor on moderately thick, cream, smooth wove paper with a slightly fuzzy feel, 11 7/8 x 8 3/4 in., 1917,
>
> *Nude No. VI*, watercolor on moderately thick, cream smooth wove paper with a slightly fuzzy feel., 12 x 8 7/8 in., 1917,

Nude Series VII, watercolor on medium thick, cream slightly textured laid
 paper, Japanese paper, 17 3/4 x 13 1/2 in., 1917,

Nude Series VIII, watercolor on medium thick, cream slightly textured laid
 paper, Japanese paper, 18 x 13 1/2 in., 1917,

Nude Series IX, watercolor and graphite on moderately thick, cream, smooth
 wove paper with a slightly fuzzy feel, 12 x 8 7/8 in., 1917,

Nude Series X, watercolor on moderately thick, cream, smooth wove paper
 with a slightly fuzzy feel, 11 7/8 x 8 7/8 in., 1917,

Nude Series XI, watercolor on moderately thick, cream, smooth, wove paper
 with a slightly fuzzy feel, 12 x 9 in., 1917,

Nude Series XII, watercolor on moderately thick, cream, smooth wove paper
 with a slightly fuzzy feel, 12 x 17 7/8 in., 1917,

Nude Series, watercolor on moderately thick, cream, smooth wove paper
 with a slightly fuzzy feel, 12 x 8 7/8 in., 1917.[57]

Stieglitz had been writing Georgia strong letters suggesting that he wanted
her near him and that she could not gain artistic recognition in faraway Texas.
Stieglitz sent Paul Strand to Texas to retrieve what he thought was a fragile
woman. With little warning, Georgia wrestled with her strong emotional feelings
for Strand.[58]

Georgia left the college suddenly, even leaving her trunk at the Shirleys'
house.[59] Why Georgia left Canyon so abruptly may never be known. The reasons
could have included her fragile health, her pacifism and Claudia's departure later
in December.

As Georgia attempted to recover from the influenza, the cold winter days
may have hastened her memory of the harsh Wisconsin winters. Her pacifist
views on World War I consisted of not paying much attention to the fighting and
wanting to be left alone to paint. Many years later Ted Reid stated that he knew of
no facts supporting the rumors that she left because of her pacifist beliefs. Ted's
son, J. W. Reid, recalled that Ted later thought she had been forced out.[60] Claudia
began her teaching career by accepting a position to student-teach in Spur, Texas,
a small town one hundred miles southeast of Canyon.[61] Claudia eventually moved
to New York, then to Beverly Hills in 1939. She founded a Montessori school,
The Hildegarde School. The school closed in 1954 and afterwards Claudia came
to Abiquiu every summer to tend to Georgia's garden.[62]

The possible reasons that Georgia left Canyon: If she had resigned she probably would have said so; Ted Reid helped her pack up and he said, "Georgia felt she didn't receive the recognition she deserved;" she told a friend she was considering returning; the college's Summer 1918 Bulletin listed her; she knew she was a problem to the administration, but they were required to support her; Georgia definitely loved the Canyon plains; and she enjoyed her teaching.[63]

As always Georgia kept her own counsel. Perhaps all these forces worked within her artistic framework to think the time was right for a mentor: Alfred Stieglitz.

Strand convinced Georgia to return to New York and she left Texas with him to arrive in New York on June 10, 1918. Georgia's acquiescing to come to New York never lessened her desire to return to the West.[64]

Georgia had joined the never-ending flow of people from America's East to West which is so characteristic of American life. Perhaps Georgia's personality reigned foremost along with the persistent westward urge of so many Americans. Indeed, perhaps she had abandoned any social pedigree in the East but had acquired another pedigree as she traveled west.

Shortly after Georgia left Texas, another teacher, Dr. Hattie J. Anderson, arrived in Canyon in 1920. Anderson became captivated by the bustling community, eager college students priming to become teachers, and the involvement of the original settlers in the community. She knew she must act quickly before the disappearance of the stories of pioneers such as Goodnight and Sanborn. With the aid of others she began preserving their history to form the nucleus of the Panhandle Plains Historical Museum, the first museum built on a college campus. In 1933 the museum opened and Georgia's work was shown in 1935. In 1994, seventy-six years after Georgia left her teaching position in Canyon, the Georgia O'Keeffe Foundation gifted the Panhandle Plains Historical Museum from Georgia's estate with *Red Landscape*, oil on board, 24 1/2 x 18 1/2 in., 1916/1917.[65]

WTSNC asked Georgia to teach a summer course in the 1930s, but by then she had ended her teaching career.[66]

The *Canyon News* reported on Thursday, November 7, 1935, that Georgia had visited the college campus the day before with her friends, Loren Mozley, a native of Taos, who currently was painting murals in the Gallup, New Mexico, courthouse, and Dorothy Brett, the English artist.[67] See figure 14-3.

14-3 *Dorothy Brett, 1932*

Georgia also visited the Panhandle Plains Historical Museum.[68] She said that this museum had a genuine local flavor and a sincerity of atmosphere which was not usually found in small museums. She enthusiastically praised

the collections of Indian blankets. She added, "You know you have some very valuable and beautiful blankets here. I wish they could be hung on the walls so that visitors could see them better and study them."[69]

Georgia insisted on making time to visit the Palo Duro Canyon State Park where she had painted many scenes. She commented to a friend as she looked into the canyon, "I have never seen a place that to me is as beautiful as this country and this canyon; I like Palo Duro Canyon better than the Grand Canyon."[70]

When Georgia left Canyon, she remarked that she hoped to spend the fall of 1936 in the Panhandle to paint all that had given her such pleasant memories.[71]

Georgia's memories consisted of the teaching skills she learned, the value of the colors in the canyon, and the friendships she formed. She knew she had learned to recognize students who had genuine talent and interest. The stark landscape colors and powerful light of the canyon connected with Georgia's lifetime work. The few friendships remained throughout her lifetime.[72]

In the 1950s, Louise and Willena Shirley visited Georgia in Abiquiu and she asked them if they would send her a pencil sketch she thought she had left behind the baseboard somewhere in the Shirley's rented bedroom. Shirley returned to Canyon searching with a flashlight to locate the sketch but couldn't find it. At one time the Shirleys still had Georgia's trunk full of drawing paper, but no drawings.[73]

Georgia left fond memories as a teacher in Canyon and as a fully seasoned artist. Her presence was also remembered in her birthplace, Sun Prairie, as preparation progressed for the 1937 Sun Prairie Centennial by the Twentieth Century Club. A letter states:

> October 5, 1935, Dear Estelle, I knew of no artists in or near Sun Prairie. Though later on a niece of Ollie Lotto's [sic] Georgia O'Keeffe—who did get quite a little notoriety for selling a picture of a barn for many thousands of dollars.
>
> She married the art promoter and I have heard that she is doing well. I am very glad for she probably deserves success for Ollie says she had a long and strenuous struggle for her art education. Josephine M. Smith.[74]

The Canyon college in the early 1980s made overtures to Georgia to award her an honorary degree but since she had celebrated some ninety birthdays, she declined the idea.[75] Georgia had taken from Canyon all she needed. If she hadn't accepted the teaching job in Canyon to experience the landscape's natural forms, she would not have been able to paint as she did. She was indebted to Canyon, rather than Canyon being indebted to her.

All the empty, ocean-like land, the dominant blue sky, and the erratic weather gave her a new perspective.[76]

MORE INFLUENTIAL YEARS
1918–1945

15

DECLARATIONS

"What does it matter? I
know I didn't want to."
—Georgia O'Keeffe

Thirty-year-old Georgia arrived in New York on June 10, 1918, to end the era of her fragmented, but purposeful, art life since age twelve, years spent learning by painting and teaching.[1]

Although her credentials did not include a college degree, highly regarded for the times, her training could not be overlooked: Chicago Art Institute, 1905-06; New York Art Students League, 1907-08; University of Virginia Summer School, 1912; Teachers College, New York City, 1914-16; Supervisor of Art, Amarillo Public Schools, 1912-1914; Teacher in University of Virginia Summer School, 1913-1916; and the most recent teaching position at WTSNC from 1916.[2]

Earlier, Stieglitz's sister, Elizabeth, had promised him that Georgia could stay at her studio at 114 East Fifty-ninth Street. Upon Georgia's arrival, her condition revealed the aftereffects of the nervous exhaustion she had suffered a few months before in Texas. Stieglitz's physician brother, Lee, examined her and prescribed rest. Stieglitz immediately took charge of restoring Georgia's health.[3]

After ten days of care, Georgia began painting and readied herself for an overlapping range of events, paintings, travels and friends that would influence her rediscovery of the eagerly anticipated earth and sky.

Stieglitz soon began photographing Georgia, which progressed to nude poses.[4] He made more than one hundred photographs of her in the first two years. Emmeline, the mother of his only child, accidentally discovered the two during a session. Not surprisingly, Emmeline demanded that Stieglitz choose between her and Georgia.[5]

Stieglitz insisted on their innocence, but by now recognized that he loved Georgia and abandoned his unhappy twenty-five-year marriage. With Georgia's permission, Stieglitz moved into her apartment on East Fifty-ninth Street.

Stieglitz wrote Arthur Dove, August 19, 1918, "I have been living as I never lived before.—O'Keeffe is a constant source of wonder to me...."[6]

Stieglitz's nude photographs provided a visual display of physical and emotional passion as he presented Georgia in light and shadows.[7] She recalled years later that she had a mirror in her room and her face seemed round to her, but when Stieglitz began the photographs, Georgia's face seemed long. She added, "I was photographed with a kind of heat and excitement."[8]

Another event enticing Georgia to paint presented itself when Stieglitz offered to underwrite a year of painting and a room of her own. This aided her financial situation and provided a quiet place to live and work.[9]

Steiglitz made his offer good by consulting with Jacob Dewald, who invested $1,000 in Stieglitz's promising artist.[10]

Until this time Georgia had worked mainly in watercolor, graphite, graphite and watercolor, pastels and charcoal with a few exceptions in oil.

Watercolors applied with a brush and water to the usual paper surface gives the work a transparent quality which distinguishes it from all other heavy painting mediums. Only whiting mixed with watercolor results in an opaqueness. Georgia's watercolor painting, as in all watercolor painting, is the opposite of oil painting in that instead of building up, Georgia left out. The moderately thick, white paper of moderate-texture paper served as the whites. Then the darkest colors were placed accordingly. The dry-brush technique of dragging the brush containing more pigment than water over rough-textured paper to create a granular appearance did not appeal to Georgia because she preferred smooth watercolor paper.

Examples of Georgia's watercolors up to 1918:

Trees in Snow, watercolor on paper, 14 7/8 x 11 in., ca. 1902,

Untitled (Vase of Flowers), watercolor on moderately thick, white, moderately textured wove paper, 17 3/4 x 11 1/2 in., 1903/1905,

Untitled (Teapot and Flowers), watercolor on thick, white moderately textured wove paper, 12 1/4 x 16 3/4 in., 1903/1905.[11]

From 1915 on, Georgia executed her watercolors not on the traditional handmade rag paper she had used for several years but on a lesser quality paper noted for its drab cream color and harmless texture. In other words, she painted on nothing that would detract from her art.[12]

Georgia's watercolors after 1915:

Black Lines, watercolor on medium, thick, cream moderately textured laid paper, 24 1/2 x 18 1/2 in., 1916,

Untitled (Red, Blue, Yellow), watercolor on moderately thick, beige, smooth paper laminate, Japanese paper, 17 3/4 x 13 1/8 in., 1916,

Untitled (Red, Blue and Green), watercolor on thin, beige, slightly textured laid paper, Japanese paper, 17 1/2 x 13 3/8 in., 1916,

Abstraction, Pale Sun, watercolor on thin, beige, slightly textured laid paper, Japanese paper, 17 1/2 x 13 1/2 in., 1916,

Blue, Green and Red, watercolor on paper, 15 7/8 x 10 7/8 in., 1916,

Red and Green No. I, watercolor on paper, 12 x 9 in., 1916,

Red and Green No. III, watercolor on thick, beige, moderately textured wove paper, Manila paper, 11 3/4 x 8 3/4 in., 1916,

Red and Green No. IV, watercolor on moderately thick, white, slightly textured wove paper, 12 x 9 in., 1916,

Red and Blue No. I, watercolor on moderately thick, cream, smooth wove paper with a slightly fuzzy feel, 12 x 9 in., 1916,

Red and Blue No. II, watercolor on moderately thick, cream, smooth wove paper with a slightly fuzzy feel, 11 7/8 x 9 in., 1916,

Blue No. II, watercolor on very thin, beige, very smooth laid paper, Japanese gampi, 15 7/8 x 11 in., 1916,

Blue No. III, watercolor on very thin, beige, very smooth laid paper, Japanese gampi, 15 7/8 x 11 in., 1916,

Untitled (Houses and Landscape), watercolor on moderately thick, cream, smooth paper with a slightly fuzzy feel, 8 7/8 x 12 in., 1916,

Untitled (Boy), watercolor on moderately thick, cream, slightly textured wove paper with a slightly fuzzy feel, 12 x 8 7/8 in., 1916,

Untitled (Girl), watercolor on moderately thick, cream, slightly textured wove paper with a slightly fuzzy feel, 12 x 8 7/8 in., 1916,

Evening, watercolor moderately thick, cream, smooth wove paper with a slightly fuzzy feel, 8 7/8 x 12 in., 1916.[13]

Georgia began drawing with graphite early in her career. Her early graphite work using a drawing instrument composed of graphite enclosed in a wood casing produced linear gray-black strokes with a substantial range of light and dark to tonally model the subject. Minimum shading was a result of rubbing the soft graphite with a soft-edged object. Georgia signed all except one of the graphite works and it could have been an exercise in visual expression or a finished work. Examples of Georgia's early graphite work:

Untitled (Hand), graphite on moderately thick, cream, moderately textured laid paper, 6 1/2 x 9 1/4 in., ca. 1902,

Untitled (Barn), graphite on paper, 8 1/2 x 11 in., 1904,

Untitled (Vases), graphite on paper, 9 x 6 in., 1904,

Untitled (Ida O'Keeffe), graphite on moderately thick, beige, slightly textured, wove paper, 12 x 9 in., 1904,

Untitled (Boy with Hat), graphite on moderately thick, beige, slightly textured wove paper, 12 x 9 in., 1904,

Untitled (Claudia O'Keeffe), graphite on moderately thick, beige, slightly textured wove paper, 12 x 9 in., 1904,

Untitled (Catherine O'Keeffe), graphite on moderately thick, beige, slightly textured wove paper, 12 x 9 in., 1904,

Untitled (Catherine O'Keeffe), graphite on moderately thick, beige, slightly textured wove paper, 12 x 9 in., 1904,

Untitled (Francis O'Keeffe), graphite on moderately thick, beige, moderately textured wove paper, 12 1/8 x 8 7/8 in., 1905,

Untitled (Ida O'Keeffe), graphite on thick, beige, moderately textured wove paper, 9 1/4 x 6 1/2 in., 1905,

Untitled (Bust), graphite on medium thick, beige smooth wove paper, 12 1/8 x 8 7/8 in., 1905/1906,

Untitled (Bust), graphite on medium, thick, beige, slightly textured wove paper, 21 1/2 x 12 in., 1905/1906,

Untitled (Bust), graphite on medium thick, beige, moderately textured wove paper, 10 1/4 x 16 in., 1905/1906,

Untitled (Bust), graphite on medium thick, beige, slightly textured wove paper, 17 5/8 x 10 5/8 in., 1905/1906,

Untitled (Claudia O'Keeffe), graphite on moderately thick, beige, smooth wove paper, 12 x 9 in., 1906,

Adah, graphite on paper, 8 1/4 x 9 1/4 in., 1907.[14]

Early in her career Georgia used watercolor with graphite, signing some works, among others:

Untitled (Lighthouse), watercolor and graphite on moderately thick, white, moderately textured wove paper, 5 5/8 x 7 3/8 in., 1902,

Untitled (Cherry Blossoms), watercolor and graphite on thick, moderately textured (twill), white wove paper, 8 7/8 x 18 in., 1903,

Untitled (Grapes and Oranges), watercolor and graphite on moderately thick, cream, slightly textured wove paper, 5 1/2 x 13 in., 1904,

Untitled (Grapes and Oranges), watercolor and graphite on medium, thick, gray blue, moderately textured laid paper, 5 1/2 x 13 in., 1904,

Untitled (Vase Of Flowers), watercolor and graphite on moderately thick, cream, slightly textured wove paper, mounted to cardboard, 20 1/4 x 14 1/8 in., 1904,

Untitled (Pansies), watercolor and graphite on paper, 10 1/4 x 12 3/4 in., 1904,

Untitled (Pansies), watercolor and graphite on medium thick, cream, slightly textured wove paper, 11 1/2 x 15 5/8 in., 1904,

Untitled (Catherine O'Keeffe), watercolor and graphite on moderately thick, cream, slightly textured wove paper, 20 3/4 x 14 3/4 in., 1905/1906,

Untitled (Street Scene), watercolor and graphite on thick, beige (with black fibers), slightly textured wove paper, 9 1/2 x 6 5/8 in., ca.1907/1908,

Untitled (Fashion Design), watercolor and graphite on medium, thick, brown, slightly textured wove paper, illustration board, 18 1/2 x 10 1/8 in., ca. 1912/1914,

Blue Lines, watercolor and graphite on moderately thick, cream, slightly textured laid paper, 25 x 19 in., 1916,

Blue No. 1, watercolor and graphite on very thin, beige, very smooth laid paper, Japanese gampi, 15 7/8 x 11 in., 1916,

Blue No. 4, watercolor and graphite on very thin, beige, very smooth laid paper, Japanese gampi, 15 7/8 x 11 in., 1916.[15]

Georgia introduced pastel in 1907–1908. Pastels are made of powdered pure pigments combined with a non-greasy binder that offers the darkest hue of a pigment which can be varied with mixtures of inert white. Once Georgia applied the colors to the paper, she could see the final colors immediately because they didn't change in color value. The works became more than drawings with linear lines as Georgia rubbed, smeared and blended the colors to obtain a painterly quality.[16]

One early pastel was: *Untitled (Flower)*, pastel on thick, black, moderately textured, wove paper, construction paper, 8 1/2 x 6 1/2 in., 1907/1908.[17]

Georgia did not work in pastel again until 1915:

No. 32 Special, pastel on thick, black, moderately textured, wove paper, construction paper, 14 1/2 x 20 in., 1915,

Special No. 33, pastel on paper, 11 x 14 in., 1915.[18]

Special No. 33 was a result of Georgia's sitting on the edge of a river, dabbling her feet in the fifteen-foot-deep red water, and conversing on abstractions in nature with her friend, Arthur Macmahon. Her rendition of what she felt and meant showed her use of the dry drawing medium.[19]

Georgia abandoned color in 1915 and burst forth in charcoal to further her theories of abstraction. The soft drawing edge of charcoal produced the broad, vigorous strokes that emphasized mass and movement rather than linear precision and attention to detail. She drew on laid papers, specially designed for charcoal, which presented an even, modest texture to hold the charcoal.[20] From

these drawings emerged Georgia's concept of working from the emotions she had been struggling with as she worked her way through her relationship with Arthur Macmahon.[21]

Georgia executed more charcoals, a continuation of the charcoal *Specials* that she drew and mailed to Anita Pollitzer, who showed them to Stieglitz in 1915:

Drawing, charcoal on moderately thick, cream, slightly textured wove paper, 24 3/4 x 18 1/2 in., ca. 1915/1916,

Abstraction with Curve and Circle, charcoal on medium thick, cream, moderately textured laid paper, 23 3/4 x 18 3/8 in., ca. 1915/1916,

No. 14 Special, charcoal on medium thick, cream, moderately textured laid paper, 24 3/4 x 18 3/4 in., 1916,

First Drawing of the Blue Lines, charcoal on moderately thick, cream, slightly textured laid paper, 24 3/4 x 18 7/8 in., 1916,

Untitled (Abstraction), charcoal on moderately thick, cream, slightly textured paper, 24 7/8 x 18 7/8 in., 1916,

Abstraction, charcoal on moderately thick, cream, slightly textured laid paper, 24 1/4 x 18 3/4 in., 1916,

I Special, charcoal on medium thick, cream moderately textured laid paper, 24 3/4 x 18 3/4 in., 1916,

No. 12 Special, charcoal on medium thick, cream, moderately textured laid paper, 24 x 18 7/8 in., 1916,

No. 8 Special, charcoal on medium thick, white, moderately textured laid paper, 24 1/4 x 18 7/8 in., 1916.[22]

Georgia's work in oil was scattered throughout this period. The first known were:

Untitled (Claudia O'Keeffe), oil on canvas, 12 x 10 in., 1907/1908,

Untitled (Boy), oil on canvas, 13 x 8 in., ca. 1907/1908,

Untitled (Dead Rabbit with Copper Pot), oil on canvas, 20 x 24 in., 1908,

Untitled (Horse), oil on cardboard, 12 1/2 x 11 1/2 in., 1914,

Untitled (Abstraction, New York), oil on canvas, 23 7/8 x 18 1/4 in., 1916,

Anything, oil on board, 20 x 15 3/4 in., 1916.[23]

In 1918, Georgia's experience in watercolor, watercolor and graphite, pastel, oil and charcoal, with Stieglitz's insistence, turned her to oil painting. The mixing of dry pigment powder with refined linseed oil to form a paste which was then milled to disperse the pigment particles throughout the oil accorded Georgia a fine art-painting medium that had been used since the eleventh century. The oils are applied to a prepared support and, depending on the dilution, can dry slowly or somewhat quicker. Top grade brushes are generally used, but the responsiveness of oil allows for all types of tools for application.

In 1918 Georgia produced oil painting abstractions of a remarkable nature, such as:

Series I, No. 1, oil on canvas, 19 3/4 x 16 in., 1918,
Series I, No. 3, oil on board, beaver board, 20 x 16 in., 1918,
Series I, No. 4, oil on canvas, 20 x 16 in., 1918,
Music, Pink and Blue No. 1, oil on canvas, 35 x 29 in., 1918,
Music, Pink and Blue No. 2, oil on canvas, 35 x 29 in., 1918,
Series I, No. 2, oil on board, 20 x 16 in., 1918,
Untitled (Abstraction), oil on canvas covered board, 19 1/4 x 14 in., 1918,
Untitled (Abstraction), oil on Celetex board, 17 7/8 x 14 in., 1918,
Untitled (Abstraction), oil on board, 12 x 9 1/2 in., 1918.[24]

Georgia's father had been working in Petersburg, Virginia when he accidently fell off a roof to his death in November 1918. He was not buried with his wife. With the earlier death of her role model mother, Ida, in May 1916, an easy assumption could be made that with both parents deceased, Georgia now felt that Stieglitz had become more her family than ever.[25]

The year 1918 signaled another event of world magnitude: the end of World War I. According to the Armistice, the British met one hundred twenty-nine German submarines off the Essex coast and escorted them into Harwich on November 20. As the long line of submarines passed slowly into the harbor, the crowds watched silently from the shores. The next day, the German fleet of ten battleships, six battle cruisers, eight light cruisers and fifty destroyers sailed between two long lines of British escort ships into the Firth of Forth. The German ships' flags were lowered and the surrender was completed.[26]

Arthur Jerome Eddy wrote in the foreword of the second edition of the book Georgia found so interesting, *Cubists and Post Impressionism*:

> Is it not more inspiring to feel that this mighty conflict is in some mysterious way a clearing of the world's atmosphere, a destruction of spiritual not material borders?...Is it not more inspiring to feel that we are fighting to make the world safer for *ideals*, rather than for democracy which is but a form of government.[27]
>
> Democracy will spread over the globe as fast as it justifies itself by its peaceful deeds and achievements. Empires will expand as fast as their expansion is consistent with the progress of mankind. As a forcing process war is a failure.[28]

As Georgia considered the perils of war, and the conflict of military conquest and Christianity with its humanistic teachings, perhaps World War I brought her another experience of the pacifism she had been exposed to earlier in the East.

With the end of World War I, and as Georgia's range of painting intensified, so did her relationship with Stieglitz. In August 1919, Stieglitz's mother, who accepted their unusual and illicit relationship because she observed that her son was happy and productive, invited them to her summer home at Lake George, New York. Shortly after their initial visit, Georgia and Stieglitz returned to Oaklawn just before 8.67 acres of the property was sold in the late fall. The Steiglitz family retained a 3.4 acre strip to the lake.[29]

While at Oaklawn the two acted like teenage lovers and often disappeared to the privacy of their bedroom with Georgia as happy as never before, but with Stieglitz feeling guilty about the European war. But even this did not deter them from their focus on each other and their art.[30]

Georgia's surroundings remained important to her because she found inspiration in them.[31] Identifying her subject matter became as simple as knowing her itinerary.

While at Lake George Georgia painted, among others:

Untitled (Red Canna), watercolor on paper, 19 3/8 x 13 in, 1918/1920,

Red Canna, watercolor on paper, 19 3/8 x 13 in., 1918/1920,

Canna Series, watercolor on paper, 22 x 13 in., 1918/1920,

Red Canna, watercolor on paper, 22 x 13, 1918/1920,
Canna Lily, watercolor on paper, 22 x 13 in., 1918/1920,
Canna Lily, watercolor on paper, 22 x 13 in., 1918/1920.[32]

Then followed in various mediums such as charcoal, watercolor and oil a variety of paintings such as abstractions, shapes, cityscapes, and flowers. The red canna, showing possibly the influence of Stieglitz's cropping and enlarging of his photographs, culminated in one of the first close-up flower paintings which hinted at later talk of erotica, *Inside Red Canna*, oil on canvas, 22 x 17 in., 1919.[33]

During this time, the American avante-garde became entranced with Sigmund Freud's (1856-1939) psychoanalytical theories when he visited the U. S. in 1909. Freud's theory claimed:

> Women were inherently inimical to the aims of civilization. Their innate drives were too strong for them to fully repress; therefore, men must exert control in the interest of preserving all that is of value in an orderly world. Women who objected to this control were merely demonstrating their neurotic desire to possess what they could never have: a penis. Ambition in women was a sickness, a reason for pity and sympathy, but not a desire that should ever be gratified.[34]

A. A. Brill, Freud's Viennese student and English translator, often attended Mabel Dodge's salons in Greenwich Village, in addition to the sexuality debates held in Stieglitz's 291 gallery. Stieglitz adopted Freud's theory that the "ideal beauty symbolizes the psychodynamics of its creator" and "that primitive sexual urges are transfigured into acceptable forms."[35]

At first Stieglitz's promotional skills latched onto the idea, though he later abandoned it, of Georgia's enlarged flowers being sexual, but not pornographically degrading. Georgia denied this for years, then let people think what they wanted. In 1939, in a catalogue for her "Georgia O'Keeffe: Exhibition of Oils and Pastels" at An American Place, she stated:

> I made you take time to look at what I saw and when you took time to really notice my flower you hung all your own associations with flowers on my flower and you write about my flower as if I think and see

what you think and see of the flower—and I don't.[36]

Undaunted, Georgia continued to work intermittently on the subject of flowers until 1957.[37]

A routine of summers in Lake George with their headquarters at the Farmhouse at The Hill provided only a three-quarter mile walk down the steep hill into the village. Winters in New York eventually led to Georgia fleeing to have time alone, first to York Beach, Maine, in 1920, as a place for solitude. York Beach was part of a sprawling area consisting of York Village ("Old York"), York Harbor and Cape Neddick. She stayed with Stieglitz's friends, Bennet and Marnie Schauffler, to absorb the rocky Maine coast that led to a long stretch of sandy white Atlantic coast beaches where peace reigned and where one could see the waves roll in and seagulls soaring overhead. Not to be excluded in this atmosphere was Nubble Lighthouse, the Victorian Keeper's house featuring gingerbread and red shutters.[38]

To Georgia, the most important view for a painting existed not north, south, east or west, but again from where she stood and how she felt. Georgia's first trip to York Beach produced:

Seaweed No. II, watercolor on moderately thick, cream, rough wove paper, 18 3/4 x 12 3/8 in., 1920,

Untitled (Seaweed), watercolor on moderately thick, cream, rough wove paper, 18 7/8 x 11 1/4 in., 1920,

Abstraction Seaweed and Water—Maine, pastel on moderately thick, beige, slightly textured laid paper, 28 3/8 x 17 3/4 in., 1920.[39]

Stieglitz's February 1921, exhibition of his nude photographs of Georgia created a sensation. After that she was never less than a celebrity.

Stieglitz received many comments on his photographs. Waldo Frank said "The work of Stieglitz is more than half upon his subject.... By talk, atmosphere, suggestion and the momentum of a personal relationship, Stieglitz lifts the features and body of his subject into a unitary design that his plate records." Changing his focus in 1922, Stieglitz began a series of cloud photographs. Clouds had interested him since 1887 and his efforts resulted in a series of photographs called "Music: A Sequence of Ten Cloud Photographs."[40] These clouds, he said,

"Are snapshots of a momentary detail lodged in a vast plane—and a fleeting image of an emotion, perhaps a picture of God."[41]

Stieglitz's concept of equivalents combined words and images in an abstract, yet specific way that resonated a third emotional and visual effect simultaneously... and more powerfully than the words or response.[42]

Nancy Parker Newhall (1908-1974) studied at the Art Students League and became knowledgeable about photography after her marriage to Beaumont Newhall. Beaumont's career began at the Metropolitan Museum of Art, then the MoMA and the Eastman House in Rochester, Minnesota. Nancy wrote of seeing Stieglitz's cloud photographs: "It is extraordinary experience to observe how a different text or sequence or general context can change what people see and feel in the same photograph."[43]

Meanwhile, Georgia's 1922 retreat trip to the seashore produced:

Blue Sea with Rocks, pastel on paper, 19 x 25 in., 1922,

Waves, pastel on moderately thick, white slightly textured laid paper mounted to gray cardboard, 19 x 25 in., 1922,

The White Wave, pastel on paper, 19 x 25 in., 1922,

Wave, pastel on paper, 19 x 25 in., 1922,

A Storm, pastel on moderately thick, white, slightly textured laid paper mounted to gray cardboard, illustration board, 18 1/4 x 24 3/8 in., 1922,

Lightning at Sea, pastel on medium thick, cream, moderately textured laid paper mounted to gray cardboard, illustration board, 19 x 25 1/4 in., 1922,

Sun Water Maine, pastel on moderately thick, white, slightly textured laid paper mounted to gray cardboard, illustration board, 20 1/2 x 26 3/4 in., 1922.[44]

In May 1923, Georgia's destinations included Cos Cob, Connecticut on the Mianus River between Greenwich and Stamford. The name was derived from the Algonquian "high rock." Cos Cob offered shore and sea views and woodlands and backcountry farms. Artists loved the Cos Cob art colony experience in the late 1800s and early 1900s. The gathering of like-minded people provided a band of artists who took their lead from the European schools and put forth the

idea that a certain locale could provide inspiration. In this harbor town, John Twacthtman had begun offering landscape painting classes.[45]

In 1923, Georgia's travels to the Maine seacoast at York Beach produced:

Seaweed, oil on canvas, 7 x 7 in., ca. 1923,
Untitled Abstraction, oil on canvas, 20 x 17 in., ca. 1923.[46]

As a recognized celebrity, Georgia held her first major exhibition in 1923 at the Anderson Galleries: "Alfred Stieglitz Presents 100 Pictures, Oil, Water Colors, Pastels, Drawings by Georgia O'Keeffe."[47] Georgia wrote in the program:

> I say that I do not want to have this exhibition because, among other reasons, there are so many exhibitions that it seems ridiculous to me to add to the mess, but I guess I'm lying. I probably do want to see my things hang on a wall as other things hang so as to be able to place them in my mind in relation to other things I have seen done. And I presume, if I must be honest, that I am also interested in what anybody else has to say about them and also in what they don't say because that means something to me too.[48]

On many days, as many as five hundred people crowded into the small rooms to see what the woman artist had accomplished: the flaming red cannas, the snapdragons.[49]

As Georgia became better acquainted with Stieglitz's circle of friends in the early 1920s, she met Jean Toomer. Toomer was born Nathan Pinchback Toomer in 1894 in an upper-class Negro family from Washington, D. C. His father deserted his wife and son and Nathan's mother, Nina, renamed him Nathan Eugene, which he shortened to Jean. At age ten, Jean suffered severe stomach ailments which enabled him to develop strengths early in life. Rather than wringing his hands, he searched for a plan of action. In the 1980 collection of his writings, Wayward and Seeking, Toomer wrote, "I had an attitude towards myself that I was superior to wrong-doing and above criticism and reproach... I seemed to induce, in the grownups, an attitude which made them keep their hands off me; keep, as it were, a respectable distance."[50]

Within a period of four years after high school, he had studied at five different places of higher education. Toomer inherited his wanderlust from his

parents and grandparents. But it was in Sparta, Georgia, that he found his ancestral roots. In Sparta he began to write poems, stories and sketches about southern women in particular, whose stretch to self-realization forced them into a conflict with American society's moral attitudes. When he returned to Washington, D. C., he repeated his efforts with a focus on the inhibited Negroes in the North. He made friends with Waldo Frank and was able to publish in prestigious journals. The result was his 1923 *Cane*, featuring the images of black women.[51]

Cane forecast by several years the Harlem Renaissance, a time after World War I when all Negro art forms flourished. What Negro at the time couldn't understand the bigotry in the book experienced by the book's character, Becky. Toomer was praised for realizing a new way for treatment of Negro subjects.[52]

Toomer wrote Georgia, January 13, 1924:

Dear Georgia

Yours was no simple invitation to call; you opened the way and initiated a spiritual form. There were four of us, but the clear mobility of that evening did not come from the lowest common denominator (as it almost always does, whatever the group); it issued from the highest. This is achieved only in rituals when religions are young.

Have you come to the story "Bona and Paul" in *Cane?* Impure and imperfect as it is, I feel that you and Stieglitz will catch its essential design as no others can. Most people cannot see this story because of the inhibitory luggage they bring with them. When I say "white," they see a certain white man, when I say "black," they see a certain Negro. Just as they miss Stieglitz's intentions, achievements! Because they see "clouds." So that at the end, when Paul resolves there contrasts to a unity, my intelligent comentors wonder what its all about. Someday perhaps, with a greater purity and a more perfect art, I'll do the thing. And meanwhile the gentlemen with intellect will haggle over the questions as to whether or not I have expressed the "South."

Before so very long, I'd like another evening with you.[53]

During this time Toomer had an intense affair with Waldo Frank's wife, Margaret Naumberg, who financed his spiritual quests because he had met the principle representative of Georges Ivanovich Gurdjieff. He learned of

the beginnings of Gurdjieff's system of self-development through intellectual, emotional and physical integration. Upon seeing Gurdjieff, Toomer said:

> I saw this man in motion, a unit in motion. He was completely of one piece. From the crown of his head down the back and down the legs, there was a remarkable line. Shall I call it a gathered line? It suggested coordination, integration, knitness, power.... I was fascinated by the way the man walked. As his feet touched the floor there seemed to be no weight on them at all—a glide, a strife, a weightless walk.

He wrote:

> There was no printed program. You were not given in advance the slightest idea of what to expect. You were in no way helped to label and classify. [Yet] the movements...[of] the dancers caught hold of me, fascinated me, spoke to me in a language strange to my experience but not unknown to a deeper center of my being.... Thought I could have listened to it again and again, I had a sense from the very first that the music had not been composed to be listened to, but to be enacted. It was a call to action in those very moments that were being performed on stage, or in a march of men and women towards a destiny not even foreshadowed in the ordinary world. And so it moved me.[54]

By 1926, Toomer and Margaret had ended their relationship. Toomer then began a more intense involvement with Gurdjierff's Institute for the Harmonious Development of Man. In 1931, Toomer met Margery Latimer, a descendent of the early colonial poet, Ann Bradstreet, and the New England Puritan minister who assisted in the foundation of Boston, Massachusetts, John Cotton. Earlier Margery at first had been repelled by Gurdjieff's beliefs, but few white women could ignore the magnetism of his personality. His public reputation was tarnished with sexual innuendo. Toomer and Margery with six other unmarried couples lived in an experimental commune near Portage, Wisconsin. Rampant rumors of communism, nudity and sexual license fueled the press and doomed the experiment. After an October 1931, marriage, Margery died in childbirth in August 1932.[55]

In March 1924, Stieglitz continued O'Keeffe's exhibitions with "Alfred Stieglitz Presents Fifty-one Recent Pictures: Oils, Water-colors, Pastels, Drawings by Georgia O'Keeffe, American" at his Anderson Galleries.[56] Georgia's introduction:

My reason for the present exhibition is that I feel that my work of this year may clarify some of the issues written of by the critics and spoken about by other people. Incidentally I hope someone will buy something. I have kept my pictures small because space in New York necessitated that.[57]

On September 9, 1924, Stieglitz's divorce from Emmeline became final, a little over two months shy of their thirty-first wedding anniversary.[58]

Talk of Stieglitz and Georgia marrying surfaced after the final divorce decree, but remained only talk. Coincidences in hindsight resemble things to come. A few months after Anita Pollitzer took Georgia's charcoal drawings to Stieglitz, Georgia had bought on November 22, 1916, George Bernard Shaw's *Getting Married*, with a preface by Bernard Shaw. When Stieglitz proposed that Georgia marry him, Georgia would later say, "What does it matter? I know I didn't want to."[59]

But when they negotiated for a place to live, they had to produce a marriage license. Unable to marry in New York because of the divorce degree, they had to marry in any neighboring state that had no such law.

Three months after Stieglitz's divorce, sixty-year-old Stieglitz married thirty-seven-year-old Georgia on December 11, 1924, in Cliffside, New Jersey. Georgia retained her name and never wore a wedding ring.[60]

Georgia very likely knew that marriage was a struggle and felt it as an enclosure which would narrow her boundaries. Yet she chose not to live in solitude. And she would struggle with Stieglitz's desire to have her remain childlike in order to gain his approval, a struggle that took its toll. She soon realized that he would be a source either of her self-worth or her problems.

Stieglitz again exhibited Georgia's work in March. The 1925 exhibition at Anderson Galleries bore the title, "Alfred Stieglitz Presents Seven Americans: 159 Paintings, Photographs & Things, Recent & Never Before Publicly Shown, by Arthur G. Dove, Marsden Hartley, John Marin, Charles Demuth, Paul Strand, Georgia O'Keeffe, Alfred Stieglitz."

Georgia made a trip to Maine in 1926 to find time and quiet. Earlier she had picked up a piece of debris from reshingling the Lake George barn. She placed the shingle with a shell from her Maine trips and began painting what she thought of only as shapes:

Clam and Mussel, oil on canvas, 9 x 7 in., 1926,

Tan Clam Shell with Seaweed, oil on canvas, 9 x 7 in., 1926,

Tan Clam Shell with Kelp, oil on canvas, 8 x 11 in., 1926,

Slightly Open Clam Shell, pastel on white ground on very thick grey cardboard, 18 1/2 x 13 in., 1926,

Open Clam Shell, oil on canvas, 20 x 9 in., 1926,

Closed Clam Shell, oil on canvas, 20 x 9 in., 1926,

Shell and Old Shingle I, oil on canvas, 9 x 7 in., 1926,

Shell and Old Shingle II, oil on canvas, 30 x 18 in., 1926,

Shell & Old Shingle III, oil on board, 10 3/4 x 6 in., 1926,

Shell and Old Shingle IV, oil on board, 9 3/4 x 7 in., 1926,

Shell and Old Shingle V, oil on canvas, 30 x 18 in., 1926,

Shell and Old Shingle, VI, oil on canvas, 30 x 18 in., 1926,

Shell & Single Series VII, oil on canvas, 21 x 32 in., 1926.[61]

In the same year, within the hustle and bustle of New York City, Georgia utilized her surroundings in New York and addressed the city's architecture with paintings of her own space and form:

Untitled (New York), charcoal on medium thick, cream, slightly textured laid paper, 24 5/8 x 18 7/8 in., 1926,

Shelton Hotel, N.Y., No. I, oil on canvas, 32 x 17 in., 1926,

The Shelton with Sunspots, N. Y., oil on canvas, 48 1/2 x 30 1/4 in., 1926,

A Street, oil on canvas, 48 1/8 x 29 7/8 in., 1926,

City Night, oil on canvas, 48 x 30 in., 1926,

New York–Night, oil on canvas, 32 x 12 in., 1926,

East River with Sun, pastel on paper, 11 1/4 x 28 in., 1926,

East River–No. 1, oil on canvas, 12 1/8 x 32 1/8 in., 1926,

East River from the Shelton, No. III, oil on canvas, 12 x 32 in., 1926.[62]

In February 1926, Stieglitz exhibited Georgia's paintings in "Fifty Recent Paintings by Georgia O'Keeffe," which included her recent architectural paintings.[63] Georgia wrote, "I have painted what each flower is to me and I have painted it big enough so that others would see what I see."[64]

An event which fostered Georgia's independence occurred when she joined the National Woman's Party (NWP). In late February 1926, Georgia attended a banquet at which the NWP honored Miss Jessie Dell, a recently appointed United States Civil Service Commissioner in Washington, D. C. The dinner launched a campaign to elect women to Congress and other offices. One speaker declared, "Everywhere we shall make it clear that the next and most essential step in the equal right movement is to put into office, appointive and elective, qualified women acceptable and loyal to the women of their communities and to the country generally." Seated at the speaker's table were Mrs. Izetta Jewel Brown of West Virginia, who had seconded the nomination of John W. Davis for the presidency at the last Democratic National Convention; Miss Minnie Nielson, North Dakota state school superintendent; Mrs. Ida Clyde Clarke, editor and author; Eva Le Gallienne, actress; Gladys Calthrop, designer; Muna Lee, poet; and Georgia O'Keeffe, painter. Georgia spoke at the banquet and kept her membership until the party disbanded in the 1970s.[65]

In mid-November 1926, Stieglitz featured John Marin in his Intimate Gallery. In walked a shy, sensitive twenty-one-year-old woman with large brown eyes and a pale completion: Dorothy Norman. The Philadelphia-born woman, eighteen years younger than Georgia, was the daughter of a wealthy Jewish clothing manufacturer. After education at a boarding school, Smith College, the University of Pennsylvania and art appreciation courses at the Barnes Foundation, Dorothy had married Edward Norman, an heir to the Sears, Roebuck and Company, in 1925. She had suffered abuse from her husband from the beginning of their marriage. On a whim she walked into Stieglitz's gallery to see Marin's work and caught Stieglitz's rebuff that "art can't be explained." She returned later and became fascinated with Stieglitz's talk and his fascination with her.[66]

Georgia soon realized that she was not the only woman in Stieglitz's life, as she had so idealistically believed. This resulted in the loss of her spiritual, mental, emotional and physical innocence.[67]

But Stieglitz continued his annual exhibitions of Georgia's work with the January 1928 exhibition at The Intimate Gallery, "O'Keeffe Exhibition."[68]

16

FREEDOM ON THE HORIZON

"My Greetings to the sky."
–Georgia O'Keeffe

Georgia's earlier travels to Amarillo and Canyon had fueled feelings of freedom. These feelings resurfaced after her 1917 trip to Santa Fe, then lay dormant until she met Rebecca Salsbury Strand. See figure 16-1.

London-born Rebecca Salsbury, the daughter of Nate Salsbury, had been lured to the West because her father had traveled as William F. ("Buffalo Bill") Cody's "Wild West" show business manager.[1]

Rebecca had married Paul Strand in 1922 and through Strand's friendship with Stieglitz she met the photographer/art gallery owner. To become an intimate of Stieglitz's circle naturally created Rebecca's interest in art. She began drawing and painted without lessons, declaring that, "Something will be done each day, if it's only one stroke of the brush or pencil...."[2]

By now other artists in their circle of friends had also ventured to New Mexico: Marsden Hartley painted in Taos and Santa Fe in 1918-1919, Dorothy Brett arrived in Taos in 1924 with Frieda

and D. H. Lawrence and brought a selection of her paintings to New York in 1929, and Stieglitz's Intimate Gallery in March–April 1929 exhibited Paul Strand's portfolio of New Mexico images.[3]

16-1 Rebecca Salsbury Strand (James), ca. 1940

Georgia had struggled with her desires and both she and Rebecca had struggled with city life and with their difficult marriages since 1924 and 1922 respectively. For Georgia, the lover-father relationship with Stieglitz turned more into "father" as the reality of the relationship became evident. Each had different ways of living. She liked solitude to work, he liked company; he displayed an intellectualism, she intuitiveness; she loved the country, he the city; she wanted a child, he didn't. So many differences to rise above. Georgia needed space to flourish and her pioneering spirit provided the catalyst for traveling to New Mexico.[4]

Dorothy Brett later comforted Georgia over her relationship with Stieglitz. Brett, on a trip from Taos to New York in the fall of 1928, had met Georgia while showing her paintings to Stieglitz. He referred Brett to another gallery. While in New York, Brett stayed at Mabel Ganson Evans Dodge Sterne's apartment. When their relationship became tedious, Brett moved to the Shelton Hotel, where she visited Georgia and Stieglitz.[5]

Brett advised Georgia about Sigmund Freud, "Georgia—for the love of heaven don't you ever go and get psycho-analyzed." Brett showed an awareness that women were the patients in psychiatry, but men controlled psychiatry.[6]

Georgia remembered the open invitation from Mabel to visit her Taos home at 6,952 feet elevation. The village anchors the southwestern flank of an eighty-five-mile loop around 13,161-foot Mount Wheeler, New Mexico's highest mountain.[7]

Taos has a colorful history. One Abiqueño, Padre Antonio José Martinez, built his hacienda in Taos in 1804 with windowless exterior walls, twenty-seven rooms, and two inner courtyards as a fortress against the warring Native Americans. In 1826, Kit Carson, the noted mountain man, scout, army officer and Indian agent, arrived in Taos to further his career. In 1893, Joseph Henry Sharp visited Taos and told Ernest L. Blumenschein and Bert Geer Phillips about the unique mixture of colors, light and cultures of Taos. Blumenschein and Phillips in 1898 made a trip to the West to sketch the landscape. They had planned to travel from Denver to Mexico in their wagon but a wagon wheel broke north of Taos. With the toss of a coin Blumenschein had to ride horseback into Taos to repair the wheel. The Taos desert light and pueblos fascinated him and the two men remained in Taos. When Oscar Berninghaus, E. Irving Couse and Herbert Dunton joined them, the famous Taos Society of Artists (TSA) was formed. Although short-lived and disbanded in 1927, the TSA left a permanent legacy.[8]

Recalling the southwestern earth, sky and colors, Georgia responded to Mabel's open invitation by considering the excursion a fine idea. Georgia and Rebecca left for the West on April 27, 1929, and arrived in Santa Fe by train.[9]

The writers, Ralph Waldo Emerson, Henry Thoreau, and John Muir the naturalist, changed the American male perception of the West, that man must rule, tame and change the land to a view that unexplored land was for renewing the human spirit. Early writings by Adolph Bandelier, Charles Lummis and Edgar L. Hewitt wrote favorably of the Hispanics, Native Americans, and women's contributions to their cultural richness. Mabel, Alice Corbin Henderson, and Mary Austin followed their predecessors and claimed the Southwest as a space for renewing the human spirit. Walt Whitman in his *Leaves of Grass*, in 1855, favored an America of multi-cultural diversity.[10]

Henderson's arrival in Santa Fe in March 1916 came after a successful career as associate editor of *Poetry* magazine where she promoted, among others, Robert Frost, Carl Sandburg and T. S. Eliot. Happily married to the artist, William Penhallow Henderson, Alice struggled with the demands of managing a household and her writing. Henderson's writing blossomed in New Mexico and she found her poetic voice in Santa Fe. Her 1918 poem, "Litany in the Desert," focused on the healing powers of the Southwest. She claimed that the vastness, spaciousness, and sparse population ignited the imagination. The desert space, time, mass, light, sky and even the wind replaced the passionate human will and provided visionary powers. Henderson later wrote of the landscape as a way to think and feel to understand the land. In woman's attempt to not destroy the land, Henderson stressed the desert metaphorically as female. She would reveal that often the love of the land replaced the demands of human love.[11]

By now Mabel's marriage to Dodge had ended and in August 1917 she married Maurice Sterne, an artist who had traveled to Taos. Sterne recognized that the Native American culture appealed to Mabel and wrote her that he did not want to work without her and to come "save the Indians." Mabel's December 1917 arrival in New Mexico shaped not only her life's experiences but her writing. Coming from New York to New Mexico to redefine herself, she devoted her energies not only to playing the muse to creative males but to finding her own voice as a writer. Settling in Taos, Mabel planned to make her home the epicenter of a "new world plan" that would refreshen Anglo civilization by adopting the Pueblo peoples' ways which existed then as a strong force. Later marrying a

Native American from Taos, Antonio (Tony) Lujan, Mabel anglicized his name to Luhan. She hoped to become a "bridge between cultures" and attract the nation's best artists, writers, and activists to find the best of the native religions, aesthetics and work ethic. Often, those who used Mabel's house as a gathering place had come at a critical time in their lives and her home served as a healing place in addition to creating conflict among those present.[12]

Austin's later arrival in Santa Fe in 1924 would continue her established writing career that had begun in California and been nurtured in Europe and in Mabel Dodge's New York salon. With America's entry into World War I, Herbert Hoover, director of the National Food Administration, selected Austin to provide guidance for the distribution of food to the armed forces and civilians. As the war drew to a close, she returned to California, only to find the state full of tourists. Seeking solace, Austin accepted Mabel's invitation to visit Taos. Then she wandered for four years in England before settling permanently in Santa Fe in 1924.[13]

Austin's 1924 *The Land of Journeys' Ending* rejected California and turned to New Mexico. Here she felt she could find her creative energy in the unconcerned-for-man landscape. Placing herself in the proper place of the larger order of life, she constantly discovered that everything in the barren New Mexico landscape appeared dry, yet was so full of life. In her 1901 *Lost Borders*, Austin declared that women had found liberation from the standards of femininity in the vast scale of the spacious land. She, too, used the metaphor of land as woman:

If the desert were a woman, I know well what like she would be: deep-breasted, broad in the hips, tawny, with tawny hair...eyes sane and steady as the polished jewel of her skies, such a countenance as should make men serve without desiring her...passionate, but not necessitous, patient—and you could not move her, no, not if you had all the earth to give, so much as one tawny hair's-breadth beyond her own desires.[14]

Together, Henderson, Luhan and Austin "renamed the land" as female, whose dry terrain and climate combined with its cultural heritage would bring a new tradition to Western civilization:

A view of the land as masterless and a respect for the native populations' careful use of its limited resources; an appreciation for the

communal aspects of tribal and village cultures that integrated work, play, and worship; and a belief that the myths and symbols of long-established, non-elitist folk cultures were necessary to the creation of a vital national art and literature.[15]

They claimed that even if the land was described as "she" with its untamed, yet mild, hard rock, even surfaced, hard to reach, yet protecting life, the land was not to be exploited.[16]

Henderson, Luhan and Austin's issues paved the way for the efforts of the Director of the Bureau of Indian Affairs, John Collier, to protect Native American rights in the 1920s.[17]

Shortly after their Santa Fe arrival, Georgia and Rebecca booked a Harvey Tour to see the San Felipe Pueblo Corn Dance approximately thirty-seven miles south of the Santa Fe plaza.[18]

The Rio Grande Native American villages from near Albuquerque north to Taos comprise the Rio Grande Pueblos. These pueblos divide linguistically into four groups:

> The Keres include the people of Acoma and Laguna in western New Mexico, and those of the Rio Grande valley: San Felipe, Santa Domingo, Santa Ana, Zia and Cochiti. The Tewa language is spoken in the villages north of Santa Fe: Tesuque, Santa Clara, San Ildefonso, San Juan, and the dying Nambe. Isleta and Taos set so far apart, and Picuris belong to the Tanos group and speak the Tiwa tongue. Jemez speaks its own language.[19]

Each Pueblo differs in language but features a similarity in its ceremonies, which may include days of secret rituals. The dance often serves as the finale to a long celebration. The music, usually a chant, serves as a prayer accompanied by the drum beat. The effect is vigorous and without melody and harmony.

The San Felipe Pueblo, named for Saint Phillip the Apostle by the Spanish explorer, Francisco Sanchez Chamuscado, in 1581, was abandoned during the Pueblo Revolt of 1680. It was reestablished atop the western mesa and again abandoned before 1706 when the pueblo was re-constructed on its present site west of the Rio Grande and east of the mesa. The mission church

in 1929 resembled the eighteenth-century church.[20]

Visitors to San Felipe Pueblo parked their cars some distance from the open square, which was the dance plaza, while the boulder-strewn mesa to the west provided a backdrop, with the blue New Mexico sky above.

The day of their visit, Rebecca and Georgia met Tony and Mabel Dodge Luhan at the San Felipe Corn Dance. They found themselves relocated from a machine-driven world into a corner of the wide earth where people did things their ancestors had done ages ago. Yet above the adobe roofs and past the towers of the old mission church and across the Rio Grande could be seen the train tracks of the California Limited, representing progress. Holding to the habit of their forefathers, pueblo etiquette welcomed visitors to the religious ceremonies but required that they observe them respectfully and quietly by not interrupting the dancers. Applause was not appropriate and any sketching or photography was by permission only.[21]

Later, Mabel persuaded Georgia and Rebecca to stay with her in Taos. Georgia's reluctance may have centered on her 1925 request to Mabel to write a review of her paintings from a feminine point of view. Georgia probably remembered her displeasure with the review, but with this excursion to Taos Georgia began a pattern of spending summers in the Southwest.[22]

To reach Mabel's house in Taos, travel east from State Highway 68 at the plaza red light onto U. S. Highway 64, Kit Carson Road, for approximately 0.1 of a mile. A left turn onto quiet, short Morada Lane for 0.3 of a mile leads to the end of the paved road. Another left turn ends at Mabel's house at 240 Morada Lane. See figure 16-2.

Mabel's house featured a two-hundred-year-old long row of rooms under a *portal* with the remainder of the house built by Mabel in the 1920s. The original adobe structure contained thick walls and low ceilings and was somewhat dark. Mabel's addition of high ceilings brought in lots of light. The herringbone *vigas*, arched doorways, kiva fireplaces and carved pillars only added to the ambiance.[23]

Mabel's sanctuary was a second-floor bedroom housing a hand-carved double bed which was built in the room. Seven steps led up to Tony's bedroom. Mabel's third-floor solarium, known as her sun porch, was surrounded by glass and afforded views of Taos's Sacred Mountain. Georgia stayed in a small, quaint first-floor room which opened onto the portal and courtyard. She had twin beds and a private bath.[24]

Other Luhan guests in that 1929 meeting included notables Ansel Adams, who was an accomplished concert pianist on the verge of becoming a professional photographer, artist John Marin, Mexican artist Miguel Covarrubias, and Daniel Catton Rich, on his career path to director of fine arts at the Art Institute of Chicago and later of the Worcester Museum of Art in Worcester, Massachusetts.[25]

At some point Mabel loaned Georgia the adobe studio and placed her and Rebecca in "The Pink House," one of Mabel's guest houses located across from the main house, called Los Gallos (the rooster). Nearby, a *morada*, the Penitentes's chapel, stood in silence with a cross erected on the grounds.[26] See figure 16-3.

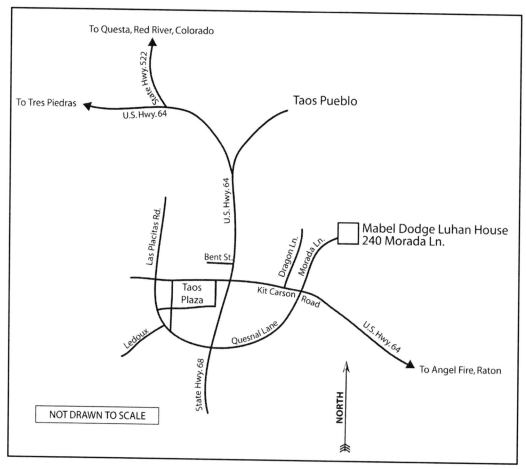

16-2 Route to Mabel Dodge Luhan's House

16-3 Georgia Near "The Pink House," 1929

Shortly afterwards, Mabel left for Buffalo for a hysterectomy and Georgia's and Mabel's relationship that year continued mostly by correspondence.[27]

Georgia wrote Mabel:

> I feel that I have two jobs—my own work—and helping him [Stieglitz] to function in his way—And by helping I sometimes mean—I don't want to get in his way—that is why I came out here—[28]

Mabel later wrote Stieglitz:

> I long to live in that free, disembodied,—carefree—functioning way that you know about. It is not egotistic—it is not destructive—and it is more fun than any other way. Georgia has a great faculty for living this way. How she enjoys herself![29]

A year later Adams wrote of Mabel from Santa Fe:

> Everything is going splendidly. I accomplished a lot at Taos, in spite of Mabel, and made some very good friends. Paul and Becky Strand are in one of Mabel's houses. The transformation in Becky from last year is amazing—she was terribly nice to me and we had a lot of fun. Paul Strand is a peach. O'Keeffe was there also breezing around in a rather cool way—but not as frigid as last year. They hardly ever see Mabel, and the entire situation is too funny for words. Will tell you all....[30]

After this journey to New Mexico as a pianist, and observing Strand's full-time dedication to photography, Adams returned home with a strong resolve to abandon music and to make photography his career. Shortly after reaching San Francisco, Adams set up a photography studio in his home.[31]

As Georgia and Rebecca painted, Rebecca noticed the sharp, clean edge of paint on the reverse side of a glass pane used by Georgia as a palette. Rebecca proceeded to paint in a medium without texture and a radiant quality of light regardless of the opaque paint and surrounding frame.[32]

Georgia's last in a series of 1926 paintings sold in 1929 for $6,000: *Shell and Old Shingle VI*, oil on canvas, 30 x 18 in., 1926. From the proceeds Georgia

purchased a black Model A Ford and learned to drive.[33]

In August 1929, Georgia, with Charles Collier, film maker Henwar Rodakiewicz and his wife, painter-writer Marie Garland, and Spud Johnson toured Arizona, Colorado, New Mexico, Utah, the Grand Canyon and Bryce Canyon National Park.[34]

Charles Collier was born in 1909 in New York, the son of John Collier, who was Commissioner of Indian Affairs under Presidents Roosevelt and Truman. Charles owned *Los Luceros* and under President Roosevelt was instrumental in starting the Soil Conservation Service in Washington. By 1968, Charles had founded the Institute of Iberian Colonial Art in Santa Fe.[35]

Henwar Rodakiewicz's first experimental film, *Portrait of a Young Man,* found a showing at Stieglitz's American Place in the early 1930s.[36]

Henwar wrote Georgia, November 25, 1975, about his account of his meeting with Stieglitz:

Georgia,

I've just asked my friend Margareta Akermark at the Museum of Modern Art to have them send you the two films you wanted to see. One is the PORTRAIT OF A YOUNG MAN (a picture without sound)...which you may remember was the first film I ever made... and many years ago, in the late twenties, when you were at the Ranch in Alcalde, you urged me to take it East and show it to Stieglitz. I did so, and we three saw it first together way up high in the Shelton Hotel, and then at An American Place, with lots of VIP's that he invited, Steichen, etc.[37]

Stieglitz liked Rodakiewicz. By 1941 Henwar's Film Associates had produced *Adventure in the Bronx,* which was shown at Radio City Music Hall.[38] By 1949 Henwar's photographs were represented in the MoMA retrospective of photography from the 1840s to the 1930s with Stieglitz's approval.[39]

Marie Tudor Garland, the wealthy Bostonian who had been educated at Radcliffe, wrote poetry. In 1917, Garland wrote *Hindu Mind Training,* and in 1920, *The Marriage Feast.* Rodakiewicz became Garland's fourth husband and together they had the H & M Ranch at Alcalde.[40]

William Willard "Spud" Johnson, born in 1897 in Illinois, spent the majority of his childhood days in Greeley, Colorado. Declining a career in his

father's lumber business, he explored every journalistic avenue. With the limits of a small town, Johnson enrolled in the University of California at Berkeley. Here he met Witter Bynner, a wealthy poet who introduced him to poetry. In 1922, with three friends, Johnson founded a small-format magazine, *Laughing Horse*. The magazine, full of learned barbs against the faculty and administration of the university, finally received an obscene book review. Johnson was expelled from the university although he continued to intermittently publish *Laughing Horse* for the next thirty years. In 1922 Johnson visited New Mexico, where he became Bynner's secretary. Still active in writing, Johnson in 1927 moved to Taos, where he became Mabel Dodge Luhan's secretary. He continued his stand against censorship and high-sounding vocabulary as he published *Laughing Horse* on a small hand press. Johnson became an active fixture on the New Mexican literary and social scene.[41]

Spud's home, built in 1887, eventually featured three rooms with *bancos* (benches), niches and earth floors. His bedroom served as his print shop and library. He only added the bedroom to accommodate his most frequent visitor, Georgia.[42]

In mid-September, Georgia was back in New York and asked Brett to sell her first Ford car in Taos. Georgia wrote to Brett, September 14, 1929:

Dear Brett,

Well that Ford!—I wonder if you have my telegram and if you are very much bored by taking my Ford to sell—

But what else can I do about it—I haven't an idea as to whether Tony is in town or not—and even if he sold it unless someone helped him I don't see how I could get the money—I don't like to bother Mabel— no telling where she is by now anyway—I hear that Spud has gone to California—Everet I don't count on at all—

Do what you can—there may be someone wanting it—I hope—and in the meantime if there is any garage charge I will pay it—I don't want anyone to drive it unless it is being tried out by a prospective buyer—

I am transferring the insurance on it today for a new Ford that I bought here—same kind—I am sorry to bother you with all this—I am [illegible] Everet with this mail to turn it all over to you.

Our winter plans can only work out by inches as the days go by.

I saw your letter and one that I had from Ida with the same mail I imagine things didn't go any too well—I hope she did not inconvenience you—

Taos all seems so faraway—and yet it all seems very near—it is over three weeks since I left—

It was nice to have your letter The news of the horses and the [illegible] See vivid—the clipping of birds is lovely.

I do hope you can rescue my Ford from Everet before he wrecks it—wire me collect anything you want to know in connection with it—and use your own judgement about the price—I hope you can sell it yourself and get the commission.

I wired Paul Jones when Everet wired me he wasn't driving East—and Jones wired back that he couldn't take the car now—so that chance to get rid of it had passed by—

Well—do what you can—I can't tell you how I dislike bothering you.

I am here as fine as anything getting back to Stieglitz is grand—it has been really very wonderful—very perfect—

He had a bad summer but feels it all was good [illegible] than in several years—is a great one—more and more its nothing else I ever saw or heard of—He is working some—we have no plans at all—except maybe to sleep tonight and have breakfast in the morning—

I have been working quite steadily—worked over two failures from New Mexico—and today finished covering another canvas that looks—so far—very good—but the whole thing must have another painting—it is all pink and lovely—really nice I think—

Charles Collier is here I had asked him to come if he wanted to if things with Mary didn't turn out well—It seems strange to look up at table and see him sitting across it here—it is nice though—I like it—He and Alfred talk and talk—When I am upstairs working I can hear just the rumble of it—I don't know whether he is bored or not—it is very quiet—I don't see how he could spend so many hours with Alfred and not get something from it—something that will do something to him—God only knows what.

Well—I'm at work—have a few ideas ahead—things I want to do—and when I feel that way everything seems alright.

Thanks for the days up at the ranch—and take care of yourself—With love Georgia[43]

Georgia wrote Brett, September 25, 1929:

Dear Brett,

The table top is the redest red—all around [illegible] green but the white porch posts and railing

Mountains hazy—lake very quiet—unbelievable quiet—Stieglitz and I alone now [illegible] the first—

Charles left Monday—early—later in the day Arkin walked in—he left yesterday noon—

While Charles was here we drove over to drive to the ocean in the new Ford—I had to see the ocean as my last desire for this summer—

Paul Rosenfeld was over there—I was satisfied—and I think Stieglitz and Charles enjoyed it

When we returned Sunday night I had your wire saying the car was sold—I hope that is all settled by now as you must have received the papers I sent you—at any rate you have some money from my [illegible] to spend when you come to New York—Is it all right—

I am trying feverishly to learn to drive in traffic—am driving ten miles everyday to the nearest uncomfortable town with our favorite taxi man driving the busiest hours and I drive up and down the main street—around corners—turn around—in and [illegible]

When ever I wake up in the night—a feeling of gloom comes over me and I decide to sell my second Ford—

In the morning my stubborness starts me off driving again—and in the dark hours of the night I despair again—That is the way I am—

Henwar—I think I could manage by myself now—but I am going to have the taxi man beside me for the rest of this week til I feel there is just nothing I can't do

Driving a bit in the little town here will make N. Y. much easier—and if I am going to drive at all I want to be able to drive anywhere—

However—it is harder work than I like—

The weather has been beautiful—[illegible] getting acquainted—really acquainted a never ending process—we are still at it—as hard as tho we had just met this morning for the first time—

Thanks for all your trouble—and my greetings to the sky—

G[44]

Georgia continued her correspondence with Brett, ca. November 2, 1929:

Dear Brett,

It rains—such a dismal dark drizzly rain—the little white clouds hang on the mountain like the last miserable little deadish leaves hang on the lilac bushes...

If they would go everything would be gray and [illegible]

I got up early to work—and here is this drizzly dark—

Maybe I will go out and work in it just for spite—

When I wrote you before I wanted to say that I left an easel and a large sketching umbrella with Everet to bring to me—if you can find them flying about will you put them away for me somewhere.

There is no telling what next summer I will want

Stieglitz has a habit of walking to the book shelves after breakfast in the kitchen for a book—anywhere—and retiring to the toilet with it—

This morning when he came out he showed me a line and asked me if I thought it might refer to your father...I didn't know—I never know anything about such details—I only half hear them and never remember the half I hear—so I told him I would ask you....

Love, Georgia[45]

Brett replied January 23, 1930:

Georgia Dear,

I mailed my last to you just before finding yours in my box—I'll come along as soon as I can —...Also as you will see—my Father died suddenly—yet peacefully—yesterday—what this will lead to I don't know—but I intend to come along—maybe I'll have to go to England instead of Philadelphia. I hope not—because I can do nothing—there is nothing one can do—

My Father was to me—a most fascinating man—debonnair, witty—charming—oh such charming. He walked this earth a little while—gracefully—brilliantly—left an indelible impression on the world—His name meant something—now my brother—a nice quiet man—inherits the name—& the name no longer has any meaning—Perhaps, I, with my painting will be able one day to give the name meaning in our generation.

Death always shocks me—when it comes—not the fact—but the silence—the stillness of it—someone whose life is familiar to me—the pattern clear—suddenly passes to an unknown existence—a patternless form—and the familiar pattern goes away.

I'll try to get up to the Marin show—I would most awfully like to see it—I'll wire you the day I start. L—Brett[46]

Stieglitz opened an exhibition at An American Place in February 1930, "Georgia O'Keeffe: 27 New Paintings, New Mexico, New York, Lake George, Etc.," to feature some of Georgia's earliest paintings of the Southwest.[47]

In March 1930, Georgia's interview with Michael Gold, editor of *New Masses*, wove together her thoughts on painting and her feminist attitude:

I am interested in the oppression of women of all classes...though not nearly so definitely and so consistently as I am in the abstractions of painting. But one has affected the other. For I agree with you that an artist reflects his generation.... Let's see how it worked out in my own case, just as an example. I have had to go to men as sources in my painting, because the past has left us so small an inheritance of women's painting that has widened my life. And I would hear men saying, "She is pretty good for a woman: she paints like a man." That upset me. Before I put a

brush to canvas I question, "Is this mine? Is it all intrinsically of myself? Is it influenced by some idea or some photograph of an idea which I have acquired from some man?

That, too implies a social consciousness, a social struggle. I am trying with all my skill to do painting that is all of a woman, as well as all of me.

Painting is form, color, pattern. It may add to life only when in these essentials it brings a new perfection, articulates a new concept. All of [art] which has survived has done so because of its command and original use of these abstractions. The subject matter of a painting should never obscure its form and color, which are its real thematic contents, since painting is a different medium than speech. So I have no hesitancy in contending that my painting of a flower may be just as much a product of this age as a cartoon about the freedom of women—or the working class—or anything else. And since the literary element will not blind the onlooker to the painting elements, I think it is much more likely to be good art.[48]

Just after the debate, Georgia traveled to York Beach, Maine, on the Atlantic coast, and in 1930 she returned to New Mexico, making one of her infrequent visits to see relatives in Chicago and Portage, Wisconsin.[49]

Again in 1930, Georgia stayed at Luhan's house in Taos, and painted:

Rust Red Hills, oil on canvas, 16 x 30 in., 1930,
Hills Before Taos, oil on canvas, 16 x 30 in., 1930,
Taos Mountain, New Mexico, oil on canvas, 16 x 30 in., 1930,
Red Hills Beyond Abiquiu, oil on canvas, 30 x 36 in., 1930.[50]

Eventually the social activity at Mabel's diverted Georgia's focus from painting. She sought a less distracting atmosphere and discovered dude ranches in the Española valley: San Gabriel, Los Luceros and H & M Ranch.

Dude ranches had started in the 1870s after the newly-built transcontinental railroads opened up the West. Curious travelers seeking earth, air, water, plants, animals and people, all needed to make a place alive, accepted ranchers' hospitality to stay weeks, sometimes months, to enjoy life in unsettled areas. Soon the expense became too much for the ranchers and the visitors started paying for

the privilege. Occasionally, the visitors carried on the tradition by establishing their own dude ranches. Tenderfoots raced to dude ranches because a person could overcome sorrow and disappointment in the wide open spaces. Something mystical surfaces when one sought comfort in times of trouble by living in the present to create the future in the untamed land that they read about in dime novels and saw in the motion pictures.[51]

As a matter of fact, dime novels originated with E. Z. C. Judson, under the pseudonym "Ned Buntline," who rose to popularity in the late nineteenth century. His meeting with William F. Cody, whom he styled "Buffalo Bill," captured his imagination and became his hero in several of dime novels that were sensational stories of heroes.[52] Also, in a fifteen-month period from 1927 to 1929, the silent motion picture was converted to sound and attracted large audiences, with each participant enjoying a private line of escape.[53]

Today, to reach these three dude ranches in the Española valley travel from Santa Fe on U. S. Highway 84/285 to the north side of Española. On U. S. Highway 84/285 (North Paseo del Oñate) turn east on Fairview Drive, which is State Highway 584 East. Travel 1.2 miles east to U. S. Highway 68 North. Turning north, Black Mesa begins. Travel 5.5 miles to County Road 41A. Turn left and travel 0.3 mile to Alcalde. At Alcalde is today's Sustainable Agriculture Science Station of the University of New Mexico, which is the former San Gabriel Ranch. To reach *Los Luceros* from Alcalde travel 1.2 miles north on County Road 0041 and on the way pass La Villita. Traveling south from Alcalde pass the rehabilitation center, Delancey Street Foundation, which was formerly the H & M Ranch (later the Swan Ranch). From Alcalde travel south 2.7 miles to an intersection. A right turn leads to San Juan Pueblo. See figure 16-4.

In Alcalde, New Mexico, at an elevation of 5,700 feet, San Gabriel Ranch was advertised in 1924 as "The Most Interesting Fifty Mile Square in America."[54] See figure 16-5.

Located halfway between Santa Fe and Taos, San Gabriel Ranch rested between the Sangre de Cristo and Jemez mountains, two miles from the Rio Grande Norte. The village of San Gabriel was the site of a settlement established by Juan de Oñate in 1598 as the first capital of New Mexico. In the early 1700s the Spanish crown granted General Juan Andres Archuleta a large spread of land which included the property later occupied by San Gabriel Ranch.

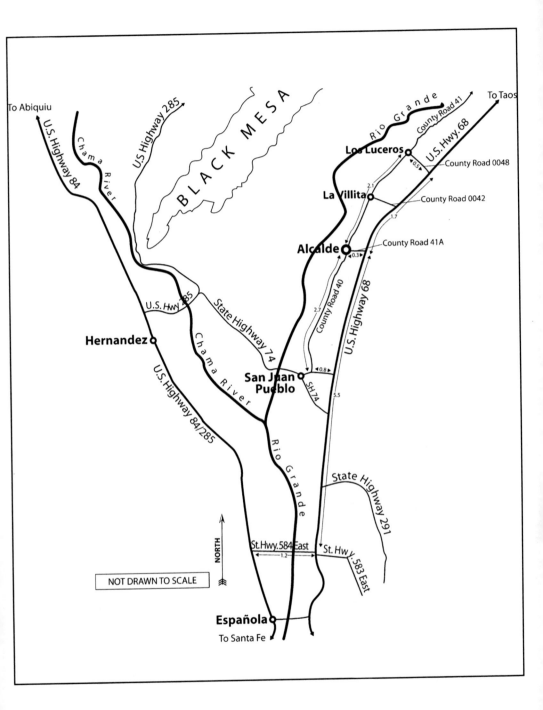

16-4 *Route to Alcalde, New Mexico*

16-5 San Gabriel Ranch, ca. 1931

Archuleta's grandson sold the ranch to Carol Stanley, a wealthy Bostonian who played piano accompaniment for a Boston Symphony Orchestra violinist. Legend says that Stanley's family disapproved of her love for the violinist who was not of her social standing. Her family sent her to New Mexico to avoid a marriage. Stanley, liking the West, returned several times, and married an Iowa-born cowboy, Dick Phaeffle. With his ranch knowledge and her Eastern connections, they established San Gabriel Ranch. The dude ranch offered trips by saddle, pack horse and automobile through New Mexico and Arizona. The most extensive trip by auto ran from Santa Fe to Alcalde, the entrance to the Entreñas Canyon. Here the ranch saddle horses took the dude to the finest mountain scenery in the high mountains, pine forests with flashing trout streams, clear mountain lakes, Indian pueblos and even prehistoric cliff dwellings, all in fifteen days' time and for $225.[55]

With Santa Fe as the gateway, the San Gabriel Ranch became a gathering place for all types of accomplished people. Georgia spent time there and often asked one of the ranch hands to find fields of flowers for her. He would find a field for her and take her to it, and she would paint one flower. When the ranch hand asked her why he couldn't just bring her one flower, Georgia replied, "It's the feeling I want."[56]

Another time at San Gabriel Ranch, a ranch hand, possibly Orville Cox, discovered Georgia examining rocks in a riverbed. She exclaimed about one particular rock while the ranch hand thought all the rocks looked the same.[57]

Another ranch, *Los Luceros* (Ranch of the Morning Star), was built in 1700 as a one-story adobe house on Sebastian Martin Serrano's land grant. In the mid–1800s, the building was made into a two-story territorial style residential structure as one of the last in America. The complex consisted of a main house with interior adobe walls forty-two inches thick and with seven fireplaces, a court room, jail, chapel and gallows, and two guest houses and an eight-room tenant house. All of this on one-half mile of Rio Grande frontage in a quiet, secluded atmosphere.[58]

Mary Cabot Wheelwright, Stanley's Boston friend, discovered *Los Luceros* and set about to make it as magical as San Gabriel Ranch. See figure 16-6.

In 1930 Georgia chose to spend time at Marie Garland's H & M Ranch, which was south of Alcalde along the Rio Grande and faced Black Mesa on the west.[59] See figure 16-7.

During the years in Alcalde, Georgia painted, among others:

Mountain Forms, oil on canvas, 10 x 15 in., 1930,
Soft Grey, Alcalde Hill, oil on canvas, 10 1/8 x 24 1/8 in., 1929/1930,
Sand Hill, Alcalde, oil on canvas, 16 x 30 in., 1930,
Small Hills Near Alcalde, oil on canvas, 10 x 24 in., 1930,
Sandhills with Blue River, oil on canvas, 16 x 36 in., 1930,
Black Mesa Landscape, New Mexico, oil on canvas, 24 1/4 x 36 1/4 in., 1930,
Out Back of Marie's I, oil on canvas, 20 x 24 in., 1930,
Toward Abiquiu, N.M., oil on canvas, 16 x 30 in., 1930,
New Mexico Landscape, Mesa with Low Hills, oil on canvas, 10 x 15 in., 1930,

Another Place Near Abiquiu, oil on canvas, 10 x 15 in., 1930,
New Mexico Landscape and Sand Hills, oil on canvas, 16 x 30 in., 1930,
Back of Marie's No. 4, oil on canvas, 16 x 30 in., 1931.[60]

There is an area fourteen miles north of Alcalde towards Abiquiu known as *Tierra Azul* (blue land). There Georgia painted:

New Mexico Landscape, oil on canvas, 16 x 30 in., 1930,
Near Abiquiu, N.M. 2, oil on canvas, 10 x 24 1/8 in., 1930,
Near Abiquiu, New Mexico, oil on canvas, 16 x 36 in., 1931,
Dark Mesa with Pink Sky, oil on canvas, 16 x 29 7/8 in., 1930.[61]

16-6 *Los Luceros, 1923*

16-7 H & M Ranch, ca. 1932

In an article called "Art, After the O'Keeffe Show," in the April 8, 1931, issue of *The Nation*, Paul Rosenfeld wrote:

"How much time must still elapse before the achievements of the Stieglitz group of painters and photographers is appreciated?... From the beginning of her meteoric rise this extraordinary girl has been giving us paintings elevated in their immediate, daring and harmonious relations of the elements of the spectrum to each other and to pure white;.... it is incredible that this achievement of hers should have failed to illuminate once and for all the achievement of the illustrious group of which she is a member."[62]

Georgia continued her pattern of returning to New Mexico from New York in late April 1931 and again rented a small house from Marie Garland at the H & M Ranch at Alcalde.[63]

During 1931, Georgia painted in New Mexico:

Another Church, oil on canvas, 10 x 24 in., 1931,
Near Alcalde, New Mexico, oil on board, 7 x 8 5/8 in., 1931,
The Mountain, New Mexico, oil on canvas, 30 x 36 in., 1931,
Bear Lake, oil on canvas, 15 3/4 x 35 3/4 in., 1931,
Taos, New Mexico, oil on canvas, 9 3/4 x 24 in., 1931,
Back of Marie's No. 4, oil on canvas, 16 x 30 in., 1931,
Untitled (Taos Landscape), watercolor and graphite on medium thick, white, smooth wove paper, 6 5/8 x 10 in, ca. 1931,
Untitled (Taos Landscape), watercolor on paper, 6 x 9 1/2 in., ca. 1931.[64]

In late April 1931, Georgia began to set the stage for finding her sense of place by driving north out of Santa Fe. A tapestry of earth colorings unfolded as the elevation descended from 6,989 feet to Rio Arriba County at an altitude of 5,930 feet. Slightly larger than Connecticut, this county spreads across three mountain ranges and two of the most fertile river valleys in New Mexico, homes of the Rio Grande and Chama rivers.[65]

Paul Horgan, in *Great River: The Rio Grande in North American History*, described the origins of the Rio Grande:

> The Rio Grande rises on the concave eastern face of the Continental Divide in southern Colorado. There are three main sources, about two and a half miles high, amidst the Cordilleran ice fields. Flowing from the west, the river proper is joined by two confluents—Spring Creek from the north, and the South Fork. The river in its journey winds eastward across southern Colorado, turns southward to continue across the whole length of New Mexico which it cuts down the center, turns southeastward on reaching Mexico and with one immense aberration from this course—the Big Bend—runs on as the boundary between Texas and Mexico, ending at the Gulf of Mexico.[66]

The Chama River forms from the joining of the East Fork and West Fork at an elevation of 8,800 feet in the San Juan Mountains of southwestern Colorado. East of the Continental Divide, the West Fork flows from Chama Lake, then over the volcanic cliffs at Chama Falls, then joins the East Fork, which flows from Dripping Lakes.

On its journey to the Rio Grande, the Chama River, with its crystal clear water over a rocky base, is joined by the Rio Puerco ("dirty river") that is muddied by passing through the red land of the *Piedra Lumbre.*

Before the Chama River finally joins forces with the Rio Grande north of Española, the mountainous landscape reveals colorful passages and lush valleys offering harvests, and closes ranks to form canyons.

Not far from the Chama River, near Abiquiu, Georgia discovered, in May 1931, a place she called the "White Place."[67]

The majestic vertical white rock formations, where violent earth movements and volcanoes one to ten million years old erupted to form ash, mud and sediment, chalky cliffs looking like spired sand castles.[68] The formations are reminiscent of Greek columns and in the sunlight shadows give off darker shadows to further bind Georgia to the black and white she so loved.[69] (See illustration number 4 on the dust jacket of the book, The "White Place.")

Today, the acreage is owned by the Dar al-Islam mosque which provides access to some of the highly erodible surfaces.[70]

Today, Georgia's "White Place" is discovered by driving 0.6 of a mile north of Abiquiu on U. S. Highway 84. Turn right on County Road 155 (Rancho de Abiquiu Road). Travel 2.3 miles, crossing the Chama River, traveling beside an irrigation ditch to the entrance of the Dar al-Islam mosque. Turn left towards the mosque on a dirt road. Travel 0.6 mile to a Y in the road. Take the right fork and travel 0.1 mile to a section of the "White Place." See figure 16-8.

Along the way in May 1931, Georgia discovered Abiquiu.[71]

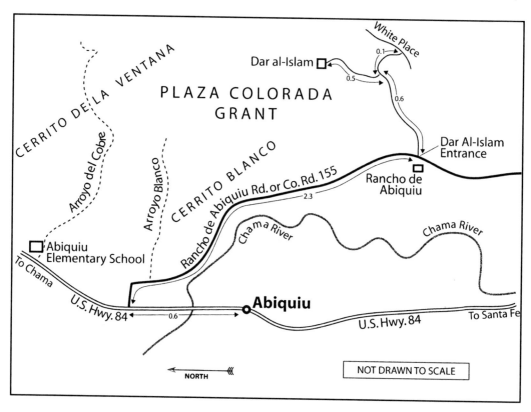

16-8 *Route to the "White Place"*

17

SERENITY AND POWER

In May 1931, the excitement of finding Abiquiu with its Saint Thomas the Apostle Catholic Church, the plaza and the old adobe ruin she would later call home, created a momentum for Georgia. Yet she returned to Mabel Dodge Luhan's for some painting to finally settle in June at Taos's El Chamiso Lodge.[1]

In 1930, Helen and Frank Hall Kentnor had begun building El Chamiso Lodge, which later became the Sagebrush Inn. They opened the hotel in 1931, catering to travelers going from the East to Arizona as well as those making the return trip.[2]

Georgia's accommodations were never as important as her painting. During her summer stay at the Sagebrush Inn, she opted for a studio room at the top of the hotel with a three-hundred-sixty- degree view for her painting. The regular rooms had baths but the studio rooms did not, so she used the bath downstairs. She ate her meals at the inn.[3]

In July 1931, Georgia returned to Lake George after shipping a collection of bones to New York that would signal a dramatic change in her subject matter. These would be the first of her collection. One could question why she would amass things that appeared of no use. But people have been collecting for centuries, so why not? Later, Georgia would place her legendary collection on *bancos* in her New Mexico homes.[4]

Indicating her curiosity and interest in life, Georgia ignored any objections to collecting bones and didn't care if she was labeled an eccentric. As Georgia related many times, the bones didn't represented death; her unfailing eyes saw shapes, forms and life. Perhaps they even represented hope.

With this first shipment and the collection of more, Georgia painted:

Cow's Skull with Calico Roses, oil on canvas, 36 x 24 in., 1931,

Cow's Skull, Red, White and Blue, oil on canvas, 39 7/8 x 35 7/8 in., 1931,

Horse's Skull with Pink Rose, oil on canvas, 40 x 30 in., 1931,

Horse's Skull on Blue, oil on canvas, 30 x 18 in., 1931,

Horse's Skull with White Rose, oil on canvas, 30 x 16 1/8 in., 1931,

Thigh Bone on Black Stripe, oil on canvas, 30 x 16 in., 1931,

Untitled (Jawbone and Fungus), charcoal on medium thick, white, smooth wove paper, 12 1/4 x 22 1/2 in., 1931,

Jawbone and Fungus, oil on canvas, 17 x 20 in., 1931,

Cow's Skull on Red, oil on canvas, 35 3/4 x 40 in., 1931/1936,

Mule's Skull with Pink Poinsettias, oil on canvas, 40 1/8 x 30 in., 1936,

Mule's Skull with Turkey Feathers, oil on canvas, 30 x 16 in., 1936,

Horizontal Horse's Or Mule's Skull with Feather, oil on canvas, 16 x 30 in., 1936,

Deer's Skull with Pedernal, oil on canvas, 36 x 30 in., 1936,

Summer Days, oil on canvas, 36 x 30 in., 1936,

Ram's Skull with Brown Leaves, oil on canvas, 30 x 36 in., 1936,

Bob's Steer Head, oil on canvas, 30 x 36 in., 1936,

Untitled (Skull with Turkey Feather), graphite on moderately thick, cream, slightly textured wove paper, 20 7/8 x 15 in., ca. 1936,

From the Faraway Nearby (Deer's Horns, Near Cameron), oil on canvas, 36 x 40 1/8 in., 1937,

Horn and Feather, oil on canvas, 9 x 14 in., 1937,

Horn and Feathers, oil on canvas, 20 x 24 in., 1937,

Ram's Head, Blue Morning Glory, oil on canvas, 20 x 30 in., 1938,

Deer Horns, oil on canvas, 36 x 16 in., 1938,

Red and Pink Rocks and Teeth, oil on canvas, 21 x 13 in., 1938,

Feather with Bird's Bone, oil on canvas, 20 x 12 in., 1942,

It Was a Man and a Pot, oil on canvas, 15 7/8 x 20 in., 1941.[5]

In the fall of 1931, Georgia traveled between Lake George, New York, and York Beach, Maine.

Georgia wrote Brett in a letter dated November 21, 1931:

> Dear Brett
>
> Yes—I am still in the country—Have the house all to myself—and have been painting away at a great pace—I drove down to the city last Tuesday and took what I had been doing—and I even say myself—it quite put my eye out—I liked it—I had liked it here—but I think I even liked it better in the Room—
>
> Yes—I drive to New York—and in New York—right up to the door of the Shelton at six o'clock when the traffic is thickest—have done it five times—It is 220 miles—yes—I am proud of it—So that is that—
>
> Stieglitz was a bit surprised to have me arrive with my paintings—and he was much surprised at the paintings—liked them much—which surprised me—I had thought them a bit too weird for him
>
> I like it here this time of year—all the leaves are gone—everything soft purplish grey with evergreens all through it. I hope to stay till it snows but will have to go down early in December about my frames as my show goes up January first—ordered some when down last week but there are more to attend to—
>
> About your work I think you must suit yourself—Every one seems to be feeling very poor and that being the case I don't imagine many pictures will be bought
>
> I know little about the Art world as my trips to the city were short—I saw very few people—attended to what I went down for and came back—
>
> I did not want to begin being a city person til I am all through up

here—My feeble mind can only follow one track at a time and I try to keep that track as clear as possible—

Up here I see no one but the woman who lives with me and does things for me—I am fond of her—take her with me to the city when I go—she has a sister down there

Her drunken husband living over the hill furnishes considerable [illegible] and human interest of a quality new to me—some times he even contributes a bit of fear—

And then I say firmly to myself, 'I'll not have a drunken man disturb my world and keep my boots on so that in case he comes I can jump over the front porch rail and run—and that way I feel safe—I always have to laugh that boots make me feel safe—So that is the way it is—'

It is a good life for work—and feeling that I can take myself to the city in six hours anytime I want to—I have done it when the urge was strong enough—start at dawn and I am there for lunch—

Give my greetings to the sky—I guess it is the best part of any place—fondly Georgia—This is written with pencil because I have had a headache and am lazy I suppose—[6]

Stieglitz's yearly exhibition, usually held at the beginning of the year, opened earlier in December 1931, at An American Place, and was titled "Georgia O'Keeffe: 33 New Paintings, (New Mexico)." This was the first exhibit featuring paintings of bones.[7]

In 1932, as Georgia explored her "sense of freedom of place," Dorothy Norman's attention to Stieglitz intensified and she became enamored with him. Their relationship soon developed into an affair.

The relationship between Georgia and Stieglitz contained an element of dealing with each other as artist to artist, so much so that his relationship with Norman should not have mattered to Georgia. But the facts differed from her feelings. Her solution would be to become self-sufficient.[8]

Against Stieglitz's wishes, in April 1932, Georgia accepted a New York Radio City Music Hall commission scheduled for completion by December. But the stress of having Dorothy Norman as a third party to her marriage probably made her sick, and she canceled the Radio City Music Hall contract in October.[9]

Surely Georgia must have realized that if Stieglitz had left his first wife for her, then he might leave her for another woman.

The January 1933 opening of Stieglitz's "Georgia O'Keeffe: Paintings— New & Some Old," at An American Place did little to lift Georgia's spirits. Attempting recuperation, she lived with her sister, Anita Young, shortly before being diagnosed with psychoneurosis at Doctor's Hospital.[10]

Anita O'Keeffe had married Robert Ralph Young in 1916. The young man started his life in 1897 in Canadian, Texas, one hundred miles northeast of Amarillo in a house built by lawyer Temple Houston, son of President Sam Houston of the Republic of Texas. Young's mother died when he was a child and he was raised by an aunt. His grandfather was a pioneer rancher and trail driver and his prominent father was president of the first bank in Canadian.[11]

Young's education began at the Canadian Academy and continued at Culver Military Academy and the University of Virginia, where he married Anita O'Keeffe. He began his business career with General Motors in the 1920s and made a fortune in the stock market in 1929. In 1931 Young bought a seat on the New York Stock Exchange. After his success on Wall Street in 1939, he gained world acclaim in a proxy battle to gain control of and modernize the New York Central Railroad. During the intense fight for control, Young enlisted the aid of Sid Richardson and Clint Murchison of Texas.[12]

Meanwhile, Georgia continued to recuperate in March and April 1933 in Bermuda with Marjorie Content, and her daughter, Susan, at Torwood, in a house owned by Marie Garland. Georgia had met Marjorie Content while Marjorie photographed the Taos Pueblo for the Bureau of Indian Affairs. The women kept up their friendship.[13]

Upon returning from Bermuda, Georgia returned to Lake George for the remainder of the year, with a few trips to New York.

Brett's concern for Georgia shows in her typed letter dated August 10, 1933:

Georgia dear,

I want you to do something, I want you to buy a book called "The Way of All Women" by M. Esther Harding, M.D., M.R.C.P. It is a very wonderful book and I feel will help you get well quicker than anything. It is extraordinarily lucid, clarifies many of those things that one feels

subconsciously, makes those things that are oppressive, mysteries, upsetting to one's health and serenity, clear and understandable, by the method of exposure and revellation. I feel that to read this book will bring back to you your own serenity, your own power as well as your health.... if not write to her and go and see her. I am writing to her to ask if I may come to see her when I come to New York.... I am all right, except for a slight slowing up of energy....but Georgia dear, please read her book...many things that I have half consciously felt, without knowing why, have been clarified for me, the cause of my instinctive feeling given and a strange feeling of power and security follows...Those things that trouble you...you will find...you will then know what to do...be able to do it...and thus restore you own calm inner life and your health....

After weeks of blazing heat we have had almost a week of storm, ending in two solid days of rain, now the clouds are clearing away, the sun is out once more, and I hope tomorrow will bring a clear sky and the sun once more.

My love to you Georgia dear. Yrs Brett[14]

Harding does not claim, in *The Way of All Women*, to offer a solution for all of life's ills, but makes suggestions for action to build a stronger foundation. This inner security, based on middle ground between "the extremes of materialism and of other-worldliness," withstands the shock of misfortune in anyone's life. In the first chapter, "All Things to All Men," Harding discusses throwing out the idea that either man or woman is superior. The next chapter, "The Ghostly Lover," deals with being in love with a man, which is more than just to love him, because being in love denotes a compulsion of not being free. The third chapter, "Work," proposes that to become an independent personality a woman must consciously step into the world and submit to all the disciplines that are considered masculine. In "Friendship," Harding claims that man has a set pattern of what his woman should be like to fulfill his fantasy of womanhood. In the fifth chapter, "Marriage," Harding emphasizes that marriage belongs to a man's personal life, while marriage for a woman reaches further; her entire life is altered. In the sixth chapter, "Off the Beaten Track," Harding quotes C. G. Jung in *The Secret of the Golden Flower*: "The most important problems of life are all fundamentally insoluble. They must be so, because they express the necessary

polarity inherent in every self-regulating system. They can never be solved but only outgrown." Woman's aging is discussed in "Autumn and Winter," in that a sophisticated woman who is aware of herself welcomes old age. Harding concludes that woman as she grows is responsible for herself.[15]

Stieglitz, unaware of the reason for her condition, wrote Ansel Adams, October 20, 1933:

> O'Keeffe is still at the Lake—& still a very sick woman. She is well out of this all for it is very terrible in spite of the outward calm & peace which seems to reign here. As for your idea about an O'Keeffe-Stieglitz Show my dear man I understand only too well about the starved souls in San Francisco as well as elsewhere. But what you ask for is absolutely impossible—physically impossible as well as otherwise impossible. The O'Keeffes are needed here. I dare not risk them out. She is not painting. May never paint again. As I know what they do here primarily to the Europeans that come here they are amazed.[16]

As Georgia's health began to return, she began drawing in October 1933. Comfort came in the form of a December 1933 visit by Jean Toomer. Toomer wrote Georgia from Chicago on January 4, 1934:

> Georgia,
> I had hardly stepped off the train but what I was moved into activities connected with Adler being here. My friend Douglas had arranged for him lectures, diners, etc., and I was moved (and moved myself) into them. Almost the first thing off the bat, a diner for him Monday evening—and Douglas proposed that after he had spoke I should read "The Blue Meridian"—which I did. About forty people were present, and the place of the dinner was only one block from "Michigan Avenue and Walton Place." A good number of the people I had never known before, so it was a sort of "Test." It came off amazingly; and I was glad I did it—because, among other things, the whole thing seemed to fit into this phase of mine of moving myself and my work into a wider world. Adler of course was impressed; and among his comments was this: that if he had my power of projection in the spoken word he would be able to do many things which he can't do.

Then came more dinner and parties and lectures, mainly at the university. Last night was the last of it, and Adler departed for New York, his whole visit here having been quite successful from many points of view. He is a pretty good man, with a manifest "something" in him, quite an expert at handling "patients." This sort of clinical expertness is evidently his real role. He is less impressive as a talker, as a philosopher, and tends, I believe, to let down the level of his ideas too much. There is little or nothing in his work that stretches one, that leads to any marked individual development, nothing "inspirational"—and some of his generalizations are, I am sure, either mistakes in themselves or put in a wrong light because of over-emphasis. What he really is is a psychological doctor—and at this I feel he is among the best. A person asked me how Adlerian psychology stood in relation to the Gurdjieff system, and my answer was, "Adler could occupy a closet in the Gurdjieff house."

My friend Douglas proposed me to Adler as a lecturer on the Adlerian ideas Adler seemed to think well of it—and, other things being equal, I may do it sometime, because I feel (1) Adler's ideas are sort of close to the mentality of the "average person," and I could speak of them (with mutual profit) to numbers of people who be would entirely unprepared to hear anything about Gurdjieff, and (2) because of the popular appeal I might be able to make a little bread and butter money for myself. Should this come about, should I see my way to do it without taking too much time and energy away from my writing—well, then, I'll do it. We'll see.

One other concrete result is this: that Douglas was so impressed by what happened as regards the Blue Meridian reading that he wants to arrange to have me read it to several "important" socities connected with the university.

Another result: In a few weeks I may speak to a special group of students at Madison. This came about because of a quite fine contact with one of the professors from there who was visiting Chicago, heard the poem read, talked with me, etc.

I've hardly had time to see the rest of Chicago and the rest of my friends and fellow-workers here, though of course I did see the baby the very first afternoon. She is very well, and very very darling, with a sort of richness and loveliness that goes straight to my heart (though I appear

to take her quite casually with the, for me, proper amount of fatherly reserve).

Tomorrow I am going out to see my friends the Walcotts at Barrington. Will stay the week-end, I had hoped to be able to go to Portage from there, but as I've hardly done anything here save be with Douglas and Adler, I'll have to return for a day or so to attend to my other businesses. Then to Portage....

During all of this, I have often visualized the house at Lake George, and the rooms, and you in them, and wondered just what you were doing. In me there is an impulse to speak about you and your paintings, to bring your presence into the consciousness of those in this region to whom you would mean a great deal. And I'm wondering very much what is at work in you.

While I write this letter, a beautiful sort of tiger-cat is on the desk nearby, and now and again she gets curious as to what is going on and begins to investigate, putting her nose on the paper, trying to catch one of the keys in her paws. And I see this cat, and I think of the kitten-cats, and I hope you received what I wrote on the train.

I haven't heard anything from the agent about the Stieglitz article. Suppose it is too soon to expect to hear.

And I haven't had any mail from Paultics or anyone, as I told everyone to send letters to Portage.

OH, How could I forget? The red scraf created a sensation! Everyone felt it was not only blazing but amazing, and amazingly becoming to me.

The mustache is growing out to full man-size.

Of course my background is ever with me. Jean.[17]

Stieglitz mounted Georgia's annual exhibition in January 1934, aware of her hiatus from painting, as "Georgia O'Keeffe at 'An American Place,' 44 Selected Paintings 1915-1927."[18]

In March 1934, Georgia spent a couple of months in Bermuda. She recalled, "There were a few pencil drawings I'd made in Bermuda, of trees. The trees were so beautiful there. Twisty shapes. Odd shapes."[19]

Georgia recalled, "Off to one side of the house was a large grove of banana trees in flower. The flowers were dark purplish red, large and heavy—and hung

down. Each petal had a row of little white flowers under it. As the petal turns back and dies the little white flowers become bananas. I made several drawings of banana flowers. It was too hot to work long outside and I never took a flower into the house. I didn't like to cut it.[20]

The drawings included:

Banana Flower, charcoal on moderately thick, cream, slight textured wove paper, 21 3/4 x 14 3/4 in., 1934,

Banana Flower No. II, charcoal on moderately thick, cream, slightly textured wove paper, 21 7/8 x 14 1/2 in., 1934,

Special No. 30, charcoal on moderately thick, beige, slightly textured wove paper, 22 x 15 in., 1934,

Untitled (Banana Flower), charcoal on paper, 21 1/2 x 14 3/8 in., 1934,

Untitled (Banana Flower), charcoal on paper, 21 3/4 x 14 3/4 in., 1934.[21]

In the spring of 1934, Toomer met Marjorie Content while visiting in Connecticut. Marjorie, a photographer and daughter of a well-to-do New York Stock Exchange member, had been married three times, once to Waldo Frank, and counted Georgia as her friend.[22]

Toomer wrote Georgia from New York City on May 15, 1934:

Georgia,

You dear splendid great woman!

The feeling in your letter is so deep and beautiful that it did things to my heart and to all of me. The largeness, the sweep, the sensitivity, the simple saying of just what you wanted to say.

When you were here I wanted to talk to you, to get into the stream of our lives, the deep stream. We did, somewhat; but as you say, it also seemed that we hardly touched at all. I suppose it had to be that way. And I felt it was somehow right—yet all the time in the background I was conscious that we had so much more to give each other, our vital mutual meanings.

You too, my dear, were amazing because of your presence. And your tanned skin with its rich warm glow seemed to belong to and express the rich dark core of you from which the iris arise—the part of you that I like

to think of as having much to do with me.

Something quite definable, and yet undefinable too, has happened between Marjorie and myself. What you wrote about it is like a blessing. She belongs to me without doubt, at this year of our lives, as woman belongs to man, as human being to human being.

Between you and Marjorie is a deep binding. No other woman means what you do to her. Between you and myself is a deep binding. I am still sort of startled that my real know of both of you has come about within these past swift four or five months—I who have been without what you have to give for so many many years—and now it is all happening, suddenly, in such a short period of time. Growth and fruit must and will come of it. The flowing of these lives must flow on, and on and on to such fulfillments as are granted to the high types of this earth. I have no wish deeper than that this happens.

I am glad—and I mean glad—that you are feeling so good, and that you are moving. Move on, you great human being! And on!

And Peter—ah, Peter. I can see you looking out the window, listening. Spring outside. And the Ford? All right? And good wold Martin? And which kitten-cat have you? Or all of them?

In a week, not much more, I should be leaving. I'll send you details as soon as I myself know them.

I want to say other things, but they will have to wait. Jean.[23]

Stieglitz wrote Ansel Adams, June 9, 1934:

Since Oct. 1 last I have been at The Place daily excepting the 4 times I visited O'Keeffe in Lake George & spent a day or two with her... She is still not painting. Looks well enough but has no vitality. And without that it is impossible for her to paint or really do much of anything....

I do hope she'll gain strength eventually. It is a trying siege for her. And it is heart-breaking to watch....

O'Keeffe has left for New Mexico to see what that will do for her.... I do hope New Mexico will restore her health somewhat—& that maybe she will feel impelled to paint a little.[24]

In June 1934, after a three-year absence, Georgia returned to New Mexico with Marjorie Content. With Garland's marriage to Rodakiewicz dissolved, they rented a house on the H & M property. Georgia rented a separate house nearby for her work.[25]

In July 1934, Georgia met Mary Wheelwright at *Los Luceros* in Alcalde, and became best friends with Carol Stanley. Wheelwright distinguished herself by recording Indian rituals and chants, which resulted in the opening in 1937 of the Museum of Navajo Ceremonial Art in Santa Fe, today known as the Wheelwright Museum of the American Indian. William Penhallow Henderson designed the hogan-type building and his wife, poet Alice Corbin Henderson, served as curator.[26]

That September 1934, Georgia witnessed Marjorie's marriage to Toomer in Taos. Jean, meanwhile, had tried another experiment at communal living, but ended up abandoning the concept. In a chance meeting, Marjorie had joined a small religious sect of Quakers whose teachings overlapped with Gurdjieff.[27]

With all the trials and tribulations of Georgia's life, her art work returned to the site of her 1904–1905 art training when the Art Institute of Chicago exhibited the first of Georgia's work at the Century of Progress Exhibition of 1934.[28]

GHOST RANCH'S EARTH AND SKY

"They told me it was hard
to find, hard to get in."
–Georgia O'Keeffe

In August 1934, Charles Collier told Georgia about northern New Mexico's mountains, mesas and hills. The range contains the eroded colors of red, black, yellow, brown, gray, and purple turning to lavender forming the *Piedra Lumbre* basin. See figure 18-1.

Twelve miles north of Abiquiu in the midst of this earthly coloring stands the Ghost Ranch entrance gate. Collier and Georgia attempted an initial Ghost Ranch visit, but aborted their plans when they could not find the entrance.[1]

On another attempt, Georgia finally found the road that led to Ghost Ranch. She later commented:

They told me it was hard to find, hard to get in. There were no fences then. We rode in. They said it was haunted and just some old cowboys lived there. They said there was a horse's head hanging on the gate post, but that the head kept disappearing. But when I went, the horse head was there.[2]

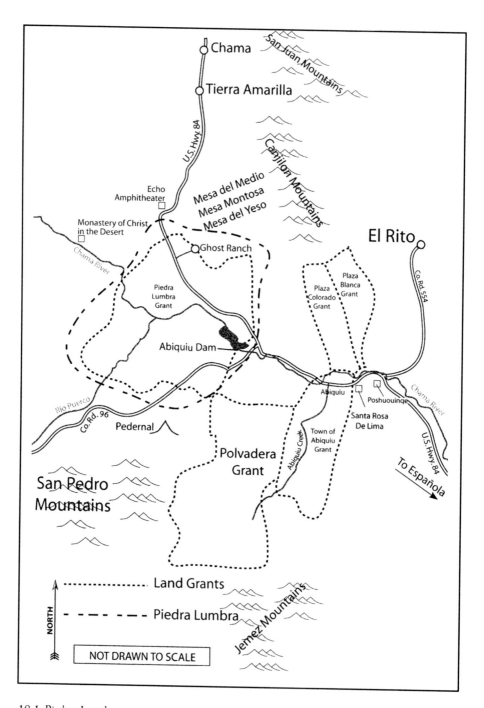

18-1 Piedra Lumbre

The almost desert land that Georgia discovered in August 1934 seemed alive, full of breath again, as if no one had been there before her.[3] Georgia said, "The Valley, from the Taos Plain toward Abiquiu, is like this ocean."[4]

The earth means many things to different people. To the farmer, the earth is fertile soil. To the naval officer, the earth provides the backdrop for the oceans. To the road contractor, the earth means tons of dirt and rock to move. But these descriptions don't tell you what the earth really is—a huge sphere measuring 24,901 miles in circumference at the equator, covered with water, soil and rock, and all of it surrounded by atmosphere. All life on earth resides on a skin-like layer, a crust of rock covered by the soil of hills, plains and mountains. To Georgia, the Ghost Ranch earth meant the form, shape and color of this skin-like layer. (See illustration number 5 on the dust jacket of the book, Ghost Ranch Area.)

This land displayed colors in unheard-of combinations and proportions and it served its intended role as a place of isolation where Georgia had envisioned a simple lifestyle. Away from the Taos and Santa Fe art centers, Ghost Ranch, in the midst of the overall desolate desert, existed as a contradiction with the separate elements of intense colors, vibrant light, unending vistas and swarming space.

The land of contradictions in and around Ghost Ranch became Georgia's sixth and final muse. The accumulation of a lifetime of muses matured at this very spot. She needed no more muses to simplify and summarize nature.

Georgia discovered that Ghost Ranch, a dude ranch, had no vacancy the night of her arrival. The owners, Brownie and Arthur Pack, accommodated her the next day by letting her stay in the Ghost House. This, the oldest house on the ranch, was named for the legend that a family murder had taken place there and that ghosts frequently appeared, which gave the ranch its Spanish name, *Rancho de los Brujos* (Ghost Ranch).[5]

In the mid-1920s, Arthur Newton Pack had launched a monthly publication, *Nature Magazine*, backed by his New Jersey father, who was a national leader in the conservation of forests and other natural resources and who dedicated most of his earnings from a successful Louisiana pine forest investment to his cause. With the purpose of writing about natural resources and forests, Pack set out to explore the Southwest. On one excursion in 1929, Arthur Pack and his wife, Brownie, departed from the San Gabriel Ranch at Alcalde with Carol Stanley

and discovered the sandstone cliffs of the *Piedra Lumbre*. His travels into rugged country lasted until the winter of 1932, when their daughter, Peggy, contracted pneumonia. Looking for a healthier climate, Arthur Pack remembered the *Piedra Lumbre*, and the land drew him like a magnet. Earlier he had searched for the ranch on a narrow dirt road leading up the twisting Chama River and marked by a animal skull. In 1933, Arthur and Peggy recalled:

> At a little general store which, except for two saloons and a pueblo-style church, constituted the entire "shopping district" of Abiquiu, we stopped to inquire about direction, and were delighted when the German storekeeper, Mr. Bode, volunteered to guide us some seventeen miles through the tortuous Chama Canyon and finally up and out across a sea of dry grassland dotted with juniper and piñon. The main road of poorly graded clay had been rough enough, but after a dozen miles we turned off on a mere track marked only by a cow's skull propped against a rock, slid down an incredibly steep hill, crossed a creek on a narrow log bridge and wound up on the other side beneath a spectacular array of cliffs seen years before. This our guide told us was called "Rancho de los Brujos."[6]

Carol Stanley, who had become the first Anglo to own Ghost Ranch, greeted the Packs. The hard times of the Great Depression caused the Pfaeffles to mortgage the ranch to Florence Bartlett, Chicago philanthropist, whose sister Maie and her husband, Dwight Heard, founded the Heard Museum in Phoenix, Arizona. Bartlett attempted to establish the International Folk Art Museum at the Alcalde site. Eventually, the difficult economic times caused the Alcalde ranch to fail, along with Stanley's marriage. In the divorce, Carol reclaimed her maiden name and kept Ghost Ranch. She then moved to Ghost Ranch with her grand piano and her English maid to continue her dude-ranching venture.[7]

The Packs laid out the floor plan on a table and had Stanley build their family an adobe house constructed around three sides of an open patio that they named "Ranchos de Burros," after the donkeys they'd bought for their children.[8] Then the Packs bought Ghost Ranch and one-third of *Piedra Lumbre* to begin a successful dude ranch. Brownie and Arthur divorced in 1934 and Brownie married Frank Hibben in 1936. Arthur married Phoebe Finley. See figure 18-2.

Brownie and Georgia remained friends. Occasionally Brownie came to Abiquiu to visit Georgia. Brownie recalled, "We had a picnic by a stream there [White Place] and a rattlesnake came up. I immediately jumped up because I was going to pick him up and throw him away. She said, 'Don't hurt him, don't hurt him. I like rattlesnakes.' So I picked him up and threw him off in the bushes."[9]

In August 1934, Georgia spent the entire summer going back and forth from Garland's house to Ghost Ranch where Phoebe befriended Georgia for many years.[10] See figure 18-3.

Georgia explored the area on foot to paint the sweeping foothills full of the piñon and juniper trees in their leopard-spot patterns, which came together as the piñons descended from the higher elevations and the junipers rose from the lower lands. Trees were no higher than twenty feet and they survived because their leaves and needles held any moisture to survive the long, dry years. They were protected from encroaching trees because the piñon, known for its short clusters of needles, pine scent, miniature pine cones, nuts and gray bark, casts off resins that inhibit the growth of anything else around it. And the juniper's upward standing branches, gnarled, green leaves, cedar scent, blue-red berries and reddish bark give off terpenes to exclude other plants' growth.[11]

Georgia, a visionary like few others, found the badlands to her liking. Her move from the East to Ghost Ranch is reminiscent of Robert Louis Stevenson writing, in *Across the Plains*, of his train ride from New York to California in the late 1800s: "I am usually very calm over the displays of nature, but you will scarce believe how my heart leaped at this. It was like meeting one's wife. I had come home again."[12]

Georgia's discovery of Ghost Ranch must have been like coming home to her because of the similarity to her Canyon, Texas, landscape.

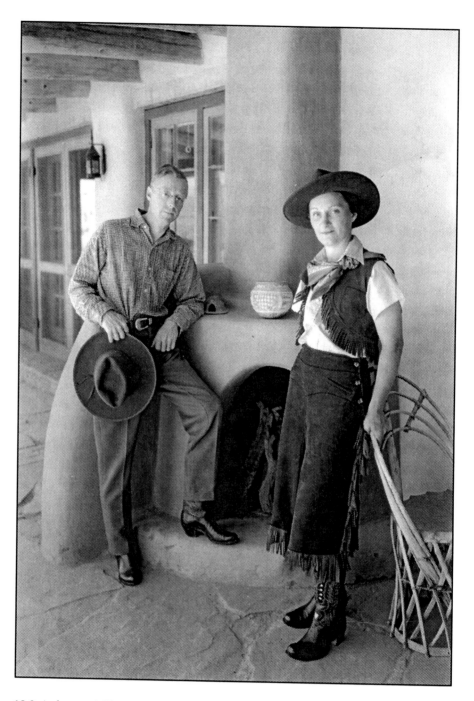

18-2 Arthur and Phoebe Pack, ca. 1935

18-3 Phoebe Pack and Georgia

19

GEORGIA'S GHOST RANCH HOME

"I wanted enough land to keep a horse—all Arthur would sell me was enough for my sewer."
–Georgia O'Keeffe

Georgia now focused her time on herself to become more self-sufficient as she discovered the unchanging land profile at Abiquiu and Ghost Ranch.

Meanwhile, Stieglitz busied himself during the summer of 1934 with the publication, *America and Alfred Stieglitz: A Collective Portrait.* The combined essays celebrated his seventieth birthday. Dorothy Norman edited the manuscript that included no essays by Stieglitz or O'Keeffe. The publisher's rejection of the lengthy manuscript forced Stieglitz to return to New York in mid-September for a consultation. Upon returning home he suffered an angina attack signaling him to slow down.[1]

In October 1934, Georgia returned to Lake George with Spud Johnson. Soon afterwards, in December, Stieglitz's book of praises and a large amount of images reached bookshelves as a Literary Guild selection.[2]

The new year, 1935, began with Stieglitz's January exhibition again calling on her past work, "Georgia O'Keeffe: Exhibition of Paintings (1919–1934)."[3]

Georgia's March 1935 trip to Lake George ended in April with an appendectomy. Stieglitz wrote Ansel Adams on May 13, 1935, "O'Keeffe was about ready to leave for New Mexico when laid low with appendicitis. She is convalescing. She has been very frail for 3 years. I hope the turn has come for her—so for me."[4]

Adams replied May 16, "Am terribly sorry to hear that O'Keeffe has been ill. Perhaps her appendix has been the cause of her former troubles."[5]

A May 1935, vacation only four miles south of York Beach, Maine, in Ogunquit took Georgia to the artists' colony. Begun as a fishing village, Ogunquit, in the late 1800s, attracted reknown artists seeking escape from the summer heat in large cities. The influx of artists found the natural beauty and clarity of light to their liking.[6]

Georgia returned to Lake George, then went on to New Mexico in July. She stayed at Garland's ranch until August 2, 1935, then moved to a room at Ghost Ranch. After side trips to Canyon de Chelly, Chaco Canyon, Truchas, Trampas and Taos, Georgia left for New York in November 1935.[7]

On her way home she drove to Canyon in November 1935, her first visit since leaving in 1919.[8] Margaret Harper, Louise Shirley's friend, said, "One day Isabel Robinson, who was head of the art program, looked up and saw Georgia O'Keeffe standing in the doorway. She walked back to the file and picked out every drawing she ever did and walked out with them. She never said a word."[9]

As early as 1936, Georgia was at odds with Santa Fe's art establishment. Although she went to Santa Fe for supplies and to visit with a small circle of friends, she shunned the art groups in town. Edgar Lee Hewitt rebuffed an offer from her and the Depression-era Federal Art Projects Office for Georgia to paint a mural on a museum wall. Hewitt, in Mexico at the time, learned of the offer through an assistant's letter that mentioned Georgia's national reputation with a reference to her as "a strange sort of freak with big hands." Hewitt responded by saying that Depression art seemed worse than the depression. Georgia would be alienated from the state museum until the 1970s, when talk surfaced of a new wing dedicated to Georgia.[10]

As standard policy in January 1936, Stieglitz's exhibition at An American Place, again featured Georgia's recent work in "Georgia O'Keeffe: Exhibition of Recent Paintings, 1935."[11]

Georgia returned to Ghost Ranch from New York in May 1936. She lived in the first house Arthur Pack built, *Rancho de los Burros*, a house she would eventually purchase from Pack. It was made of adobe bricks built around three sides of an open patio which afforded Georgia privacy and isolation from the ranch headquarters.[12]

Georgia did not isolate herself completely. On the north side of the Taos plaza, Emil Bisttram, a founder with Raymond Jonson of the Transcendental Painting Group in 1931, had opened the Heptagon Gallery. The gallery was possibly the first gallery in Taos. *The Taos Valley News*, July 16, 1936: "Georgia O'Keeffe, well-known artist of New York and Santa Fe was a Heptagon Gallery visitor Monday."[13]

Stieglitz wrote Adams, July 30, 1936: "O'Keeffe reports she is very happy in New Mexico & that is wonderful for me."[14]

During the hot days of August 1936, Georgia ventured northwest of Abiquiu and discovered a land of visual harshness near Nageezi, New Mexico, at an elevation of 6,920 feet. The land is known today as Bisti Wilderness (a Navajo word for large area of shale hills) and De-Na-Zin Wilderness (a Navajo word for crane).[15]

Today, to travel from Abiquiu to Georgia's gray-brown, featureless sites she painted near Nageezi, travel ten miles northwest from Abiquiu on U. S. Highway 84 to State Highway 96. Turn left and travel thirty-seven miles to State Highway 112. Turn left toward Regina and travel twelve miles until State Highway 112 ends at U. S. Highway 44, only four miles north of Cuba. Turn right onto U. S. Highway 44 and travel thirty-eight miles to Nageezi. Continue on U. S. Highway for eight miles to Blanco Trading Post and then six miles to Huerfano Trading Post. Turn left at Huerfano Trading Post onto Navajo Road 7500, which becomes Navajo Road 7023. The De-Na-Zin Wilderness of 22,454 acres is on the right. Continue on Navajo Road 7023 to State Highway 371. Turn right and travel a few miles to Navajo Road 7000. Turn right and travel a few more miles into the Bisti Wilderness of 3,946 acres. See figure 19-1.

In northwestern New Mexico the geology of Bisti and De-Na-Zin Wildernesses reign "in the nude" as a result of the flowing water from the glaciers of the final Ice Age. With little or no vegetation, the land eroded and laid bare strange shapes such as hoodoos, toadstools and badlands. The term "badlands" misleads because millions of years ago forests and animals thrived here. Their

dead accumulations left deposits of coal, oil and gas. For the protection of such valuable resourses and beauty, the government in 1984 designated the land a National Wilderness.

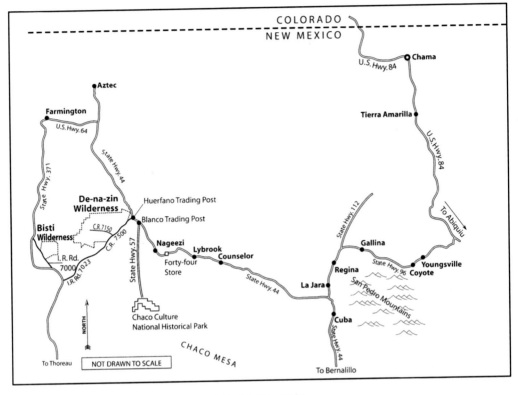

19-1 *Route to Bisti Wilderness and De-Na-Zin Wilderness*

These wilderness areas, ranging from 5,770 to 6,800 feet in elevation, feature calcite crystals and petrified wood fragments. Even today, no true trail heads exist and the topography remains confusing. To hikers, random venturing in the relatively flat areas surrounding the washes adds to the spirit of solitude and adventure in the land. It's as if the clock stops within the outcroppings, mud-like pedestals, bowl-like depressions, playas, washes and surfaces that resemble the barren, cracked soil of Mars. In hiking the land, often the only way back to your starting point is to follow your earlier footprints. Georgia named these forms the "Black Place," and described the area around Nageezi:

As you come to it over a hill, it looks like a mile of elephants—grey hills all about the same size with almost white sand at their feet.[16] (See illustration number 6 on the dust jacket of the book, The "Black Place".)

Fascinated, Georgia painted, among others:

Grey Hill Forms, oil on canvas, 20 x 30 in., 1936,
Grey Wash Forms, oil on canvas, 16 x 30 in., 1936.[17]

Following her usual routine, Georgia returned to New York in the fall 1936, and received a $10,000 commission to create a large painting for the exercise room at the Elizabeth Arden Salon. Upon completion, the never-exhibited painting was shipped immediately to the salon: Jimson Weed, oil on canvas, 70 x 83 1/2 in., 1936.[18]

Eugene Goosen, the art critic, wrote:

Historically, large paintings commissioned by the church and state were intended to communicate "public" virtues. Why were contemporary artists, with neither commissions nor any desire to communicate anything but their private virtues, painting such large works in recent history, and today, and for whom were they painted?[19]

In the mid-1950s, Goosen wrote about the prevalence of large paintings, paintings that were not only too big for most collectors to hang in their living rooms, but almost too big for the tight commercial gallery spaces in which they were originally displayed. Goosen viewed this as an extremely important development, for painting since the nineteenth century had been intended for the bourgeois living space. Big paintings reveal the importance of size to provide aesthetic power and the sublime, as well as declaring the importance of the painting's meaning, whatever it might be.[20]

In January 1937, Georgia received an invitation to teach at the Palo Duro School of Art, held at the Palo Duro State Park from June 2 to July 13. In addition, a new exhibit opened at the Mary E. Hudspeth Gallery at the Panhandle Plains Historical Museum and featured a painting by Georgia.[21]

With a burst of new paintings, a February 1937 Stieglitz exhibition ended

the tradition of past paintings with: "Georgia O'Keeffe: New Paintings."[22]

Georgia's travels continued with a visit to Palm Beach, Florida, with Anita, then to Lake George and another summer in New Mexico, where Peggy Bok and her husband, Henwar Rodakawicz, joined her at Ghost Ranch. Among the guests at Ghost Ranch that summer were Anne and Charles Lindbergh and Leopold Stokowski. A September trip to Arizona and Utah with Spud Johnson followed.[23]

In late September 1937, Georgia joined Ansel Adams and David McAlpin on a trip to Colorado and Arizona that included the Grand Canyon and Canyon de Chelly. Adams wrote Stieglitz on September 21, 1937:

> O'Keeffe is supremely happy and painting, as usual, supremely swell things. When she goes out riding in a blue shirt, black vest and black hat, and scampers around against the thunderclouds—I can tell you, it's something—all that is needed to complete the picture is to have you out in the gardens at six am in your green cape. I am certain you would like it here. But it is a long way from New York, especially for a person with your kind of schedules to fill.[24]

By December 1937, Stieglitz's frail physical condition had ended his photography career. He continued the exhibitions for Georgia and featured an additional exhibition in December 1937 at An American Place with "Georgia O'Keeffe: The 14th Annual Exhibition of Paintings With Some Recent O'Keeffe Letters."[25]

A few months later the ten-cent February 14, 1938, issue of *Life* magazine featured on the cover sixteen-year-old Farida, Queen of Egypt, and bride of seventeen-year-old King Farouk. The editorials praised *Life* for showing photographs of the carnage of war. An article, "Georgia O'Keeffe: Dead Bones and Live Pictures," was tucked on page twenty-eight between a photograph of the Roosevelts and friends at a White House party and a photograph of Hermann Göring.[26]

The article showed Georgia in photographs by Ansel Adams, Carl Van Vechten and Fernand Bourges, who in the mid-1930s had photographed American products for leading manufacturers.[27] This issue, along with the celebrity surrounding her because of Stieglitz's now famous nude photographs, made Georgia the most famous woman artist in America, a title she didn't like.[28]

Georgia received a commission from Steuben for a design on a glass plate in the spring of 1938. She executed the drawing with a later comment:

> I did the drawing—was promptly paid for the use of the drawing—on condition that they be permitted to buy the drawing later if they want it.[29]

About that time, Mrs. John D. Rockefeller, Jr., donated an O'Keeffe painting to William and Mary College in Williamsburg, Virginia: *White Flower*, oil on board, 15 3/4 x 19 7/8 in., 1932.[30]

The College wanted to confer on Georgia a Doctor of Fine Arts honorary degree and the painting became part of the ceremonies. The chairman of the art department since 1935, Leslie Cheek, Jr., a Yale graduate, probably initiated the conferring of the degree as an important element in his renovation of the art department.[31]

The College knew of her reclusiveness and Stieglitz's protection of her, so they sent a family friend, Earl B. Thomas, to make the first request, which resulted in turning the whole affair over to Cheek. The college mailed an invitation for Sunday, May 7, 1938, announcing that they would confer the degree at eleven o'clock in the morning at the Phi Beta Kappa Memorial Hall (now known as Ewell Hall). An enclosure in the invitation announced that some of Georgia's paintings would be displayed from May 4 to May 9 in the same hall.[32]

Georgia showed her pleasure in receiving the degree with a letter dated March 26, 1938, to the college president, Dr. John Stewart Bryan:

> It will be lovely seeing the Williamsburg country again with the spring leaves. I must assure you that I never even imagined ever going there or any other place for an honorary degree. It is quite outside my usual way of thinking so it is very much of a surprise to me. A pleasant surprise.[33]

Stieglitz, concerned as always over the hanging of the exhibition, sent his gallery assistant, William Einstein. A distant cousin of Stieglitz, Einstein, born in 1907, spent time in Russia showing the Russians reproductions of abstract art. Returning to America, Einstein rejected art completely and in 1933 embraced Wall Street. But in 1934 he returned to painting, met Stieglitz, and attended to odd jobs at An American Place. Two years later Stieglitz gave Einstein his first

exhibition. Einstein and Georgia developed such a keen friendship that Einstein later lived in Abiquiu for a time. Georgia welcomed Einstein to oversee the hanging of the exhibition in the hall where the lighting emerged indirectly from free-standing pylons onto the bluish-white walls.[34]

The nine paintings on exhibit, ranging from 1927 to 1937, included a wide representation of subject matter and sizes. Georgia chose *White Flower* for the entrance to the exhibit.[35]

The paintings bore title notations differing from Stieglitz's notes. Those chosen by Georgia:

Red Poppy, oil on canvas, 7 x 9 in., 1927,
Black Hollyhock and the Blue Larkspur, oil on canvas, 30 1/8 x 40 in., 1930,
Trees at Glorieta, New Mexico, oil on canvas, 30 x 40 in., 1929,
Purple Hills II, Ghost Ranch, oil on canvas, 16 1/4 x 30 1/4 in., 1934,
Yellow Hickory Leaves with Daisy, oil on canvas, 30 x 40 in., 1928,
New York, Night, oil on canvas, 40 1/8 x 19 1/8 in., 1928/1929,
Hollyhock Pink with the Pedernal, oil on canvas, 20 x 30 in., 1937,
Deer's Skull with Pedernal, oil on canvas, 36 x 30 1/8 in., 1936.[36]

Georgia, dressed in a white ensemble with high-heeled sandals, attended the awarding of her first honorary degree with some family members, Anita, Ida and Claudia. Stieglitz's major coronary and pneumonia in April did not permit his attendance. Dr. Bryan authored the citation, "Williamsburg may well find a grateful bond in recalling that in its quiet atmosphere her talents for vision and craftsmanship were first given an opportunity to mature."[37]

Following Bryan's address, Georgia refused to deliver an acceptance speech, establishing a pattern of referring to her work in color as non-transferable to words and wishing the paintings to speak for her. Her demeanor, ranging from hostile to pleased with the event, left the audience wishing for her remarks.[38]

Upon Georgia's return to New York, Bryan sent Stieglitz a copy of his address. Georgia wrote of her honorary degree:

He [Stieglitz] was very pleased when he read the copy of the address you sent and wished me to thank you. It was so kind of you to send it. The days in Williamsburg seem like a dream to me now.[39]

They then traveled to Lake George so Stieglitz could recuperate. Georgia wrote to William Einstein dated July 19, 1938:

> From my bed in Lake George—the first morning here—July 19—
>
> I arrived yesterday afternoon—everything quiet—damp and misty.
>
> Alfred came up last Thursday—six days ago. He is nicely settled—sleeping in the dining room—the nurse came with him but hurt her leg someway getting off the train so has been laid up ever since she was here—She left a couple of hours after I arrived—It is really lovely here—but my aim is to rest myself as much as I can during this time I feel I must stay and to leave as soon as I can—
>
> It was hot in the town but I didn't mind—Every time I waked last night enough to know anything I was surprised that it was cool enough to have a blanket over me.
>
> I have a lame arm—a bad nose—mostly need a dry open space all by myself. Alfred remarked, "None of your particular friends will be out here this year—what will you do?"—my answer—"Be by myself which I like—or make some new friends"—Alfred's answer in a very sad voice, "Yes I know."
>
> Dave and Godfrey invite me on a trip into the high Sierras in California for September—Adams going too. I am going if everything is alright here and I am alright and get in some riding before then—Adams knows the places to go and can get the best equipment together—all I need is to be fit to go—This morning I don't feel much like it—sitting here in this damp place—comfortable—But Oh my God!
>
> I'm too tired to even write straight.
>
> I showed your drawings to Hoffman. He was much surprised and amused. I let him take them to show to some one he thought might use them. I explained that you were doing more and I thought they would even be better—He asked if he might take them—was very enthusiastic—It was just a few days before I got away—He will write me here. I will send you the letter—I told him to keep the drawings for me—or you can write him for them if you want them and nothing comes of his effort to market them.
>
> I've been asked to do some work for a Pineapple Co out in Hawaii—by an advertising co—We telephone and telegraph and talk—and now a

man has gone out to Hawaii on the china clipper to see the people—etc. I don't know whether any thing will come of it or not.

At this moment I don't much care—but about ten days ago after I had looked over all the maps and folders and pictures I was much interested...

I believe there is nothing else in my head at the moment

My greetings to Eli

I am glad your figure is improving—your state of mind is undoubtedly much more shapely too—Ross is coming August 15 I think—G.[40]

In the summer of 1938, Georgia received a commission from the N. W. Ayer & Son advertising agency to go to Hawaii for the Dole Pineapple Company. Dole invited Georgia along with other artists such as Pierre Roy and Isamu Noguchi.[41]

Pierre Roy (1880-1950), a French surrealist artist, by 1938 had had three of his paintings accepted at the MoMA, in 1930, 1931 and 1935.[42]

Noguchi, born in Los Angeles in 1904 of Japanese-American parents, lived part-time in Japan before moving to the United States. In 1912, Noguchi's sister, Ailes, was born. After their father abandoned the family, Noguchi eventually apprenticed with sculptor Gutzon Borglum in Connecticut. After an attempt at medical school, Noguchi devoted his career to sculpture. His terra-cotta and stone sculptures expressed the spirit and mystery of Japanese earthenware. From his medical studies he recognized the relationship between bone and rock forms. He visited Stieglitz's Intimate Gallery during 1925-1926 and in 1935 began creating stage designs for Martha Graham, which eventually included *Appalachian Spring*. In 1962, Noguchi was elected to the American Institute of Arts and Letters and in 1971 to the American Academy of Arts and Letters. He received the Gold Medal for sculpture in 1977 from the Academy. After many sculpture commissions, Noguchi embarked on making sculpture useful in everyday life by designing furniture, which led to his making in 1951 his first akari lantern of crinkly paper and bamboo.[43]

While in Hawaii, Georgia, unhappy with her set-up, managed to meet one of her neighbors, Richard Pritzlaff, who lived near Sapello on his San Ignacio Ranch some thirty-five miles east of Santa Fe in the Santa Fe Mountains. He raised Arabian horses and chow dogs.[44]

Although purebred Arabian horses from Egypt had been imported to America as early as 1895, Pritzlaff, in 1947 purchased the pure Egyptian Saqlawiyah filly, Rabanna. With additional purchases Pritzlaff dedicated half a century to producing Arabian horses that thrived in the rocky terrain of his San Ignacio Ranch.[45]

The paintings from the Hawaiian trip:

Fishhook from Hawaii, No. 1, oil on canvas board, 18 x 14 in., 1939,

Fishhook from Hawaii, No. 2, oil on canvas, 36 x 24 in., 1939,

Heliconia, oil on canvas, 19 x 16 in., 1939,

Crab's Claw Ginger Hawaii, oil on canvas, 19 x 16 in., 1939,

Pink Ornamental Banana, oil on canvas, 19 x 16 in., 1939,

Bella Donna with Pink Torch Ginger Bud, oil on canvas, 19 x 16 in., 1939,

Hibiscus with Plumeria, oil on canvas, 40 x 30 in., 1939,

Cup of Silver Ginger, oil on canvas, 19 x 16 in., 1939,

Untitled (Hibiscus), oil on canvas, 18 7/8 x 15 7/8 in., 1939,

Hibiscus, oil on canvas, 19 x 16 in., 1939,

White Lotus, oil on canvas, 20 x 22 in., 1939,

White Bird of Paradise, oil on canvas, 19 x 16 in., 1939,

Black Lava Bridge, Hāna Coast, No. 1, oil on canvas, 24 x 20 in., 1939,

Black Lava Bridge, Hāna Coast, No. 2, oil on canvas, 6 x 10 in., 1939,

Waterfall End of Road Ioa Valley, oil on canvas, 19 x 16 in., 1939,

Waterfall, No. 1, Iao Valley, Maui, oil on canvas, 19 x 16 in., 1939,

Waterfall, No. 2, Iao Valley, oil on canvas, 24 x 20 in., 1939,

Waterfall, No. III, Iao Valley, oil on canvas, 24 x 20 in., 1939,

Pawpaw Tree, Iao Valley, Maui, oil on canvas, 19 x 16 in., 1939.[46]

Georgia had been unhappy about not being able to stay in the worker's housing near the pineapple fields. So she busied herself painting the many species of flowers. The Dole Pineapple Company was displeased with her output of paintings, none of which included any reference to pineapple. The company sent her a pineapple and Georgia painted: *Pineapple Bud*, oil on canvas, 19 x 16 in., 1939.[47]

Stieglitz opened An American Place in January 1939 with "Georgia O'Keeffe: Exhibition of Oils and Pastels." At that time Georgia made a statement

that rejected the Freudian interpretations of her enlarged flower paintings: "Well–I made you take time to look at what I saw and…you hung all your own associations with the flowers on my flower."[48]

Georgia's activities included in June 1939 the Business and Professional Women's Day at the World's Fair in New York, which honored Anne O'Hare McCormick as their "Woman of the Year." The committee named twelve outstanding women of the previous fifty years, with Eleanor Roosevelt heading the list. The other recipients were: Ida M. Tarbell, "dean of American women writers;" Dr. Florence Sabin, scientist; Annie Warburton Goodrich, dean emeritus of the Yale University School of Nursing; Carrie Chapman Catt, women's rights leader; Eleanor Robson Belmont, founder of the Metropolitan Opera Guild; Mary Ritter Beard, scholar and historian; Dr. S. Josephine Baker, pioneer in reducing the infant mortality rate; Malvina Hoffman, sculptor; Helen Adams Keller, who although deaf and blind inspired others; and Georgia, ranked as "one of the most original of contemporary American painters." Georgia chose not to attend. In fact, only four from the group attended.[49]

To represent New York State, the World's Fair chose for its exhibition Georgia's painting, *Sunset, Long Island*, oil on canvas, 10 x 14 in., 1939.[50]

February 1940 brought Stieglitz's exhibition at An American Place, "Georgia O'Keeffe: Exhibition of Oils and Pastels." Georgia noted:

> If my painting is what I have to give back to the world for what the world gives to me, I may say that these paintings are what I have to give at present for what three months in Hawaii gave to me.[51]

At age fifty-three in October 1940, Georgia bought Arthur Pack's first house at Ghost Ranch, *Rancho de los Burros*, and seven acres, the first home she had owned. Years later she commented, "I wanted enough land to keep a horse–all Arthur would sell me was enough for my sewer!"[52]

In 1940 Georgia had met twenty-six-year-old Mary Lea (Maria) Chabot, a hopeful writer, at Mary Cabot Wheelwright's *Los Luceros*. For separate reasons they befriended each other. Georgia needed an assistant to manage her household and Chabot needed a quiet atmosphere in which to write.[53]

Chabot's English-born paternal grandfather had held the position of British consul to Mexico during the 1860s. He fled to San Antonio, where his

son, Charles Jasper Chabot, and Charles's third wife had Maria in 1913.[54]

Chabot graduated from a San Antonio high school at age fifteen, determined to be a writer. After several years working as an advertising copywriter, at age nineteen she abandoned her job. She began what would become a nomadic life by traveling to Mexico City to study Spanish and archeology. There she met some New Mexicans, among them a leader in the New Mexico Association of Indian Affairs. After several years traveling and working in France, Chabot traveled to New Mexico where she worked for the WPA providing work for artists and writers. One of her assignments included photographing and documenting Native American and Spanish Colonial arts and crafts. She met Mary Cabot Wheelwright when she photographed Wheelwright's extensive collection of Indian artifacts at *Los Luceros* in Alcalde, New Mexico. For the next twenty years, Chabot managed *Los Luceros* and Wheelwright eventually deeded eighteen acres to her.[55] See figure 19-2.

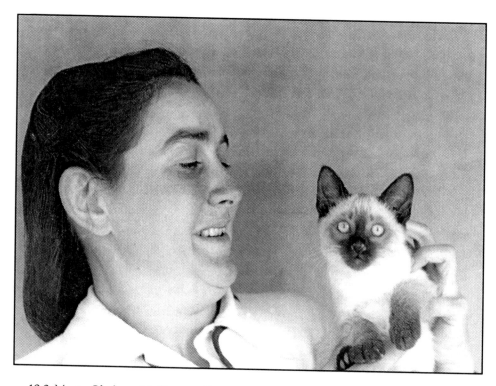

19-2 Maria Chabot with Siamese Cat at Ghost Ranch, ca. 1940

Chabot also served as president of the New Mexico local irrigation system. In 1936, Chabot realized that the Native Americans had no market for their crafts, as Mexicans did, and she began what today are the Native American markets on the Plaza in Santa Fe.[56]

After her Native American market work, Chabot met Georgia through Wheelwright and spent her summers at Ghost Ranch from 1941 to 1944 to find writing time. But Chabot discovered that most of her time involved managing the details of Georgia's daily life and remodeling the Ghost Ranch house.[57] See figure 19-3.

As Chabot's role increased at Ghost Ranch, the two women dealt with other issues such as wartime rationing of tires, sugar and other essentials, growing or buying fresh vegetables, Chabot's obsession with starting a garden and attempts to buy a house and garden at Barranca near Abiquiu, tax assessments, maintaining a gasoline-powered generator that provided electricity and undrinkable water, no telephone, a mailbox a mile away, Chabot's reference to herself as the "hired man," and Georgia's instructions.[58]

The Ghost Ranch house resembled *Casa del Sol*, the Old Director's House at Ghost Ranch, today used for spiritual retreats. The U-shaped adobe house had been built in 1933 by Arthur Pack's carpenter-builder, Ted Peabody. Georgia had rented the house since 1937. Its doors opened onto a central flagstone patio and offered a direct southern exposure, placing *Cerro Pedernal* firmly in the main view.[59]

Chabot knocked out walls, added large windows, and made a large studio. With Georgia in New York, Chabot sent detailed itemized reports in 1941 about building instructions. So the house would be ready when Georgia arrived, the reports contained such items as: "small roll of tar paper has been purchased and will be put on pantry door before I depart; I have brought in 50 of the Bennet adobes and will bring in the rest at the first opportunity."[60]

The simple adobe Ghost Ranch house remained isolated, with no telephone or radio linking Georgia to the outside world, although the first telephone installed in New Mexico took place in 1879 in Las Vegas. Year after year, telephone exchanges opened in Albuquerque, Santa Fe, Raton, and other New Mexico cities. By the time New Mexico joined the United States in 1912, long-distance service ran from the Atlantic to the Pacific.[61] But Ghost Ranch and Abiquiu still lacked telephone communication.

The single-story Ghost Ranch house sits on seven and one-half acres amidst Pack's Ghost Ranch. A roof line of the house's chimneys rests at the base of the red and yellow cliffs featuring a formation now called Chimney Rock and quite similar to the Palo Duro Canyon's Lighthouse.[62] (See illustration number 7 on the dust jacket of the book, Chimney Rock.)

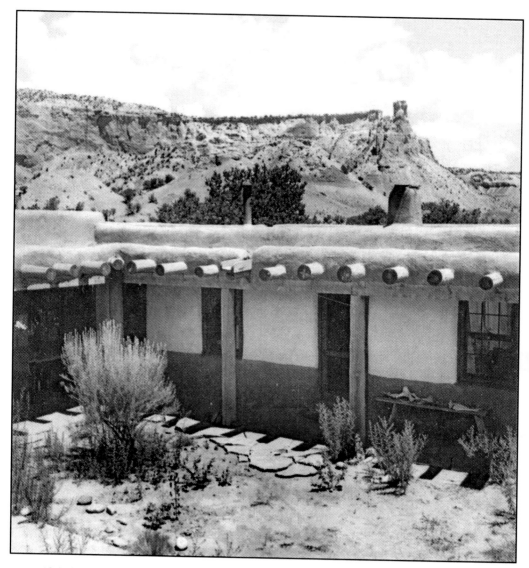

19-3 Georgia's Ghost Ranch House, ca. 1940

The grounds of the Ghost Ranch house are as nature designed with interspersed wild grass and a minimum of shrubbery. Today, the patio houses driftwood, sea shells, and bleached animal bones from Georgia's years of collecting.[63] The house can be entered through a personal dining room with a table for one, surrounded by windows, or through a white kitchen.[64]

The house features adobe walls as an extension of the earth, *viga*-and-*latilla* (beam and ceiling deck) ceilings and wooden floors. The central patio full of native gray-green chamisa includes a wooden ladder to the roof where Georgia entertained guests and watched the colors change, and where she often slept.[65]

Georgia's studio of whitewashed adobe walls and a hardwood floor contains an adobe fireplace beneath a mantel with a white animal skull. On the windowsills and cedar ledges around the room rest more bones and weathered branches. A picture window, shaded by white cotton curtains, frames the view. Other items include a simple wooden table, rush-seated chairs, a red canvas-and-chrome Le Corbusier-style lounge chair, a wooden bench, an easel and her ever-present metal table on rollers that held her painting supplies.[66]

Next to the studio a bedroom/sitting room again holds few furnishings: a table, black chair, stereo and desk.[67]

Georgia's corner bedroom contains two perpendicular glass windows, again for the view, and a flagstone floor. Cedar ledges display her treasured collections. Her twin bed is covered in white cotton sheets.[68]

The dining room has a long plywood table with tall Chinese chairs surrounding the eating space. An Art Deco floor lamp provides lighting. Black stones line the window sill.[69]

Adjacent to the dining room are the white kitchen and pantry, distinctly organized for her food preferences. She ate her meals sitting on a *banco* in a small vestibule adjacent to the kitchen, again for the view, which she would paint many times.[70]

With many paintings of the surrounding hills, Georgia would not paint *Cerro Pedernal* until 1936. Then she painted *Cerro Pedernal* in various ways in the background, middle ground, and foreground:

Deer Skull with Pedernal, oil on canvas, 36 x 30 in., 1936,
Red Hills with the Pedernal, pastel on moderately thick, beige, sand-covered paper mounted to grey cardboard, pastel board, 21 1/2 x 27 1/4 in., 1936,

Red Hills with Pedernal, White Clouds, oil on canvas, 20 x 30 in., 1936,

Pedernal with Red Hills, oil on canvas, 20 x 30 in., 1936,

Pedernal, New Mexico, oil on canvas, 10 1/8 x 12 1/8 in., 1936,

Untitled (New Mexico Landscape), graphite on paper, 10 x 13 3/4 in., ca. 1936,

Ghost Ranch Landscape, oil on canvas, 12 x 30 in., ca. 1936,

The House I Live In, oil on canvas, 14 x 30 in., 1937,

Hollyhock White with Pedernal, oil on canvas, 16 x 30 in., 1937,

Hollyhock Pink with the Pedernal, oil on canvas, 20 x 30 in., 1937,

Datura with Pedernal, oil on board, 11 x 16 1/8 in., 1940,

Road to Pedernal, oil on canvas, 6 1/8 x 10 in., 1941,

Untitled (Pedernal), oil on board, 7 x 16 in., 1941,

Pedernal, oil on canvas, 19 x 30 1/4 in., 1941,

My Front Yard, Summer, oil on canvas, 20 x 30 in., 1941,

Pedernal, oil on canvas, 20 1/8 x 30 1/4 in., 1941/1942,

Pelvis with Moon–New Mexico, oil on canvas, 30 x 24 in., 1943,

Pelvis with Pedernal, oil on canvas, 10 x 22 in., 1943,

Pedernal, pastel on paper, 21 1/2 x 43 1/4 in., 1945,

Spring, oil on canvas, 48 1/4 x 84 1/4 in., 1948,

Cottonwood and Pedernal, oil on canvas, 10 x 12 in., 1948,

Antelope Head with Pedernal, oil on canvas, 20 1/4 x 24 1/4 in., 1953,

Pedernal–From the Ranch I, oil on canvas, 30 x 40 in., 1956,

Pedernal–From the Ranch II, oil on canvas, 30 x 40 in., 1958,

Ladder to the Moon, oil on canvas, 40 x 30 in., 1958,

Untitled (Pedernal), oil on canvas, 10 x 10, ca. 1958.[71]

By 1944, Chabot and Georgia's complex relationship had escalated to uncompromising problems. Chabot insisted on a more significant role in Georgia's life and Georgia kept Chabot at a distance.[72]

During the time when she was buying the Ghost Ranch house, she discovered an old ruined house in Abiquiu that fascinated her.

Meanwhile, from January 30 to March 25, 1941, Stieglitz assembled an "Exhibition of Georgia O'Keeffe," again at An American Place.[73]

Georgia made a series of trips to Richmond, Charlottesville and Chicago in 1941. Then, in June, Chabot moved into the Ghost Ranch house, worked on

her own writing projects, and managed the house through 1945.[74]

Georgia's love of the sheer physical pleasure of being outdoors at Ghost Ranch led to many camping and painting trips that Chabot organized. In August 1941, Georgia and Chabot traveled to the vertical white rock formations near Abiquiu that Georgia called the White Place. Nine years after discovering the Abiquiu cliffs, Georgia began a series devoted to them:

From the White Place, oil on canvas, 30 x 24 in., 1940,

White Place in Shadow, oil on canvas, 19 x 10 in., 1941,

Blue Sky, oil on canvas, 36 x 16 in., 1941,

The White Place–A Memory, oil on canvas, 30 x 20 in., 1943,

The White Place in Sun, oil on canvas, 28 x 22 in., 1943.[75]

In September and November 1941, Georgia and Chabot traveled to the Nageezi area and Georgia again painted the Black Place: Grey Hills, oil on canvas, 20 x 30 in., 1941.[76]

Georgia's time painting in the Black Place resulted in three paintings of the Black Place featured in Stieglitz's February 12 to March 10, 1942 exhibition at An American Place, "Georgia O'Keeffe: Exhibition of Recent Paintings."[77]

On Monday, June 1, 1942, Georgia received an honorary degree from the University of Wisconsin. Others awarded at the same ceremony were Hu Shih, the Chinese Ambassador to the United States; General Douglas MacArthur; and Edgar Eugene Robinson, historian at Stanford University. MacArthur, directing the war effort, did not attend. Major-General George Grunert accepted for him. Georgia attended with Shih and Robinson.[78] See figure 19-4.

Hu Shih's citation read:

Hu Shih, the Chinese Ambassador to the United States. Distinguished representative of the world's largest republic whose fortunes are now interwoven with our own. Cultured emissary of a people in whom this University has had a special interest resulting from the hundreds of able Chinese students who have come here and the many Wisconsin alumni, Chinese and American, who have gone there to serve China in one capacity or another. Brilliant poet, man of letters, and philosopher.

Thoroughly grounded not only in the ancient learning of the East, but also in the modern learning of the West. Believing that no living literature can be created in a dead language, he became the leader, by precept and example, in making the spoken language of China the language also of education and literature—an achievement that in the perspective of time may rank as his greatest.

Because he is one of the world's great scholars, a tireless leader in the full democratization of China, and diplomatic representative pre-eminently capable of interpreting China and the United State to each other.[79]

Edgar Eugene Robinson's citation read:

Historian, Native son of Wisconsin and alumnus of its University. For more than thirty years professor of American history at Leland Stanford University and one of the mainstays in the work of that distinguished institution. Able, executive, inspiring teacher, keen analyst of the American scene, and particularly of American political life, as shown in his scholarly and graceful published writings.[80]

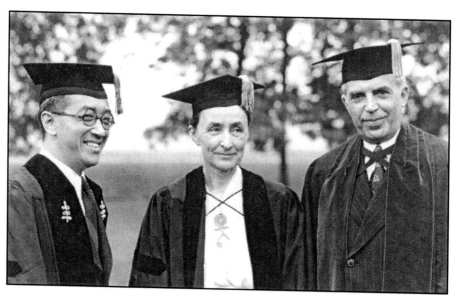

19-4 Hu Shih, Georgia, Edgar Eugene Robinson, University of Wisconsin

General Douglas MacArthur's citation read:

Grandson of the MacArthur who was an eminent Wisconsin jurist, Lieutenant-Governor, and for a few days Governor of the State. Son of the MacArthur who at the head of the 24th Wisconsin Infantry emerged from the Civil War a Colonel before was of age.

Douglas MacArthur, worthy bearer of a noble ancestral heritage. Appointed to West Point from Wisconsin, he graduated at the head of the class of ninety-three. Every inch a soldier, and destined to become a commanding general in the two greatest wars of history, he participated in the great defensive and offensive campaigns in France a quarter century ago, at the end commanding the celebrated Rainbow Division in which many Wisconsin soldiers fought; he served as superintendent of the United State Military Academy, the youngest officer ever to hold the post; he was chief of staff of the United States Army for six years, retiring at fifty-five; he believed the Philippines could be defended and years before Pearl Harbor received the thanks of the Philippine National Assembly for organizing and developing the Philippine Army; and as general in command of the United States Armed Forces in the Far East he conducted the brilliant defense of the Bataan Peninsulas that astounded the enemy and thrilled our United Nations.[81]

Georgia's citation read:

Daughter of Wisconsin by birth and early education. Both a creative artist and a creative teacher of art. A distinguished painter whose work has won a coveted place in the great galleries of America. Recipient of a distinctive award when at the time of the New York World's Fair she was chosen one of the twelve most outstanding American women of the past fifty years.

In recognition of her enviable achievements as a painter, and as tribute to a Wisconsin woman who has triumphed in the difficult field of the fine arts, I present to you, Mr. President, upon recommendation of the Faculty and by vote of the Regents, Georgia O'Keeffe for the honorary degree, Doctor of Letters.[82]

From all accounts, during the time Georgia was receiving the university's honorary degree she did not visit Sun Prairie. She greeted her friends and relatives at a Madison reception given by Dean F. O. Holt and his wife. Mrs. Zed Eidson, a teacher in attendance from the Town Hall School in Sun Prairie, commented on the reception:

> Of course, there was not much chance to visit, but she detained me a moment and said "fall in and come back again," which I did. She looked much like her father and when I told her this she seemed very pleased, and smiled with both eyes and mouth, and then she did look like him.[83]

In January 1943, Georgia traveled to Chicago to install sixty-one works featured in the winter exhibitions at the Art Institute of Chicago from January 21 to February 22. This retrospective, "Georgia O'Keeffe," curated by Daniel Catton Rich, became the first showing in any museum.[84] See figure 19-5.

Because of Georgia's exhibition at the Art Institute of Chicago, Stieglitz delayed his annual exhibition at An American Place until March 20, 1943: "Georgia O'Keeffe, Paintings—1942-1943."[85]

With Georgia's summer travels to New Mexico now a definite routine, she arrived in April 1943 to begin painting the cottonwood trees. One of the most significant was *Cottonwood III*, oil on canvas, 20 x 30 in., 1943.[86]

An easy dismissal of the cottonwood tree is impossible as its stately presence has flourished along the Chama River for millions of years. This water-loving tree that thrives in a semi-arid environment only reproduces when the wind-borne, cottony seeds settle on an open, flooded, sandy spot. The cottonwood's roots can grow as much as five feet deep in one short season. Above ground, they can grow five to fifteen feet in the same short season. In ten to twenty years, the cottonwood reaches its mature height, then thickens in the trunk and limbs with a canopy spreading overhead to give shade. As winter approaches, the tree explodes with color.[87]

William DeBuys, who wrote of water use and the environment, described the cottonwood:

> An icon of the West. Its arching canopy offers shelter and shade in a land where both are scarce. Its furrowed bore stands fast against restless

skies. Most important, the cottonwood signals water amid dryness. And its fat leaves, the size of a child's hand, applaud the slightest breeze with a sound like rain.[88]

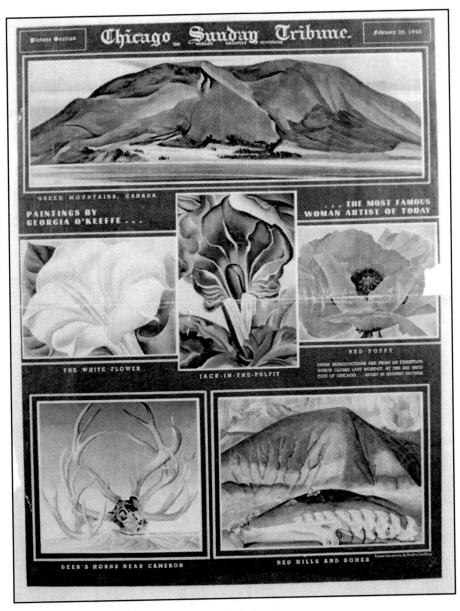

19-5 *Chicago Sunday Tribune*, February 28, 1943

Georgia continued with the cottonwood series, featuring only a partially dead tree trunk with a fully leafed tree in the background topped with blue sky: *Dead Cottonwood Tree*, oil on canvas, 36 x 30 in., 1943.[89]

The series continued with:

Cottonwood Tree, oil on canvas, 36 x 30 in., 1943,
Cottonwood Tree in Spring, oil on canvas, 30 x 36 in., 1943,
Cottonwood I, oil on canvas, 30 x 36 in., 1944,
Dead Tree with Pink Hill, oil on canvas, 30 x 40 in., 1945,
Untitled (Cottonwood Tree), oil on canvas, 24 1/4 x 20 in., 1945,
Spring Tree No. I, oil on canvas, 30 x 36 in., 1945,
Spring Tree No. II, oil on canvas, 30 x 36 in., 1945,
Yellow Cottonwoods, oil on canvas, 36 x 30 in., 1946,
Cottonwood and Pedernal, oil on canvas, 10 x 12 in., 1948,
Grey Tree, Fall, oil on canvas, 40 x 30in., 1948.[90]

In two trips in August and October 1943, Georgia and Chabot traveled to the Black Place. Georgia painted: *The Black Place*, oil on canvas, 20 x 36 in., 1943.[91]

On January 9, 1944, Stieglitz's exhibition at American Place was "Georgia O'Keeffe Paintings–1943." Of the floating pelvises, Georgia wrote:

When I started painting the pelvis bones I was most interested in the holes in the bones...particularly the blue from holding them up in the sun against the sky as one is apt to do when one seems to have more sky than earth in one's world.[92]

Georgia's support for the National Women's Party surfaced when on February 10, 1944, she wrote Mrs. Franklin D. Roosevelt, who opposed the Equal Rights Amendment (ERA). She wrote Roosevelt that women who had worked for the ERA had made it possible for the president's wife to have the power to work in our country and to participate in a public life. Georgia continued that true democracy meant "that all men and women stand equal under the sky."[93]

In May and June 1944, Georgia and Chabot again traveled to the Black Place. Georgia painted:

Black Place, I, oil on canvas, 26 x 30 in., 1944,
Black Place II, oil on canvas, 23 7/8 x 30 in., 1944,
Black Place III, oil on canvas, 36 x 40 in., 1944,
Black Place No. IV, oil on canvas, 30 x 36 in., 1944.[94]

In August 1944, Georgia organized support for the health clinic in Abiquiu. Arthur and Phoebe Pack aided with their philanthropy. North of Española scant medical care existed. By June of 1945 the clinic had opened for those who often felt the old ways were the best. The caregivers had not only to study the patient's symptoms but to observe their customs and personality. Eventually Dr. Michael Pijoan founded the Española Medical Center and Española Hospital, for which Winfield Morten later endowed a fine medical library. In the waiting rooms a surprising conglomeration of people waited, an ailing man with a rope tied around his waist to prevent back pain from traveling to the heart, a Penitente with back wounds from secret Easter rites, and wealthy people who owned beautiful homes for respite from business pressures.[95]

Stieglitz's exhibit at An American Place in January 1945 was: "Georgia O'Keeffe Paintings, 1944." In May 1945 Georgia traveled to New Mexico. By now Wheelwright had deeded several acres of *Los Luceros* to Chabot. Georgia and Chabot continued traveling together and Chabot stayed at Ghost Ranch part-time.[96] See figure 19-6.

During the 1940s, Georgia met Mary Callery (1903–1977) during an exhibition of Callery's sculpture. Callery, born to a prominent family in New York and raised in Pittsburgh, developed an interest in sculpture at age twelve. She lived in Paris between 1930 and 1940 and became part of Pablo Picasso's modern movement. Returning to America in 1940, she developed her distinctive style of linear, open sculptures that resemble drawings in metal. In September 1945, Callery visited Georgia in Abiquiu. Together they traveled to the Black Place.[97]

Georgia's final paintings of the Black Place:

Black Place, Grey and Green, oil on canvas, 36 x 48 in., 1949,
Black Place Green, oil on canvas, 37 1/4 x 47 1/4 in., 1949.[98]

Ever since 1940, when Georgia saw the abandoned house in Abiquiu, she had been trying to buy the property. Martin Bode, who owned the general store in Abiquiu with Miguel Gonzales, had purchased the property and eventually gave it to the Archdiocese of Santa Fe for a convent or school.[99]

Georgia wrote Maria Chabot on February 17, 1943, "Yes-that dream of that [Abiquiu] house-and that garden-isn't it awful the way it persists-"[100]

Georgia had already offered a lesser amount to the church when she raised her price to $4,000 with $3,000 as a gift to the church later in 1943. With Bode and the priest at odds, Georgia's chance of securing the house declined. Maria Chabot's friend suggested that the $4,000 would make a nice start toward a clinic for Abiquiu. Georgia later participated in the possibility of a clinic as a means to establish a stronger tie with the Abiquiu community.[101]

In late November 1943, Georgia even considered sending the priest a check in hopes that he would just cash it.[102]

Finally, in July 1945, Georgia re-opened negotiations with Bode and he relented on the property being made a convent or school. Now, the property was actually for sale.[103]

In mid-October 1945, Georgia and Chabot met in Santa Fe with the Archbishop about transferring the property. They agreed that Georgia would possess the house for a gift of $4,000 to the church, which also would be a tax write-off for Georgia. J. O. Seth, her attorney, continued the negotiations.[104]

Georgia, still not certain as late as November 1945, wrote Chabot:

> And then too there is the Abiquiu house-It is odd the way I cannot make the decision-more of that-tomorrow or the day after-And all the time I think I am going to do it in spite of my stalling- [105]

Finally on December 3, 1945, Georgia wrote Chabot:

> -it is strange that it should be so difficult for me to finally say yes-But that Abiquiu thing has become part of what I really look forward to in New Mexico-I know it will be a suffering but it will also be good-so I'm saying Yes-[106]

By December 24, 1945, Georgia had sent her check for the house and later

would send her gift. The deed was not clear, so she expected the acquisition of the house to linger until spring.[107]

O'Keeffe wrote Chabot on December 30, 1945:

> Mr. Seth wired me yesterday that I can have the Abiquiu place—extending between the north and south roads and bounded by arroyos on east and west—arroyo bottoms—
>
> I wired him to take it—Had sent him my check some time ago—so it is probably fixed—That is that—Finally—.[108]

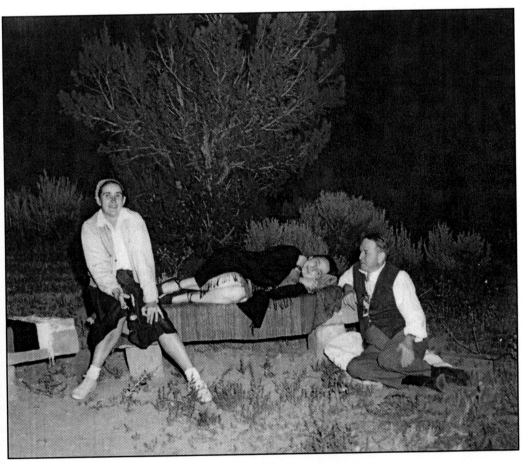

19-6 *Maria Chabot, Georgia, Unidentified Person, mid 1940s*

DOCUMENTATION ABBREVIATIONS IN NOTES

ASAAS** Norman, Dorothy, *Alfred Stieglitz, An American Seer*, An Aperture Book, New York, 1960

CA&L** Updike, John, ed., *A Century of Arts and Letters*, Columbia Press, New York, 1998

CSA** Kandinsky, Wassily, *Concerning the Spiritual in Art*, Dover Publications, New York, 1977

BJE** *Britannica Junior Encyclopedia*, Encyclopedia Britannica, Inc., Chicago, 1969

BR** Fine, Ruth E., Glassman, Elizabeth, Hamilton, Juan, *The Book Room: Georgia O'Keeffe's Library in Abiquiu*, The Georgia O'Keeffe Foundation, Grolier Club, New York, 1997

C** Dow, Arthur Wesley, *Composition, A Series of Exercises in Art Structure for the Use of Students and Teachers*, Doubleday, Doran & Company, Inc., New York, 1938

C&PI** Eddy, Arthur Jerome, *Cubists and Post-Impressionists*, A. C. McClurg & Co., Chicago, 1914

EB** *Encyclopedia Britannica*, Encyclopedia Britannica, Inc., Chicago, 1969

EBHP** *Encyclopedia Britannica*, Encyclopedia Britannica Home Page, 2000

FC** Bement, Alon, *Figure Construction, A Brief Treatise on Drawing the Human Figure, For Art Students, Costume Designers, and Teachers*, The Gregg Publishing Company, New York, 1921

FFN** Merrill, Christopher, Bradbury, Ellen, *From the Faraway Nearby, Georgia O'Keeffe as Icon*, University of New Mexico Press, Albuquerque, New Mexico, 1998

GOK** Robinson, Roxana, *Georgia O'Keeffe*, Harper Perennial, New York, 1989

GOKCR(1)** Lynes, Barbara Buhler, *Georgia O'Keeffe, Catalogue Raisonné*, vol. 1, Yale University Press, New Haven, Connecticut, 1999

GOKCR(2)** Lynes, Barbara Buhler, *Georgia O'Keeffe, Catalogue Raisonné*, vol. 2, Yale University Press, New Haven, Connecticut, 1999

GOKIC** Stoker, Fred, *Georgia O'Keeffe in Canyon*, Canyon-Randall Centennial
 Committee, Canyon, Texas, 1990

GOKIW** *Georgia O'Keeffe in Williamsburg*, Muscarelle Museum of Art, The
 College of William and Mary, Williamsburg, Virginia, 2001

GOKP** Berry, Michael, *Georgia O'Keeffe, Painter*, Chelsea House Publishers, New
 York, 1988

GOKPT** Turner, Elizabeth Hutton, *Georgia O'Keeffe, The Poetry of Things*, Yale
 University Press, New Haven, Connecticut, 1999

GOKVP** O'Keeffe, Georgia, *Georgia O'Keeffe*, Viking Press, New York, 1976

JC Chase, Joe

LG** Giboire, Clive, *Lovingly, Georgia*, Simon and Schuster, Inc., New York,
 1990

MA&A** Greenough, Sarah, *Modern Art and America, Alfred Stieglitz and His New
 York Galleries*, Little, Brown and Company, New York, 2000

MC** Lynes, Barbara Buhler, Paden, Ann, eds., *Maria Chabot - Georgia
 O'Keeffe, Correspondence, 1941-1949*, University of New Mexico Press,
 Albuquerque, New Mexico, 2003

MDLNW** Rudnick, Lois, *Mabel Dodge Luhan, New Woman, New World*, University
 of New Mexico Press, Albuquerque, New Mexico, 1984

MWL** Magill, Frank, ed., *Masterpieces of Women's Literature*, HarperCollins
 Publishers, New York, 1996

NHR Reily, Nancy Hopkins, author, correspondence, interviews

OKDL** Merrill, Carol, *O'Keeffe, Days In a Life*, La Alameda Press, Albuquerque,
 New Mexico, 1995

OKT** Udall, Sharyn R, *O'Keeffe and Texas*, Marion Koogler McNay Art
 Museum, San Antonio, Texas, 1998

PHPHM* Panhandle Plains Historical Museum Research Center, Canyon, Texas

PK Klein, Peter

PK(1)*** Klein, Peter, unpublished papers on O'Keeffe family

PK(2)*** Klein, Peter interviews with NHR, April 2-4, 2000

PK(3)*** Klein, Peter, unpublished walking guide of Sun Prairie, Wisconsin

PK(4)*** Klein, Peter, Guest Guide Notes for 1998 Museum Season

PK(5)*** O'Keeffe: Myths and Legends or Facts?

POAA** Lisle, Laura, *Portrait of an Artist, A Biography of Georgia O'Keeffe*,
 Washington Square Press, New York, 1980

SAB** Whelan, Richard, *Stieglitz, A Biography*, Little Brown and Company, New
 York, 1995

SMB** Lowe, Sue Davidson, *Stieglitz, A Memoir/Biography*, Farrar, Straus Giroux,
 New York, 1983

370

SPHM* Sun Prairie Historical Museum, Sun Prairie, Wisconsin

SPL* Sun Prairie Library, Sun Prairie, Wisconsin

SPP** Klein, Peter, *Sun Prairie's People, Part I, Shadows and Dreams*, Sun Prairie
 Historical Library and Museum, Sun Prairie, Wisconsin, 1993

WOP** Pollitzer, Anita, *A Woman on Paper*, Simon & Schuster Inc., New York,
 1988

YCAL* Yale Collection of American Literature, Beinecke Rare Book and
 Manuscript Library, New Haven, Connecticut, Alfred Stieglitz/Georgia
 O'Keeffe Archive, YCAL MSS 85.

* Archives, Collections, Records
** Published Sources
*** Unpublished Sources

NOTES

Chapter 1

1. Barbara Buhler Lynes, *Georgia O'Keeffe, Catalogue Raisonné*, vol. 2, (New Haven, Conn.: Yale University Press, 1999), 1142 (hereafter cited as GOKCR[2]). Roxana Robinson, *Georgia O'Keeffe*, (New York: Harper Perennial, 1989), 15-16 (hereafter cited as GOK).
2. Onno Brouwer, Joshua Hane, Steven Hoelscher, Robert Ostergren, and David Woodward, "Cultural Map of Wisconsin," (Madison, Wis.: University of Wisconsin Press, 1996). *Encyclopedia Britannica*, 1969, s.v. "Wisconsin" (hereafter cited as EB). *Britannica Junior Encyclopedia*, 1969, s.v. "Wisconsin" (hereafter cited as BJE).
3. Peter Michael Klein, *Sun Prairie's People, Part 1, Shadows and Dreams*, (Sun Prairie, Wis.: Sun Prairie Historical Library and Museum, 1993), 4 (hereafter cited as SPP). *Rand McNally Commercial Atlas and Marketing Guide*, 127th ed., (Rand McNally Company, 1996), 572.
4. Brouwer, "Cultural Map." SPP, 11. BJE, s.v. "Wisconsin."
5. "Early Roads in the Vicinity of Sun Prairie;" "Celebrate Sun Prairie's Sesquicentennial, 1837-1987," Royle Publishing, Special Marketing Section for the *Star/Advertiser*, June 18, 1987, 4, Sun Prairie Library (hereafter cited as SPL). SPP, 4. Peter Klein unpublished papers on O'Keeffe Family (hereafter cited as PK[1]).
6. SPP, 9.
7. "Celebrate Sun Prairie's Sesquicentennial," SPL.
8. On April 3, 2000 Peter Klein (hereafter cited as PK) suggested I contact Joe Chase (hereafter cited as JC). JC told of Georgia's life in Sun Prairie. Nancy Hopkins Reily (hereafter cited as NHR) interview with JC, April 3, 2000. "Celebrate Sun Prairie's Sesquicentennial," SPL.
9. NHR interview with PK, June 20, 2003.
10. "Celebrate Sun Prairie's Sesquicentennial," SPL. *Rand McNally Commercial Atlas*, 570.
11. "Celebrate Sun Prairie's Sesquicentennial;" Estelle Hayden, "History of Growth, Progress and Development of Village of Sun Prairie," 1, SPL.
12. SPP, 5.
13. Ibid., 6.

14. Ibid. "The Early History of Sun Prairie;" Estelle Hayden, "History of Growth," James Melville, Principal of Sun Prairie High School from 1891 to 1901 said that he saw this tree while surveying. The large burr oak with a two foot diameter trunk was still standing when Melville saw it in 1906. In 1919 the tree was gone when he looked for it and was told the tree was dying and cut down, SPL.

15, "Celebrate Sun Prairie's Sesquicentennial;" "The Early History of Sun Prairie;" Hayden, "History of Growth," SPL. NHR interview with PK, June 20, 2003.

16. Lynn Pyne, "Drama in the Skies," *Southwest Art*, 28, 11 (April, 1999), 67.

17. Sharyn R. Udall, *O'Keeffe and Texas*, (San Antonio, Tex.: The Marion Koogler McNay Art Museum, 1998), 17 (hereafter cited as OKT).

18. Georgia O'Keeffe, *Georgia O'Keeffe*, (New York: Viking Press, 1976), unpaginated, Foreword (hereafter cited as GOKVP).

19. PK(1). PK stated that "O'Keeffe" in the early records was spelled with one 'f.'

20. Stephan Thernstrom, ed., *Harvard Encyclopedia of American Ethnic Groups*, (Cambridge, Mass.: Harvard University Press, 1980), 528-530. Melvin Ember and David Levenson, eds., *American Immigrant Cultures, Builders of a Nation*, (New York: McMillan Reference USA, 1997), 463-466.

21. Thernstrom, *Harvard Encyclopedia*, 530.

22. Ibid., 528-530.

23. *Dedication*, 1999-2001. www.duffus.com/dedication.htm (11/2/2001).

24. GOK, 6.

25. SPP, 42-44, 48.

26. PK, "Pierce and Land Purchase," September 20, 2001, personal e-mail (9/21/2001).

27. GOK, 6.

28. PK, "Pierce and Land Purchase," Town of Bristol, Issue Date of January 1, 1850, NW&W1/2NE, 240 acres, Section 32, Township 9-N, Range 11-E, Document 31292; Town of Bristol, Issue Date of January 1, 1850, SESW, 40 acres, Section 32, Township 9-N, Range 11-3, Document 31536. PK(1).

29. PK(1).

30. PK walking tour with NHR, April 2, 2000. PK, "Pierce and Land Purchase."

31. PK (1).

32. Laura Lisle, *Portrait of an Artist, A Biography of Georgia O'Keeffe*, (New York: Washington Square Press, 1980), vi (hereafter cited as POAA).

33. SPP, 46.

34. *Countryman, Centennial Edition*, 1877-1977, A7, SPL.

35. SPP, 41.

36. PK(1).

37. NHR interview with PK, April 2-4, 2000 (hereafter cited as (PK[2]). SPP, 75.

38. PK(1).

39. NHR interview with PK, June 20, 2003.

40. SPP, 29. PK(1).

41. Information taken from Pierce O'Keeffe tombstone in Sacred Hearts Cemetery, Sun Prairie, Wisconsin.

42. PK(1).

43. POAA, 9-10. GOK, 22, 24, 27, 387.

44. Hedy Weiss, "Georgia O'Keeffe, A Centennial Exhibition Comes to Chicago's Art Institute," *Chicago Sun-Times*, Sunday Arts and Show, February 28, 1988, 1, Panhandle Plains Historical Museum, Research Center, Canyon, Texas (hereafter cited as PHPHM).

45. PK, "O'Keeffe Foundation," July 12, 2001, personal e-mail (7/12/2001). PK(1).

46. POAA, 6.

47. POAA, 3-4. Totto is pronounced: Tot-toe.

48. GOK, 6.

49. Thernstrom, *Harvard Encyclopedia*, 462. Ember, *American Immigrant*, 401.

50. Thernstrom, *Harvard Encyclopedia*, 463.

51. GOK, 6.

52. Ibid. *The Hungary Page - Louis (Lajos) Kossuth: Father of Hungarian Democracy*, 1997. www.hungary.org/users/hipcat/kossuth.htm (11/3/2001).

53. *The Hungary Page - Louis (Lajos) Kossuth.*

54. Ibid.

55. Ibid.

56. Thernstrom, *Harvard Encyclopedia*, 464.

57. Ibid.

58. *The History of Columbia County, Wisconsin*, (Chicago, Ill.: Western Historical Company, 1880), 741-744.

59. Ibid.

60. San Diego Historical Society, *Agoston Haraszthy*. www.sandiegohistory.org/bio/haraszthy/haraszthy.htm (11/3/2001).

61. *The History of Columbia County*, 741-744.

62. Ibid.

63. Ibid.

64. Ibid.

65. Ibid.

66. San Diego Historical Society, *Agoston Haraszthy*.

67. GOK, 7.

68. Ibid.

69. Ibid., 7-8. JC letter to NHR, July 12, 2000. PK(1).

70. GOK, 10-12. PK(1).

71. GOK, 12.

72. *Dedication*, 1999-2001. PK(1).

73. GOK, 15.

74. GOKCR(2), 1142. *Dedication*, 1999-2001.

75. GOK, 16-17.

76. PK(1).

77. SPP, 64. Brad Goldberg, *Go West Young Man!*, 7/23/2003. www.bkgoldberg.tripod.com/gowest/ (7/6/2004).

78. SPP, 70.

79. PK(1).

80. NHR interview with PK, June 20, 2003.

81. PK(1).

82. Ibid.

83. Ibid.

84. EB, s.v. "United States of America, History."

85. SPP, 80.

86. PK(1).

87. SPP, 67.

88. Ibid., 84-85. PK(1).

89. SPP, 5-6. PK(1).

90. Ibid., 74.

91. Ibid., 73.

92. Estelle Hayden, "The Origin of the Twentieth Century Club," March 29, 1922, SPL. PK(1).

93. SPP, 71, 90.

94. Peter Klein unpublished walking guide of Sun Prairie (hereafter cited as PK[3]). Estelle Hayden, "The Twentieth Century Club, A Mini-Resume of Highlights and Credits," SPL.

95. SPP, 74.

96. "The Early History of Sun Prairie;" Hayden, "The Twentieth Century Club;" "The Origin of the Twentieth Century Club," SPL.

97. PK(1).

98. Frank N. Magill, ed., *Masterpieces in Women's Literature*, (New York: Harper Collins, 1996), 28, 113 (hereafter cited as MWL).

99. EB, s.v. "Woman's Suffrage." MWL, 114, 255.

100. MWL, 131, 147.

101. Ibid., 147, 149.

102. SPP, 119.

103. In the Sun Prairie Historical Museum exhibition for Georgia O'Keeffe are two framed Twentieth Century Club programs with Ida's name listed. PK(1).

104. EB, s.v. "Seward, William Henry;" "Alaska Purchase."

105. EB, s.v. "Whittier, John Greenleaf."

106. SPP, 75.

107. Ibid., 3.

108. PK(1).

109. SPP, 76. PK(1). Elizabeth Schuster, born September 11, 1870, married Frank Benasch, died December 15, 1958.

110. PK(2).

Chapter 2

1. Georgia O'Keeffe's maternal grandmother, Catherine Mary Shortall had a sister, Maria, who married William Bradley.
2. H. Wayne Morgan, *Kenyon Cox*, (Kent, Ohio: The Kent State University Press, 1994), 173.
3. Judge Elisha W. Keyes, *History of Dane County*, (Madison, Wis.: Western Historical Assoiciation, 1906), 319.
4. GOKCR(2), 615-620. PK(1).
5. NHR interview with PK, June 20, 2003.
6. Philpot Hayden, "Sun Prairie Native Writes Pageant of Early Badger Life," SPL.
7. PK(3)
8. Ibid.
9. Ibid.
10. SPP, 28-29.
11. PK(1).
12. PK(2).
13. SPP, 29.
14. PK(1). Sacred Hearts Cemetery marker for Bernard O'Keeffe.
15. PK(1). SPP, 83.
16. POAA, 12.
17. "Off the Beaten Path, Dane County Day Trips," "Northeastern Dane County," Dane County Executive Office.
18. SPP, 98.
19. PK(1). Peter Klein, "Guest Guide Notes for 1998 Museum Season" (hereafter cited as PK[4]).
20. Georgia O'Keeffe letter to Pastor Ardin D. Laper, June 26, 1976, "O'Keeffe, Myths and Legends or Facts?" (Hereafter cited as PK[5]).
21. PK(1).
22 Idid.

Chapter 3

1. SPP, 57, 82. PK(1).
2. GOKVP, unpaginated, page one. GOK, 27. POAA, 2.
3. David B. Cohen, *Stranger in the Nest*, (New York: John Wiley and Sons, Inc., 1999), 93.
4. Margaret E. Broadley, *Your Natural Gifts, How to Recognize and Develop Them for Success and Self-fulfillment*, (McLean, Va.: EPM Publications, Inc., 1972), 1-9.
5. Ibid., 12, 113-114.
6. Ibid., 115.

7. Ibid., 113.

8. Ibid., 114.

9. Ibid., 4-5.

10. Ibid., 115.

11. Ibid., 116-117.

12. Ibid., 5. Dean Trembly, *Learning to Use Your Aptitudes*, (San Luis Obispo, Cal.: Erin Hills Publishers, 1974), 52.

13. Broadley, *Your Natural Gifts*, 17-18.

14. Ibid., 6-7.

15. Ibid., 14, 114.

16. "Johnson O'Connor Research Foundation, Inc., Bulletin," vol. 153, (March, 1999), New York.

17. Cohen, *Stranger in the Nest*, 92.

18. Ibid., 93.

19. Carol Merrill, *O'Keeffe, Days In a Life*, (Albuquerque, N.Mex.: La Alameda Press, 1995), 84 (hereafter cited as OKDL).

20. POAA, 17.

21. Mary Lynn Kotz, "A Day with Georgia O'Keeffe," *Art News*, 76, 10 (December, 1977), 7, PHPHM.

22. Katherine Kuh, *100 Artists, 100 Years: Alumni of the School of the Art Institute of Chicago*, Centennial Exhibition, November 23, 1979 - January 20, 1981. Art Institute of Chicago, "History of the School & Museum. www.artic.edu/saic/about/why/history.html (1/11/2003).

23. Kuh, *100 Artists, 100 Years*.

24. OKDL, 69. POAA, 9, 17-18.

25. NHR interview with PK, June 20, 2003.

26. PK(1).

27. Mrs. Wilbur Renk, "Two Sun Prairie Women Bring Fame to Village," *Sun Prairie (Wis.) Star Countryman*, September 2, 1948, Sun Prairie Historical Museum (hereafter cited as SPHM).

28. PK(2).

29. Renk, "Two Sun Prairie Women," SPHM.

30. POAA, 18-19. PK(1). The Bucholz family came from Srenz, Prenzlaw, Germany. Minnie Thormann (born June 23, 1855) married first William Bucholz in Germany and had Mary, Louise William and Ferdinand. They came to America in 1884. William died in 1885, Minnie married William's brother, August Bucholz and they had Lena and Emma (Mrs. George Baker of DeForest). The family lived in the village of Sun Prairie before moving to a farm about two miles southeast of the village. Lena Bucholz married George Graper and lived in Oconomowoc, Wisconsin. Her brother, Ferdinand William, lived with her. When Ferdinand died he was buried in Sun Prairie cemetery. There is no cemetery record for Lena in Sun Prairie. PK Research, June 15, 2003. GOKVP, unpaginated.

31. PK(1).

32. Sally Anne Rolke, "Remembering a Famous Daughter," SPHM. PK(1).

33. Barbara Buhler Lynes, *Georgia O'Keeffe, Catalogue Raisonné*, vol. 1, (New Haven, Conn.: Yale University Press, 1999), 29 (hereafter cited as GOKCR[1]).

34. Fred Stoker, *Georgia O'Keeffe in Canyon*, (Canyon, Tex.: Canyon-Randall Centennial Committee, 1990), 5 (hereafter cited as GOKIC).

35. Cecile S. Holmes, "A Passion for Women's Art Drives Washington Museum," *Houston Chronicle*, July 23, 2000, 1G.

36. Ibid.

37. Ibid.

38. Ibid. The National Museum of Women in the Arts, *Permanent Collection*. www.nmwa.org/collection/detail.asp?WorkID=1860 (1/11/2003). GOKCR(1), 180.

39. Herman J. Viola, *Exploring the West*, (New York: Smithsonian Books, Harry N. Abrams, Inc., 1987), 13.

40. Ibid., 15. Landon Y. Jones, "Leading Men," *Time*, 160, 2 (July 8, 2002), 56.

41. Viola, *Exploring*, 15, 18.

42. Walter Kirn, "Lewis and Clark, The Journey That Changed America Forever," *Time*, 160, 2 (July 8, 2002), 39. Jones, "Leading Men." Christopher Sullivan, "Millions Honoring Lewis and Clark," *The Dallas Morning News*, January 12, 2003, 8A.

43. Kirn, "Lewis and Clark," 38, 41.

44. Viola, *Exploring*, 20. Jones, "Leading Men."

45. Kirn, "Lewis and Clark," 58.

46. Ibid., 39, 41.

47. Margaret L. Brown, ed., "Intriguing Paths," *Southwest Art*, 28, 6 (November, 1998), 17.

48. EB, s.v. "Cooper, James Fenimore." Donald A. Ringe, *James Fenimore Cooper*, (New York: Twayne Publishers, 1962), 11. Lawrence H. Klibbe, *Cliffs Notes on Cooper's The Deerslayer*, (Lincoln, Neb.: Cliffs Notes, Inc., 1970), 5-8, 12.

49. Ringe, *James Fenimore Cooper*, 20-21.

50. GOK, 21. Michael Berry, *Georgia O'Keeffe, Painter*, (New York: Chelsea House Publishers, 1988), 22 (hereafter cited as GOKP).

51. Ringe, *James Fenimore Cooper*, 42.

52. James Fenimore Cooper, *The Prairie*, (New York: Dood, Mead and Company, 1957), 6-7.

53. Clive Giboire, ed., *Lovingly Gerogia*, (New York: Simon and Schuster, Inc., 1990), 323 (hereafter cited as LG).

54. PK(1).

55. Maria Costantino, *Georgia O'Keeffe*, (New York: Smithmark Publishers, Inc., 1994), 9. Sister Marjorie Buttner, OP letter to NHR, July 17, 2003.

56. GOKCR(2), 1142. GOK, 23-25. NHR notes on visiting the site of the Sacred Heart Academy.

57. Buttner letter to NHR.

58. Costantino, *Georgia O'Keeffe*, 9. GOKCR(1), 29.

59. GOKCR(1), 29. POAA, 24.

60. Buttner letter to NHR.

61. PK(1). PK(2).

62. Bonnie G. Kelm, Ann C. Madonia, eds., *Georgia O'Keeffe in Williamsburg*, (Williamsburg, Va.: The Muscarelle Museum of Art, 2001), 10 (hereafter cited as GOKIW). The Colonial Williamsburg Foundation, John D. Rockefeller, Jr. Library, Williamsburg, Virginia, "Map of Colonial Williamsburg." GOK, 39.

63. GOK, 55.

64. POAA, 30.

65. Keyes, ed., *History of Dane County*, 318. GOK, 24, 32. POAA, 16, 25.

66. POAA, 26.

67. GOKCR(2), 1142.

Chapter 4

1. *Rand McNally Commercial Atlas*, 551.

2. Herman J. Viola, *After Columbus, The Smithsonian Chronicle of the North American Indians*, (Washington, D. C.: Smithsonian Books, 1990), 18. BJE, s.v. "Virginia, The People."

3. E. B., s.v. "Virginia." Colonial Williamsburg Foundation, *The History of Colonial Williamsburg*, 2004. www.history.org/Foundation/cwhistory.cfm (12/4/2004).

4. Colonial Williamsburg Foundation, *The History*. GOK, 39.

5. POAA, 31. GOKIW, 22. Costantino, *Georgia O'Keeffe*, 9.

6. Chatham Hall, *Chatham Hall - Chatham Hall School Profile*, 2004. www.chathamhall.com/101 (12/4/2004).

7. GOKCR(1), 36-40. Christopher Merrill, Ellen Bradbury, *From the Faraway Nearby*, (Albuquerque, N.Mex.: University of New Mexico Press, 1998), 3-4 (hereafter cited as FFN). GOKP, 27.

8. Kappa Delta Sorority, *Kappa Delta Sorority*, 2003-2004. www.kappadelta.org/ (12/4/2004).

9. GOKCR(1), 378.

10. Costantino, *Georgia O'Keeffe*, 9.

11. GOK, 43.

12. Ibid., Illustration 17.

13. POAA, 39, 210. GOK, 24, 49. Hedy Weiss, "The Infinite Beauty of Georgia O'Keeffe," *Chicago Sun Times*, February 28, 1998, PHPHM. Costantino, *Georgia O'Keeffe*, 9.

14. Weiss, "The Infinite Beauty," PHPHM.

15. John H. Vanderpoel, *The Human Figure*, (New York: Dover Publications, Inc., 1935), 12.

16. Ibid., 131.

17. Costantino, *Georgia O'Keeffe*, 9. Barbara Rose, "The Great Big Little Paintings of Georgia O'Keeffe," *House and Garden*, 160, PHPHM.

18. GOKIW, 11. Costantino, *Georgia O'Keeffe*, 9.

19. Anita Pollitzer, *A Woman on Paper*, (New York: Simon & Schuster Inc., 1988), 87 (hereafter cited as WOP).

20. Trembly, *Learning to Use*, 6, 21, 51-54.

21. GOK, 56-57.

22. GOKCR(2), 1142. WOP, 87-90.

23. Ronald G. Pisano, *William Merritt Chase, 1849-1916*, (Seattle, Wash.: Henry Art Gallery, University of Washington, 1983), 23.

24. Ibid.

25. Ibid., 23-24.

26. Ibid., 24.

27. Kathleen D. McCarthy, *Women's Culture*, (Chicago, Ill.: University of Chicago Press, 1991), 23-24, 93.

28. Pisano, *William Merritt Chase*, 24.

29. Ibid., 25.

30. Ibid.

31. Stanley Meisler, "William Merritt Chase," *Smithsonian*, 31, 11 (February, 2001), 84.

32. Pisano, *William Merritt Chase*, 27-28.

33. Ibid., 27.

34. Ibid.

35. Ibid.

36. Ibid.

37. Robert Hughes, *American Visions, The Epic History of Art in America*, (New York: Alfred A. Knopf, 1997), 382.

38. Peter Hastings Falk, *Who Was Who in American Art, 1564-1975*, vol. 1, A-F, (Madison, Conn.: Sound View Press, 1999), 993. EB, s.v. "Duveneck, Frank."

39. Falk, *Who Was Who*, 993.

40. Ibid., 3356. Peggy and Harold Samuels, *The Illustrated Biographical Encyclopedia of Artists of the American West*, (Garden City, NY: Doubleday & Company, Inc., 1976), 493-494. EB, s.v. "Twachtman, John Henry."

41. Pisano, *William Merritt Chase*, 39.

42. Morgan, *Kenyon Cox*, 83.

43. Pisano, *William Merritt Chase*, 41.

44. Ibid., 70.

45. McCarthy, *Women's Culture*, 65-66.

46. Pisano, *William Merritt Chase*, 41-45.

47. Ibid., 41.

48. Hughes, *American Visions*, 262.

49. McCarthy, *Women's Culture*, 97.

50. Meisler, "William Merritt Chase." McCarthy, *Women's Culture*, 95.

51. McCarthy, *Women's Culture*, 93, 105.

52. Pisano, *William Merritt Chase*, 57-58.

53. Steven M. L. Aronson, "Celebrating Brendan Gill," *Architectural Digest*, 55, 7 (July, 1998), 26.

54. John Updike, ed., *A Century of Arts and Letters*, (New York: Columbia University Press, 1998), 302, 308, 320 (hereafter cited as CA&L).
55. Pisano, *William Merrritt Chase*, 71, 121, 135-142.
56. Ibid., 139.
57. Ibid., 140, 166.
58. POAA, 50. GOKCR(1), 48. Richard Whelan, *Stieglitz, A Biography*, (New York: Little Brown and Company, 1995), 404 (hereafter cited as SAB).
59. Pisano, *William Merritt Chase*, 145, 181.
60. Meisler, "William Merritt Chase."
61. CA&L, 302-303, 309.
62. Pisano, *William Merritt Chase*, 87.
63. Ibid., 82.
64. Ibid., 89.
65. Ibid., 175.
66. Ibid., 89.
67. Ibid., 87.
68. Ibid., 92.
69. EB, s.v. "Chase, William Merritt." Aronson, "Celebrating Brendan Gill." Pisano, *William Merritt Chase*, 96. Dean Porter, Teresa Hayes Ebie, and Suzan Campbell, *Taos Artists and Their Patrons, 1898-1950*, (South Bend, Ind.: Snite Museum of Art, University of Notre Dame, 1999), 372.
70. Pisano, *William Merritt Chase*, 99.
71. Ibid., 100.
72. Ibid., 183.
73. Ibid., 179.
74. Ibid., 180.
75. Ibid., 183.
76. Ibid., 15.
77. Morgan, *Kenyon Cox*, 31.
78. Ibid., 32.
79. Ibid., 34-36.
80. Ibid., 36-48.
81. Ibid., 53.
82. Ibid.
83. Ibid., 68-69.
84. Ibid., 82.
85. Ibid., 18.
86. Ibid., 83.
87. Ibid., 113.
88. Ibid., 12. GOKCR(2), 1142.
89. Morgan, *Kenyon Cox*, 117, 126, 212.
90. Ibid., 86.
91. Ibid.

92. Ibid., 93-94.

93. Ibid., 197.

94. Ibid., 196-197.

95. Ibid., 69.

96. Ibid., 200. CA&L, 303.

97. Falk, Who Was Who, 2322. Samuels, The Illustrated Biographical, 331.

98. LG, 206.

99. SAB, 404. Hunter Drohojowska-Philp, Full Bloom, The Art and Life of Georgia O'Keeffe, (New York: W. W. Norton and Company, 2004), 51.

Chapter 5

1. Sue Davidson Lowe, Alfred Stieglitz, A Memoir/Biography, (New York: Farrar, Straus Giroux, 1983), 126-127 (hereafter cited as SMB). SAB, 309.

2. Sarah Greenough, Modern Art and America, Alfred Stieglitz and His New York Galleries, (Washington, D. C.: Little Brown and Company, 2000), 23-24, 73 (hereafter cited as MA&A). Arthur Jerome Eddy, Cubists and Post Impressionism, (Chicago, Ill.: A. C. McClurg and Company, 1919), 217 (hereafter cited as C&PI).

3. POAA, 48-49.

4. POAA, 49. Edward Abrahams, "Let Them All Be Damned—I'll Do As I Please," American Heritage, 38, 6 (September/October 1987), 44, PHPHM.

5. POAA, 50.

6. MA&A, 75.

7. Vivian Robinson, "A Teacher In An Earlier Day," The Amarillo Globe-Times, August 26, 1965, PHPHM.

8. Ibid.

9. SAB, 6-7.

10. Dorothy Norman, Alfred Stieglitz, An Amreican Seer, (New York: An Aperture Book, 1960), 14, 19 (hereafter cited as ASAAS).

11. ASAAS, 14. SMB, 379.

12. SAB, 48.

13. SAB, 16-17. ASAAS, 15-16.

14. SAB, 49, 53, 201, 506.

15. SMB, 379-380. ASAAS, 20.

16. SAB, 35, 37-38.

17. Kathryn E. O'Brien, The Great and Gracious on Millionaires' Row in its Glory, (Utica, NY: North Country Books, 1978), 13, 15. William Preston Gates, History of the Sagamore Hotel, (Bolton Landing, NY: W. P. Gates Publishing Company, 2001), 9, 121.

18. O'Brien, The Great, 202-203.

19. SAB, 142-143.

20. SMB, 380-381.

21. O'Brien, *The Great*, 274. SMB, 86-89.

22. SMB, 380-381.

23. SAB, 86-93. EB, Encyclopedia Home Page, *Photography: The history...aturalistic photography*, 1996. (2/24/01) (hereafter cited as EBHP).

24. SAB, 124-125.

25. Ruth E. Fine, Elizabeth Glassman, and Juan Hamilton, *The Book Room: Georgia O'Keeffe's Library in Abiquiu*, (New York: The Georgia O'Keeffe Foundation, Grolier Club, 1997), 60 (hereafter cited as BR).

26. SAB, 127.

27. Patricia Johnson, "Balancing Act, Stieglitz Photos Span Development of a Career," *Houston Chronicle*, October 12, 2002, 9D.

28. Weston J. Naef, *The Collection of Alfred Stieglitz*, (New York: A Studio Book, 1978), 28.

29. SMB, 381. SAB, 137.

30. SMB, 382.

31. SAB, 144-146. Christian A. Peterson, *Alfred Stieglitz's Camera Notes*, (New York: W. W. Norton and Company, Inc., 1993), 17.

32. Peterson, *Alfred Stieglitz's Camera Notes*, 17-19.

33. Ibid., 41-42.

34. SAB, 154-155.

35. Ibid., 166.

36. BR, 55. EBHP, s.v. "Steichen, Edward." "Steichen," *Town and Country*, (November, 2000), 282.

37. SAB, 166-167.

38. Ibid., 167.

39. Helen Pinet, *Rodin, The Hands of Genius*, (London: Thames and Hudson, Limited, 1992), 12-13.

40. Ibid., 13-14.

41. Ibid., 16-17.

42. Ibid., 18-24.

43. Ibid., 24.

44. Ibid., 24-25.

45. Ibid., 26-46.

46. Ibid., 87.

47. Ibid., 89.

48. "Rare Portrait of Edward Weston to Highlight Christie's Photographs Sale," *Antiques and the Arts Weekly*, March 22, 2002, 10.

49. Pinet, *Rodin*, 117.

50. Ibid., 116.

51. Peterson, *Alfred Stieglitz's Camera Notes*, 52. Simone Philippi, ed., *Alfred Stieglitz Camera Work, The Complete Illustrations 1903-1971*, (New York: Taschen, 1997), 10-11.

52. SAB, 178-179.

53. SMB, 385. EBHP, s.v. "Stieglitz, Alfred." SAB, 190-191, 385. Philippi, ed., *Alfred Stieglitz Camera Work*, 12, 20, 21.

54. BR, 24. EB, s.v. "Stieglitz, Alfred." Jeffrey Schaire, "Georgia in Love," *Art and Antiques*, (September, 1987), 61.

55. Carl Zigrosser, *The World of Art and Museums*, (Philadelphia, Pa.: Art Alliance Press, 1975), 193. EBHP, s.v. "Stieglitz, Alfred."

56. SMB, 384. SAB, 218-219.

57. Falk, *Who Was Who*, vol. 2, G-O, 3088. Delia Gaze, *Dictionary of Women Artists*, (London: Fitzroy Dearborn Publishers, 1999), 1289-1292.

58. SAB, 219.

59. Ibid., 224–225, 384. "Photography," *Art and Antiques*, 28, 3 (March, 2000), 101. Johnson, "Balancing Act, Stieglitz Photos."

60. Kathrine Graham, *Personal History*, (New York: Vintage Books, 1998), 14, 19-20. SAB, 234-235.

61. SAB, 342-343.

62. SMB, 382. EBHP, s.v. "Stieglitz, Alfred."

Chapter 6

1. GOKIW, 11, 12. Letter to NHR from Del Moore, Reference Librarian, John D. Rockefeller Library, Colonial Williamsburg Foundation, Williamsburg, Virginia, September 12, 2002. GOK, 39, 55, 74.

2. GOKCR(2), 1142. GOK, 75-76.

3. EB, s.v. "Charlottesville.'

4. GOK, 76.

5. Landmark Commission, Department of Community Development, September, 1974, Map and Parcel, 10-26, Census Track and Block; 2-203: Historical Marker, Q-26, Department of Historic Resources, 2001, Charlottesville, Virginia.

6. GOK, 76.

7. Ibid., 75. Joseph S.Czestochowski, *Georgia O'Keeffe, Visions of the Sublime*, (Memphis, Tenn.: International Arts, 2004), 166.

8. Robinson, "A Teacher In An Earlier Day," PHPHM. Costantino, *Georgia O'Keeffe*, 12-13.

9. Costantino, *Georgia O'Keeffe*, 12-13. GOKCR(2), 1142.

10. GOKCR(2), 1142.

11. Ibid.

12. Ibid. GOKP, 32.

13. GOK, 79-80.

14. GOKCR(2), 1142.

15. SAB, 277.

16. Lois P. Rudnick, *Mabel Dodge Luhan, New Woman, New Worlds*, (Albuquerque, N.Mex.: University of New Mexico Press, 1984), 59-60 (hereafter cited as MDLNW). SAB, 310.

17. Ibid., 6, 15-26.

18. Ibid., 15-23, 66.

19. GOKCR(2), 1142. GOK, 80.

20. Susan Tyler Hitchcock, *University of Virginia/Short History*, 2002. www.virginia.edu/uvatours/shorthistory/ (4/1/2003).

21. GOKCR(2), 1142. GOKP, 32. FFN. 5.

22. Falk, *Who Was Who*, vol. 1, A-F, 274. Alon Bement, *Figuer Constuction, A Brief Treatise on Drawing the Human Figure, For Art Students, Costume Designers, and Teachers*, (New York: The Gregg Publishing Company, 1921), title page (hereafter cited as FC).

23. Falk, *Who Was Who*, 274.

24. FC, iii.

25. Ibid., iii-iv.

26. Ibid., v.

27. Ibid., vii-xi.

28. GOKVP, plate 11.

29. Weiss, "The Infinite Beauty," PHPHM. Britta Benke, *Georgia O'Keeffe, 1887-1986, Flowers in the Desert*, (Hohenzollernring, Köln: Benedikt Taschen, 1995), 10.

30. Elizabeth Hutton Turner, *Georgia O'Keeffe, The Poetry of Things*, (New Haven, Conn.: Yale University Press, 1999), 1, 41 (hereafter cited as GOKPT).

31. Nancy E. Green, "Arthur Wesley Dow: American Arts and Crafts," *American Art Review*, xi, 6, 214. Ask Art, *AskART-Biography for the Artist Dow, Arthur Wesley*, 2000-2002. www.askart.com/biography.asp (2/11/2003). Avis Berman, "Arthur Wesley Dow, Rediscovering the American Artist's Unique Vision," *Architectural Digest*, 57, 3 (March, 2002), 62. AFA: Education: AFA; education: Arthur Wesley Dow and American Arts and Crafts (2). www.afaweb.org/education/dow2.asp (4/8/2003).

32. Green, "Arthur Wesley Dow." Tom Bross, Patricia Harris, and David Lyon, *DK Eyewitness Travel Guides, Boston*, (New York: Dorling Kindersley Publishing, Inc., 2001), 99. Berman, "Arthur Wesley Dow," 62.

33. Stuart Jackson Gallery, *Stuart Jackson Gallery - Fine Japanese Prints*, 2002. www.jacksonarts.com/pages/informat.htm (4/1/2003).

34. EBHP, s.v. "Hokusai."

35. Bross, *DK Eyewitness*, 109.

36. Ibid. BR, 29. Green, "Arthur Wesley Dow."

37. EBHP, s.v. "Fenollosa, Ernest F." BR, 29.

38. EBHP, s.v. "Fenollosa, Ernest F."

39. Bross, *DK Eyewitness*, 109. EBHP, s.v. "Fenollosa, Ernest F."

40. BR, 29. GOKPT, 3.

41. Berman, "Arthur Wesley Dow."

42. Sharyn R. Udall, "Finding a Self in Nature," *El Palacio*, 102, 1 (Summer/Fall 1996), 26.

43. Berman, "Arthur Wesley Dow."

44. Ask Art, *AskART - Biography for the Artist, Dow, Arthur Wesley*. Frederick M. Logan,

Growth of Art in American Schools. www.noteaccess.com/APPROACHES/artEd/
History/Logan/1900-1920Comp.htm (9/7/2003). Arthur Wesley Dow, *Composition,*
(New York: Doubleday, Doran and Company, Inc., 1938), 5 (hereafter cited as C).

45. Ask Art, *AskART.*
46. GOKPT, 2. Ask Art, *AskART.*
47. C, 3.
48. Ibid.
49. Ibid.
50. Ibid., 5.
51. Udall, "Finding," 26. GOKPT, 2.
52. Ask Art, *AskART.*
53. C, 7-128.
54. Stephen May, "A New Aesthetic, Artist/Teacher Arthur Wesley Dow Created a
 'Synthesis of East and West,'" *Art and Antiques,* xxiii, 5 (May 2002), 54. Ipswich
 Historical Society, *About Ipswich,* 1996-2003. www.ipswichma.com/directory/about.
 asp (4/8/2003). Berman, "Arthur Wesley Dow." Green, "Arthur Wesley Dow." AFA:
 Education: AFA; *Education; Arthur Wesley Dow and American Arts and Crafts* (2).
55. Green, "Arthur Wesley Dow."
56. May, "A New Aesthetic."
57. Berman, "Arthur Wesley Dow."
58. Logan, *Growth of Art in American Schools.*
59. Ask Art, *AskART.*
60. Arthur Wesley Dow, *Theory and Practice of Teaching Art,* (New York: Teachers College,
 Columbia University, 1912), 1.
61. Berman, "Arthur Wesley Dow."

Chapter 7

1. *Amarillo Sunday News-Globe,* January 29, 1989, PHPHM.
2. GOK, 85. GOKCR(2), 1142. GOKP, 34-35.
3. Pisano, *William Merritt Chase,* 87, 99.
4. Ibid., 100.
5. GOKIC, 5. March, 1913, Sanborn Map Comapny, The Sanborn Library, LLC.
6. GOK, 7.
7. OKT, 15.
8. Robinson, "A Teacher In An Earlier Day," PHPHM.
9. Mike Cox, *Historic Amarillo, An Illustrated History,* (San Antonio, Tex.: Historical
 Publishing Network, 2000), 12.
10. Philip Kopper, *The Smithsonian Book of North American Indians Before the Coming of
 the Europeans,* (Washington, D. C.: Smithsonian Books, 1986), 171.
11. Frederick W. Rathjen, *The Texas Panhandle Frontier,* (Austin, Tex.: University of Texas
 Press, 1973), 3-4.

12. Ibid., 4-5, 8.

13. Kopper, *The Smithsonian Book of North American Indians*, 17-18, 169.

14. Rathjen, *The Texas Panhandle*, 53.

15. Hjalmar R. Holland, *Explorations in America Before Columbus*, (New York: Twayne Publishers, Inc., 1962), 32.

16. BJE, s.v. "Leif the Lucky."

17. Paul Horgan, *Great River, The Rio Grande in North American History*, (New York: Rinehart and Company, Inc., 1954), vol. 1, 174-177.

18. Robert H. Fuson, trans., *The Log of Christopher Columbus*, (Camden, Maine.: International Marine, 1992), xiii-xvii.

19. Samuel Eliot Morison, *Admiral of the Ocean Sea, A Life of Christopher Columbus*, (Boston, Mass.: Little Brown and Company, 1942), 224.

20. Charles Norman, *Discoverers of America*, (New York: Thomas Y. Crowell Company, 1968), 1.

21. Viola, *After Columbus*, 41. Fuson, *The Log*, 1.

22. Viola, *After Columbus*, 41-44. Fuson, *The Log*, 1.

23. Kopper, *The Smithsonian Book of North American Indians*, 18.

24. Ibid., 18-19.

25. BJE, s.v. "Cabeza de Vaca, Alvar Núñez." Rathjen, *The Texas Panhandle*, 56.

26. EB, s.v. "Núñez, Cabeza de Vaca, Alvar."

27. EB, s.v. "De Soto, Hernando."

28. Rathjen, *The Texas Panhandle*, 55-60. "Amarillo History and Trivia," 2001. www.amarillopages.com/amarillohistory.html (4/28/2001). EB, s.v. "Coronado, Francisco Vázquez de."

29. EB, s.v. "Coronado, Francisco Vázquez de." Rathjen, *The Texas Panhandle*, 58-60.

30. Frederick W. Hodge, ed., *Spanish Explorers in the Southern United States*, (New York: Barnes and Noble, Inc., 1965), 280.

31. EB, s.v. "Oñate, Juan de." Viola, *After Columbus*, 47.

32. BJE, s.v. "Texas History."

33. Ibid. Cheryl Laird and Greg Hassel, "Color Guard," *Texas Journey*, 6, 1 (January/February 2002), 19.

34. Norman, *Discoverers*, vii. EB, s.v. "Hakluyt, Richard." Horgan, *Great River*, 362.

35. Paula L. Grauer and Michael R. Grauer, *Dictionary of Texas Artists, 1800-1945*, (College Station, Tex.: Texas A&M University Press, 1999), xvii.

36. Frances Battaile Fisk, *A History of Texas Artists and Sculptors*, (Abilene, Tex.: Frances Battaile Fisk, 1928), 3.

37. Grauer, *Dictionary of Texas Artists*, xvii. Fisk, *A History of Texas Artists*, 3.

38. Fisk, *A History of Texas Artists*, 3.

39. Grauer, *Dictionary of Texas Artists*, xvii.

40. Fisk, *A History of Texas Artists*, 3.

41. Ibid., 7-10.

42. Ibid., 10-12.

43. Ibid., 18-20.

44. Grauer, *Dictionary of Texas Artists*, xvii. Fisk, *A History of Texas Artists*, 52-59, 146-150.

45. Fisk, *A History of Texas Artists*, 52-58.

46. Ibid., 146-150. Grauer, *Dictionary of Texas Artists*, 18.

47. Fisk, *A History of Texas Artists*, 58-59.

48. Grauer, *Dictionary of Texas Artists*, xvii.

49. Jim W. Kuhlman, *The Block Pasture*, (Mason City, Iowa: Printing Services, Inc., 1998), 11. While visiting the Georgia O'Keeffe Museum in Santa Fe in June 2001 I met by coincidence James Weldon Kuhlman. He told me of his family's land in Canyon, Texas where Georgia walked to the Palo Duro Canyon. A series of letters and e-mails followed our meeting. I received his book, *The Block Pasture*. Kuhlman, born in Amarillo, Texas in 1937, lived with his parents on a farm in "The Block" four miles east of Canyon, Texas. Kuhlman graduated from West Texas State University in 1959 and received a master's degree from the University of Nebraska in 1961. He served in the United States Department of Agriculture Extension Service in Nebraska and Iowa. His awards: Distinguished Service Award from the National Association of County Agricultural Agents, The R. K. Bliss Citation, and the Meritorious Service Award from Epsilon Sigma Phi. His writings have appeared in many magazines and newspapers. In addition to *The Block Pasture*, Kuhlman authored *The History of the Nance Hereford Ranch* and *From Kirchhatten (Germany) to Canyon (Texas)*.

50. Rathjen, *The Texas Panhandle*, 3, 6.

51. EB, s.v. "*Llano Estacado*." Rathjen, *The Texas Panhandle*, 110.

52. Rathjen, *The Texas Panhandle*, 110.

53. J. Evetts Haley, *Charles Goodnight, Cowman and Plainsman*, (Norman, Okla.: University of Oklahoma Press, 1989), 277. Terry Christesson, "*Llano Estacado*, A Rare Diamond in the Rough," *New Mexico*, 79, 5 (May, 2001), 46-50.

54. Nelson England, "Song of the Plains," *Travel Magazine of Texas Highways*, 47, 9, 4. Darwin Spearing, *Roadside Geology of Texas*, (Missoula, Mont.: Mountain Press Publishing Company, 1991), 355.

55. Christesson, "*Llano Estacado*, A Rare Diamond in the Rough."

56. Joe Nick Patoski, "High Plains Drifting," *Texas Monthly*, 27, 7 (July, 1999), 72.

57. Spearing, *Roadside Geology of Texas*, 355.

58. Rathjen, *The Texas Panhandle*, 82.

59. *Amarillo Globe-News*, Amarillo, *Frequently Asked Questions*, 2000. www.Amarillo.com/faq/ (7/31/2001).

60. *Amarillo History and Trivia*. www.amarillo.com/visitamarillo/rout66.html (4/28/ 2001).

61. EB, s.v. "Railway, Westward Movement."

62. Claude Dooley and Betty Dooley, *Why Stop, A Guide to Texas Historical Roadside Markers*, (Houston, Tex.: Lone Star Books, 1985), 87.

63. *Amarillo History and Trivia*. Rathjen, *The Texas Panhandle*, 244.

64. The Texas State Historical Association. "AMARILLO, TX." *The Handbook of Texas Online*, 2001. www.tsha.utexas.edu/handbook/online/articles/view/AA/hda2 html (12/30/2001). Della Tyler Key, *In the Cattle Country: History of Potter County*,

1887-1966, (Quanah - Wichita Falls, Tex.: Nortex Offset Publications, Inc., 1972), 41. Red River Authority of Texas, *LX Ranch*, 1999-204. www.rra.dst.tx.us/c_t/ranchesLX%20RANCH.cfm (1/5/2005).

65. GOKCR(1), 105. OKT, 56.

66. Ibid.

67. EB, s.v. "Amarillo;" "*Llano Estacado.*" Cox, *Historic Amarillo*, 10.

68. "AMARILLO, TX." The Handbook of Texas Online. *Amarillo History and Trivia.* Kuhlman, *Block*, 19. Key, *In the Cattle Country*, 77-78. Cox, *Historic Amarillo*, 26.

69. "AMARILLO, TX." The Handbook of Texas Online. William C. Hunt, Chief Statistician, *Fourteenth Census of the United States Taken in the Year 1920*, vol. 1, (Washington, D. C.: Government Printing Office, 1920), 303.

70. Cox, *Historic Amarillo*, 34.

71. *Amarillo History and Trivia.*

72. GOKCR(2), 1142.

73. LG, 290-291.

74. Robinson, "A Teacher In An Earlier Day," PHPHM.

75. *Amarillo History and Trivia.*

76. Spearing, *Roadside Geology of Texas*, 367-368. EB, s.v. "*Llano Estacado.*" Eric R. Swanson, *Geo-Texas, A Guide to Earth Sciences*, (College Station, Tex.: Texas A&M Press, 1995), 32. WOP, 103. LG, xiii.

77. George Oxford Miller, *Texas Parks and Campgrounds*, (Houston, Tex.: Lone Star Books of Gulf Publishing Company, 1999), 204-205.

78. Scott Parks, "Panhandle's Wind-swept History Can't Be Overblown," *The Dallas Morning News.*

79. *Amarillo History and Trivia.*

80. Ibid.

81. OKT, 16.

82. POAA, 61. Nelson England, "Georgia O'Keeffe in Texas," *Texas Highways*, (May, 1995). William C. Hunt, Chief Statistician, *Fourteenth Census of the United States*, 303. Cox, *Historic Amarillo*, 5.

83. GOK, 88. Amarillo Public Library, "*1912 Amarillo City Directory*," January 3, 2002, personal e-mail (1/3/2002). England, "Georgia in Texas." WOP, 103. March, 1913, Sanborn Map Company, The Sanborn Library, LLC. Georgia refers to the "Magnolia House," the *1919 Amarillo City Directory* lists "Magnolia Hotel, Sanborn Digital Map lists "Magnolia Ho." Robinson, "A Teacher In An Earlier Day;" "Retired Dean Researched the O'Keeffe Years in Area," *Amarillo Sunday News-Globe*, March 25, 1990, 6D, PHPHM.

84. Robinson, "A Teacher In An Earlier Day," PHPHM.

85. Ibid.

86. Drohojowska-Philp, *Full Bloom*, 80.

87. GOK, 89. March, 1913, Sanborn Map Company.

88. GOKCR(2), 1142.

89. GOK, 91.

90. England, "Georgia O'Keeffe in Texas."
91. Ibid. OKT, 77.
92. GOKPT, 19.
93. GOK, 90-91.
94. Robinson, "A Teacher In An Earlier Day," PHPHM.
95. Grauer, *Dictionary of Texas Artists*, 83. Fisk, *A History of Texas Artists*, 181.
96. *Amarillo Sunday News-Globe*, January 29, 1989, PHPHM.
97. WOP, 103, 106.
98. GOKCR(1), 49-50.
99. GOKCR(2), 1142. WOP, 107.
100. POAA, 65.
101. WOP, 106-107.
102. GOK, 91.
103. *Amarillo Sunday News-Globe*, January 29, 1989, PHPHM.
104. GOKIC, 6. Texas State Historical Association, "O'Keeffe, Georgia Totto," The Handbook of Texas Online, 2002. www.tsha.utexas.edu/handbook/online/articles/view/OO/fo'8.html (1/5/2005).
105. WOP, 108.

Chapter 8

1. GOKCR(2), 1142.
2. Christine L. Roch, *From "Rube Town" to Modern Metropolis: The Growth and Public Acquisition of Modernist Art Collections in Chicago, 1913-1933.* 1996. www.mtholyoke.edu/~croch/thesis.html (11/10/02). Martin C. Tangora, *HES: QUERY - Arthur J. Eddy,* 1999. www.eh.net/lists/archives/hes/feb-1999/0046.php (10/2/2002). The Art Institute of Chicago, *Arthur Jerome Eddy Collection/Art Institute of Chicago,* 2001. www.artic.edu/artacess/AA_Modern/pages/MOD_AJEddy.html (10/2/2002).
3. C&PI, 107. The Art Institute of Chicago, *Arthur Jerome Eddy Collection/Art Institute of Chicago.*
4. C&PI, 14, 107. The Art Institute of Chicago, *Arthur Jerome Eddy Collection/Art Institute of Chicago.*
5. The Art Institute of Chicago, *Arthur Jerome Eddy Collection/The Art Institute of Chicago.* The Art Institute of Chicago, *1913 Armory Show (Gallery J): The Leap of the Rabbit, Amadeo de Souza Cardoso.* www.xroads.virginia.edu/~MUSEUM/Armory/galleryJ/sousa..467.html (10/4/2002).
6. Peter Brooke, *Albert Gleizes, For and Against the Twentieth Century,* (New Haven, Conn.: Yale University Press, 2001), 36.
7. Brooke, *Albert Gleizes,* ix, 36.
8. BR, 28-29. Ann Lee Morgan, *Arthur Dove, Life and Work, With a Catalogue Raisonné,* (Newark, Del.: University of Delaware Press, 1984), 104.

9. GOK, 108, 248. C&PI, unpaginated, Illustrations. The Art Institute of Chicago, *Arthur Jerome Eddy Collection/Art Institute of Chicago.*

10. Morgan, *Arthur Dove, Life,* 104.

11. John W. McCoubrey, *American Art, 1700-1960,* (Englewood Cliffs, N.J.: Prentice Hall, Inc., 1965), 196-197.

12. Avis Berman, "The Quiet Man of American Modernism," *Smithsonian,* 78, 10 (November, 1997), 122. *ARTBURST.com-Arthur Dove Art and Biography.* www.artburst.com/arthurdove/ (4/13/2003). Sally Mills, *Arthur G. Dove.* www.burlerart.com/pc_book/pages/ARTHUR%20DOVE.htm (4/13/2002).

13. C&PI, 1.

14. Ibid., 5, 9.

15. Ibid., 11.

16. Ibid., 33-35, 43.

17. Ibid., 38.

18. Ibid., 43.

19. Ibid.

20. Ibid., 82

21. Ibid., 72.

22. Ibid., 78.

23. Ibid., 100.

24. Ibid., 78.

25. Ibid., 112.

26. GOK, 108, 248. C&PI, unpaginated, Illustrations, 116. The Art Institute of Chicago, *Arthur Jerome Eddy Collection/The Art Institute of Chicago.*

27. C&PI, 116, 117.

28. Ibid., 113.

29. Ibid., 138.

30. Ibid., 145-146.

31. Ibid., 149.

32. Ibid., 153.

33. Ibid., 154-156, 160.

34. Ibid., 172-173, 180-181.

35. Arthur Jerome Eddy, *Delight the Soul of Art,* (Philadelphia, Penn.: J. B. Lippincott Company, 1902), 52-53. BR, 28.

36. GOKCR(2), 1142. Wassily Kandinsky, *Concerning the Spiritual in Art,* (New York: Dover Publications, 1977), iv, ix (hereafter cited as CSA). BR, 41-42.

37. EBHP, s.v. "Kandinsky, Wassily." Ramon Tio Bellido, *Kandinsky,* (New York: Portland House, 1990), 14, 15.

38. Otto G. Ocvirk, Robert O. Bone, Robert E. Stinson, and Philip R. Wigg, *Art Fundamentals Theory and Practice,* (Dubuque, Iowa: W. C. Brown Company Publishers, 1978), 157. EBHP, s.v. "Kandinsky, Wassily." CSA, v. *Hammond Universal World Atlas,* (Maplewood, N.J.: Hammond, Inc., 1989), 52-53.

39. Bellido, *Kandinsky,* 5-6. EBHP, s.v. "Kandinsky, Wassily."

40. EBHP, s.v. "Kandinsky, Wassily."
41. EB, s.v. "Kandinsky, Wassily." EBHP, s.v. "Kandinsky, Wassily." Bellido, *Kandinsky*, 17. CSA, vi.
42. CSA, vi-vii.
43. EBHP, s.v. "Kandinsky, Wassily." Sharyn R. Udall, *Contested Terrain*, (Albuquerque, N.Mex.: University of New Mexico Press, 1996), 85.
44. CSA, 29.
45. OKT, 75.
46. CSA, 38.
47. EBHP, s.v. "Kandinsky, Wassily." Marjorie E. Bevlin, *Design Through Discovery*, (New York: Holt, Rinehart and Winston, Inc., 1970), 245. Bellido, *Kandinsky*, 15.
48. Alexander Boguslawski, *Kandinskii*, 1998. www.rollins.edu/Foreign_Lang/Russian/ kandin.html (11/16/2002).
49. Boguslawski, *Kandinskii*. Bellido, *Kandinsky*, 21.
50. *Hermus Fine Arts Blaue Reiter (Blue Rider)*. www.hermus.com/blaue.htm (11/16/2002).
51. CSA, vii. Bellido, *Kandinsky*, 22. EBHP, s.v. "Kandinsky, Wassily."
52. Boguslawski, *Kandinskii*.
53. EBHP, s.v. "Schoenberg, Arnold." EB, s.v. "Schoenberg, Arnold." C&PI, 9. Vivian Endicott Barnett, *Vassily Kandinsky, A Colorful Life*, (New York: Harry N. Abrams, Inc., 1995), 301.
54. CSA, 16, 17.
55. CSA, xii. Bellido, *Kandinsky*, 6-7. Barnett, *Vassily Kandinsky*, 301.
56. CSA, 1-4.
57. Ibid., 6-9.
58. Ibid., 14, 16.
59. Ibid., 19-20.
60. Bellido, *Kandinsky*, 8. CSA, xi, 23.
61. CSA, 25-26.
62. Ibid., 27, 44.
63. Ibid., 28, 36. EBHP, s.v. "Kandinsky, Wassily."
64. CSA, 29.
65. Ibid., 36-45.
66. Ibid., 46, 52.
67. Ibid., 53-54.
68. Ibid., 57.
69. EBHP, s.v. "Kandinsky, Wassily." Hilton Kramer, "Kandinsky—A Russian Master in Exile," *Arts and Antiques*, xxii, 9 (October, 1999), 146.
70. EBHP, s.v. "Kandinsky, Wassily." EB, s.v. "Bauhaus." Kramer, "Kandinsky—A Russian."
71. EBHP, s.v. "Kandinsky, Wassily." EB, s.v. "Bauhaus."
72. Barnett, *Vassily Kandinsky*, 15-16.
73. Bellido, *Kandinsky*, 11-12, 15.
74. EBHP, s.v. "Kandinsky, Wassily." Bellido, *Kandinsky*, 12, 44-45.

Chapter 9

1. Devid Devoss, "Searching for Gavrilo Princip," *Smithsonian*, 31, 5 (August, 2000), 42.
2. C&PI, vii-viii.
3. LG, xvii.
4. Alacritude, LCC, *Printable Verison of Encyclopedia.com.* 2002. www.encarda.com/printable.asp?url=/ssi/B/Bourne=R1.html (11/10/2002).
5. SAB, 373.
6. GOK, 113-116. SAB, 373.
7. GOKCR(2), 1142.
8. Columbia College, *Columbia College About History.* 2002. www.columbiacollegesc.edu/about/history2.html (9/28/2002).
9. Columbia College, *Columbia College About History.* A third fire in 1964 nearly destroyed the campus leaving only the columns of Old Main which became a symbol of Columbia College.
10. LG, 3-4.
11. Ibid., 5.
12. Ibid., 9.
13. Ibid., 15.
14. Floyd Dell, *Women as World Builders, Studies in Modern Feminism*, (Westport, Conn.: Hyperion Press, Inc., 1976), 7-8.
15. LG, 22.
16. Randolph S. Bourne, *Youth and Life*, (Freeport, N.Y.: Books for Libraries Press, Inc., 1913), unpaginated, Contents.
17. Ibid., 3, 31-32, 55-56.
18. Ibid., 102-103, 138, 161.
19. Ibid., 195.
20. Ibid., 217, 229.
21. Ibid., 249, 295, 298, 331.
22. Ibid., 342, 345-346.
23. Columbia College, *Columbia College About History.*
24. Ibid.
25. LG, 32-33.
26. Ibid., 33.
27. Ibid., 24.
28. Ibid., 47.
29. Ibid.,71.
30. Ibid., 60.
31. EB, s.v. "Line."
32. GOKCR(2), 1142.
33. Ibid., OKT, 24-26.
34. GOKCR(1), 51-56.

35. Carter Ratcliff, "Georgia On Our Minds," *Travel and Leisure*, 17, 11 (November, 1987), 160; Jane Adams Allen, "Human Face of An American Icon," *Insight*, (November 23, 1987), 58; Janet Hobhouse, "A Peculiar Road to Sainthood," *Newsweek*, (November 9, 1987), 74, PHPHM.

36. Abrahams, "Let Them All Be Damned," 44, PHPHM. LG, 46.

37. LG, 87.

38. Ibid., 92.

39. Ibid., 95.

40. Ibid., 96.

41. Ibid., 115-116.

42. Ibid., 117.

43. Ibid., 122-123.

44. Ibid., 125.

45. Ibid., 135.

46. Ibid., 143.

47. Ibid., 142.

48. Ibid., 149-150.

49. GOKIC, 6. GOKCR(2), 1142. WOP, 145. November, 1920, Sanborn Map Company, The Sanborn Library, LLC.

50. LG, 152.

51. GOKCR(2), 1142.

52. LG, 152-153

53. GOKCR(2), 1142.

54. POAA, 91.

55. Sarah Greenough, *Alfred Stieglitz, The Key Set*, (Washington, D. C.: Harry N. Abrams, Inc., 2002), 278.

56. GOKCR(1), 60-61.

57. OKT, 93-99.

58. LG, 159, 222.

59. Ibid., 173.

60. Ibid., 164.

Chapter 10

1. Lois Palken Rudnick, *Utopian Vistas, The Mabel Dodge Luhan House and the American Counterculture*, (Albuquerque, N.Mex.: University of New Mexico Press, 1996), 31-32. Harry Ransom Humanities Research Center, *Alice Corbin Henderson Collection, Biographical Sketch*, 1996. www.hrc.utexas,edu/fa/henderson.bio.html (1/10/2002). Alice and William had one child, Alice Henderson, who married John Evans, the only child of Mabel Ganson Dodge Evans Sterne Luhan. Alice Henderson Evans had a daughter, Natalie, who married Bill Mauldin, the cartoonist.

2. MDLNW, 143, 147.

3. The Texas State Historical Association, *Goodnight, Charles, The Handbook of Texas Online*, 1999. www.tsha.utexas.edu/handbook/online/articles/print/GG/fgo11. html (8/31/2001). Haley, *Charles Goodnight*, x, 2, 4, 5. Goodnight's birthplace in Macoupin County, Illinois is only a few miles from the birthplace of my mother, Pauline Richardson (Hopkins) and her sister Helen Richardson (Morten) in Medora, Macoupin County, Illinois.

4. The Texas State Historical Association, *Goodnight, Charles*.

5. Ibid.

6. Ibid.

7. Ibid. Haley, *Charles Goodnight*, 46-47.

8. The Texas State Historical Association, *Goodnight, Charles*.

9. Haley, *Charles Goodnight*, 122, 402.

10. Ibid., 403.

11. David Grant Noble, "Goodnight-Loving Trail," *New Mexico*, 79, 3 (March, 2001), 64. *The Roads of New Mexico*, (Fredericksburg, Tex.: Shearer Publishing, 1998), 126.

12. The Texas State Historical Association, *Goodnight, Charles*.

13. "Canyon's Founder," *Canyon News, Discover Canyon, Texas*, 2000, May 14, 2000. Kuhlman, *Block*, 11, 22, 151.

14. Kuhlman, *Block*, 26.

15. Ibid., 24-26.

16. Ibid., Preface A, 42, 54, 138-144.

17. Kuhlman, *Block*, Preface A, B, 61, 67-68, 75. Robert Strein, John Vaughn and C. Fenton Reynolds, Jr., *Santa Fe, The Chief Way*, (Santa Fe, N.Mex.: New Mexico, 2001), 36.

18. Kuhlman, *Block*, 74.

19. Ibid., Preface B.

20. Ibid., 19, 62-64, unpaginated, page following C.

21. Ibid., 19, 61, 63, 449.

22. Ibid., 148.

23. Ibid., 87.

24. EB, s.v. "Automobile." Kuhlman, *Block*, 75. GOKIC, 7. LG, 180.

25. WOP, 145. GOKIC, 6-7.

26. Haley, *Charles Goodnight*, 277. Kuhlman, *Block*, 86. Edward L. King, *Famous Masons: Albert Pike*, 1998-2003. www.masonicinfo.com/pike.htm (2/23/2003).

27. Kuhlman, *Block*, 115. Katherine Kuh, *The Artist's Voice: Talks with Seventeen Artists*, (New York: Harper and Row, 1962), 189.

28. "Georgia O'Keeffe's Garden of Earthly Delight," *The Virginian*, (November/December 1987), 93. PHPHM.

29. Ibid.

30. Dr. Peter Petersen, *A Brief History of West Texas A&M University*, 1996. www.wtamu.edu/administrative/pre/com/facts/history.htm (4/1/2001). "A Look Through the Century," *Canyon News*, February 6, 2000, Progress Edition.

31. Kuhlman, *Block*, 54. POAA, 95. Petersen, *A Brief History of West Texas A&M University.* "A Look Through the Century," *Canyon News.*

32. Ruth Lowes and W. Mitchell Jones, *We'll Remember Thee, An Informal History of West Texas State University, The Early Years*, (Canyon, Tex.: West Texas State University Alumni Association, 1984), 32.

33. J. A. Hill, *More Than Brick and Mortar*, (Canyon, Tex.: West Texas State College Ex-students Association, 1984), 32.

34. "A Look Through the Century," *Canyon News.* Petersen, *A Brief History of West Texas A&M University.* Lowes, *We'll Remember Thee*, 32.

35. LG, 180.

36. GOKIC, 10.

37. Ibid.

38. LG, 181-182.

39. Moira Hodgson, "The Lady of the Southwest," *Savvy*, (November, 1987), 20, PHPHM.

40. POAA, 98. Lavern Hays, "Home Once Housed O'Keeffe," *The Canyon News*, November 26, 1981, PHPHM.

41. "Canyon's Past," *The Canyon News*, PHPHM.

42. Bill Marvel, "The O'Keeffe Century," *The Dallas Morning News*, July 32, 1988, 1C.

43. GOKIC, 10.

44. Ibid.

45. LG, 206.

46. GOKCR(1), 84-85.

47. Ibid., 88.

48. Ibid., 88-89.

49. GOKCR(2), 143. GOKIC, 24-25. "Canyon's Past," *The Canyon News*, PHPHM.

50. Marvel, "The O'Keeffe Century."

51. GOKIC, 10.

52. Marvel, "The O'Keeffe Century."

53. OKT, 45.

54. NHR, *Classic Outdoor Color Portraits, A Guide for Photographers*, (Santa Fe, N.Mex.: Sunstone Press, 2001), 80-81.

55. LG, 183-184.

56. Robinson, "A Teacher In An Earlier Day," PHPHM.

57. GOKIC, 10.

58. Texas Historical Commission marker, "Mary E. Hudspeth House," located in front of her home.

59. Hudspeth House Bed and Breakfast, *Hudspeth House Bed and Breakfast.* www.hudspethinn.com/history.html (2/23/2003).

60. LG, 207.

61. Hudspeth House Bed and Breakfast, *Hudspeth House Bed and Breakfast.*

62. Petersen, "A Brief History of West Texas A&M University."

63. GOKCR(2), 1143.

64. Lowes, *We'll Remember Thee*, 156.

Chapter 11

1. Saloman Reinach, *Apollo, An Illustrated History of Art Throughout the Ages*, (New York: Scribner's Sons, 1924), 248, 250. EB, s.v. "Reni, Guido." Photograph PH Art Class, 1, 220/37.008b, PHPHM.
2. Reinach, *Apollo*, ix-x.
3. Ibid., xi-xv, 1-2.
4. Ibid., 2.
5. Ibid., 334-335.
6. LG, 212.
7. SAB, 356. Santa Monica Mirror, *Santa Monica Mirror: Santa Monica's Wright Brothers The Muralist and the Writer*, 1999. www.smmirror.com/volume1/issue29/santa_monicas_wright.html (11/5/2002).
8. Ibid.
9. SAB, 356-357. LG, 343.
10. SAB, 361, 377. LG, 355.
11. Santa Monica Mirror, *Santa Monica Mirror: Santa Monica's Wright Brothers*.
12. W. H. Wright, *Modern Painting, Its Tendency and Its Meaning*, (New York: John Lane Company, 1915), 8-10.
13. Ibid., 308, 331, 339, 342.
14. Wright, *The Creative Will*, (London: John Lane Company, 1916), unpaginated, Contents.
15. LG, 227, 238.
16. Wright, *Creative*, 91.
17. Ibid.
18. EB, s.v. "Bell, Clive;" "Bloomsbury Group."
19. EB, s.v. "Bell, Clive."
20. Frank Alvah Parsons, *Interior Decoration, Its Principles and Practice*, (Garden City, NY: Doubleday, Page and Company, 1915), vii.
21. LG, 187, 332.
22. Allen Johnson, ed., *Dictionary of American Biography*, vol. 3, (New York: Charles Scribner's Sons, 1957), 403.
23. Charles H. Caffin, *How to Study Pictures*, (New York: The Century Company, 1906), 3-7.

Chapter 12.

1. Rathjen, *Texas Panhandle*, 9. EB, s.v. "Red River."
2. Cox, *Historic Amarillo*, 11.
3. *Amarillo Globe-News, Palo Duro Canyon*, 2000. www.amarillo.com/visitamarillo/palodurocanyon.html (7/31/2001).

4. *Amarillo Globe-News, Palo Duro Canyon*, 2000. Spearing, *Roadside Geology of Texas*, 382-383.

5. West Texas A&M University Geological Society, *Guidebook of Palo Duro Canyon*, (Canyon, Tex.: West Texas A&M University Geological Society, 2001), 7.

6. *Amarillo-Globe-News, Palo Duro Canyon.*

7. West Texas A&M University Geological Society, *Guidebook*, 7.

8. Ibid., 9. *Amarillo Globe-News, Palo Duro Canyon.*

9. West Texas A&M University Geological Society, *Guidebook*, 9-11.

10. Ibid., 11.

11. Ibid.

12. Ibid., 11-13.

13. Spearing, *Roadside Geology of Texas*, 382.

14. *Amarillo Globe-News, Palo Duro Canyon.* George Oxford Miller, *Texas Parks and Campgrounds*, (Houston, Tex.: Lone Star Books, 1999), 203.

15. Kuhlman, *Block*, 13.

16. David Grant Noble, "Goodnight-Loving Trail," *New Mexico*, 79, 3 (March, 2001), 64. Haley, *Charles Goodnight*, x, 283. Linda Gillan Griffin, "Plains and Fancy," *The Dallas Morning News*, June 27, 1999, G1.

17. Kuhlman, *Block*, 13-14.

18. Cox, *Historic Amarillo*, 19-20. Kuhlman, *Block*, 17, 19-20.

19. Haley, *Charles Goodnight*, 423.

20. Eric R. Swanson, *Geo-Texas, A Guide to Earth Sciences*, (College Station, Tex.: Texas A&M Press, 1995), 43.

21. Haley, *Charles Goodnight*, 423.

22. Kuhlman, *Block*, 24, 89-90, 107, 115, Addendum 5.

23. Ibid., 89-90, 98-99, 102, 120, Addendum 1.

24. Ibid., 92, 94, 113, Addendum 4.

25. Ibid., 187-188.

26. Ibid., 188.

27. Dooley, *Why Stop*, 87-89.

28. Kuhlman, *Block*, 97, 117. Jim W. Kuhlman, "Georgia O'Keeffe," June 13, 2001, personal e-mail (June 13, 2001).

29. Kuhlman, "Georgia O'Keeffe," June 13, 2001. Kuhlman, *Block*, 120-121.

30. Jim W. Kuhlman, "Georgia O'Keeffe," June 9, 2001, personal e-mail (June 9, 2001).

31. Rathjen, *Texas Panhandle*, 36-37. Jim W. Kuhlman, "Georgia O'Keeffe," June 24, 2001, personal e-mail (June 24, 2001).

32. Kuhlman, "Georgia O'Keeffe," June 24, 2001.

33. Ibid.

34. Miller, *Texas Parks*, 204. Susan Kirr, "Grand Canyon of the High Plains: Palo Duro," *Texas Highways*, 50, 6 (June, 2003), 28.

35. England, "Georgia O'Keeffe in Texas," 32. OKT, 23.

36. Taken from a wall hanging in the front lobby of the PHPHM, 2003.

37. LG, 186.

38. Kuhlman, *Block*, 117.
39. GOKCR(1), 115-118.
40. Vivian Robinson, "Artist's Journey to the Top Began at West Texas," *Amarillo Globe-Times*, August 27, 1965, PHPHM.
41. GOKIC, 19.
42. Ibid. POAA, 98, 104.
43. GOKCR(1), 97, 99.
44. GOKIC, 12.
45. Ibid., 15, 18.
46. Lowes, *We'll Remember Thee*, 157.
47. LG, 238-239.
48. GOKIC, 19-20.
49. Ibid., 18. Lowes, *We'll Remember Thee*, 156.
50. Lowes, *We'll Remember Thee*, 157.
51. Robinson, Artist's Journey to the Top Began," PHPHM.
52. Kuhlman, *Block*, 271. Margaret Seewald, interview by Michael Grauer, November 21, 1989, PHPHM.
53. Texas Parks and Wildlife, *Palo Duro State Park in Texas.* www.tpwd.state.tx.us/park/paloduro/ (11/8/2004). Art Chapman, "Historic Park Becomes Even Bigger Attraction, " *Houston Chronicle*, May 8, 2005, B15.
54. Kuhlman, *Block*, 359. Carroll Wilson, "Texas and the Woman Behind It," *Accent West*, (June, 1980), 36.
55. Kuhlman, *Block*, 359-360. Margaret Seewald, interview by Michael Grauer, PHPHM.
56. "Texas Begins 2000 With New and Exciting Features," *Canyon News, Discover Canyon, Texas*, 2000.

Chapter 13

1. GOK, 121, 165. GOKIC, 18.
2. BR, 29.
3. LG, 210.
4. EBHP, s.v. "Gilman, Charlotte Anna Perkins." Encarta, *Gilman, Charlotte Perkins*, 1996. www.encarta.msn.com/find/Concise.asp?ti=04616000 ((5/4/2002). MWL, 251, 582-584.
5. Ibid.
6. Dell, *Women As World*, 22.
7. LG, 216.
8. EBHP, "The Art of Music;" "Dynamism."
9. *The New Encyclopedia Britannica*, 1991, s.v. "Nietzsche."
10. Ibid.
11. Ibid.

12. George Allen Morgan, *What Nietzsche Means*, (New York: Harper and Row, Publishers, 1941), 30-31, 37.
13. *The Encyclopedia Americana*, International Edition, 1993, s.v. "Nietzsche, Friedrich."
14. *The New Encyclopedia Britannica*, 1991, s.v. "Nietzsche, Friedrich."
15. EBHP, s.v. "Nietzsche, Friedrich."
16. EBHP, s.v. "Affections, Doctrine of the."
17. EBHP, s.v. "Nietzsche, Friedrich."
18. GOKIC, 18.
19. LG, 208.
20. GOKIC, 18.
21. Ibid., 12.
22. *Le Mirage, 1916-1917*, 39, 112, PHPHM.
23. LG, 217.
24. WOP, 152. NHR interview with E. Morten Hopkins, July 30, 2003. Burnett Ranches, Limited, *The Four Sixes*, 2000-2003. www.6666ranch.com/history.shtml (8/13/2003). Ted Reid file, PHPHM.
25. GOKCR(2), 1143. WOP, 152-153. Hill, *More Than Brick*, 318.
26. OKT, 77.
27. GOKCR(2), 798.
28. GOKCR(1), 155.
29. GOKCR(2), 784-785. OKT, 13.
30. GOKIC, 13, WOP, 153.
31. GOKIC, 13. Kuhlman, *Block*, 118. WOP, 152-154. Ted Reid File, PHPHM.
32. GOKIC, 13-14.
33. Ibid., 14.
34. Ibid.
35. BR, 20.
36. GOKIC, 20.
37. Ibid., 24.
38. Robinson, "Artist's Journey to the Top," PHPHM.
39. WOP, 151. LG, 199.
40. WOP, 152.
41. Robinson, "Artist's Journey to the Top," PHPHM.
42. LG, 227.
43. GOKIC, 24-26.
44. WOP, 151.
45. LG, 238.
46. Ibid.
47. GOKCR(1), 54, 59.
48. Ibid. GOKCR(2), 1143. OKT, 25, LG, 241. WOP, 160.
49. EB, s.v. "World War I, II. The War on Land, G. The Penultimate Year, 1. U. S. Declaration of War."
50. POAA, 105. SAB, 380.
51. GOKCR(1), 82.

52. Ibid., 329, 336, 390. OKT, 75-76.
53. GOKCR(2), 1143. WOP, 156.
54. WOP, 158. SMB, 207.
55. Greenough, *Alfred Stieglitz, The Key Set*, xxxiii-xxxiv, 280-281.
56. GOKIC, 23. LG, 255. SAB, 387. BR, 60.
57. GOKIC, 23-24.
58. "Picks and Pans," *People*, 29, 9 (March 7, 1988), PHPHM.
59. GOKCR(1), 86. GOKCR(2), 1143. WOP, 156. SAB, 523.
60. *Bulletin of the West Texas State Normal College, 1917*, (Canyon, Tex.: West Texas State Normal College, 1917), 14, PHPHM.
61. Ibid., 17.
62. Ibid., 38.

Chapter 14

1. LG, 246-249.
2. WOP, 158. POAA, 110-111.
3. Nancy E. Green, Frederick C. Moffatt, Marilee Boyd Meyer, Richard J. Boyle, Barbara L. Michaels, and Lauren Berkley, *Arthur Wesley Dow (1857-1922), His Art and Influence*, (New York: Spanierman Gallery, LLC, 1999), 30.
4. Ibid., 37, 130.
5. Cathryn Keller, "Peter Hassrick: On O'Keeffe," *El Palacio*, 102, 1 (Summer/Fall 1997), 11. Green, *Arthur Wesley Dow (1857-1922) His Art*, 148.
6. Halka Chronic, *Roadside Geology of New Mexico*, (Missoula, Mont.: Mountain Press Publishing Company, 1987), 27-31.
7. EB, s.v. "New Mexico, History, Prehistory."
8. EB, s.v. "New Mexico, History, Exploration."
9. EB, s.v. "Oñate, Juan de."
10. EB, s.v. "New Mexico, History, Colonization."
11. Ruthjen, *The Texas Panhandle*, 63-65.
12. EB, s.v. "New Mexico, History, Colonization."
13. Ibid.
14. EB, s.v. "New Mexico, History, Territorial Period."
15. WOP, 158. POAA, 110-111.
16. Gussie Fauntleroy, "New Mexico Magic," *Southwest Art*, 32, 10 (March, 2003), 92. Ratcliff, "Georgia On Our Minds," PHPHM.
17. The Palace of the Governors, NNOCA - *Palace of the Governors, Museum of New Mexico*. www.nmoca.org/palaceofthegovernors.html (3/7/2003). The Palace of the Governors. *Palace of the Governors*. www.newmexicoindianart.org/pog.html (3/7/2003).
18. J. K. Shishkin, *An Early History of the Museum of New Mexico Fine Arts Building*, (Santa Fe, N.Mex.: Museum of New Mexico Press, 1968), unpaginated.

19. Enda Robertson and Sara Nestor, *Artists of the Canyons and Caminos, Santa Fe, the Early Years*, (Salt Lake City, Utah: Peregrine Smith, Inc., 1976), 54-62. Shishkin, *An Early History*, unpaginated.

20. GOK, 189.

21. EB, s.v. "Utes;" "Colorado History." Jack L. Benham, *Silverton and Neighboring Ghost Towns*, (Ouray, Colo.: Bear Creek Publishing Company, 1981), 5, 7 10, 36, 45. Lilliths Realm from the Mists of Time, *Lilliths Realm - History of the Ute Mountain Utes - Broken Promises*. www.members.aol.com/_ht_a/lillithsrealm/myhomepage/Sterilization/Utes_BrokenPromis... (3/19/2003). Laurie Evans, "J-9 Narrow Gauge Scenic Byway," *New Mexico*, 82, 5 (May, 2004), 38.

22. Sandra Dallas, *No More Than Five in a Bed, Colorado Hotels in the Old Days*, (Norman, Okla.: University of Oklahoma Press, 1967), 87-89.

23. Benham, *Silverton*, 59.

24. Lucius Beebe, All Aboard for the Old West," *Houston Post, This Week*, May 25, 1958. Mary Ann Johanson, *The FlickFilosopher|Around the World in 80 Days*, 1997-2005. www.flickfilospher.com/oscars/bestpix/aroundworld.shtml (1/9/2005).

25. Benham, *Silverton*, 5.

26. GOK, 189.

27. Ibid.

28. *Ward - Colorado Ghost Town*, www.ghosttowns.com/states/co/ward.html (3/9/2003). Sylvia Pattem, *Red Rocks to Riches, Gold Mining in Boulder, Colorado, Then and Now*. (Boulder, Colo.: Stonehenge Books, 1980), 65-66. Perry Eberhart, *Guide to the Colorado Ghost Towns and Mining Camps*, (Thousand Oaks, Cal.: Sage Books, 1974), 100-101.

29. GOKCR(1) 120.

30. Ibid., 121.

31. Ibid., 124-125.

32. Ibid., 123.

33. Chronic, *Roadside Geology of New Mexico*, 108, 138.

34. GOK, 189.

35. Hope Stoddard, *Famous American Women*, (New York: Thomas Y. Crowell Company, 1970), 101-198. EB, s.v. "Cather, Willa Sibert." *Willa Siebert Cather*. www.nde.state.ne.us/SS/notable/cather.html (6/23)2002). *Willa Cather Chronology*. www.geocities.com/Wellesley/3005/Catherintro.html (6/23/2002).

36. West Texas State Normal College, *Bulletin of the West Texas State Normal College, 1917-1918*, 11, PHPHM.

37. SPP, 103-106.

38. ASAAS, 124, SAB, 335.

39. Andrew R. Cecil, *Three Sources of National Strength*, (Austin, Tex.: University of Texas Press, 1986), 135-145.

40. GOKCR(2), 1143.

41. England, "Georgia in Texas," PHPHM. Kuhlman, *Block*, 118. GOKP, 41. OKT, 101. West Texas State Normal College, *Le Mirage, 1918*, 3, 17, PHPHM. Robinson, "Artist's Journey to the Top," PHPHM.

42. Ted Reid Oral History Interview by Byron Price, July 28, 1980, 160/1, PHPHM.

43. Hill, *More Than Brick*, 319. West Texas State Normal College, *Le Mirage, 1918*, 17, PHPHM.

44. West Texas State Normal College, *Bulletin of the West Texas State Normal College, 1917-1918*, 17-18, PHPHM.

45. Jim Kuhlman letter to NHR, May 31, 2002.

46. WOP, 158.

47. "First General Session of Teachers Brings Overflow Attendance," *Waco Daily Times-Herald*, November 30, 1917.

48. Ibid.

49. "Many Prominent Speakers Will Deliver Addresses to the Teachers' Convention," *Waco Daily Times-Herald*, November 28, 1917.

50. "Prominent Men and Women Address Last Session of Teachers' Association Here," *Waco Daily Times-Herald*, December 2, 1917.

51. Milly Billings, *Influenza Pandemic*, 1997. www.standford.edu/group/virus/uda (1/24/2002). PBS Online, *The American Experience | Influenza | 1918 | People & Events | The First Wave*. www.pbs.org/wgbh/amex/inflluenza/peopleevents/pandeAMEX86.html (1/24/2002).

52. Hill, *More Than Brick*, 319.

53. GOKCR(1), 124-131.

54. Ibid.

55. Ibid., 129.

56 Photograph taken by Jim W. Kuhlman. The Texas State Historical Association, *Handbook of Texas Online: WARING, TX*. 2002. www.tsha.utexas.edu/handbookk/online/articles/print/WW/hnw19.html (3/10/2003).

57. GOKCR(1), 106-111.

58. SAB, 396-398.

59. GOKIC, 28. Hill, *More Than Brick*, 319.

60. GOKIC, 28.

61. GOKP, 41. POAA, 113.

62.Greenough, *Alfred Stieglitz, The Key Set*, vol. 1, 437. Drohojowska-Philp, *Full Bloom*, 457-458.

63. GOKIC, 28-29.

64. SAB, 396-398.

65. GOKCR(1), 99. Kuhlman, *Block*, 118, 159. Cox, *Historic Amarillo*, 94.

66. GOKIC, 29.

67. "Former Teaacher at W. T. Visited Here Views Palo Duro," *The Canyon News*, November 7, 1935, PHPHM.

68. GOKIC, 29.

69. Mrs. T. V. Reeves, "Great Woman Artist Pays Canyon Visit," *Amarillo Sunday News-Globe*, November 10, 1935, PHPHM.

70. Reeves, "Great Woman Artist;" "Former Teacher at W. T. Visited," PHPHM.

71. Reeves, "Great Woman Artist," PHPHM.

72. OKT, dustjacket.

73. Marvel, "The O'Keeffe Century," PHPHM.

74. SPP, 76.

75. GOKIC, 30.

76. England, "Georgia in Texas."

Chapter 15

1. GOKCR(2), 1143.

2. GOKIC, 44.

3. SAB, 396-400.

4. Greenough, *Alfred Stieglitz, The Key Set*, vol. 1, xxxiii, 298-321.

5. SAB, 398. Greenough, *Alfred Stieglitz, The Key Set*, vol. 1, xxxiv.

6. Morgan, *Arthur Dove, Life*, 20.

7. GOK, 20.

8. OKDL, 65. Mark Stevens, "Georgia On My Mind," *Vanity Fair*, 50, 11 (November, 1987), 72, PHPHM.

9. SAB, 397.

10. Drojohojowska-Philp, *Full Bloom*, 567n30.

11. GOKCR(1), 30-31.

12. Ibid., 25.

13. Ibid., 60, 64-67, 69-71, 74, 76.

14. Ibid., 29, 32-34, 41-43, 45.

15. Ibid., 29-30, 34-36, 44, 46, 49, 61, 70.

16. Ibid., 47.

17. Ibid.

18. Ibid., 57.

19. Ibid.

20. Ibid., 25.

21. GOK, 123.

22. GOKCR(1), 58-60, 72-73, 81-82.

23. Ibid., 45, 47-48, 50, 62, 68.

24. Ibid., 137-140, 142, 144-145.

25. Ibid., 1142-1143. GOK, 219.

26. EB, s.v. "World War I. M, Final Phase. Peace Terms."

27. C&PI, xii.

28. Ibid., xi.

29. SAB, 399-401. SMB, 385, 445.

30. SAB, 400.

31. GOKCR(1), 11.

32. Ibid., 146-147.

33. Ibid., 165.

34. MWL, 399.

35. BR, 32.

36. GOKCR(2), 1099.

37. Ibid., 1145.

38. *Welcome to York, Maine, 1996.* www.communitynetwork.com/york/york.html (11/15/2003). *York, York Harbor and York Beach Maine.* www.visitmaine.net/York. htm (11/15/2003).

39. GOKCR(1), 175-176.

40. SAB, 431.

41. Patricia Johnson, "Balancing Act,"*Houston Chronicle*, October 12, 2002.

42. SAB, 512, 530.

43. Vera Norwood and Janice Monk, *Desert Is No Lady, Southwestern Landscapes in Women's Writing and Art*, (New Haven, Conn.: Yale University Press, 1987), 52, 56.

44. GOKCR(1), 206, 209.

45. *The Legacy of the Hartford Steam Boiler Collection.* www.flogris.org/exhibitions/ hsbcoscobtext.html (11/15/2003). R. J. Steiner, *Art Times*, April, 2001. www. arttimesjournal.com/art/art_archive/coscob/coscob.htm (1/10/2005).

46. GOKCR(1), 237.

47. GOKCR(2), 1112-1114. Sanford Schwartz, "Georgia O'Keeffe Writes a Book," *The New Yorker*, liv,. 28 (August 28, 1978), 87.

48. GOKCR(2), 1098.

49. Schaire, "Georgie O'Keeffe in Love," PHPHM.

50. Scott W. Williams, *Jean Toomer Biography.* www.math.buffalo.edu/~sww/toomer/ toomerbio.html (9/3/2001). There is some discrepancy on Jean Toomer's father being caucasian. Scott W. Williams reports on his web page, "The Jean Toomer Pages," "his father was a second husband of Amanda America Dickson (and she was his second wife), and in the book *Woman of Color, Daughter of Privilege*, by Kent Anderson Leslie, he is said to be mixed as was Amanda. In fact, a Toomer genealogy chart is offered giving his mother as Kit, a mulatto slave, father?. Nathan Toomer had four children by his first wife, Harriet, none by Amanda, and Jean by Nina Pinchback Toomer. He seems to have been something of an aristocratic con, at least with Nina."

51. MWL, 289.

52. Paul P. Reuben, *PAL: Jean Toomer (1894-1967).* www.csustan.edu/english/reuben/ pal/chap9/toomer.html (9/3/2001).

53. Yale Collection of American Literature, Beinecke Rare Book and Manuscript Library, New Haven, Connecticut, Alfred Stieglitz/Georgia O'Keeffe Archive, YCAL MSS 85 (hereafter cited as YCAL), Box 216, Folder 3831.

54. Williams, *Jean Toomer Biography.*

55. Ibid.

56. GOKCR(2), 11143.

57. Ibid., 1098.

58. SMB, 382-386.

59. GOK, 43-44. BR, 56.
60. Jo Ann Lewis, "Georgia O'Keeffe, All-American Artist," *Reader's Digest*, (March, 1988), 181, PHPHM.
61. GOKCR(1), 304-310.
62. Ibid., 294-301.
63. GOKCR(2), 1143.
64. Ibid., 1098.
65. "Starts a Campaign to Elect More Women," *The New York Times*, March 1, 1926.
66. SAB, 488-490.
67. SAB, 499-500, 531, 538, 539-540.
68. GOKCR(2), 1144.

Chapter 16

1. GOKCR(2), 1144.
2. Suzan Campbell, *Brilliant Sunlight, Enchanted Air: Rebecca Salsbury James in New Mexico*, (Santa Fe, N.Mex.: Museum of New Mexico Exhibition Catalogue, 1991), unpaginated.
3. James Moore, "So Clear Cut Where the Sun Will Come...Georgia O'Keeffe's Gray Cross with Blue," *Artspace Magazine*, (Spring, 1986), 32, PHPHM.
4. Stevens, "Georgia on My Mind," PHPHM.
5. SAB, 503. Rudnick, *Utopian Vistas*, 132.
6. BR, 32. MWL, 565.
7. *Rand McNally Commercial Atlas*, 429.
8. "Hacienda de los Martinez, circa 1804," Kit Carson Historic Museums, Taos, New Mexico. John Sherman, *Taos, A Pictorial History*, (Santa Fe, N.Mex.: William Gannon, 1990), 17, 20. Robert R. White, *The Taos Society of Artists*, (Albuquerque, N.Mex.: University of New Mexico Press, 1983), 1-12.
9. Campbell, *Brillian Sunlight, Enchanted Air*.
10. Norwood, *The Desert Is No Lady*, 10-11.
11. Ibid., 12-13.
12. Rudnick, *Utopian Vistas*, 7-8.
13. Arrel Morgan Gibson, *The Santa Fe and Taos Colonies, Age of the Muses, 1900-1942*, Norman, Okla.: University of Oklahoma Press, 1983), 199-217.
14. Norwood, *The Desert Is No Lady*, 16-18.
15. Ibid., 11.
16. Ibid., 16-18.
17. Ibid., 25.
18. GOKCR(2), 1144.
19. Erna Fergusson, *Dancing Gods, Indian Ceremonials of New Mexico and Arizona*, (Albuquerque, N.Mex.: University of New Mexico Press, 1991), 29.
20. Taken from the Official Scenic Historic Marker.

21. "Pueblo Etiquette," 2001, *Eight Northern Indian Pueblos Council Visitors Guide*, 3. Rozier Paul Hughes, "Yesterdays Along the Santa Fe, The Faith of San Felipe," *The Santa Fe Magazine*, 26, 12 (November, 1932), 33.

22. Moore, "So Clear Cut Where the Sun Will Come," PHPHM.

23. "Mabel Dodge Luhan House, A Self-Guided Tour."

24. Ibid.

25. Rhoda Barken and Peter Sinclaire, *From Santa Fe to O'Keeffe Country*, (Santa Fe, N.Mex.: Ocean Tree Books, 1996), 54. Jan Castro Gardner, *The Art and Life of Georgia O'Keeffe*, (New York: Crown Publishers, Inc., 1985), 107. GOK, 453, 498.

26. Rudnick, *Utopian Vistas*, 42, 133.

27. Moore, "So Clear Cut Where the Sun Will Come," PHPHM.

28. Ibid.

29. Ibid.

30. Mary Street Alinder and Andrea Gray Stillman, eds., *Ansel Adams, Letter and Images, 1916-1984*, (Boston, Mass.: Little, Brown and Company, 1988), 46.

31. Ibid., 47, 392.

32. Campbell, *Brilliant Sunlight, Enchanted Air.*

33. POAA, 229. GOKCR(1), 305-310.

34. GOKCR(2), 1144.

35. "Obituaries," *The Santa Fe New Mexican*, April 9, 1987, B-7.

36. YCAL, Box 211, Folder 3709.

37. Ibid.

38. YCAL, Box 211, Folder 3704.

39. SAB, 514, 525, 566.

40. Jeffrey Hogrefe, *O'Keeffe, The Life of An American Legend*, (New York: Bantam Books, 1992), 183. Today the H & M Ranch is the Delancey Street Foundation, a drug rehabilitation center. SAB, 514, 529.

41. Harry Ransom Humanities Research Center, *Spud Johnson Collection, Biographical Sketch*, 2000. www.hrc.utexas.edu/fa/spud.bio.html (3/4/2002).

42. Laughing Horse Inn, *Taos Bed and Breakfast - The Laughing Horse Inn b and b, Taos, New Mexico.* www.laughinghorseinn.com?History.html (10/30/2003).

43. YCAL, Box 181, Folder 3021.

44. YCAL, Box 181, Folder 3022.

45. Ibid.

46. YCAL, Box 181, Folder 3023.

47. GOKCR(2), 1144.

48. Moore, "So Clear Cut Where the Sun Will Come," PHPHM.

49. GOKCR(2), 1144.

50. GOKCR(1), 451-453.

51. Judith Graham, "Dude Ranches Saddled with Cancellations," *The Houston Chronicle*, July 22, 2001, 6F.

52. EB, s.v. "Judson, E. C. Z."

53. EB, s.v. "Motion Pictures, The Motion Picture Experience."

54. "Ranches, New Mexico," Museum of New Mexico, History Library, Vertical File. *Rand McNally Commercial Atlas*, 427.

55. "Dude Ranches," Museum of New Mexico, History Library, Vertical File.

56. "Margaret and Sandy at the San Gabriel Ranch," *Grand Canyon Macleans*, (Champaign, Ill.: Leonard and Millán, 1996), Issue 3.

57. "Margaret and Sandy."

58. YCAL, Box 187, Folder 3133.

59. GOKCR(2), 1144.

60. GOKCR(1), 415, 441-451. United States Department of the Interior/National Park Service, *Study of Alternatives, Environmental Assessment, Georgia O'Keeffe*, (Washington, D. C.: United States Department of Interior/National Park Service, May, 1992), 43.

61. GOKCR(1), 446, 448, 450, 486. Barbara Buhler Lynes, Lesley Poling-Kempes and Frederick W. Turner, *Georgia O'Keeffe and New Mexico, A Sense of Place*, (Princeton, N.J.: Princeton University Press, 2004), 17, 19, 28-31, 33, 71.

62. Paul Rosenfeld, "Art, After the O'Keeffe Show," *The Nation*, 132, 343 (April 8, 1931), 387.

63. GOKCR(2), 1144.

64. GOKCR(1), 467, 482-485, 487.

65. "Abiquiu," Museum of New Mexico, History Library, Vertical File. *Rand McNally Commercial Atlas*, 429.

66. Horgan, *Great River*, 4-5.

67. GOKCR(2), 1144.

68. Barken, *From Santa Fe*, 76.

69. FFN, 101.

70. United States Department of the Interior/National Park Service, *Study of Alternatives, Environmental Assessment*, 42.

71. GOKCR(2), 1144.

Chapter 17

1. GOKCR(2), 1144.

2. Ibid.

3. Sherman, *Taos, A Pictorial History*.

4. GOKCR(2), 1144.

5. GOKCR(1), 468-469, 471, 473, 489, 543-549, 563, 569-570, 586-587, 589. GOKCR(2), 650-651.

6. YCAL, Box 181, Folder 3025.

7. GOKCR(2), 1144.

8. Ratcliff, "Georgia On Our Minds," PHPHM.

9. GOKCR(2), 1144.

10. Ibid.

11. Dooley, *Why Stop*, 86.

12. Ibid.

13. GOKCR(2), 1144.

14. YCAL, Box 181, Folder 3025.

15. M. Esther Harding, *The Way of All Women, A Psychological Interpretation*, (New York: Longmans, Green and Company, 1945), v, 2, 41, 78, 103, 137, 269-272, 334-335.

16. Alinder, ed., *Ansel Adams, Letters and Images*, 63.

17. YCAL, Box 216, Folder 3831.

18. GOKCR(2), 1144.

19. Kotz, "A Day With Georgia O'Keeffe," PHPHM.

20. GOKCR(1), 516.

21. Ibid., 516-518.

22. Williams, *Jean Toomer Biography*.

23. YCAL, Box 216, Folder 3831.

24. Alinder, ed., *Ansel Adams, Letters and Images*, 71.

25. GOKCR(2), 1144.

26. BR, 64.

27. SAB, 550-551. Williams, *Jean Toomer Biography*.

28. Kathryn Kerr, "Georgia O'Keeffe, New Exhibition Traces Her Work," Champagne, Ill., *News-Gazette*, March 11, 1988, PHPHM.

Chapter 18

1. OKDL, 30, 47.

2. "O'Keeffe Shows in New York," *The New Mexican*, October 8, 1970.

3. OKDL, 50.

4. "O'Keeffe Shows in New York," *The New Mexican*.

5. Presbyterian Church, USA, Ghost Ranch Education and Retreat Center, Abiquiu, New Mexico.

6. Arthur Newton Pack, *We Called It Ghost Ranch*, (Abiquiu, N.Mex.: Ghost Ranch Education and Retreat Center, 1979), 22-23.

7. Lesley Poling-Kempes, *Valley of Shining Stone, The Story of Abiquiu*, (Tucson, Az.: University of Arizona Press, 1997), 126. "Margaret and Sandy." Florence Bartlett donated the land to the State of New Mexico. The Museum of New Mexico received part of the ranch and sold it in 1953 for $80,000.00 to New Mexico State University. San Gabriel Ranch is now the Sustainable Agriculture Science Center.

8. Pack, *We Called*, 26-27. Brownie Hibben, Interview by Suzan Campbell, October 25, 1991, Archives of American Art, Smithsonian Institute, San Marino, California.

9. Hibben, interview.

10. Presbyterian Church, USA, Ghost Ranch Education.

11. Stanley Crawford, "Fifty Miles North, The Buddy System," *Santa Fean*, 29, 5 (June, 1002), 46.

12. Margaret L. Brown, "A Sense of Place," *Southwest Art*, 29, 4 (September, 1999), 17.

Chapter 19

1. SAB, 551-552.
2. Ibid., 552.
3. GOKCR(2), 1144.
4. Ibid. Alinder, ed., *Ansel Adams: Letters and Images*, 77.
5. Ibid., 78.
6. GOKCR(2), 1144. The Dunes Inc., "Ogunquit Maine Area Information." 2003. www. dunesmotel.com/mainpages/areainfo.htm (11/15/2003).
7. GOKCR(2), 1144.
8. Reeves, "Great Woman Artist," PHPHM.
9. Bill Marvel, "In Texas, Georgia Stood Out," *The Dallas Morning News*, July 31, 1988, 1C, PHPHM.
10. William Hart, "O'Keeffe Country," *The Dallas Morning News*, July 31, 1988, PHPHM.
11. GOKCR(2), 1145.
12. Dana Mucucci, "Historic Houses: Georgia O'Keeffe's Ghost Ranch House," *Architectural Digest*, 59, 3 (March, 2002), 181. Pack, *We Called*, 27.
13. *Taos Valley News*, July 16, 1936, Museum of New Mexico, History Library. Sherman, *Taos, A Pictorial History*, 78.
14. Alinder, ed., *Ansel Adams: Letters and Images*, 83.
15. *Rand McNally Commercial Atlas*, 429.
16. GOKCR(2), 559.
17. GOKCR(1), 560. GOKCR(2), 643, 684, 701.
18. GOKCR(1), 552-553.
19. Sheldon Memorial Art Gallery, "Big Canvas: Paintings from the Permanent Collection," *Gallery Notes*, Lincoln, Nebraska, Spring, 2003.
20. Ibid. Eugene Goosen, *Art International*, 2, 8 (November, 1958), 45.
21. "New Features of Summer Session Are Announced," *Canyon News*, January 14, 1937, PHPHM.
22. GOKCR(2), 1143.
23. GOKCR(2), 1145.
24. Alinder, ed., *Ansel Adams, Letters and Images*, 998.
25. GOKCR(2), 1145.
26. "Georgia O'Keeffe, Dead Bones and Live Pictures," *Life*, 28, 4 (February 14, 1938), 28.
27. Naomi Rosenblum, *A World History of Photography*, (New York: Abbeville Press, 1984), 494.
28. SAB, 418.
29. GOKCR(1), 591.
30. Ibid., 507.
31. GOKIW, 7, 9.
32. Ibid., 7, 14, 15.
33. Ibid., 17.
34. SAB, 558, YCAL, Box 189, Folder 3206.

35. GOKIW, inside front cover.

36. Ibid., 32-40.

37. Ibid., 8, 18.

38. Ibid., 20.

39. Ibid.

40. YCAL, Box 189, Folder 3204.

41. GOKCR(2), 1145. *Isamu Noguchi On His Life and Work.* www.noguchi.org/intextall. html (1/19/2003).

42. Museum of Modern Art, MoMA.org | MoMA *Provenance Research Project | List of Works,* 2002. www.moma.org/collection/provenance/list.html (1/23/2005).

43. EB, s.v. "Noguchi, Isamu." "Chronology of the Life of Isamu Noguchi (1904-1931). www.noguchi.org/chrono.html (1/19/2003). "Furniture." www.noguchi.org/furni-ture.html (1/19/2003). "Lowell Gets Medal," *The New York Times,* May 19, 1977. CA&L, 314.

44. GOK, 427.

45. Carolyn Bednarz and Bob Adams, *God Gas Us Arabians,* 2003-2004. www.ggu. manyinterests.com/ (7/20/2004).

46. GOKCR(2), 607-609, 611-615, 617-620.

47. Ibid., 609. GOK, 427.

48. Ibid., 1099.

49. "Anne M'Cormick is 'Woman of 1939.'" *The New York Times,* June 6, 1939.

50. GOKCR(2), 616.

51. Ibid., 1099.

52. Carol Mackey and Sylvia Deaver, "Georgia O'Keeffe and Ghost Ranch," Ghost Ranch Education.

53. Barbara Buhler Lynes and Ann Paden, *Maria Chabot - Georgia O'Keeffe, Correspondence, 1941-1949,* (Albuquerque, N.Mex.: University of New Mexico Press, Georgia O'Keeffe Museum, 2003), xi (hereafter cited as MC).

54. Ibid. xiv.

55. Ibid., xiv-xviii, 119-203, 208, 212, 218, 222, 236-237, 297, 353, 410, 452, 458. Carmella Padilla, "*Los Luceros,*" New Mexico, 83, 4 (April, 2005), 44.

56. "Obituaries," *The New York Times,* July 15, 2001.

57. Ibid.

58. MC, 11, 32, 34-35, 84, 90, 93.

59. Barbara Schmidtzinsky, Ghost Ranch, "Georgia O'Keeffe," September 22, 2003, personal e-mail (9/22/2003). MC, 10, 18.

60. YCAL, Box 183, Folder 3073.

61. "MST&T Celebrates Birthday Mañana," *The New Mexican,* July 16, 1964; Letter from Milton E. Bernet to Alfred Staddard, July 3, 1939, Museum of New Mexico, History Library.

62. MC, 11.

63. Robinson, "Artist's Journey to the Top," PHPHM.

64. Kotz, "A Day With Georgia O'Keeffe," PHPHM.

65. Mucucci, "Historic Houses: Georgia O'Keeffe's Ghost Ranch House."

66. Ibid.

67. Ibid.

68. Ibid.

69. Ibid.

70. Ibid.

71. GOKCR(1), 546, 561-563, 565, 567-568, 574-575. GOKCR(2), 627, 641-642, 647, 659, 662, 705, 726, 728, 815, 837-838.

72. MC, 515.

73. GOKCR(2), 1145.

74. Ibid.

75. GOKCR(2), 629, 646, 667, 1145. MC, 11.

76. GOKCR(2), 643, 1145. MC, 11.

77. GOKCR(2), 1145.

78. Steve Masar, University of Wisconsin, Archives "Research on Georgia O'Keeffe," January 2, 2002, personal e-mail (1/2/2002). Cathy Jacob, University of Wisconsin Archives, "Research on Georgia O'Keeffe," January 4, 2002, personal e-mail (1/15/2002).

79. Cathy Jacob, University of Wisconsin Archives, University of Wisconsin.

80. Ibid.

81. Ibid.

82. University of Wisconsin Archives, Series 5/46, Box 1.

83. Renk, "Two Sun Prairie Women Bring Fame." Georgia's relatives in Sun Prairie: Mrs. J. J. Conrad, Mrs. George Chase, Mrs. Charles Nutting, Mrs. Charles Alberts and Mrs. Louis Huber, SPHM.

84. Daniel Catton Rich, "Exhibition of Paintings by Georgia O'Keeffe," *Bulletin of the Art Institute of Chicago*, xxx, 2, Mount Holyoke College Archives and Special Collections.

85. GOKCR(2), 1145.

86. Ibid., 668.

87. Caroly Jones, "Icons of the West," *New Mexico*, 79, 3 (March, 2001), 58.

88. Ibid.

89. GOKCR(2), 669.

90. Ibid., 670-671, 686, 706-709, 720, 728.

91. Ibid., 664.

92. Ibid., 1099.

93. "Georgia O'Keeffe's Garden of Earthly Delight," *The Virginian*, 92, PHPHM.

94. GOKCR(2), 682-685, 1145.

95. Albert Rosenfeld, "Where the Clock Walks," *Collier's*, 137, 3 (February 3, 1956), 24.

96. GOKCR(2), 1145.

97. POAA, 372-373. "AskArt - Biography for the Artist Gallery, Mary," 2003. www.askart.com/biography.asp (11/25/2003).

98. GOKCR(2), 734, 736.
99. Ibid., 1145. MC, 44, 287.
100. MC, 70.
101. Ibid., 119, 136, 139, 196.
102. Ibid., 142.
103. Ibid., 288.
104. Ibid., 291.
105. Ibid., 294.
106. Ibid., 298.
107. Ibid., 300.
108. Ibid., 301.

CREDIT FOR ILLUSTRATIONS

BLACK AND WHITE ILLUSTRATIONS

Front Cover: Georgia O'Keeffe Reclining on Bench, Campfire Outing, Ghost Ranch, Near Abiquiu, New Mexico, ca. 1940. Photograph by John Candelario, courtesy of Palace of Governors (MNA/DCA), 165666.

COLOR ILLUSTRATIONS

DUST JACKET

1. Town Hall Road and County Road T Area, 2000
 Photograph courtesy of Nancy H. Reily
2. Palo Duro Canyon State Park
 Photograph courtesy of Nancy H. Reily
3. Lighthouse, Palo Duro Canyon State Park
 Photograph courtesy of Nancy H. Reily
4. The "White Place"
 Photograph courtesy of Nancy H. Reily
5. Ghost Ranch Area
 Photograph courtesy of Nancy H. Reily
6. The "Black Place"
 Photograph courtesy of Nancy H. Reily
7. Chimney Rock
 Photograph courtesy of Nancy H. Reily
Nancy Hopkins Reily, Sun Prairie, Wisconsin, 2000
 Photograph courtesy of Don Reily

INDEX

ABOUT THE AUTHOR

Nancy Hopkins Reily was a classic outdoor color portraitist for more than twenty years and has taught portrait workshops at Angelina College in Lufkin, Texas where she had a one-woman show of her portraits. Her advance studies included an invitational workshop with Ansel Adams. Reily graduated from Southern Methodist University and lives in Lufkin, Texas.

Printed in the United States
87579LV00005B/1-48/A